KU-429-479

VISUAL POLITICS

VISUAL POLITICS

The Representation of Ireland
1750–1930

Fintan Cullen

CORK UNIVERSITY PRESS

First published in 1997 by
Cork University Press
Crawford Business Park
Crosses Green
Cork
Ireland

© Fintan Cullen 1997

All rights reserved. No part of this book may be reprinted or reproduced or utilized in any electronic, mechanical, or other means, now known or hereafter invented, including photocopying or recording or otherwise without either the prior written permission of the publishers or a licence permitting restricted copying in Ireland issued by the Irish Copyright Licensing Agency Ltd, The Irish Writers' Centre, 19 Parnell Square, Dublin 1.

British Library Cataloguing in Publication Data
A CIP catalogue record for this book is available from the British Library.

ISBN 1 85918 023 X

Typesetting by Red Barn Publishing, Skibbereen

Printed in Ireland by ColourBooks Ltd.

CONTENTS

Acknowledgements *vii*

List of illustrations *ix*

INTRODUCTION 1
 Representing Ireland

 In the Beginning

 An Acceptable Ireland

1 ARTISTS ON THE MAKE: IRISH ARTISTS IN LONDON 14
 Irish Artists and the Royal Academy

 Outsiders

 Hone's *The Conjuror*

 James Barry

 The Education of Achilles

 Acceptability

 Shee, Mulready and Maclise

2 THE ROLES OF HISTORY PAINTING 50
 The Secular and the Dynastic

 The Historical Background of Wheatley's *Volunteers*

 Up-to-Date History Painting

 Enter St Patrick

 A Symbol of Unity

3 PUBLIC AND PRIVATE: PORTRAITS OF UNCERTAINTY 81
 The Public Image

 Reynolds's *The Earl of Bellamont*

 Wilkie's *Daniel O'Connell*

Haverty's *Daniel O'Connell*

Home's *The Marquis of Wellesley*

The Private Image

Hamilton's *Richard Mansergh St George*

4 THE PEASANT, GENRE PAINTING AND NATIONAL CHARACTER 116

How to Depict a Nation

Generalised Readings of Ireland

The Role of Contemporary Fiction

Denying Difference

The Peasant Immigrant

Courbet and the Irishwoman

Ireland as a Woman

5 PAINTING THE MODERN 160

The Case for Realism

Conclusion

Notes and References 175

Bibliography 209

Index 217

ACKNOWLEDGEMENTS

The preoccupations of this book began interesting me many years ago. They found their first exposure during studies at Yale University where I benefited a great deal from the help of Jules Prown, especially in learning how to concentrate on the individual art object. I am also grateful to my other teachers and fellow students at Yale for their intellectual guidance. Assistance has been given to me over the years by libraries and institutions and of course individuals. I would particularly like to thank the staffs of the Yale Center for British Art, New Haven and the Paul Mellon Centre for Studies in British Art, London, the National Gallery of Ireland, Dublin, and the libraries at Trinity College Dublin, the National College of Art and Design, Dublin, the National Library of Ireland, Dublin, the University of Birmingham and the University of Nottingham. I am grateful to various agencies at Yale for initial financial assistance and subsequently to Trinity College Dublin and more recently the University of Nottingham for providing assistance for travel.

Individuals deserving my thanks include Nicholas Alfrey, Brian Allen, Anne Crookshank, Colin Cruise, Robert Dietle, Peter Funnell, Luke Gibbons, Bob Horton, Michael Jacobs, Cathy Leeney, Julian Robinson, Alistair Rowan, Helen Smailes, Paul Stirton, Robert Towers, Nicholas Tromans and John Turpin. Some aspects of this book appeared earlier in article form; I am grateful to the editors of both *Art History* and the *Oxford Art Journal* for their guidance and assistance, in particular Marcia Pointon and Richard Wrigley, respectively. Some of the research included in these pages has been aired at academic seminars and conferences, London, Paul Mellon Centre, 1987; Dublin, Eighteenth Century Ireland Society, 1989; Washington, DC, College Art Association, 1991; Leeds and Birmingham, Association of Art Historians, 1992 and 1994; The University of Leicester, Victorians and Race Conference, 1995; New Haven, Connecticut, Symposium in Honour of Jules Prown, Yale University, 1995 and University College, Galway, The Society for the Study of Nineteenth-Century Ireland, 1996. I am grateful to the organisers and to the audiences of all of these presentations for their reactions.

The anonymous readers of my book proposal to Cork University Press made some very useful suggestions and I hope the book fulfils, to some degree, the support they showed in it. Finally, I thank Eleanor Cullen, who always knew I would do it, and Felicity Woolf, who just wished I would get on and do it. I dedicate the book to them and to Ruairí and Samuel Cullen.

Birmingham and Nottingham
June 1996

LIST OF ILLUSTRATIONS

All measurements are in centimetres. Paintings are oil on canvas unless otherwise stated.

1 Francis Wheatley, *The Volunteers in College Green*, 1779–80, National Gallery of Ireland, detail with James Napper Tandy

2 John Derricke, *The Image of Irlande*, 1581, woodcut, from facsimile edition of 1883, The University of Birmingham

3 John Derricke, *The Image of Irlande*, 1581, woodcut, from facsimile edition of 1883, The University of Birmingham

4 John Derricke, *The Image of Irlande*, 1581, woodcut, from facsimile edition of 1883, The University of Birmingham

5 Temple West (?), *The Corsican Locust*, 1803, engraving, 22.5 × 33, Trustees of the British Museum, London

6 P. Roberts, *An Attempt on the Potatoe Bag*, 1803, engraving, 23.1 × 32.2, Trustees of the British Museum, London

7 David Wilkie, *Chelsea Pensioners Reading the Waterloo Despatch*, 1822, oil on wood, 97 × 158, Apsley House, Victoria and Albert Museum, London

8 George Barret, *View of Powerscourt, County Wicklow*, 1760–2, 73.4 × 92.2, Yale Center for British Art, Paul Mellon Collection, New Haven

9 Jacob More, *The Falls of Clyde, Corra Linn*, 1771, 79.4 × 100.4, National Gallery of Scotland, Edinburgh

10 William Ashford, *View of Dublin from Chapelizod*, 1790s, 114 × 183, National Gallery of Ireland, Dublin

11 Nathaniel Hone, *The Pictorial Conjuror, Displaying the Whole Art of Optical Deception*, 1775, 145 × 173, National Gallery of Ireland, Dublin

12 Johann Zoffany, *The Academicians of the Royal Academy*, 1771–2, 100.7 × 147.3, The Royal Collection © 1996 Her Majesty Queen Elizabeth II

13 James Barry, *The Education of Achilles*, 1772, 103 × 129, Yale Center for British Art, New Haven, Paul Mellon Collection

14 Gavin Hamilton, *Agrippina Landing at Brindisium with the Ashes of Germanicus*, 1772, 182.2 × 25.7, Tate Gallery, London

15 *The Torso Belvedere*, first century BC, marble, height: 159, Vatican Museums (photo in reverse)

16 James Barry, *Self-Portrait with Paine and Lefèvre*, c. 1767, 59.7 × 49.5, National Portrait Gallery, London

17 James Barry, *Self-Portrait as Timanthes*, c. 1780–1803, 76 × 63, National Gallery of Ireland, Dublin

18 Daniel Maclise, *Merry Christmas in the Baron's Hall*, 1838, 183 × 366, National Gallery of Ireland, Dublin

19 Daniel Maclise, *Daniel O'Connell and Richard Lalor Sheil MP*, 1834, 21.2 × 13.1, lithograph from *Fraser's Magazine*, National Gallery of Ireland, Dublin

20 Daniel Maclise, *The Origin of the Harp*, 1842, 111.8 × 86.4, City of Manchester Art Galleries

21 Daniel Maclise, *The Marriage of Strongbow and Eva*, 1854, 309 × 505, National Gallery of Ireland, Dublin

22 Benjamin West, *The Battle of the Boyne*, 1778, 152.5 × 211, Collection of the Duke of Westminster

23 Francis Wheatley, *A View of College Green with a Meeting of the Volunteers on 4 November 1779, to Commemorate the Birthday of King William*, 1779–80, 175 × 323, National Gallery of Ireland, Dublin

24 John Singleton Copley, *The Collapse of the Earl of Chatham in the House of Lords, 7 July 1778*, 1779–81, 228.5 × 307.5, Tate Gallery, London, on loan to the National Portrait Gallery, London

25 Vincent Waldré, *Sketch for ceiling of St Patrick's Hall, Dublin Castle*, c. 1788–90, oil on canvas, 137 × 83, Royal Dublin Society

26 Francis Wheatley, *The Volunteers in College Green*, National Gallery of Ireland, Dublin, detail of the Duke of Leinster

27 Francis Wheatley, *The Volunteers in College Green*, National Gallery of Ireland, Dublin, detail with FitzGibbon and La Touche

28 Grinling Gibbons, *Equestrian statue of William III*, 1700–1, bronze, destroyed

29 Francis Wheatley, *The Irish House of Commons*, 1780, Lotherton Hall (Leeds City Art Galleries)

30 Valentine Green after John Trumbull, *General Washington*, 1781, mezzotint, 63.5 × 40.6, National Portrait Gallery, Smithsonian Institution, Washington, DC

31 *Richard Montgomery*, 1777, engraving, 15.6 × 8.6, from the *Hibernian Magazine*, 1777

32 *James Napper Tandy*, 1784, line engraving, 20.5 × 11.7, National Gallery of Ireland, Dublin

33 *Prerogatives Defeat or Liberties Triumph*, 1780, engraving, 23.4 × 29.8, Trustees of the British Museum, London

34 Regalia of Order of St Patrick, Badge and Collar, c. 1910

35 Vincent Waldré, *George III, supported by Liberty and Justice*, c. 1788–c. 1801, 678 × 678, Dublin Castle, The Office of Public Works, Ireland

36 Vincent Waldré, *St Patrick converting the Irish to Christianity*, c. 1788–c. 1801, 325 × 683, Dublin Castle, The Office of Public Works, Ireland

37 Vincent Waldré, *King Henry II receiving the submission of the Irish Chieftains*, c. 1788–c. 1801, 325 × 683, Dublin Castle, The Office of Public Works, Ireland

38 Benjamin West, *The Institution of the Order of the Garter*, 1787, 137 × 83, The Royal Collection © 1996 Her Majesty Queen Elizabeth II

39 John Tenniel, 'Two Forces', *Punch*, 29 October 1881

40 Joshua Reynolds, *Earl of Bellamont*, 1773–4, 245 × 162, National Gallery of Ireland, Dublin

41 David Wilkie, *Daniel O'Connell*, 1836–8, 239 × 140, Royal Bank of Scotland Art Collection

42 J. Kenny Meadows, 'The Irish Frankenstein', *Punch*, 4 November 1843

43 David Wilkie, *Gen. Sir David Baird Discovering the Body of Sultan Tippoo Saib*, 1835–8, 350.4 × 268, National Gallery of Scotland, Edinburgh

44 Thomas Lawrence, *George Canning, MP*, 1825–6, 238.8 × 147.3, National Portrait Gallery, London

45 William Ward after Joseph Patrick Haverty, *Daniel O'Connell, MP*, 1836, mezzotint, 73.5 × 45, National Gallery of Ireland, Dublin

46 Henry Raeburn, *The MacNab*, c. 1814, 243.8 × 152.4, United Distillers, Edinburgh. Reproduced by courtesy of the Trustees, The National Gallery, London

47 Robert Home, *Richard, Marquess Wellesley*, c. 1801, 233 × 152.4, private collection

48 Hugh Douglas Hamilton, *Lieutenant Richard Mansergh St George*, 1796–8, 214 × 152.5, National Gallery of Ireland, Dublin

49 David Wilkie, *The Peep-O-Day-Boy's Cabin, in the West of Ireland*, 1835–6, 125.7 × 175.2, Tate Gallery, London

50 David Wilkie, *The Irish Whiskey Still*, 1840, 119.4 × 158, National Gallery of Scotland, Edinburgh,

51 Thomas Roberts, *Lucan House Demesne*, early 1770s, 61 × 100, National Gallery of Ireland, Dublin

52 David Wilkie, *An Irish Baptism*, 1835, graphite and watercolour on paper, 41.8 × 29.6, Trustees of the British Museum, London

53 David Wilkie, *The Spanish Posada: A Guerrilla Council of War*, 1828, 74.9 × 91.4, The Royal Collection © 1996 Her Majesty Queen Elizabeth II

54 Léopold-Louis Robert, *The Brigand Asleep*, 1826, 46.3 × 37.2, Wallace Collection, London

55 Correggio, *An Allegory of Virtue*, c. 1525–30, oil on panel, 100 × 83, National Gallery of Scotland, Edinburgh

56 Joseph Patrick Haverty, *Advocates in a Good Cause. Fr. Mathew Receiving a Repentant Pledge-Breaker*, c. 1846, 107 × 137, National Gallery of Ireland, Dublin

57 George Petrie, *The Last Circuit of Pilgrims at Clonmacnoise, c.* 1838, graphite and watercolour on paper, 67.2 × 98, National Gallery of Ireland, Dublin

58 Ford Madox Brown, *Work*, 1852–63, 137 × 197.3, City of Manchester Art Galleries

59 Ford Madox Brown, *Work*, City of Manchester Art Galleries, detail of Carlyle and Maurice with Irish immigrants behind

60 *The Irish Street Seller*, 1861, from Mayhew's *London Labour and the London Poor*, 1861–62

61 Ford Madox Brown, *The Irish Girl*, 1860, oil on canvas laid on board, 28.5 × 27.3, Yale Center for British Art, New Haven, Paul Mellon Fund

62 'Height of Impudence', *Punch*, 1846, vol. XI, p. 245

63 George Frederic Watts, *The Irish Famine*, 1849–50, 180.34 × 198.12, Watts Gallery, Compton, Surrey

64 Walter Howell Deverell, *The Irish Vagrants*, 1853–4, 63.4 × 77.2, Johannesburg Art Gallery

65 Gustave Courbet, *The Studio of the Painter: A Real Allegory Summing up Seven Years of my Artistic Life*, 1854–5, 361 × 598, Musée d'Orsay, Paris

66 Gustave Courbet, *The Studio*, Musée d'Orsay, Paris, detail

67 James Barry, *Study for the Act of Union between Great Britain and Ireland, c.* 1801, pen and ink over black chalk, 709 × 524, Ashmolean Museum, Oxford

68 *Carrying the Union*, 1800, engraving, 25.6 × 47.5, Trustees of the British Museum, London

69 Gustave Courbet, *Portrait of Jo, the Beautiful Irish Girl, c.* 1865, 54 × 65, Nationalmuseum, SKM, Stockholm

70 James McNeill Whistler, *Weary*, 1863, drypoint, 19.5 × 13, Trustees of the British Musem, London

71 John Butler Yeats, *Lily Yeats Reclining, c.* 1897, graphite on paper, 25.6 × 35.5, private collection

72 John Butler Yeats, *W. B. Yeats*, 1889, black wash with white highlighting over graphite on blue paper, 10 × 17.7, private collection. Photo: Albany Institute of History and Art

73 Seán Keating, *Allegory, c.* 1925, 102 × 130, National Gallery of Ireland, Dublin

74 Seán Keating, *Night's Candles Are Burnt Out*, 1928–9, 99.1 × 104.1, Oldham Art Gallery

75 Mainie Jellett, *Decoration*, 1923, tempera on board, 89 × 53, National Gallery of Ireland, Dublin

INTRODUCTION

THIS BOOK EXAMINES THE DEVELOPMENT AND TRANSFORMATION OF IRISH subject matter in painting from the late eighteenth century to the early twentieth century. The aim is to see how Ireland has been defined visually and to examine the role of cultural identity in a series of carefully analysed images. The thrust of much of the argument is focused on individual paintings. In discussing those images, attention is paid to the traditional academic hierarchy for painting: history painting, portraiture, genre, etc., leading to a final consideration of the introduction of a form of modernism in the 1920s. This generic format also assists in the chronological thrust of the book, the discussion of history painting being largely confined to the late eighteenth century, that of portraiture extending into the early nineteenth century and so on.

The book examines how Ireland was represented. The representation of Ireland is a broad term: it does not just mean the representation of the landscape but encompasses a more varied concern with the issue of Ireland, its people, its history, as well as political and cultural concerns. In examining how Ireland was represented, this book is not about 'Irish art', that is, an exclusory preoccupation

1

with defining a particular school. Rather it is about the relationship between Ireland and the visual, primarily painting. The focus is on painting, but that preference does not mean to imply that this is a superior medium to, for example, graphic images, sculpture or architecture. To attempt a cross-media discussion of the type proposed in this book, over the period covered, would make for an unnecessarily long and unfocused survey, as opposed to the series of concentrated analyses that is offered.

The individual chapters examine representations by both native and foreign-born artists. The role of the work of foreign artists, in the main British artists, in the history of the portrayal of Ireland has long been recognised, but rarely studied in any detail. This situation is perhaps due to the fact that the historiography of Irish imagery of the eighteenth through to the early twentieth centuries has been dominated by connoisseurship and biography with an emphasis on revealing a forgotten canon of Irish artists. Given that political and cultural integration was one of the most dominant features of Irish life during the period, it is surprising how little attention this subject has received from art historians.[1] In the chapters that follow, an attempt will be made to discuss how different forces worked towards creating a culture of acceptance where difference was allowed, but only under the banner of imperial dominance. This work will acknowledge the pioneering research of those who listed and identified Irish visual material, but it will also recognise the need to expand our understanding of the art of the period through a more thorough awareness of political and cultural history.

The cultural implications of colonialism within the former United Kingdom of Great Britain and Ireland have of late been the preserve of literary, intellectual and social historians. The Field Day pamphlets published in Ireland throughout the 1980s, culminating in the colossal three-volume (soon to be four) *Field Day Anthology of Irish Writing*, have focused attention on the need to study Irish literature in terms of its colonial past.[2] To these volumes can be added the separate work of Seamus Deane and Luke Gibbons, as well as researches by David Lloyd, Terry Eagleton and W. J. McCormack.[3] Historians, too, have contributed to the debate, most especially Roy Foster, Tom Dunne and Oliver MacDonagh.[4] It seems timely for the visual arts to take their place around the table of Irish cultural studies.

In saying that the concentration in Irish art historiography has been largely connoisseurship is not to say that things are not changing. Twenty-five years ago the subject was hardly taught in Irish third-level institutions, and reproductions of Irish paintings and other images were very difficult to obtain. This has fortunately all changed. The major collections in Dublin, Cork and Belfast frequently

produce well illustrated and researched catalogues, while monographs and spe-cific period studies are on the increase.[5] Recent texts such as *Ireland: Art into History*, edited by Raymond Gillespie and Brian P. Kennedy and *Visualizing Ireland: National Identity and the Pictorial Tradition*, edited by Adele Dalsimer, are welcome contributions to a slowly growing literature.[6] These two texts are, on the whole, issue led. In this they are innovatory in an Irish context. Gillespie and Kennedy's collection of essays as well as Dalsimer's compilation are ambitious in their scope, their contributors ask useful questions or reveal rich areas for research, but the overall results are disappointingly limited in their achievement. In her introduction to *Visualizing Ireland* Adele Dalsimer says that the study of the pictorial representation of Ireland has to be 'subjected to as ambitious an analysis as, for example, Andrew Hemingway's *Landscape Imagery and Urban Culture in Early-Nineteenth Century Britain* (1992)'.[7] This is all very well, but Hemingway's ambitious volume is the result not only of extensive primary research into London's thriving nineteenth-century art market, but was also possible due to the scholarship that had gone before. Generations of monographs on indi-vidual artists and more recent revisionist examinations of the place of landscape in English culture allowed the author to ask new questions about the nature of British visual imagery, without the burden of biographical detail or connois-seurial niceties. The problem with the study of Irish imagery is that it has not yet fully gone beyond this stage and one has to accept that the exploratory work has to be done. But in exploring the pictorial material available, a greater aware-ness of the cultural role of the visual needs to be addressed.

One essay in *Visualizing Ireland* will prove my point. In an essay on Francis Wheatley's Irish paintings, a topic that I will examine in Chapter Two, James Kelly neatly pulls all the facts together, informs us of this English born artist's years in Ireland from 1779 to 1783 and discusses the large oil of a Volunteer demonstration on College Green, Dublin, dated 1779–80, now in the National Gallery of Ireland (Figs. 1 and 23).[8] Kelly checks the reality of the incident against Wheatley's representation and concludes that the latter does not tally with the former. The problem is that Wheatley was producing art, not fact. The Dublin painting has to be seen in terms of what Wheatley (and other artists of his day) and perhaps his potential patrons were trying to achieve. There is a strong case for seeing this image as a new type of history painting and thus a challenge to the dominant genre in the academic hierarchy. All of which leads one to ask the question as to what an essay such as Kelly's is trying to do, for if, as the editor of *Visualizing Ireland* says in her introduction, Irish imagery needs a more rigorous analysis, should not that analysis be done with a sensi-tivity to the peculiarities of the visual?

It is the application of that more rigorous analysis to the discource of the visual that *Visual Politics* attempts to achieve. In Chapter Five the discussion focuses on the two modes of representation available in a newly independent Ireland: the traditionalist, realist art of the academician Seán Keating and the innovative, avant-garde abstractions of Mainie Jellett (Figs. 74 and 75). In a study of the connection between the visual and the political, where context is uppermost, questions have to be asked as to which is the most appropriate, the accessible and immediately relevant as in the case of Keating's visualization of

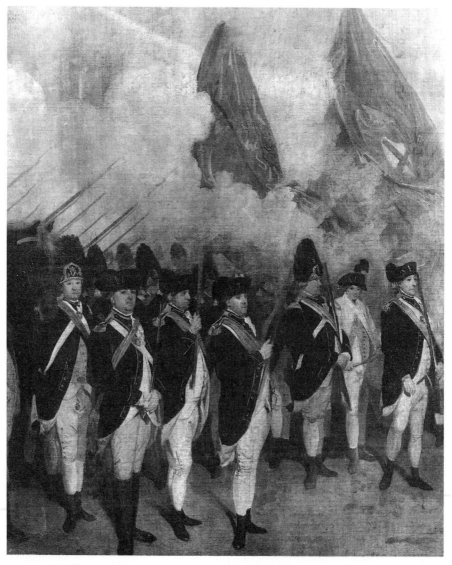

1) Francis Wheatley, *A View of College Green with a Meeting of the Volunteers*, 1779–80, detail with James Napper Tandy on the far right

the building of a hydro-electricity complex on the River Shannon in the late 1920s, or the arcane, highly private art of Jellett, concerned as it is with 'the inner principle and not the outer appearance'.[9]

REPRESENTING IRELAND

In attempting to discuss the representation of Ireland one is immediately drawn into making a distinction between *what* is represented and *who* represented it. This book discusses both subject matter and the artists involved, be they Irish born or from abroad. Most of the images discussed are by artists who either lived in or visited Ireland, but that does not always mean that they necessarily had a very complete understanding of what they represented. As Chapter Four will demonstrate, the two paintings that sprang from the Scottish-born Sir David Wilkie's short visit to the west of Ireland in 1835 (Figs. 49 and 50), are illuminating exercises in the development of a nineteenth-century international recognition of Ireland's worth as the subject matter of large-scale exhibition paintings. Although based on experience and developed from drawings made on the spot, these images deny, through their final compositional form, an acknowledgement of Irish difference. The Irish peasant families portrayed in Wilkie's large canvases convey the acceptable charms of a tightly-knit Holy Family, recalling the dramatic colouring and grace of many a celebrated painting by Titian or Correggio.

Ireland was also represented by artists who never visited Ireland. Reference is made to the cartoons and caricatures, usually emanating from London, that have for so long ridiculed the Irish both at home and abroad. But the concentration of this book is on high art and the representation of the Irish in exhibited or more considered forms of representation. The reason for this is that it has not been adequately done before. Ireland, during the period covered by this book, was formulated into a series of stereotypes that have been examined and continue to be examined largely through the extensive satires that appeared in *Punch* and similar journals. What has perhaps not been recognised is the equally rich, even if less abundant, representation of the people and issues of Ireland in paintings by such distinguished names within the canon of British art as Sir Joshua Reynolds, Ford Madox Brown and George Frederic Watts (Figs. 40, 58, 61 and 63). Thus Chapter Three discusses Reynolds's portrait of the Irish peer, the Earl of Bellamont (Fig. 40), painted in London between 1773 and 1774. Reynolds is not thought to have visited Ireland, but such an oversight should not prevent us from discussing his highly dramatic

and impressive portrayal of an Irishman, especially when one places the por-
trait in the context of eighteenth-century literary and, in particular, stage rep-
resentations of the Irishman in London. Images of less exalted Irish immigrants
produced by artists associated with the Pre-Raphaelite Brotherhood (Figs. 58,
61 and 64) during the immediate post-Famine years will be discussed in Chap-
ter Four, leading on to an analysis of how and why the French artist Gustave
Courbet included a poor Irishwoman, whom he claimed he saw on the streets
of London, in his immense *The Studio of the Painter: A Real Allegory Summing
up Seven Years of my Artistic Life* (Fig. 65), painted between 1853 and 1854.
None of these painters visited Ireland and it is even doubtful whether Courbet
visited London.

The historical representation of Ireland cannot be viewed except in relation
to traditions current, on the one hand in England and, on the other, within the
context of the dominant Western academic norms. A link between the various
chapters of this book is the analysis of the visual language used in painting to
represent a nation. The use of the word 'language' refers to the variety of styl-
istic traditions at the disposal of the artist over the two hundred year period
from *c.* 1750. Thus the representation of Ireland undergoes a series of transfor-
mations that sees the country represented in terms of Renaissance Holy Fam-
ilies (Figs. 49–50), Counter-Reformation altarpieces (Fig. 36) or idealised
classical landscapes (Figs. 8 and 51). It can thus be claimed that, in general
terms, the crude answer as to how Ireland is represented over the period cov-
ered is that it is done in a highly conservative manner and yet that is not to say
that the history of that representation is necessarily dull or uninspired. Rather
we need to investigate how form conveys purpose.[10] Thus, the rejuvenated
Baroque language used by the Dublin executive to decorate a ceiling in Dublin
Castle at the very end of the eighteenth century (Figs. 35–37), where the
national image of St Patrick is allowed to greet visitors to the great ceremonial
Hall, is comparable to the distinctly Van Dyckian manner in which Bellamont
had himself painted by Reynolds some twenty years earlier (Fig. 40). By rep-
resenting Ireland in an uncontroversial language, the form overrides the subject
to negate any hint of subversion. Similarily, Wilkie resorts to old master prece-
dents in his classicised genre paintings, asking us to think of any number of six-
teenth-century Italian masters as we pass our eyes over his picturesque subjects.
Finally, as outlined in Chapter Five, Seán Keating's maintenance in the 1920s
and 30s, of a staunchly academic approach in the face of modernist innovations
(Fig. 74), especially from late Cubist Paris (Fig. 75), indicates a continuation of
a defiantly conservative tradition.

IN THE BEGINNING

The fact of the visual representation of Ireland being so deeply connected with the visual language of external forces, be it England or the rest of Europe, is perhaps so obvious an observation that its examination has not received the attention it deserves. But ignoring the obvious can often lessen our power to understand historical development. Although this book will concentrate on the late eighteenth century to the early twentieth century, the representation of Ireland in visual modes determined by the coloniser has, of course, a longer history. An early example is John Derricke's series of woodcuts to illustrate his poem, *The Image of Irlande*, published in 1581 (Figs. 2–4). Formally, these cuts initially stem from the narrative woodcut designs of Hans Holbein the Younger, of Basle, who died in England in 1542. Derricke's designs are also products of the more indigenous English histories produced as pro-Protestant propaganda from the mid-century onwards.[11] Derricke's book is ostensibly a descriptive account of the woodkern, or native Irish soldier, during the late Tudor period. The focus is on the MacSweeney clan of Co. Donegal and tells us a great deal about 'their habit and apparell', but the book's twelve woodcuts are also very much a celebration of English supremacy.[12] Fitting into the formula for representing Protestant heroes, as in Foxe's *Actes and Monuments* (1563), the book's tightly-knit groups of columnar figures frequently dominate the composition, surrounded by wide-view scenes, full of incident, with castles, horses and armour.[13]

Derricke's account is based on hearsay, and recent assessments see it as Derricke's imaginative image of what the Irish may have been like.[14] Representations of the fighting Irish appear in up to half the prints but, despite the title of *The Image of Irlande* and the subtitle of 'A notable discouery most lieuly describing the state and condition of the Wilde men in Ireland, properly called Woodkarne', the series is really about Sir Henry Sidney, Elizabeth's viceroy in Ireland, and is intended to convey his total control of the Irish situation.[15] Dedicated to Sidney's son, Sir Philip, the father enacts a triumphal conclusion to the book in that we are offered a description of Thurlough Luinagh O'Neill's submission to Sidney in 1575. The series of woodcuts and their accompanying verses have various themes, including an account of the wildness of the Irish, their uncivilised manners and their eventual submission. These themes are punctuated with anti-Catholicism and the brutally crude underlining of English military power. At least half of the twelve woodcuts show the might of the English forces. Reference is continuously made to the ill-equipped nature of the Irish forces, while visually we are offered print after print of serried ranks of well-disciplined English infantry. The courteous, benign face of Sidney is equally

offered as a contrast to the rugged features of the Irish chieftains; where Sidney's dress is smart and refined the Irish appear dishevelled and crude.

There are similarities between the representation of the wild Irish in Derricke's woodcuts and the depiction of the Irish on the Elizabethan stage. Kathleen Rabl has discussed the various ways in which the Irish were represented in dumbshows and plays from the 1580s onwards.[16] Derricke's poem was published in 1581, a few years before the appearance of *The Misfortunes of Arthur* in 1587. Here the wild Irish are symbols of disorder in the realm, a position held by Derricke's woodkerns, as represented in the original Plate 2, where they rebel against the English yet also ravage their own population (Fig. 2). In the woodcut an Irish couple on the far right react in terror as their home is set on fire:

> Here creepes out of Sainct Filchers denne a packe of prowling mates,
> Most hurtfull to the English pale, and noysome to the states:
> Which spare no more their country byrth, then those of th' English
> But yeld to each a lyke good turne, when as they come in place.[17]

In *The Misfortunes of Arthur* the wild Irish are likened to the Devil. Rabl claims that 'the Catholic Celt epitomizes the disruptive moral and political sins that must be eradicated in the peaceful Anglican commonwealth of an ideal monarch like the "Faerie Queen"'.[18] To Derricke the Irish priest is an easy

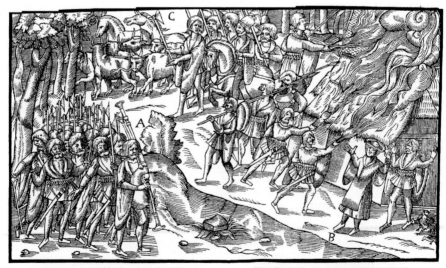

2) John Derricke, *The Image of Irlande*, 1581

target for devil-like representation. In Derricke's Plate 4 (Fig. 3) a friar appears three times; twice he blesses the chieftain, MacSweeney, while in the final section of the print the verse beneath informs us that:

> The fryer then, that traytrous knaue, with Ough, Ough hone lament,
> To see his coosin Deuills sonnes, to haue so fowle euent.[19]

In the lower right of the woodcut, the flapping hands of the friar resemble devil-wings, while his tonsured head appears to sprout horns. Behind this lamenting group a flame-haired Irish kern also appears devil-like. Rabl goes on to point out how the villainous Celt is soon joined in late sixteenth-century drama by the appearance of the Irish kern as a comic turn, the *miles gloriosus*. Citing the example of *The Famous History of Captain Stukeley*, a play popular in the 1590s, Rabl discusses how the historical Shane O Neale and his followers are reduced to a funny, drunken rabble who undergo a series of humiliating scenes.[20] Again Derricke's woodcuts offer comparable visual representation. In the well-known Plate 3, *The MacSweeney at Dinner* (Fig. 4), much is made both in word and image of the lack of a table and of basic cooking implements, the eating of uncooked offal and of defecating kerns off to the right.[21] G. C. Duggan and J. O. Bartley have brought our attention to the dialogue between the various Irishmen in the Dundalk scene of *Captain Stukeley*, pointing out the

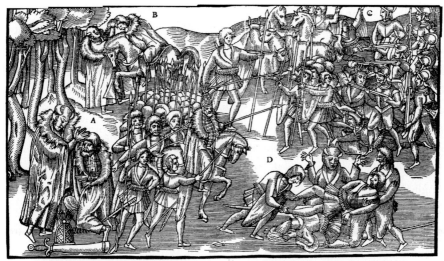

And when with myth and belly cheere, they are sufficed well,
Marke what ensueth, a playne discourse, of Irish sleightes I tell:
A The fryer then absolues the theefe, from all his former sinne.
 And bids him plague the princes frendes, if heauen he minde to winne.
D which being sayd, he takes his horse, to put in practise then,
 The spoyling and destroying of, her graces loyall men.

4

C But Loe the souldiers then the plague, vnto this Karnish rowt:
 To yeeldethem vengaunce for their sinnes, in warlicke sort rise out.
 They presse the rancoure of the theeues, by force of bloudy knife.
 And slay the pray they filch away, depriuing them of life:
D The fryer then that traytrous knaue, with Ough Ough hone lament:
 To see his coosin Deuills sonnes, to haue so fowle euent.

3) John Derricke, *The Image of Irlande*, 1581

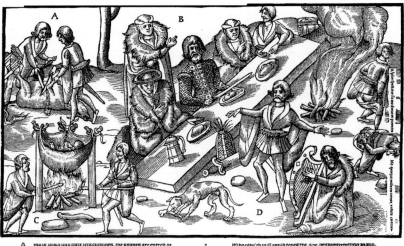

A yᵃⁱⁱ ᵗᵒ ᵂᴴᵏᵉᴺ ᴀⁿⁱ tᴴᵉⁱʳ ᵗᵉⁿᵗ ᵉⁿᵗᵒⁱⁱⁱⁱ, ᵗʰᵉ ᶠⁱᵃᵘᵉˢ ᵃʳᵉ ᵉⁿᵗʳᵉⁱ ⁱⁿ,
 To ſmite and knocke the catteil doʷne, the hangmen doe beginne.
 One pluckerh off the Oxes cate, which he euen noʷ did ʷeare:
 Another lacking pannes, to boyle the fleſh, his hide prepare.
c Theſe themes attend vpon the fire, for ſeruing vp the feaſt:
B And Fryer ſmelfeaſt ſneaking in, doth preace amongſt the beſt.

3 ʷho play’ th in Romiſh toyes the Ape, or counterfeiting Paull.
 For which they doe aʷard him then, the higheſt roome of all.
 ʷho being ſet, becauſe the cheere, is deemed little ʷorth:
 Except the ſame be intermixt, and lae de ʷith Iriſh myrth.
D Both Barde, and Harper, is preparde, which by their cunning art,
 Doe ſtrike and cheare vp all the geſtrs, ʷith comfort at the hart.

4) John Derricke, *The Image of Irlande*, 1581

seeming authenticity of how O Neale and his men criticise the English for their inability to adapt to the Irish diet and climate. Despite the English author's possible knowledge of the locality and his use of a smattering of Gaelic, the joke is in fact on the Irish, who praise Irish butter and oatmeal and dismiss English 'bread and beere, porrage and powdered beefe'.[22] Instead of beer the Irish drink water which 'brings [the English] to the flixe', an old term for diarrhoea. The Stukeley play may divert Derricke's attention from Irish to English bowel movements, but the humour is still on the Irish who depend on such an unsophisticated libation. This dialogue is really all about the difference between the Irish and the English. D. B. Quinn rightly points out that the woodcut of the Mac-Sweeneys feasting 'is mainly intended as a satire on Irish residual primitiveness', and the same could be said of the Stukeley play.[23] This concentration on difference is also part of an ongoing process, in various media, of the Elizabethan propaganda machine to depict the Irish in a wide range of negative guises. Derricke is very specific in his Preface as to whom he is referring: 'that it is not our Englishe Pale, which in any respect I have touched . . . but a people out of the Northe, whose usages I behelde after the fashon there sette doune'.[24] Disorder is clearly in operation here in the wild north, while vice is represented in the character of the friar attending the banquet, referred to as Friar Smellfeast. Together with the scatological humour on the right, this print neatly draws together both the theatrical and visual representation of the Irish.

The focus on eating habits in both Derricke's woodcut and the play, *The Famous History of Captain Stukeley*, highlights the difference between civilised

English behaviour and the wild Irish. Andrew Hadfield and Willy Maley have argued that 'one of the most important ways in which Ireland was read in this period was as a series of negative images of Englishness . . . The development of "Englishness" depended on the negation of "Irishness".'[25] Derricke's wood-kerns and by implication all the native Irish are shown to be not good enough to be English.

AN ACCEPTABLE IRELAND

One of the ambitions of this book is to outline how, from the late eighteenth century and through the nineteenth century, Ireland, in visual terms, became 'good enough' to be represented, not necessarily as English but as at least comparable to the neighbouring island. A culture of difference, as will be seen, is softened in favour of an art of union. A little over three hundred years after Derricke's woodcuts, a culture of political interdependence is most graphically demonstrated in a large number of prints produced in London in 1803. Acting as pleas for national unity, only a few years after the passing of the Act of Union, these sheets display the loyalty of the Irish in the face of French aggression and fears of a Napoleonic invasion. In the *Corsican Locust* (Fig. 5), a winged Bonaparte envies the hearty diet enjoyed by the free-born subjects of George III: 'Bless me,' he says, 'how comfortably thes [sic] people live.' Below, John Bull, Paddy the Irishman and Sandy the Scot sit around a picnic of their national diets, roast beef, potatoes and Scotch broth, respectively. To a degree such images as these are merely illustrations of Lord Grenville's statement when Prime Minister a few years later that 'We want men, Ireland wants a vent for its superabundant population: could not these two wants be reconciled?'[26] But, at the same time, such prints are proof of a change of heart. The Irish have the potential to be acceptable. As the catch-all trope for Ireland, the potato features again in *An Attempt on the Potatoe Bag* (Fig. 6), where Napoleon endeavours to bribe the Irishman into assisting his cause. A few Irish ('a few . . . that are rotten at the Core') have helped the French, but the Irishman says that the 'Sly Teaf of the World' will never 'get the whole Bag'.[27] This print is datable to August 1803, which would suggest that the Irish potatoes which have turned rotten by exposure to French contagion may specifically refer to the Emmet rebellion of the previous month.[28]

A couple of decades later this military representation of union found one of its most popular expressions in a painting commissioned by the Irish-born Duke of Wellington. In 1816 he suggested a painting to the Scottish-born genre painter David Wilkie, which became the *Chelsea Pensioners Reading the*

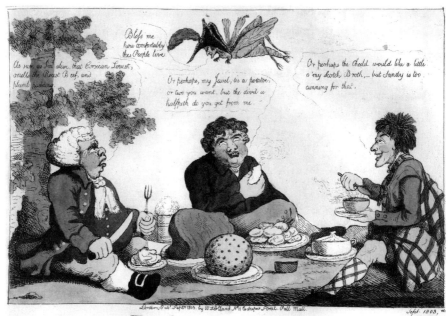

5) *The Corsican Locust, 1803*

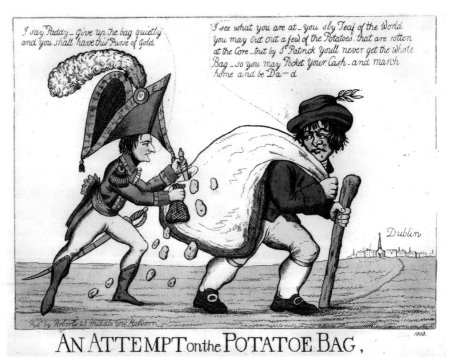

6) *An Attempt on the Potatoe Bag, 1803*

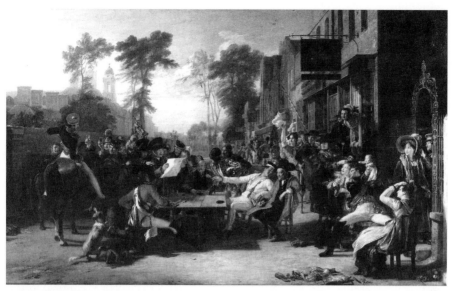

7) David Wilkie, *Chelsea Pensioners Reading the Waterloo Despatch*, 1822

Waterloo Despatch (Fig. 7), exhibited to great acclaim at the Royal Academy in 1822.[29] An indirect celebration of Wellington's victory over Napoleon, the painting is also an acknowledgement of the many types and regional backgrounds that were present in the British army during the Napoleonic era. Of the fifteen prominent characters who perform leading parts in the painting, at least two are Celts. On the far left we find a Scottish Highlander, while an Irishman of the Twelfth Dragoons appears at the centre right. Although Wilkie aimed for accuracy in his depiction of the soldiers gathered outside Chelsea Hospital, and even consulted Maria Edgeworth on the details of Irish military dress,[30] his characterisation of the Irish soldier, the man dressed in white conversing with a Chelsea pensioner, ends up fulfilling the traditional stereotypes of the Irishman as drinker and braggart. The Irish soldier holds a beer tankard, 'telling the news', as Wilkie's biographer would have it, 'to the veteran who is hard of hearing . . . both are touched with liquor, and the youngest seems to be saying to the elder, Bunker Hill was but a cock-fight to this'.[31]

In Wilkie's painting, Ireland fulfils well-worn stereotypical expectations and yet the inclusion of the Irishman, in what was one of the most popular paintings exhibited at the Royal Academy in the nineteenth century, is but one example of the rich array of national representations that historians of Irish visual imagery have too long ignored.

— 1 —

ARTISTS ON THE MAKE

IRISH ARTISTS IN LONDON

THE LITERATURE OF IRISH ART, AS WITH THE COMPARABLE LITERATURE of Scottish art, has rightly emphasised the stylistic affinities that existed in the eighteenth century between developments in London and those that took place in Dublin and Edinburgh.[1] Country house landscapes by the Irish-born artist George Barret (Fig. 8) dating from the early 1760s and by the Scottish painter Alexander Nasmyth dating from later in the century have similar aims, both aesthetically and ideologically, to English and Welsh views by Richard Wilson. Formally such paintings are part of the British pictorial tradition derived from the classical landscape paintings of Claude Lorrain and his European followers. The Barret shows obvious structural similarities to Claude: the lucidity and highly ordered nature of the view asks for immediate comparison with scenes of a settled classical world where no strife is ever evident. This is not to disregard the clear topographical ambitions that lie behind the production of these paintings. What needs to be emphasised is not the empirical fact of the production of sophisticated visual records of carefully maintained estates, but the fact that by the second half of the eighteenth century parts of Ireland, and Scotland for that matter, were being physically created into 'little replicas of England'.[2]

Just as the landscape painter Richard Wilson had created the Roman Campagna in deepest Wiltshire, so too Irish artists and landscape artists from abroad working in Ireland recorded, and at times improved upon, the transformation

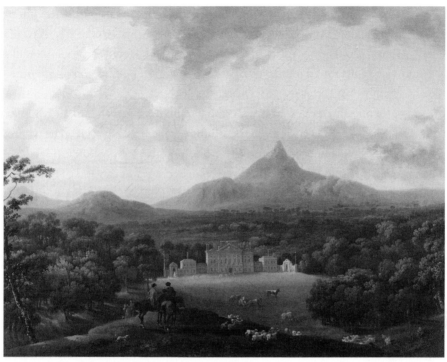

8) George Barret, *View of Powerscourt*, 1760–2

of their local landscapes. J. H. Andrews has written that, throughout Ireland, 'the noblemen's and gentlemen's residences of the 18th century were the most imposing new houses to be built since the middle ages . . . [whatever style] they all made the same historical point: peace had come to Ireland, apparently for good'.[3]

In the Barret, that 'peace' is indicated by the Palladian solidity of Powerscourt, as well as by the appropriation of the language of universal classicism. Such views as Barret's Powerscourt and views of the neighbouring Dargle River in Co. Wicklow are the earliest recorded images of Ireland shown at a public exhibition in London. Two such views appeared in the 1764 exhibition of the Society of Artists and provide a useful comparison with a collection of Scottish views, in particular the Falls of Clyde exhibited at the same venue by Jacob More in 1771 (Fig. 9).[4] The image of the Celtic Fringe conveyed to the London spectator is that of wild yet noble landscapes. Prior to this date, London was unacquainted with imagery of the periphery, but in these images the Irish country house can be seen to be maintaining a taming influence over the sublime mountain behind, while its rich pastures are encroaching on the surrounding forest. More's *The Falls of Clyde, Corra Linn*, also possesses a wild sublimity, but this too is tempered by the presence of the toga–clad group in the foreground.[5]

Representations of Ireland appeared more frequently in London after about 1775, when William Ashford regularly dispatched landscapes to the Royal Academy.[6] Ashford's Ireland consists of Claudian-inspired views of peaceful walks through well cared for estates or topographical views of Dublin and its environs. The image of Ireland conveyed to a London viewer was of a serene environment boasting a richness in natural beauty. In the Dublin paintings the urban complex is suitably removed to a far distance and dominance is seemingly given to nature, a river in the foreground with a nearby wood populated by wildlife (Fig. 10).[7] All of this was of course standard landscape practice towards the end of the eighteenth century, yet in the context of Ireland in the late 1790s things are not always that simple. On the left of Ashford's painting, directly above the stag, on a hill overlooking the city of Dublin, the artist has included the Magazine Fort in Phoenix Park where the British army kept munitions. A cortège of soldiers winds its way towards the heavily protected structure. On one level we can read the painting as a highly positive image, a wide open landscape, framed by a host of military buildings, the Fort on the left and on the right the elegant spire of the Royal Hospital with the gloomy pile of Kilmainham Gaol nearby. The expanding city lies beyond. Classical structures are visible both on the horizon,

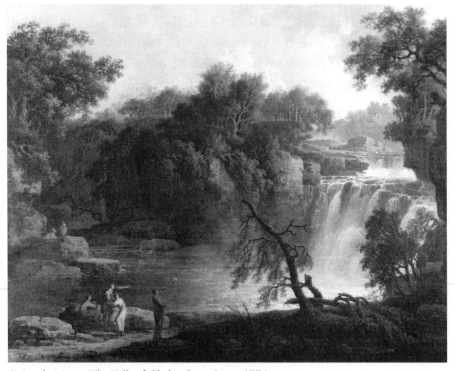

9) Jacob More, *The Falls of Clyde, Corra Linn*, 1771

with James Gandon's newly opened Four Courts, and in the foreground an equally new bridge at Islandbridge.[8] Such signs of civilisation, placed in union with the stag, the grazing cows by the river and the untroubled traveller on the road in the bottom right, convey a land of peace and contentment. David Solkin has said as much about the representation of Wales by Richard Wilson some thirty years earlier. Solkin has convincingly found irony in the fact that, in the light of agrarian disturbances in England after the Seven Years' War, the Welsh landscape:

> As portrayed in the works of Wilson and other artists . . . offered itself as a refuge of tranquillity, a place inhabited by happy swains who remained blissfully deaf to the 'voice of discontent'. In Wales the natural, organic social structure existed as it had done for centuries, continuing to bring contentment to peasant and landlord alike: here was true liberty, impervious to the licentiousness that abounded elsewhere. Hence what was presented as a landscape of liberty actually functioned, when we examine it closely, as a landscape of reaction.[9]

In the Ashford painting a seemingly peaceful Claudian construction is grafted on to a potent symbol of British presence in Ireland. By including the Magazine Fort and the mounted guard, reference is made to Ireland's colonial status. Commissioned by Earl Camden, Lord Lieutenant from 1795 to 1798,

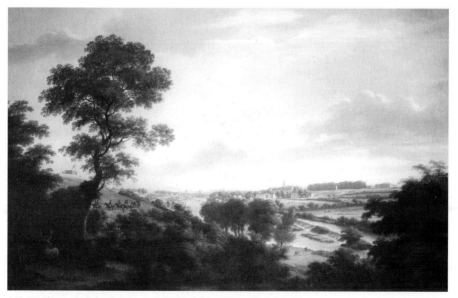

10) William Ashford, *View of Dublin from Chapelizod*, 1790s

a period of unease that resulted in the rebellion of 1798, Ashford's view is one that conveys not so much a landscape of reaction as a landscape permanently under surveillance.[10]

One of the important things to be noted about the artists already discussed is that they depended on London for survival. Works were either continuously sent for exhibition to the Royal Academy, as in the case of William Ashford, or the artist pursued his career in the metropolis. Dublin's modest quota of patrons was not capable of supporting a wide range of artists. Dublin could indeed boast of the establishment of one of the earliest training schools for artists in these islands, but the opportunities for public exhibition were limited and, even then, portraiture was the chief ingredient of most displays.[11] What we have, then, in the history of the representation of Ireland is a story not so much of an Irish school of artists as of the metropolis appropriating, through approved visual forms, an Irish subject matter, initially in landscape, as in the examples of Barret and Ashford, but also, as will be seen, in portraiture and genre painting.

Of those artists who remained in or returned to Ireland after time abroad, many felt they lived in a vacuum. Letters of the Irish portraitist Hugh Douglas Hamilton written from Dublin to his friend, the Italian sculptor Antonio Canova, between 1794 and 1802, tell of the feeling of isolation and cultural despair felt by the Dublin-based artist.[12] In Ireland, he claims, there is no one with whom he can discuss art. Writing in Italian, Hamilton laments that to be in Dublin 'è quasi in esilio per uno che ama l'arte dal vero' (is like being in exile for the person who truly loves art), going on to wish that he was in Rome where he could see Canova's work:

> There is little evidence here of artistic talent and that that I have has been ruined by the endless portraits that I am forced to produce. Accordingly my health has deteriorated, and yet I do get some satisfaction and amusement from producing the occasional historical drawing. But my enthusiasm soon wanes due to the total lack in this country of an understanding or liking for such things.[13]

Such a situation is seconded by an anonymous Dublin diarist who, on visiting one of the occasional exhibitions held in Dublin at the time, commented that:

> As usual in an infant exhibition, that of this year, consists in the figure line almost entirely of portraits; in fact had the artists practising in Ireland inclination, ability and sale for composition, portraiture is at present so much the rage, that they have not leisure for any other branch of study.[14]

In his letters to Canova, Hamilton asks for news of his artistic friends in Rome and laments Dublin's lack of taste, art critics and exhibitions. A comparison with artistic life in Edinburgh in the early years of the nineteenth century is constructive. In 1819, the portrait painter Henry Raeburn wrote in similar vein to David Wilkie in London, begging for information on the art world and artists in the south and saying how he has had:

> as little communication with any of them and know almost as little about them as if I were living at the Cape of Good Hope. I send up generally a picture or two to the Exhibition, which serve merely as an advertisement that I am still in the land of the living, but in other respects it does me no good for I get no notice from anyone nor have the least conception how they look beside others . . . I know not in what London papers any critiques of that kind are made and our Edinburgh ones take no notice of these matters.[15]

The problem with Dublin and Edinburgh was that everything happened elsewhere. Local influence was minimal. The overriding influence on the development of Irish artists was the taste and ideals of the European academy. The Dublin art schools looked, as did all European schools of the time, with respect on the classical past, they attempted to preserve Renaissance traditions of correct draughtsmanship and encouraged admiration for the modern masters. The message learnt by young artists was that they acquire a basic training and then go to the centre, in this case London, usually after a period of further study in Italy.[16]

How then can we discuss those artists who went away in relation to the representation of Ireland? It is perfectly true that they all executed the occasional Irish work, but what about their careers in general? Are patterns discernible that might help us to gauge the status of Irish-born artists operating in London from the middle of the eighteenth century to the middle of the nineteenth century?

IRISH ARTISTS AND THE ROYAL ACADEMY

A recent essay by Roy Foster entitled 'Marginal Men and Micks on the Make: The Uses of Irish Exile, c. 1840-1922' has outlined an intriguing array of individual case studies of both Irish and English intellectuals and politicans who, to use Foster's words, 'were in some sense "caught" between the two countries'.[17] The examination of the often awkward relationship that resulted from being involved in both camps can just as easily be brought back a hundred years and

the focus placed on a selection of Irish-born artists who became members of the Royal Academy of Arts, the most elevated institution for artists in these islands, between its foundation in 1768 to the early years of Victoria's reign. The experience of the artists to be discussed will be seen as one that changes from aggression and confrontation to respect and acquiescence. The concentration will be on five men. Two of the artists are from the eighteenth century, Nathaniel Hone (1718–84) and James Barry (1741–1806), and three from the nineteenth century, Sir Martin Archer Shee (1769–1850), William Mulready (1786–1863) and Daniel Maclise (1806–70). The concentration on these five artists is, of course, deliberate. They were all members of the Royal Academy, the earliest, Nathaniel Hone, being a founding member; Barry became Professor of Painting and the only member in the history of the Academy to be expelled, while Shee rose to the exalted position of fourth President.

Combativeness defines Hone's and Barry's relationships with the Academy and it is one of the tidy coincidences of history that the year 1775 saw them launch separate yet weighty attacks on the London art establishment. In both cases the figure of Sir Joshua Reynolds, the first President of the Royal Academy, looms large. Hone is famous for his attack on Reynolds in the painting he entitled *The Pictorial Conjuror, Displaying the Whole Art of Optical Deception* (Fig. 11), which he attempted to display at the annual exhibition held in the spring of that year. Some months earlier, in January, Barry published his first book, *An Inquiry into the Real and Imaginary Obstructions to the Acquisition of the Arts in England*. Here, among other things, Barry lamented the dearth of British patronage for history painting and a lack of concern for such a situation among British artists. Although Reynolds is never mentioned by name, he must surely, as William Pressly has pointed out, be at the back of Barry's mind when he calls for a change of heart:

> It is . . . to be hoped that they will no longer find it practicable to play the part of the dog in the manger, as they have hitherto done; for indeed a great many of the blocks and impediments that were thrown in the way of superior art, have been greatly owing to the secret workings and machinations of these interested men: and if they can do nothing else, they will at least endeavour to turn the attention of dilettanti towards the breeding up of history-painters for the next age.[18]

The behaviour of both Hone and Barry was hot-headed, turbulent and probably egotistical. Their actions have, perhaps, parallels in the careers of such Irish literary *émigrés* as Oliver Goldsmith and Richard Brinsley Sheridan, who,

in Seamus Deane's words, carry in their life and work, 'a suppressed ambiguity which owes its origins to [their] Anglo-Irish inheritance'.[19] By contrast, the three nineteenth-century Royal Academicians represented Irish success stories in London. Shee, the eldest, together with Mulready and Maclise, demonstrated an excessive zeal for the Academy's authoritative systems, while publicly and privately they strove for respectability and metropolitan acceptance. As with the case of yet another Irish literary *émigré*, the poet Thomas Moore, who was known to all three of the second group of painters, by the 1840s the role of the Irish artist was not one of being an outsider and a malcontent, but one who pleases the centre and thus by extension strengthens the Union.

When charting the markedly different relationships that Irish-born artists had with the Royal Academy, it should be made clear at the outset that member-ship of that Academy was an important ingredient in professional fulfilment. What artists of the late eighteenth and early nineteenth centuries sought, as has been recently claimed, 'was the realization of the status academic theory said they should have' and the right to 'pursue subjects which were not trivial, and to execute on a large scale — and yet still find buyers'.[20] Both Barry and Shee were also leading members of a small band of London-based artists who took to the defence of their profession in print. Both artists wrote lengthy polemics on the academic system, even if their views were essentially very different. Writing from a decidedly radical viewpoint, Barry supported a more demo-cratic role for art, seeing it as an instrument for improving public taste, while Shee represented a more conservative shift, advocating what has been termed 'the patronage lobby', which privileged the power of individual collectors and connoisseurs.[21] An occasional poet as well as a painter, Shee saw the Academy as a metaphor for maintaining the status quo:

> In yonder pile by royal bounty plac'd,
> The Graphic Muse maintains the throne of Taste,
> Surveys again reviv'd, her ancient powers,
> And smiles as genius there unfolds her flowers.
> Though public favours still but feebly glows,
> And no fond care th' incumber'd state bestows;
> Surpris'd she views in vigorous verdure rise
> Th' exotic blooms that bless'd serener skies;
> And lays exulting, as the fruits refine,
> Her annual offering at the public shrine.[22]

ST. MARY'S COLLEGE
BELFAST. 12.

OUTSIDERS

Johann Zoffany's well-known group portrait of Royal Academicians (Fig. 12) is a splendid example of the growing confidence that the founding of the Royal Academy gave the artistic profession in London. Over thirty Academicians gather in person or in effigy, as in the case of the two women founding members, Angelica Kauffmann and Mary Moser, in the life class of Somerset House, the home of the early Academy. Standing directly behind the nude model to the right and leaning elegantly against a white backdrop, Zoffany has placed the portrait painter Nathaniel Hone.[23] Painted between 1771 and 1772, Zoffany's group pre-dates the scandal surrounding Hone's painting of *The Conjuror* by three years, but here he unknowingly supplies us with a tantalising tableau of the protagonists. With his head in profile, Hone directs our gaze across the room to the discussion in the centre left, involving the ear-trumpet-holding President of the Academy, Sir Joshua Reynolds. Finally, just above Hone's head, Zoffany has placed a rectangular portrait of that other leading actor in *The Conjuror* saga, Angelica Kauffmann.

Hone's *The Conjuror*

The story of Hone's famous visual attack on Reynolds has been told many times, but what has not been asked is how his Irish origins may have played a part in his highly combative behaviour. Hone's painting of *The Conjuror* (Fig. 11) ridiculed the President, underlining his tendency to borrow extensively from the old masters to achieve flattering and dignified compositions for his aristocratic sitters. For the conjuror, the Irish artist refrained from using Reynolds's own features but instead opted for the easily recognisable visage of one of the President's models, an aged pavior named George Wright. This witty substitution, combined with the shower of prints that reveal Reynolds's extensive 'borrowings', are the main themes of the painting. Shown at the Academy's annual exhibition in 1775, the painting was removed after complaints from Angelica Kauffmann.[24] Originally, Hone had included a background group of naked figures parading in front of St Paul's Cathedral. The reference here was to the recent scheme to decorate the interior of the cathedral, a project supported by Reynolds and James Barry.[25] A possible female figure was discernible amongst this group. Kauffmann objected to the Academy, seeing a direct reference to herself, as she was one of the six artists involved in the scheme. Kauffmann was, it should be added, rumoured to be involved in a

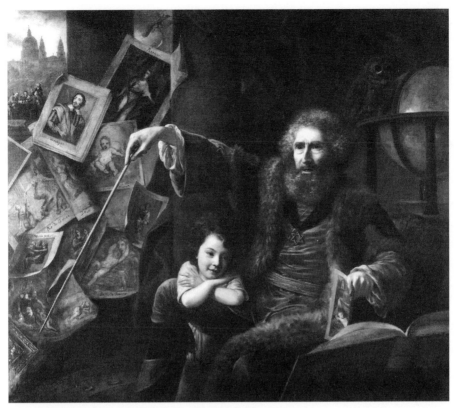

11) Nathaniel Hone, *The Pictorial Conjuror*, 1775

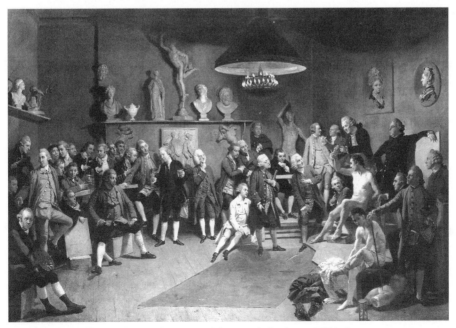

12) Johann Zoffany, *The Academicians of the Royal Academy*, 1771–2

relationship with Reynolds and, it has also been suggested, is to be seen as the young girl leaning against the conjuror's knee.[26] Hone painted out the offending nudity, leaving us with the fully-clad group now visible in the painting, but to no avail – the Academy still refused to show the painting.[27] In defiance Hone held what must be one of the earliest one-man-shows in London, exhibiting *The Conjuror* along with some one hundred of his other paintings. A range of issues is thus addressed in the painting, from accusations of plagiarism to sexual libel. But is there more to it than mere jealousy and a wish to undermine the most successful painter of the day?

Recent discussion of Goldsmith and Sheridan has highlighted the element of 'otherness' in their writings that can only be explained by their Irish origins. Owen Dudley Edwards has suggested that Sheridan attacks the false sophistication of his day by tearing it asunder before the audience's eyes: 'victory is achieved when provincial life proves superior to that of the metropolis', reminding us of how Lady Teazel, in his most famous play, returns her diploma to the London School for Scandal. 'Naturally', Dudley Edwards remarks, Sheridan did not say 'Ireland' instead of the regions:

> it was difficult enough to command a modest victory for the English provinces. But Ireland was at the back of it: even if Richard Sheridan left Ireland young, his art came first of all from his Irish parents. We certainly need to recognise in *The School for Scandal* (1777) a whole flame of anger.[28]

Note the date, 1777. Hone's *The Conjuror* was exhibited only two years earlier. Was there a contemporaneous and comparable 'flame of anger' attending Hone's visual as opposed to theatrical attack? And did that flame emanate from a friction between the periphery and the centre? Firm answers cannot be given to these questions and we must remain in the realms of speculation. But, in the context of a study on the relationship between the visual and the cultural politics of a given period, parallels can be drawn which at least suggest that the right questions are being asked. Goldsmith, for example, raised the issue of the tension between the metropolis and the periphery by highlighting the gap between the hard life of the village (*The Deserted Village* was published in 1770) and the luxury of town life, 'the Lissoy of his youth, and the Vauxhall he patronized in his maturity'.[29] Much of Hone's anger in *The Conjuror*, and much of the thrust of his ingenious and highly scholarly satire, is aimed at Reynolds' so-called plagiarism. The magician-figure conjures up a plethora of prints after old master paintings that bear testimony to Reynolds' failure in imaginative composition. Most of the prints are Italian in origin, produced by or after artists

such as Michelangelo, Raphael, Marcantonio Raimondi and Pietro da Cortona.[30] An anti-Italian stance is being taken by Hone, but he is also indulging in an anti-metropolitan attack. Although a founding member of the Royal Academy, Hone in his own work did not attempt the historicised grandeur of his rival. Instead, much of his portraiture has a Dutch precision about it, doubtless inherited from his earlier career as a portraitist on enamel, but it also exhibits a penchant for Dutch, genre-like, details.[31] Hone's work can be placed within the naturalist style of Hogarth and what could be seen as the beginnings of an English empirical tradition,[32] but, as an Irishman, did this still simmering battle of traditions prematurely spill over into the more politically sensitive area of national rivalry?[33]

In time, Hone himself was, ironically, to become the victim of satire. In 1796, Anthony Pasquin, in his often libellous *An Authentic History of the Artists of Ireland*, vehemently condemned Hone's attack on Reynolds and then finished his entry on the Irish artist by telling a story, the authenticity of which can be considered doubtful, of how Hone contrived to get commissions as an itinerant portrait painter. Pasquin's story is of interest for two reasons. It sends up the Reynolds-led custom of pandering to the vanities of the gentry and the aristocracy by dressing them in classical garb, but spins such practice on its head by claiming that the anti-Reynolds Hone did the same. Even more interestingly, Pasquin's account is clearly reminiscent of Goldsmith's famous passage in *The Vicar of Wakefield* (1766) where the Primrose family are painted in allegorical fashion. A further connection between Hone and Goldsmith as Irish debunkers of metropolitan fashions is thus created. Pasquin relates how Hone:

> was accustomed to ride up to the best inn in town, and beg to dine with the family. If there were any children, he began his operations in flattering the feelings of the mother, by praising the exceeding beauty of Master or Miss. This eulogy was followed by an enquiry, if their pictures had been drawn; which, if succeeded by a negative, he immediately disclosed his profession, and offered his services – the portmanteau was unpacked, and the operations began; while the fond and partial parents hung in rapture over his shoulder: the lady exclaiming at intervals, 'Well, I protest, that is the very model of our Bobby! how charmingly his eyes are done! and then, husband, how natural is the frill round his sweet neck! – Lord, Sir! I vow you shall do me too, and all the rest.' Thus he made his establishment secure, and gave general satisfaction, by offending truth and outraging taste; making the children as angels, the mother as a Venus, and the husband as a well-fed Job, in a brown periwig![34]

Goldsmith had described a comparable scene in his novel of thirty years earlier. The vanity of the Primrose family is memorably revealed in the representation of the family 'in one large historical family piece'. The Vicar's wife 'desired to be represented as Venus . . . Her two little ones were to be as Cupids by her side.' The Vicar himself would appear presenting his wife with his books on 'the Whistonian controversy. Olivia would be drawn as an Amazon . . . Sophia was to be a shepherdess.' Moses would appear with a hat and a white feather while the 'Squire appears as Alexander the Great, at Olivia's feet'.[35]

Pasquin attempts to indicate a volte-face on Hone's part, that hypocrisy lurks behind his attack on Reynolds' borrowings when in fact the Irish artist played the same game himself. Unfortunately for Pasquin, there is little evidence of Hone painting many classically inclined pieces and nothing as elaborate as the satirist's fantasy.[36]

James Barry

Barry's relationship with the Academy and, by extension, the English artistic establishment was as fraught as Hone's, but more complex. Their separate attitudes to the St Paul's project highlight the differences between the two men. In *The Conjuror*, Hone ridiculed the (to him) pretensions of the artists involved to paint the interior of the cathedral, perhaps the only British attempt in the eighteenth century to rival the history-based schema of so many continental decorative projects. By contrast, Barry, who may well even have set up the plan,[37] saw its failure as a major stumbling block in promoting history painting in England. Two contrasting attitudes to the metropolis are discernible. Hone disliked the Italianate bent of the new Academy and, although his favouring Dutch realism over the generalised abstractions of Reynolds does not imply anti–intellectualism as such, his creation of *The Conjuror* speaks of a distrust of erudition. Barry was inherently a more learned man who, as both his art and his writings show, saw the cultures of the Mediterranean as explaining human development. And yet his relationship with the Academy was difficult. Although an Academician by the age of thirty-one and Professor of Painting at the Academy at forty, Barry's perceptions of the role of the institution differed greatly from his colleagues. The story of Barry's endless run-ins with the administrators of Somerset House, leading to his expulsion in 1799, has been well told by William Pressly;[38] suffice it here to recall one particular concern that preoccupied him in his criticisms of the establishment. Dedicated to history painting and to the instruction of the young, the Irishman, for well over a quarter of a century,

criticised the Academy for failing to promote the former or adequately equip the latter. Much of his incriminating *A Letter to the Dilettanti Society*, published over two years, 1798 to 1799, tells of the inadequacies rife at the Academy.[39] Education, or the lack thereof, is one of the main areas of complaint:

> is this British Royal-Academy never to be in reality what it has so long pretended to be, a school for the painters of an enlarged, sublime character, comprehending all the great requisites of art? Where is the generous patriotism that has achieved so much for the health, convenience, and information of our public, by the hospitals, repositories, and other noble institutions which grace this metropolis of the British empire? [40]

Barry suggests physical improvements to Somerset House so that the teaching and viewing of art might be improved. The purchase of art for instruction had always been a concern of Barry's; he had even gone off on a lengthy tangent on the subject in the middle of his published description of the painting *The Distribution of Premiums* in the Royal Society of Arts,[41] and now in the final year of the century he was carrying on the battle.

The Education of Achilles

The artist's concern with education as a tool of enlightenment was central to his philosophy and, when we turn to an early painting such as *The Education of Achilles* of 1772 (Fig. 13), we can examine how these life-long preoccupations are visually manifest, as is a desire to subtly allude to his native country, Ireland. Exhibited at the Royal Academy in 1772, *The Education of Achilles* is the work of a young man, newly returned from a six-year study period in France and Italy. It is among the first four paintings that the artist exhibited at the Academy, all of which were history subjects, and the first such painting that he sold in London.[42] As such, the painting was a success. But given Barry's subsequent tumultuous relationship with the Academy, it is worth exploring this early piece to examine how it anticipates preoccupations and themes that can be encountered in Barry's later career. Such preoccupations include his belief in the didactic role of art, the glorification of Greek culture, the importance of religion and the possible drawing of connections between his admiration for the lost Hellenic world with the all-too-present state of his home country.

Deeply committed to high art, the young Irishman had spent his time in Paris and Rome viewing the antique and the modern, returning in a determined

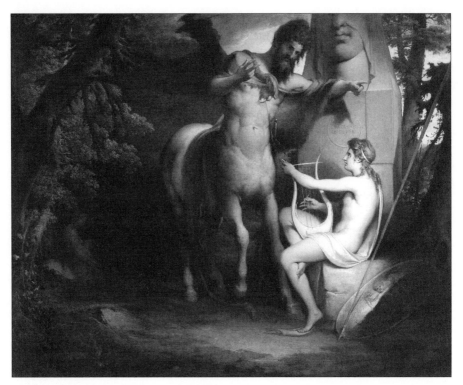

13) James Barry, *The Education of Achilles*, 1772

mood to promote the cause of his chosen genre. So what do we see? Firstly, it is a modest-sized canvas in which two figures predominate. The centaur in the middle with the finely elongated torso is Chiron, an immortal, famed for his teaching skills and wisdom. The young Achilles, the future warrior-hero of Homer's *Iliad*, sits to the right. The setting is a forest glade where Chiron instructs his charge in the playing of the lyre. Achilles plucks the strings 'with those hands', as Ovid tells us, 'which were one day to send Hector to death'.[43] Achilles listens to his master; Chiron gesticulates, the tools of his teaching being much in evidence: a sword hangs from his side, he points towards a spear, next to which lies a shield, while on the ground, much foreshortened and drawn in the dirt, in front of Achilles' foot, is a Euclidean theorem. Beyond, deeper into the forest on the left, is a female centaur nursing an infant – an alternative, private world, it could be suggested, to the public life of leadership and war ordained for Achilles. More dramatically, rearing up behind is a massive carved head, its upper face veiled; a Greek inscription, framed in a serpent on the plinth, reads 'All things: one and in one'. This is Minerva, the goddess of wisdom, appropriate for the tale of pedagogy being depicted, but also, as William Pressly has indicated, a reference to 'veiled, enigmatic wisdom . . . [a] mute witness to

the belief that ultimate knowledge is only to be found in the transcendence of liberating death'.[44] Some twenty years later, writing on the iconography of Minerva, Barry would quote from Plutarch's *Isis and Osiris* referring to the inherent mystery that surrounds the Minerva/Isis cult. In a modern translation the section reads:

> A king chosen from among the warriors instantly became a priest and shared in the philosophy that is hidden for the most part in myths and stories which show dim reflections and insights of the truth, just as they of course suggest themselves when they place sphinxes appositely before the shrines, intimating that their teaching about the gods holds a mysterious wisdom. At Saïs the seated statue of Athena, whom they consider to be Isis also, bore the following inscription: 'I am all that has been and is and will be; and no mortal has ever lifted my mantle.'[45]

The artist creates Minerva's enigmatic status through the use of the veil and by the tantalising cropping of the top of her head and the absence of her eyes. By giving her such a central, albeit in formal terms, background role in the composition, and aided by the Greek inscription surrounded by an ouroboros, a serpent with its tail in its mouth, we are reminded of Minerva's shared Egyptian and Greek heritage and of the importance of replication and continuity. In terms of the depicted narrative, Minerva acts as an inspiration for the young Achilles, but she might also act as an inspiration for the artist himself and his own religious and cultural traditions. By placing his protagonists before Minerva's veiled image, Barry calls attention to the awesome power of history and its on-going relevance.

The puzzling inscription and veiled head suggest unease, a sensation conveyed in more ways than one. Although he dramatically crops the great monolith of Minerva, Barry allows her form and plinth to dominate almost a third of the canvas. Her colossal almost pneumatic representation is reminiscent of what Leo Steinberg has seen as Michelangelo's compulsion 'to take possession of the entire field'. There is a tendency in the earlier artist, Steinberg has observed, that 'any concentration of forms wants to expand, to outgrow its beginnings'.[46] Similarly in the Barry painting Minerva is invested with the potential for expansion, her eyes are beyond our sight while her meaning is not readily discernible. Unease is equally conveyed by Chiron's pointing left hand which casts a shadow which conveniently points downwards towards his protégé. The centaur calls attention to the weaponry of war and the spear in particular, the tip of which rests precariously near Achilles' left heel, reminding us

of how the hero will eventually die. Chiron's fate is equally implied by the shield in the lower right which carries an image of the infant Hercules, clearly a reference to youthful strength, but also a reminder that a poisoned arrow of the adult Hercules would eventually lead to the centaur's death. Pressly has also called our attention to the menacing trees to the left, the oppressive sky and the blood-like flecks of red that litter the ground.[47]

A serious theme, then, from a serious and ambitious artist anxious to make his presence felt in London's artistic circles. Within nine months Barry was elected an Academician and had ready access to the most illustrious intellectual set in the London of the time, dining frequently with his patron, Edmund Burke, and Joshua Reynolds. Preoccupied with elevated themes, a workaholic and highly opinionated to boot, Barry would seem to have had it all. So what are the issues that this image raises about neo-classical history painting, about Barry and his relationship with the Academy?

An inherently conservative art form, history painting celebrated resolved, ostensibly uncomplicated issues: an evocation of masculine heroism, for example, or female fidelity, both neatly summarised in Gavin Hamilton's *Agrippina with the Ashes of Germanicus* (Fig. 14) which was shown at the 1772 Royal Academy exhibition along with the *Achilles*.[48] Barry the history painter, as recent discussion of the artist from an Irish point of view is beginning to indicate, does not necessarily fit the conventional mould. As an Irish Catholic, he was aware

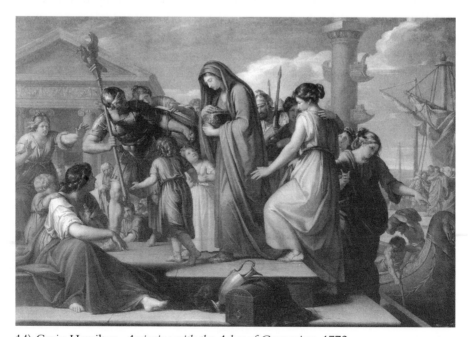

14) Gavin Hamilton, *Agrippina with the Ashes of Germanicus*, 1772

of unresolved problems, and in time his art would address these more openly.[49] For the moment, at the start of his career, he alluded to them more obliquely.

Education is clearly one of the main themes of *Achilles*, underlined as it is by the subject and title of the painting. Running parallel with that is Barry's admiration for ancient art and civilisation and his reading of the public role of art, particularly in Greece. In *The Political Theory of Painting*, John Barrell has led us admirably through some of the more long-winded passages of James Barry's writings.[50] The artist was an inveterate essayist. His first book, *An Inquiry into the Real and Imaginary Obstructions to the Acquisition of the Arts in England*, published in 1775, is in part an attack on a claim by Winckelmann and others that for climatical reasons Britain was incapable of producing worthwhile art.[51] This text also included a brief history of art. This narrative approach to making a point is a feature of most of his writings, including the lectures he later gave to the students of the Royal Academy when, in time, he was made Professor of Painting. Equally, such a narrative approach is central to his cycle of paintings on the history of civilisation in the Great Hall of the Royal Society of Arts in London. We move from the origins of western culture with Orpheus to the golden age of Greek culture, and then jump a couple of millennia to celebrate contemporary England. The final painting, *Elysium*, acts as a kind of bridge for those absent centuries, packed as it is with portraits of great men from all ages and places.

Barrell has pulled together Barry's most important ideas and directs us to the artist's celebration of Greek art, claiming that, possessed as they were of the ideal:

> the Greeks were not simply content to represent it in statuary: they developed a system of education which was designed to encourage the forms of men to approximate to the ideal standard, and not, as do modern systems of education, to oblige them to depart from it.[52]

In the *Inquiry*, written while working on the *Achilles*, Barry claims that the role of art was to present the moral character. In general throughout his writings he enthuses about Greek art and culture in ways that had become quite conventional, but what is new are Barry's repeated remarks about the public nature of ancient art, its moral purpose being closely tied up with its civic display. This didactic attitude to art, he claims, fed into Roman art and in time was adapted for Christian purposes in the republics of pre-reformation Italy and in particular in what Barry called the 'little republic of Florence'.[53] The guiding principle behind this long history of public display was the moral structure of religion. It is thus apt that Chiron teaches Achilles the arts and music, geometry and war, in

the presence of Minerva, a representation of ancient religion. As we know from his writings, Barry admired the tight bond between art and belief that led to an imagery that explained principles to the public at large.

In the *Achilles*, Barry not only chooses a Greek subject but, in tune with his ongoing and subsequent writings, he refers specifically to a monument of Greek art that he mentions continuously in his letters and essays, the *Torso Belvedere* (Fig. 15). Chiron's admittedly elongated torso echoes the celebrated block, minus the jutting thighs, most particularly if seen in reverse and from the side. Barry's painting discusses the merits of Greek education, its attempt to 'approximate to the ideal standard', but certainly in the case of the figure of Chiron, he visualises that process through one of the most famous surviving examples of Greek sculpture.

The *Torso*, Barry wrote in a Royal Academy lecture:

15) *The Torso Belvedere* (photo in reverse)

will appear the most complete, perfect system, or arrangement of parts, that can possibly be imagined, for the idea of corporeal force, which it was intended to represent. The character of all the parts most perfectly correspond with each other, and with the general idea; and if the length, and taper form of the thighs are calculated to obtain the victory in the foot race, which Hercules won at Olympia, yet their agility appears more the consequence of force than lightness, and they are in perfect unison with the loins, abdomen, chest and back, which exhibit a power that might well crush Antaeus.[54]

The importance of the sculpture to Barry is demonstrated by the fact that it had already appeared in the background of an early *Self-Portrait* (Fig. 16) executed in Rome in 1767. Here he appears with two friends, copying the *Torso* which towers above them.[55] A few years later he presented a history painting of the uncommon subject of the abandoned Philoctetes on the Island of Lemnos to the Accademia Clementina in Bologna, where the *Torso* again acted as an inspiration.[56] The piece pops up again and again in Barry's *oeuvre*, terminating in its transformation into the figure of the cyclops which appears on the canvas being held by the artist in the late *Self-Portrait* (Fig. 17) completed in 1803.[57] Here the Irishman portrays himself in no less a guise than as Timanthes, the classical Greek painter, holding one of his pictures.

Barry's admiration for Greece was based on a variety of things: a somewhat romantic notion that the Greek republics were egalitarian idylls: 'Here were no degrading and vile distinctions of tyrants and slaves', he wrote, 'which are ever infallibly sure to render both abominable and useless'.[58] The republicanism of ancient Greece equally encouraged support for religion and art. A fervent supporter of the Americans in the 1770s, Barry was an avowed republican.[59] As a Roman Catholic, Barry sympathised with the Italianate tradition of public church art, seeing it as the most accessible forum for the display of art as well as being directly descended from the Greek tradition. Such a tradition also provided the artist with a more meaningful relationship with his public.

An early painting, and one of the first he exhibited at the Royal Academy, Barry's *Achilles* suggests a number of themes that would preoccupy him throughout his career. As well as a republican and a Roman Catholic, Barry was also of course Irish. The first two categories, as explained, influenced the artist's choice of ancient Greek subjects and his continued preoccupation with the Hellenic tradition. The visual echoes of the *Torso Belvedere* that pepper so much of his work may be just one example of Barry's continued respect for Greek art, but comment must also be made on one other ancient monument that features in the *Achilles*. The painted monument of Minerva, at the foot of which the

young hero sits, does not recall any known sculpture, but to Barry its subject held a personal, cultural significance. Some thirty years after painting the *Achilles*, Barry wrote an account of the story of Pandora to accompany a large print he had made from his original painting which highlights the role of Minerva.[60] Here he draws a direct parallel between the 'majestic regal power of Minerva, or Wisdom' and the saga of an Irish princess reduced to slavery. The implication is that the qualities of Minerva, symbolic as she is of wisdom and what Barry calls the 'superior sensibilities and affectionate tenderness of the heart, which so happily and necessarily accompany the female or maternal character through all animal nature',[61] have over time repeated themselves in later personages from different cultures and epochs. Including a reproduction

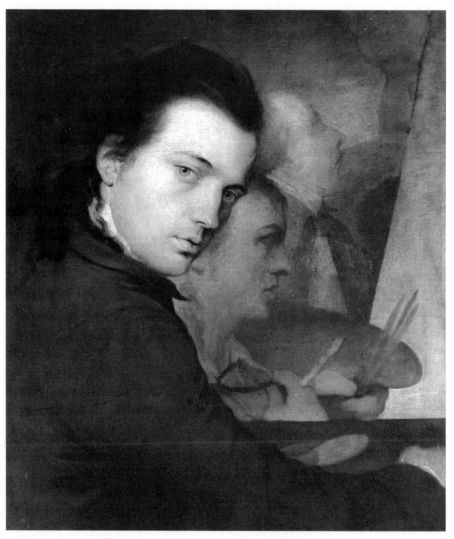

16) James Barry, *Self-Portrait with Paine and Lefèvre, c. 1767*

of a 'Bronze figure of Minerva found in the Tomb of Achilles' in his account, Barry comments on Phidias' inclusion of a sphinx 'on the top of the helmet of the famous statue of Minerva, in the Acropolis', going on to say that:

> This ingenious symbol comprehends more than a mere union of even the bodily force of Ajax and the intellectual provident skill of Ulysses; for the head and breasts shew it to be feminine, and consequently endowed with all the interesting advantages derived from the superior sensibilities and affectionate tenderness of the heart, which so happily and necessarily accompany the female or maternal character through all animal nature, and which, by the capacious reason of humanity, becomes sublimated into a

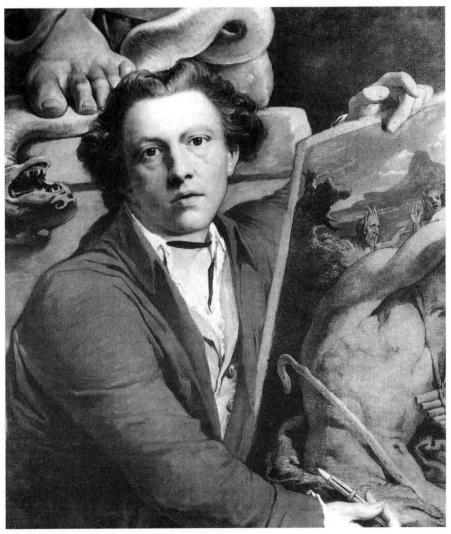

17) James Barry, *Self-Portrait*, *c.* 1780–1803

Cornelia, an Aristopateira, the heroic daughter of my Diagoras; or into a character which appears even superior to either of them, namely the Irish princess, whose interesting story is related by Dr Thorkelin from an old unsuspicious Danish record.[62]

Barry's drawing of parallels between heroines from Mediterranean culture and from ancient Ireland suggests a previously unacknowledged significance for the Minerva in the Achilles painting. Just as the subject of education and the *Torso* quotation inform us of Barry's admiration for Hellenic culture and by extension its influence on public art in succeeding generations, so the great, brooding Minerva has the potential to become a reference to his native country. This realisation of an Irish connection is underlined by Barry when he states that the tale of the Irish princess is 'superior' to the Greek examples that he mentions. What he is doing in the *Achilles* with the inclusion of Minerva is reminding us of the ongoing relevance of history. Minerva is Greek but her inscription recalls Egypt. Different periods in time are thus seamlessly linked, a process that Barry is suggesting in his later writing can now allow ancient Egypt and Greece to be linked with ancient Ireland. For an Irish Catholic of radical politics to be making such links, to be giving the legitimacy of antiquity to such an unresolved problem as 'Ireland', and then exhibiting it at the British Royal Academy, was indeed a novel use of history painting. To Barry, the discourse of history was not a passive force but demanded an active response.

This process of undermining or going beyond the Greco-Roman preoccupations of history painting had been with Barry from the very beginnings of his career. William Pressly and Luke Gibbons have both alerted us to the artist's first attempt at subject painting when still in Ireland in 1763. A painting of *The Baptism of the King of Cashel by St Patrick* was that year exhibited in Dublin and presented to the Irish House of Commons. It can, Gibbons says:

lay claim to be the earliest recorded painting on an Irish historical subject. By its very conception, it represented a triumph of history over art, for in looking to the native past rather than classical exemplars for inspiration, it broke with the axiom that art was born of art rather than the vicissitudes of history.[63]

A few years later, while working on his mural of *Elysium* for the Royal Society of Arts, a similar national bias affected his choice of poet to sit at the apex of his great array of intellectual achievement. For here we find 'our ancient bard Ossian' in the company of Chaucer, Shakespeare, Milton and Moliere. Barry

stresses Ossian's Irishness: 'I have . . . given Ossian the Irish harp, and the lank black hair, and open unreserved countenance peculiar to his country'.[64]

Despite his erudition, the public response to Barry's art was rarely positive. The high idealism of his art and the hectoring tone of his writings and, one supposes, of his conversation made him many enemies. Within months of the exhibition of the *Achilles*, Barry was singled out for abuse by a London critic, Fresnoy, the pseudonym of an Anglican cleric.[65] Barry's Irishness was used to cut him down to size, reference being made to Irish bogs and an abundance of arrogance. The critic says that he will not shirk from criticising the exhibited works of the Academicians:

> I mean to shew your works in other glasses than you yourselves have seen
> them; and I shall first kneel down (I would I had a Milesian bog for a cush-
> ion) at the feet of *Mr Barry*; for he is the most luxuriant of all! but if I do
> not prune his scyons close to the trunk, and that too most carefully, I am
> no gardener in the arts.[66]

This was followed a couple of weeks later by a long open letter to Barry which concentrates its attack more on the artist's opinions and pronouncements rather than just his art, although the *Achilles* is denounced as a painting 'that shuts up our senses and leaves us in a state of *torpor*'.[67] Fresnoy betrays a dislike of history painting and in particular the vehemence with which Barry went about trying to create a place for such an art in the Britain of his day. Fresnoy's assault, which was to be continued in two further letters, includes all the usual criticisms of the Irish. Barry is attacked for his 'mustard-bowl eloquence', of 'beastly *self-adulation* . . . common enough in . . . Irishmen', of vanity and of being an intellectual bully:

> your friend Sir Joshua Reynolds, whose ignorance is your constant theme
> in every place, but at his *own table*, where you are a *constant guest*; I am
> amazed he will suffer you to enter his doors; for he must have heard of
> your *notorious* calumnies; but, perhaps, you have frightened *him* too.[68]

Years later, in *A Letter to the Dilettanti Society*, Barry attempted to counteract the prejudice that he claimed existed towards the Irish by asking for tolerance and acceptance:

> and whenever, by the mercy of God, that time shall arrive, it will be then,
> and not before, that an ingenious artist may expect to find himself the

native of a country that will not be afraid to take an honest interest in the integrity and glory of his labours.[69]

The problem was that the English could not accept an intellectual Irishman. Barry claimed that:

it is a native of Ireland only that is likely to experience the superior excru-
ciating curse of struggling alone, his best friends perhaps so warmly
engaged in the interests of some of his rivals, as to leave him unaided by
any cheering partialities, and without other reliance than what may be
expected from magnanimity and generous candour. An Irish artist may
think himself well off, if his countrymen are not against him, in order to
curry favour for themselves; and that he be not sacrificed to their timidity,
servility, or convenience, whenever he should attempt high matters, where
the success would justify pretension to take any lead or superiority. A can-
didate for a watchman's place, or to carry milk or a sedan chair, may stand
a common chance; but that it is very different in high matters, is too well
known to need my offering instances of great lustre, which may occur to
every man's recollection.[70]

In 1786, Anthony Pasquin, who as we have seen was to lampoon Hone a
decade later, satirised Barry along with many other artists of the day in a pub-
lished but never performed farce entitled *The Royal Academicians*. Dubbed
Jemmy O'Blarney, and described as a 'rough-hewn son of Hibernia', Barry is
continuously in argument with other artists, in particular his fellow Irishman,
the painter of mild erotica, Matthew William Peters, whom Pasquin renames
as the Rev. Mr Priapus. Pasquin's satire was written, he claimed, in response to
the failed scheme to paint St Paul's a decade earlier and thus, like Hone's *The
Conjuror*, criticises a select group of Academicians for their pretensions and in
Pasquin's case for their failure to produce high art.[71] Reynolds becomes Sir Var-
nish Dundizzy, a portraitist; Richard Cosway, seen as a fop, becomes Tiny Cos-
metic. The irony is that Barry was the one artist among the group who actually
did spend his life producing history painting and yet as O'Blarney he shouts and
rages in an Irish brogue, coming out with all the clichés of the satirical prints
of the time: 'shelela', 'agra', 'Na bocklish, honey', etc. Having a touch of the
'Blarney', he is also a great boaster, in this case regarding his proficiency at
ancient Greek. O'Blarney is, according to his fellow Academicians, 'one of the
most extraordinary oddities on the face of the creation, for his *actions* and his
heart are in continual state of warfare'. He is a 'barbarian', a 'bog-trotter', one

'begot in fornication and spawned in infamy' with 'no judgement in anything but the choice of a potatoe'.[72]

Pasquin's reference, in his farce, to Blarney and its famous castle in Co. Cork was to be picked up again long after Barry's death in one of the most sustained satires on the artist. It came from a fellow Irishman and, indeed, a fellow Corkman, Francis Sylvester Mahony, a defrocked Jesuit who wrote scurrilous satires for London magazines in the 1830s, many years after Barry's death. Under the pseudonym of 'Father Prout', in 1836, he published a long, rambling send-up of Barry's time in Rome. In one long passage Barry goes to the Vatican late at night to view the great *Torso Belvedere*, but Mahony refuses to acknowledge Barry's serious purpose. A love affair with Marcella, the daughter of the caretaker of the museums, is revealed, Jesuit espionage is suspected and a murder occurs:

> But what set the seal to the custode's approbation, was the unbounded veneration both felt in common for the huge Torso at the extremity of the gallery – a colossal fragment, known throughout Europe from the many casts which have been taken therefrom, and which, in shape, size, and wonderful attributes, can only be compared to the Blarney stone; of which to the vulgar, it appears an exact facsimile.[73]

The Blarney stone, it will be remembered, when kissed endows one with the gift of the gab, an integral ingredient of the stereotypical Irishman. Luck is also bestowed on one who kisses the Blarney stone. Barry misses out on this good fortune, for the artist's high moral purpose and unending torrent of words, collected and published in two volumes shortly after his death, could not have met with a more devastating rebuke.

Mahony's line in droll verse and humorous essays was to endlessly entertain, being part of a growing nineteenth-century *émigré* Irish fashion to entertain the English and in turn give 'literary respectability to the revamped figure of the stage Irishman'.[74] By ridiculing Barry's idealism and by refusing to understand or acknowledge the artist's attempts to rekindle history painting, Mahony reduces Barry to the condescension and hilarity of Samuel Lover's *Handy Andy* (1842) and other happy-go-lucky Irishmen of mid-nineteenth-century fiction. In Seamus Deane's memorable phrase, 'the Irish were scamps not rebels'.[75] Barry himself had complained that the English thwart the Irish when they 'attempt high matters'; Mahony, despite being an Irishman, does the same. Early in his satire on Barry, Mahony/Fr Prout remembers how in Rome, 'the sportive spirit would rush upon Barry, and . . . [he] would burst forth a wild and grotesque

song, composed in honour of the maritime village where he had spent his young days, manifestly an imitation of that unrivalled dithyramb the "Groves of Blarney"'. This 'grotesque song', *The Attractions of a Fashionable Irish Watering-place*, is supplied in full, but here a single verse is sufficient to get the flavour:

> Mud cabins swarm in
> This place so charming,
> With sailor garments
> Hung out to dry;
> And each abode is
> Snug and commodious,
> With pigs melodious
> In their straw-built sty.[76]

Barry, of course, was never so entertaining, nor did he use his Irishness to gain acceptance. Rather it was met with opposition. *The Education of Achilles* is an early work by one of the most uncompromising of late eighteenth-century artists. Through its historical and in particular its Greek subject matter and its focus on education, Barry lays the foundations of his mature art of the succeeding thirty years: themes of high moral principle that are not passive recollections of a heroic past but active statements on the civic nature of both citizens and artists. As Greek art fed into Christian art, a civic tradition of public art was kept alive. In the *Achilles*, education, a private and civic activity, is celebrated: in the background we are reminded of the family, in the foreground we observe the public sphere. Equally, in the *Inquiry*, published three years after the exhibition of the *Achilles*, Barry quoted Lucian's dialogue, *Of Gymnastik Exercises*, where stress is laid on the civic role together with the personal development of the individual. After discussing the importance of physical exercise, one of the speakers, Solon, goes on to say that:

> There is a contest . . . of another kind, and of much more general concern,
> in which all good citizens should be engaged; and a crown, not made up
> of olive, pine, or parsley, but comprehending the happiness and welfare of
> mankind, as liberty, private and public wealth, &c. All these things are
> interwoven in this crown, and are the result of the contest I speak of, and
> to which these exercises and these labours are not a little conducive.[77]

Finally, it is with the veiled monolith of Minerva who broods so defiantly in the background of *The Education of Achilles* that we get a possible foretaste of

the political potency of Barry's subsequent attempts to transform history paint-
ing into a relevant, contemporary genre.

ACCEPTABILITY

Barry was expelled from the Academy in April 1799 for making allegations,
during the course of his official lectures, of financial corruption by members of
the Academy's Council and also, it has been suggested, for holding pro-repub-
lican sympathies.[78] His removal from the Academy's premises by no means
brought Irish involvement in the Academy to an end. In fact, Barry's actual
participation in the annual exhibitions had been limited. In total he showed
only fifteen paintings or drawings and then only between the years 1771 and
1776; all of these were seen before his taking on the Professorship of Painting
in 1782.[79] And yet, an Irish presence at the Royal Academy was never lacking.
As has been mentioned earlier, Irish landscapes had been exhibited in London
even prior to the foundation of the RA, as in the example of George Barret's
views of Powerscourt from the early 1760s (Fig. 8), and this tradition was con-
tinued by Ashford (Fig. 10) and Thomas Roberts (Fig. 51). Here, representa-
tion was not concerned with fostering an enquiring national consciousness, be
it subtle or otherwise. Instead, these landscapes portray an Ireland of rich nat-
ural beauty fortuitously controlled by an unchallengeable power structure, be
it the presence of the military in the Magazine Fort in Ashford's view of Dublin
from the Phoenix Park or Agmondisham Vesey's ownership of the demesne at
Lucan, as portrayed in Roberts's painting.[80] There is no room here for specu-
lative ruminations on Irish history.

Barry's place on the Academy was soon filled, ironically, by a fellow-Irishman,
Martin Archer Shee.[81] Other Irish artists were also to succeed in the Academy,
such as the history painter Henry Tresham (1751-1814), who became an Acade-
mician in 1799 and was to follow in Barry's footsteps as Professor of Painting in
1807.[82] But in Academy terms, no Irishman succeeded as much as Shee, who
went on to become President in 1830.

Shee, Mulready and Maclise

Shee's life was largely uneventful and his art even more so. A recent history of
the Royal Academy claimed that Shee's 'dignified bearing and Irish tongue were
great assets' to the institution, yet the same source goes on to quote Benjamin

Robert Haydon that Shee was 'the most impotent painter in the solar system'.[83] A sweet talker and an unremarkable painter he may have been, but Shee's rise to the presidency of the Academy saw him become the first Irish-born artist to receive a knighthood.[84] In his account of the artist's career, Strickland usefully supplies us with a witty epigram of the day:

> See Painting crowns her sister Poesy
> The world is all astonished! – so is *Shee*. [85]

Shee's personality and behaviour, from his arrival in London at the age of nineteen in 1788 to his retirement from the presidency of the Academy in the late 1840s, were a dramatic contrast to the careers of his fellow Irish *émigré* artists, Hone and Barry. Within days of that initial arrival in London, Shee visited Barry and left a memorable description of the older artist's foul living and working conditions.[86] Barry showed none of the social graces or courtesies that were to mark his young countryman's rise in the art establishment of early nineteenth-century London.

Shee's friend Byron saw him as 'the poet's rival, but the painter's friend',[87] and certainly the latter is quite an apt summation of his life's achievement. From his days as a student at the Academy's Schools to his holding the presidency, Shee dedicated his life to the institution. Shortly after becoming an Academician, as the war against Napoleon heated up, he tried to organise an Academic Corps, while years later, in the mid-1830s, he immersed himself in a series of lengthy defences of the Academy in anticipation of its move to Trafalgar Square against the attacks of what he saw as 'radicals' in the House of Commons.[88] His pro-Academy stance was such that he also assisted some of his fellow-artists back in Ireland in their attempts to set up a comparable institution that finally became the Royal Hibernian Academy in 1823.[89] The result was, hardly surprisingly, a carbon copy of the London establishment, with Shee becoming an honorary member.[90] Full integration into the cultural life of the metropolis was Shee's aim. His son's all too hagiographic biography ends its first volume with an impressive list of his father's achievements by the 1830s: president of the RA, the recent recipient of a knighthood, a member of the Athenaeum, a trustee of the new National Gallery and of the British Museum, as well as a fellow of the Royal Society. In the light of the histories of Hone and Barry, the Irish artist had now truly made it in London. Indeed, Shee's Irishness does not seem to have been a hindrance, *pace* his Irish tongue as an asset, though the fact that the family rid themselves of what his son and biographer called 'the obnoxious prefix' 'O' may have helped.[91] A comparable

Anglicisation of surname was undertaken by Shee's younger Irish colleague, Daniel Maclise, who in the 1830s as he gained fame at the Royal Academy exhibitions, slowly changed his family name from McClise to MacClise and finally to the unproblematic, Maclise.[92] A stripping down of the hindrances of the Celtic Fringe is clearly in operation here.

The 1830s was in fact a good decade for the growing status of Irish artists in London. Catholic Emancipation had been achieved, an important event for someone like Shee, as he would no longer have to contemplate deceit, as evidenced in a letter of 1825, four years before the passing of the Act, 'I expect in a short time to exercise my pencil in painting "no popery" on my door as a means of guarding my house and family from the visitation of a Protestant *auto da fe*.'[93]

A similar sense of ease would have affected his fellow-immigrant, William Mulready, who was the son of a Catholic craftsman but became an Academician in 1816 just before his thirtieth birthday. Like Shee, Mulready found comfort in the Academy. It was, as a recent biographer of the artist has written, 'the focal point of his life' and 'assured [him] of social as well as professional status'.[94] Again like Shee, Mulready was active officially in the Academy and generous as an instructor at the Schools, and in time gathered a collection of both national and international awards and honours.[95]

Throughout the 1830s, what with the gaining of a modicum of religious toleration, Shee's election to the presidency of the Academy and his knighthood, the social acceptance of Irish artists in London and in particular in the Academy was growing apace. That trenchant critic of art, William Makepeace Thackeray, in his account of the 1838 Royal Academy exhibition under the pseudonym of M. A. Titmarch in *Fraser's Magazine*, referred to the two stars of the show as 'King Mulready' and 'Prince Maclise'.[96] The former earned his title for producing what Thackeray called 'the crowning picture of the exhibition', the unfinished *Seven Ages of Man*, or *All the World's a Stage*, based on Jacques' allegorical speech in *As You Like It*.[97] Maclise exhibited five paintings in contrast to Mulready's one, including the large *Merry Christmas in the Baron's Hall* (Fig. 18), with its 'upwards of one hundred figures', together with his equally exuberant *The Wood Ranger with a Brace of Capercailye* or *Cock of the Wood*, both of which display a sympathy for what one recent commentator has termed 'the political mood of the 40s, represented by Disraeli's Young England party with its nostalgia for a hierarchical, pre-industrial society'.[98]

The dominance of the London Academy's annual exhibition by two Irish artists, with such uncontroversial subjects as a scene from *As You Like It* and a re-creation of a feudal Christmas, was a far cry from the more uncompromising

stance taken by Hone and Barry back in the 1770s. Mulready's visualisation of Shakespeare's speech and Maclise's selection of entertaining paintings inform us only too clearly as to the artist's avoidance of contentious subject matter. Granted, Maclise had exhibited Irish subjects some years earlier, for example *Snap-Apple Night, or All-Hallows Eve, in Ireland* in 1833, followed by *The Installation of Captain Rock* the year after.[99] Such Irish themes, it might be thought in the context of the 1830s, imply a nod in the direction of O'Connellite radicalism. Indeed, *Snap-Apple* actually carries an image of O'Connell on the back of a shawl worn by the woman in the foreground, while *Captain Rock* deals with the initiation rites of a secret society involved with the overthrow of church dues or tithes that had to be paid to the Anglican clergy.[100] The Ireland of Maclise's paintings is a colourful mix of David Wilkie's Scottish peasant interiors and a growing English interest in the exotica of Irish rural life. *Captain Rock* might suggest an up-to-date subject matter of rural agitation, but in fact what we are offered is an undisciplined assembly of grotesques arranged in a composition not dissimilar to the supposedly less fractious themes of *Snap-Apple Night* or *Merry Christmas in the Baron's Hall* (Fig. 18). In a review of the Royal Academy exhibition of Maclise's *Captain Rock*, the artist's brother-in-law and fellow-Irishman, P. W. Banks, wrote of his regret that:

> MacClise painted this particular picture, for I am much afraid that he will be mistaken for a Radical, or still worse, a whig: the fact being that he has never dabbled the least in politics, and has nothing of political feeling, excepting perhaps that instinctive disposition to free and gentle Toryism, which is proper in high-minded gentlemen.[101]

But, despite Banks's worries, we are a long way here from the subtleties of Barry's visual language, where the veiled Minerva asks us to consider Ireland's history. Instead, with Maclise, we get the heroics of a fictitious outlaw recently made famous by Tom Moore's highly popular pseudo-biography, *Memoirs of Captain Rock* (1824).[102] We are in fact closer to the pro-Tory views of Maclise's contemporary, Shee. The latter's biography tells of him, on the one hand meeting and admiring O'Connell whilst also reading yet another biography by Moore, *Memoirs of the Life of the Right Honourable Richard Brinsley Sheridan* (1825), and becoming disgruntled with the 'cloven foot of Whiggery' which 'peers out from under the graceful folds of [Sheridan's] eloquence'.[103]

Marcia Pointon has rightly pointed out that James Barry was not 'a role model' for an aspiring Irish Royal Academician in the first half of the nineteenth century, 'having died in squalor in 1806 after a life distinguished for its

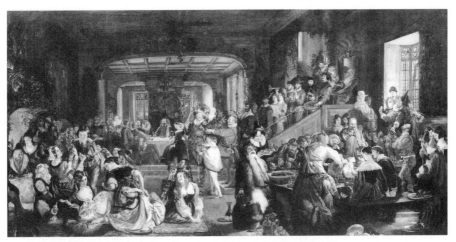

18) Daniel Maclise, *Merry Christmas in the Baron's Hall*, 1838

contribution to the Fine Arts but dogged by controversy and dissent'.[104] Another recent commentator on Mulready has claimed that, 'in the field of domestic genre',[105] Mulready rivalled and perhaps surpassed David Wilkie, and yet he never painted an Irish peasant scene. Pointon goes on to say that Mulready 'was in no position to exploit his ethnic origins', as Ireland, unlike Wilkie's Scotland, 'connoted not heroism and romance but dirt, ignorance, poverty and unresolvable problems for British demographers'. This is partly true, but it also shows a certain timidity on Mulready's part, an expression of what has been called his 'innate and carefully regulated conservatism'. Pointon has further remarked that it is significant that it was Wilkie who painted *The Irish Whiskey Still* (Fig. 50) and not Mulready. 'Such a subject', she claims, for the Irish-born artist 'would have constituted a declaration of affiliation that he evidently strove to disavow even to the extent of leaving instructions that his funeral should be conducted according to Anglican rites.'[106] Fair enough; but as we have seen with Maclise, some London-based Irish artists did paint Irish subjects and got away with it.

Maclise's early excursions into Irish subject matter are detached and entertaining, not that different from the caricatures and illustrations he was contemporaneously supplying to *Fraser's Magazine*. Mention was made earlier in the discussion of Barry to Francis Sylvester Mahony's comic *The Reliques of Father Prout*, which first appeared in *Fraser's* in 1836. An *émigré* Corkman like Maclise, Mahony's offensive and certainly bitter caricatures of Irish life were illustrated by Maclise under the pseudonym of Alfred Croquis. There is no championing of an Irish cause here. A couple of years earlier, as one of Maclise's 'Gallery of Illustrious Literary Characters', *Fraser's* carried a pen and

ink portrait of O'Connell with his fellow Irish MP, Richard Lalor Sheil (Fig. 19). William Maginn, yet another Corkman and editor of the magazine, supplied the text, where he bitingly described O'Connell's behaviour towards Sheil during a recent Commons' speech:

> O Connell pawed him with patronizing hand, as Sheil sat clawing his hair and clasping his knee . . . There is the bulky and swaggering figure of O Connell, and the slim, cowering, ill-cut, and haunchless shape of Sheil. The face of the member for Tipperary [Sheil] . . . is too much agonized by the sense of his unhappy predicament to allow us to say that it presents its usual air of smirking insignificance . . . The countenance of O Connell is that of ten thousand of his countrymen – good-humoured in surface, but indicative of deep, deep treachery within.[107]

19) Daniel Maclise, *Daniel O'Connell and Richard Lalor Sheil*, 1834

The careers of Shee, Mulready and Maclise show that it was not impossible to adapt your Irishness to an acceptable metropolitan form of behaviour and/or representation. The more famous and more spectacular career of Tom Moore was making this only too clear. His modern biographer might claim that Moore's 'considerable achievement [was] to have brought Ireland's story into London lives',[108] but then Hazlitt famously said of the poet that he 'converts the wild harp of Erin into a musical snuff-box'. The poet himself, in his preface to the third number of the *Melodies* in 1810, had spoken of how his work was not aimed at the lower and more inflammatory classes of people. 'It looks much higher for its audience and readers', he claimed, 'it is found upon the pianofortes of the rich and educated'. As Seamus Deane has recently commented:

> [Moore] could not have been more specific about the 'respectable', bour-
> geois nature of Irish nationalism and its wish to achieve a homologous rela-
> tionship with the England from which it seemed so eager to distinguish
> itself.[109]

The visual representation of Ireland as seen in London is not very different. In the 1840s Maclise was to go on to illustrate *Moore's Irish Melodies*, most mem-orably in his dramatic rendition of *The Origin of the Harp* (Royal Academy, 1842, Fig. 20). Here Ireland is a mournful, rejected siren whose hair is turned in true Ovidian fashion into the strings of the harp:

> Still her bosom rose fair – still her cheek smil'd the same –
> While her sea-beauties gracefully form'd the light frame;
> And her hair, as, let loose, o'er her white arm it fell,
> Was chang'd to bright chords utt'ring melody's spell.[110]

As symbols of Ireland, the harp and, by extension, the sorrowful woman cre-ate an image of the nation as synonymous with loss and submissiveness.[111] This makes Ireland acceptable and unproblematic. Maclise's siren with her generous form and sad tale would have found as keen an audience in London bourgeois homes as Moore's original poem.

The same applies to Maclise's most important painting of an Irish subject, the immense *Marriage of Strongbow and Eva*, exhibited at the Academy in 1854 (Fig. 21). Originally commissioned as a possible subject for a fresco in the rebuilt Palace of Westminster, the theme was to illustrate scenes depicting 'the acqui-sition of the countries, colonies and important places constituting the British Empire'.[112] The canvas tells of a moment in the consolidation of Norman

20) Daniel Maclise, *The Origin of the Harp*, 1842

control in Ireland with the conqueror, Richard de Clare, Earl of Pembroke, called 'Strongbow', marrying Eva, or Aoife, daughter of the infamous King of Dublin and Leinster, Dermot MacMurrough. Maclise may litter the painting with seemingly authentic references to medieval Irish architecture, Celtic ornament and the inevitable harp in the left foreground, but this is not a nationalist image. Recent commentators have read the painting as possessing a pro-Irish sentiment and a nostalgia for a lost Celtic world.[113] This is too literal a response. The defeated Irish crowd the foreground and allow Maclise to display an array of gold torc, tattoos and early Irish dress. This is not nationalist sympathy but

21) Daniel Maclise, *The Marriage of Strongbow and Eva*, 1854

metropolitan interest in anthropological detail. Equally, this is not history as such but entertainment. In giving such a prominent place to the wailing woman in the centre foreground who throws up her arms in despair, we are reminded of the equally dispirited siren in *The Origin of the Harp*. Here again a weeping woman enshrines the nation and our emotions are aroused in ways comparable to what Moore achieves in his verse. As W. J. McCormack has pointed out, Moore's drawing-room songs:

> signalled the convergence of a defeated Gaelic past and a metropolitan
> audience that was intellectually curious but not intellectually demanding.
> *Drawing room* might be emphasized to indicate the abandonment of polit-
> ical rhetoric with the extinction of the Irish parliament, and the elevation
> in its stead of the family as a collective image of Irish ambition.[114]

Maclise, it could be argued, echoes this by concentrating on that perfect sym-bol of the family, the act of marriage itself. Equally, we have here not just a domestic union but a painting that was specifically commissioned to record the political union of Britain and Ireland.

– 2 –

THE ROLES OF
HISTORY PAINTING

T RADITIONAL HISTORY PAINTING, THE MOST ELEVATED GENRE OF THE academic hierarchy, offered a passive, allegorised representation of either the nation or an event whereby heroes could be worshipped via the safe distance of the past. This form of painting was thus concerned with concluded history. Ireland was an unresolved problem within the context of late eighteenth-century British politics.[1] The means by which Ireland was represented visually raises questions regarding the role of history painting. As this chapter will demonstrate, the production of an alternative form of historical representation, from the 1770s onwards, be it called pictorial *reportage* or contemporary history painting, addresses late eighteenth-century Irish politics head-on.

Benjamin West's *The Battle of the Boyne* (Fig. 22), commissioned by Lord Richard Grosvenor in 1778 and exhibited at the Royal Academy in 1780,[2] is as closed a view of history as one could possibly ask for. William of Orange's victory in 1690 over James II is represented in assured terms by the centralised image of the future king on his splendid white horse. We may be asked to acknowledge the compositional borrowings from the equestrian monument to Marcus Aurelius on the Capitoline, but what we are offered is a problem solved: the Catholic cause defeated, or at least under control, and a nation, Ireland, subdued. On the other hand, as recent discussion of James Barry's great series of paintings for London's Royal Society of Arts has shown, history painting did

50

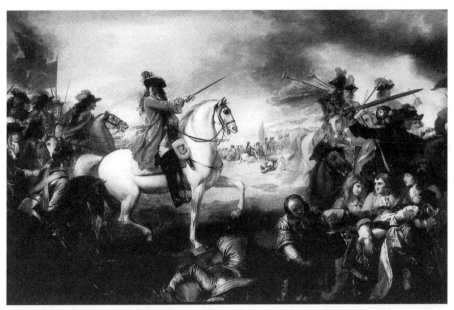

22) Benjamin West, *The Battle of the Boyne*, 1778

not necessarily have to be about resolved issues. Barry's inclusion of Irish and
Roman Catholic elements within his vast canvas, *Elysium and Tartarus or the State
of Final Retribution* (1777–84), and in the subsequent amended engravings, is an
example of how the artist broke some of the standard taboos of historical rep-
resentation. Controversial issues were not expected in history painting and cer-
tainly not subjects relating to Britain's troubled rule of Ireland.[3]

Almost at the same time as West's *Battle of the Boyne* was hanging on the walls
of the Royal Academy in London, Francis Wheatley was exhibiting in Dublin,
at the Society of Artists' exhibition, a large, ambitious painting of a contempo-
rary subject. Entitled *A View of College Green with a Meeting of the Volunteers on 4
November 1779 to Commemorate the Birthday of King William* (Fig. 23), the canvas
celebrated an important incident that had occurred six months prior to its
appearance at the exhibition.[4] The setting of Wheatley's painting is College
Green, in the centre of Dublin. In the foreground the leading members of the
newly formed Volunteer corps gather around an equestrian statue of William
III. As the celebration of a moment in contemporary life, Wheatley's painting is
an important early example of what was then becoming a fashionable form of
history painting. The basic ingredients of such contemporary history paintings,
as for example in John Singleton Copley's *The Collapse of the Earl of Chatham in
the House of Lords, 7 July 1778* (Fig. 24), were innumerable portraits, a recognis-
able location and a stirring event of recent memory.[5] Both Copley and Wheat-
ley had started their careers as portraitists, with Wheatley specialising particularly

23) Francis Wheatley, *A View of College Green with a Meeting of the Volunteers*, 1779–80

24) John Singleton Copley, *The Collapse of the Earl of Chatham*, 1779–81

in the conversation piece. This early apprenticeship was to prove vital, for, as Edgar Wind has shown, the new type of history painting that appeared from the 1770s onwards, after the success of West's *The Death of General Wolfe* (National Gallery of Canada, Ottawa), 'represent[s] the transition from the private group portrait to a form of pictorial *reportage* that needs only a more dramatic . . . subject and a larger scale to become history painting in contemporary costume.'[6]

THE SECULAR AND THE DYNASTIC

In creating the *Volunteers*, Wheatley uses different pictorial languages: group portraiture dominates the foreground while conversation-piece vignettes of officers saluting each other offer variety. Topographical accuracy dominates the background while drama is created by cannon fire and fluttering flags. Painting on a large scale, Wheatley has concentrated on the here and now. Just as was the case with his American contemporaries, West and Copley, so too Wheatley uses portraits as an essential component in what is a 'modern' history painting; the important difference here is that the emphasis is not on a uniquely British event, a great imperial battle or the demise of a senior politician at Westminster, but the recording of a regionalist event in Dublin in 1779. Ann Uhry Abrams has described West's oil of *William Penn's Treaty with the Indians* (The Pennsylvania Academy of Fine Arts, Philadelphia) of a decade earlier as 'an allegory of provincial [American] politics'.[7] Similarly, Wheatley's large canvas privileges Irish contemporary politics in a sophisticated visual language, in this case historical *reportage* as opposed to allegory.[8] Yet, it will be argued that, in the context of 1780s Ireland, the reformist politics of the Volunteers and their parliamentary supporters, the actuality of Wheatley's image and the plethora of Volunteer imagery that accompanied it, proved a threat to the executive in Dublin. It is thus worth contrasting Wheatley's painting with a ceiling decoration for St Patrick's Hall in Dublin Castle (Fig. 25), the seat of the British executive in Ireland, which echoes in its subject matter the fundamental principle of Britain's Irish policy, the preservation of control.[9] Commissioned some time in the late 1780s from Vincent Waldré, the ceiling, both in style and content, displays a return to universalism through a dependence on the safe language of Baroque allegory and picturesque historical narrative. The tripartite organisation of the ceiling (Figs. 35–37), with its circular centrepiece and two rectangular side panels containing scenes from ancient, in this case, Irish history, is clearly reminiscent of Rubens's Whitehall scheme, where the oval central panel of the Apotheosis of James I of England and VI of Scotland is flanked on one side by

a rectangular image of the union of the two crowns of England and Scotland, a historical occasion albeit represented allegorically. By contrast, Wheatley's representation of Ireland is firmly rooted in the present. Instead of an allegorised Hibernia in Waldré's central panel (Figs. 25 and 35), we see prominent Irish reformist politicians (Fig. 1. James Napper Tandy is seen standing on the far right); instead of a winged Fame blowing her trumpet, we see the firing of contemporary cannon and musket; instead of a fictive, classicised architectural background, we see a range of specific eighteenth-century buildings, from Edward Lovett Pearce's purpose-built neo-Palladian Irish Parliament House and the façade of Trinity College, to the undulating frontages of Dublin town houses.

Waldré's ceiling decoration is an exercise in traditional history painting in both its formal arrangement and in its use of allegory and events from ancient history. Yet it is in its very reactionary elements that its potency becomes apparent. The formal arrangement of George III flanked by Hibernia and Britannia (Figs. 25 and 35) implies imperial union, while by including a narrative of St Patrick, the national saint of Ireland (Figs. 25, lower panel and 36), the executive, and by implication the monarchy, utilised a powerful symbol of national unity, attractive to all cultural groups, both Catholic and Protestant. Wheatley's painting, on the other hand, is about confrontation and change, but change that will affect only a minority.

The Volunteers and the executive in Dublin Castle had conflicting ambitions. How then did paintings realise those ambitions? Although both Wheatley's canvas and Waldré's decorative ensemble are, without doubt, high art images and over time experienced limited exposure to the public at large, they did initially enjoy public access. Added to that, the Volunteers as a movement, from the late 1770s to the mid-1780s, generated a wealth of imagery in a wide range of media that would have brought the aspirations of the group into wider circulation. Equally, the native imagery employed by the executive, especially their use of St Patrick, as will be outlined later, tapped into an ongoing cultural re-evaluation of Irish history that would have appealed to a wide audience.

Both the Wheatley and two of the three Waldré canvases were exhibited at artist-organised public exhibitions in Dublin, albeit with a gap of some twenty years between the showing of the *Volunteers* in 1780, where it attracted 'considerable notice',[10] and the 1801 and 1802 display, respectively, of *St Patrick Converting the Irish to Christianity* and *King Henry II receiving the submission of the Irish Chieftains* (Figs. 36 and 37), from the Dublin Castle ceiling.[11] Comment on the Waldrés was mixed, with reference only being made to formal issues.[12] In terms of dating and relevance to the Wheatley painting, it is important to point out at this stage that the actual conception of the Waldré paintings dates

from the late 1780s. As will be discussed at greater length later on, the ensemble thus belongs historically to the decade of the Irish Volunteers.

The large scale and blatant contemporaneity of Wheatley's painting was unusual for Dublin exhibitions of the period. The Society of Artists' exhibition in Dublin in 1780, like so many of its predecessors (it had held its first exhibition in 1765), was unexceptional in being dominated by conventional head and shoulder portraits and domestic landscapes.[13] It is thus not surprising that Wheatley's *Volunteers*, due to its size and subject matter, attracted notice. Public awareness was soon increased by the production in London in 1784 of a line

25) Vincent Waldré, *Sketch for ceiling of St Patrick's Hall, Dublin Castle, c.* 1788–90

engraving after the painting which was soon pirated in Dublin.[14] Knowledge of the image was assured by Wheatley's collection of a large subscription for the engraving while, slightly earlier, he advertised a raffle to dispose of the picture. The *Volunteers* eventually found a home in the collection of the Duke of Leinster, who figures so prominently in the centre foreground (Fig. 26); in time his descendants bequeathed it to the National Gallery of Ireland.[15]

Wheatley's painting and its ancillary images are but part of a veritable visual packaging of the Volunteers that occurred in Ireland in the early 1780s. Individual oil and engraved portraits of leading Volunteers were commissioned, as were marble busts, transfer-printed pottery and printed linen bearing Volunteer motifs and mottoes. Commemorative medals were struck and specially designed flags were created which boasted the cause of Protestant nationalism.[16]

In discussing the conflicting forms of history painting utilised in 1780s Ireland, the methodology used must include a close visual analysis of the images and an examination of the details that emerge. A useful model for such an approach has been articulated by Edward Said, who, in discussing the relationship between art, national identity and colonial manipulation, the very ingredients of Wheatley's painting and Waldré's decoration, commented that his 'whole point is to say that we can better understand the persistence and durability of saturated hegemonic systems like culture when we realize that their internal constraints upon writers and thinkers were *productive* not unilaterally inhibiting'. What interests Said as a scholar is:

> not the gross political verity but the detail, as indeed what interests us in someone like [Edward William] Lane or Flaubert or Renan is not the (to him) indisputable truth that Occidentals are superior to Orientals, but the profoundly worked over and modulated evidence of his detailed work within the very wide space opened up by that truth. One only need remember that Lane's *Manners and Customs of the Modern Egyptians* is a classic of historical anthropological observation because of its style, its enormously intelligent and brilliant details, not because of its simple reflection of racial superiority, to understand what I am saying here.[17]

Similarly, when we examine the Protestant exclusivity of the Volunteers, as a cultural group within a largely Catholic Ireland, or Waldré's ceiling and what it offers in terms of a late eighteenth-century vision of Ireland in tune with its Christian and colonial history, we arrive at a more subtle understanding of the actuality of cultural power. As will be made clear, conflicting concepts of what the nation could be were being made available in the 1780s, or to put it another

way, *pace* Benedict Anderson, differing views of what constituted a community were being imagined. Identifying the late eighteenth century as the 'dawn of the age of nationalism', Anderson has proposed that 'nationalism has to be understood, by aligning it not with self-consciously held political ideologies, but with the large cultural systems that preceded it, out of which – as well as against which – it came into being'.[18] More recently, Linda Colley has added that, 'historically speaking, most nations have always been culturally and ethnically diverse, problematic, protean and artificial constructs that take shape very quickly and come apart just as fast'.[19] The role of art in this process is informative. Timothy Brennan has commented that 'Nations . . . are imaginary constructs that depend for their existence on an apparatus of cultural fictions in which imaginative literature plays a decisive role.'[20] So too can the visual arts.

THE HISTORICAL BACKGROUND OF WHEATLEY'S *VOLUNTEERS*

Wheatley's *Volunteers* (Fig. 23) commemorates a group of late eighteenth-century Irishmen who, although loyal to the King, were eager to demonstrate a separate Irish identity. Due to a scarcity of British troops in Ireland caused by the need for men to fight in the American Wars, the Irish Volunteers were organised in the late 1770s, independent of government, as a national defence force.[21] The defence of Ireland against a possible French invasion was the major concern of the disparate groups that formed themselves into local militia, usually led by a member of the local gentry. Enrolment was initially limited to Protestants, as it was forbidden for Catholics to carry arms. Middle-class Protestants, small farmers and urban artisans, as well as junior members of the legal profession and tradespeople, made up the rank and file of the Volunteers. In time, manoeuvres were held, uniforms and flags designed, and an air of pride in the cause took hold of the organisation.

Concurrent with this formation of a large number of Volunteer corps, Irish political life underwent a major transformation. Almost exclusively composed of landowners, the Irish Houses of Lords and Commons, which again excluded the Catholic population, divided themselves between those who supported the administration in London and, by extension, the resident Lord Lieutenant of Ireland, the Crown's representative in Dublin Castle, and those who favoured a more independent executive and legislature for Ireland. Labelled the British and the Irish parties respectively, the latter were in the main of a Whig persuasion.[22]

Throughout the eighteenth century, Ireland was subject to a series of harsh laws, one of the most economically crippling being the Trade Laws. Irish trade

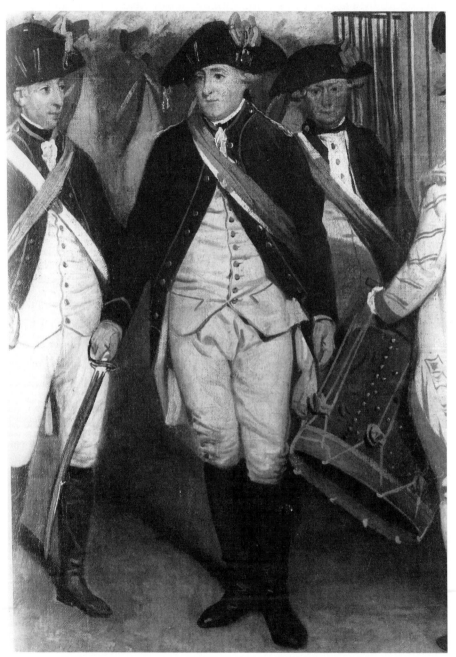

26) Francis Wheatley, *Volunteers*, detail of the Duke of Leinster

was controlled to the advantage of English merchants: all Irish goods had to pass through English ports; Ireland was not allowed to sell directly to the colonies. By the third quarter of the century, this situation was no longer acceptable to the majority of Irish landowners, who resented their loss of profits and questioned the control exercised by the Westminster Parliament on their lives. A campaign for the repeal of the Trade Laws was mounted, and repeal was eventually achieved in February 1780. The move towards Free Trade was supported by those who sat on the opposition benches in the College Green Parliament, many of whom were also active members of the Volunteers, including the leader of that opposition or Irish Party, Henry Grattan, Colonel of the Dublin Independent Volunteers.

Westminster's reluctance to grant Free Trade was fortified by the obvious connection between the parliamentary lobby and the newly formed military force. London was justifiably of the opinion that the latter was becoming a military wing of Grattan's Irish Party, or the Repealers, as they were also called. In time, larger and more elaborate military reviews were staged by the Volunteers and Wheatley's painting of 1780 records one such occasion. Exhibited in May 1780, some three months after the passage of the Irish Free Trade Bill, Wheatley's canvas could be read as a commemorative statement of the power of the Volunteers (and to a less obvious extent of the parliamentarians) in achieving the successful passage of the Bill. But it must be emphasised that, although historically linked with the repeal of the Trade Laws, the Volunteer aspect of the painting is emphasised over that of the Repealers, the military over the political. Contemporary accounts inform us that pro-Free Trade decorations, placards and banners were draped over the statue of William III in College Green on 4 November 1779,[23] but Wheatley omitted all of these references to the Free Trade controversy in this record of a colourful moment in the history of the Volunteers as a military force. The focus is on spectacle, the mood optimistic and even defiant.

UP-TO-DATE HISTORY PAINTING

In Wheatley's painting, some forty to fifty Volunteers and onlookers, many of whom can be identified, are gathered in College Green while cannon and guns are being fired at the command of the Duke of Leinster, the then Commander-in-Chief of the Volunteers.[24] Located in the centre of the painting (Fig. 26) Leinster, as premier peer of Ireland, leads the aristocratic element within the group. To the left are members of the various Light Horse corps, in the main composed of land-owning gentlemen, parliamentarians and wealthy businessmen, while to

the right are members of the more urban bourgeoisie, the Lawyers' Corps and the Goldsmith Company. Amongst the parade of personalities are the iron-monger James Napper Tandy (to the left of the Leinster group, Fig. 1), who later spoke out against executive corruption, while among the Dublin élite on our left we see John FitzGibbon, later Earl of Clare but at this time MP for Dublin University (Fig. 27, in centre with sword). Next to him is David La Touche of the banking family. In front, leading the County Dublin Light Horse Corps is Luke Gardiner, the building speculator (Fig. 23). Above, leaning from the windows of College Green, fashionable Dublin and distinguished foreign visitors look on (Figs. 23 and 27). We are offered generalised spectacle instead of a specific political issue.

By gathering beneath an image of William III (Fig. 28), the Volunteers were remembering the Glorious Revolution and thus honouring the political father of the Irish Whig opposition. The focus of an annual parade since its erection by Dublin Corporation in 1701, Grinling Gibbons's royal statue held an impor-tant place in demonstrations of public loyalty to the Crown. Throughout the eighteenth century, the birthday of William of Orange was celebrated by

27) Francis Wheatley, *Volunteers*, detail with FitzGibbon and La Touche

representatives of the Crown, city officials and parliamentarians who marched from Dublin Castle along Dame Street to College Green. Orange banners and flags were placed around the statue of William and salutations were offered honouring the saviour of the constitution.[25]

On 4 November 1779, the day commemorated in Wheatley's painting, there:

> assembled in College Green – the Dublin Volunteer artillery, commanded by James Napper Tandy, with the labels bearing the inscription, *Free Trade or Speedy Revolution*, suspended on the necks of their cannon – the Volunteers of Dublin and the vicinity under the orders of the Duke of Leinster. The sides of the pedestal on which stood the statue of the Deliverer, were ornamented with collections of the most significant political reasoning, and under the angry eyes of the executive, such teachings as the following were given at once to the governors and the governed. On one side of the pillar was inscribed, *Relief to Ireland*, on another, *A Short Money Bill, A Free Trade, or Else* ——, on a third *The Volunteers, quinquaginta millia juncti [sic], parati pro patria mori* [fifty thousand united people (Irishmen), prepared to die for their country] and in front of the statue were two cannons bearing an inscription

28) Grinling Gibbons, *Equestrian statue of William III*, 1700–1

on each, Free Trade or this. The people were assembled in thousands around
the Volunteer troops, and their enthusiasm re-echoed in deafening applause
the thunder of the artillery.[26]

Wheatley has omitted these banners and presented a wide frieze-like arrange-
ment of figures. This is necessary so as to include as many identifiable faces as
possible. As pointed out earlier, Copley was doing this kind of thing at exactly
the same time in London, while later others would fully exploit the possibilities
of group portraiture, and reap extensive profits from their endeavours. Wheat-
ley, by contrast, did not succeed in making much money from the *Volunteers*.
The painting was not commissioned and, as stated, the artist did not get a print
made of the picture until 1784.

An equally large, and as it turned out an equally difficult canvas to dispose of,
was Wheatley's next essay in contemporary Irish representation. *The Irish House
of Commons* of 1780 (Fig. 29) was seemingly planned as a subscription-based
group portrait of Members of Parliament, but the artist ran into trouble by fail-
ing to include the whole house.[27] The dissatisfaction voiced by those left out of
the painting is a possible reason why it was not exhibited in Dublin during

29) Francis Wheatley, *The Irish House of Commons*, 1780

Wheatley's lifetime. We are offered a view of the interior of the House with Henry Grattan making a speech on the motion 'that the King's most excellent majesty, and the Lords and Commons of Ireland, are the only power competent to make laws to bind Ireland'. This speech was delivered on 19 April 1780.[28] Surrounding Grattan on the right-hand side of the chamber is the Irish Party, many of whose members, including Grattan himself, sport Volunteer uniforms.

The numerous images of such prominent Volunteers as Grattan and the Duke of Leinster convey the new-found political confidence of those leaders. This confidence is an important feature of Volunteer imagery and is articulated pictorially by means of declamatory gestures; for example, Leinster, in the *Volunteers*, gives the order of fire as he lowers his sword (Fig. 26), while Grattan, in the *Irish House of Commons* (Fig. 29), is caught in mid-speech, his right hand emphasising a point. Apart from the occasional full-length portrait of a newly elevated peer, Irish figurative imagery of the second half of the eighteenth century is not noted for its assertiveness. A key to the new certainty that distinguishes the portraits of the Irish Volunteers is perhaps to be found in the large number of images of heroes of the American War of Independence produced in New York and Philadelphia during the 1770s and disseminated throughout the Anglo-Atlantic world by means of engravings.[29] Prints of George Washington were available from *c.* 1777 and would have created an iconography of American heroes suitable for inspiring their Irish contemporaries. John Trumbull's 1780 portrait of Washington, engraved in London by Valentine Green and published in early 1781 (Fig. 30), was adapted by John Exshaw, a Dublin bookseller, as a frontispiece for *The Gentleman's and London Magazine*, published in Dublin in 1783.[30]

Other visual references to American heroes reinforce the awareness that a Dublin audience would have had of a close political connection. In 1777 an engraving of the Irish-born Richard Montgomery, who had died at Quebec in 1775 fighting on the American side, appeared in the Dublin-based *Hibernian Magazine* (Fig. 31). Montgomery appears in the uniform of a Major-General of the American armies, but his first name is erroneously given as 'George'.[31] There is a suave assurance in Montgomery's pose; he is at once formally posed yet relaxed. An equally assertive contemporaneous image is a 1784 Dublin print of James Napper Tandy (Fig. 32), who appears in Wheatley's painting (Figs. 1 and 23). Compositionally similar to a number of early 1780s prints of Washington, especially in the way the hand rests on a cannon,[32] Napper Tandy's role as Captain and artillery commander of the Dublin Liberty Corps of the Volunteers is here greatly enhanced. In his left hand he holds a scroll with the word 'Congress', a volatile term in the context of American Independence rhetoric, but

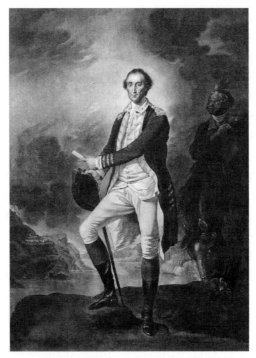

30) Valentine Green after John Trumbull,
General Washington, 1781

31) *Richard Montgomery*, 1777 32) *James Napper Tandy*, 1784

here referring directly to Tandy's attempt in 1784 to create a National Congress with delegates from each county and city who would strive for borough and franchise reform, including the extension of the franchise to Roman Catholics.[33]

The language of Wheatley's Volunteers is that of an up-to-date British history painting, a series of portraits in contemporary dress recording a dramatic moment in recent public life. In the Trumbull, Washington is portrayed in terms of the latest high portraiture conventions then on offer in a London studio, while Richard Montgomery's appearance in the *Hibernian Magazine* has all the elegance of a domestic portrait; the crude bank could be easily substituted by a plinth or studio prop. The formal appearance of the images is by no means radical, but the conventions are put to new ends: to portray an Anglo–Atlantic élite, at odds with the centre, the London government. Both groups – American and Irish – are searching for a means of visualising their ambition. In the Irish context, that ambition was achieved through the scale of Wheatley's canvas and the abundance of Volunteer imagery, in a wide variety of media, that appeared in the early 1780s. Equally, as Edgar Wind noted almost sixty years ago, 'the final breach with the Academic rules of history painting was produced by the impact of democratic ideas proclaimed by a group of American artists'.[34] Given the admiration the Irish Volunteers had for their American counterparts, it was not surprising that Wheatley represented them in the new type of history painting only then being propagated by those artists that Wind wrote about, West, Copley and Trumbull.

The visual representation of the close connection between the Volunteers and America was not limited to the dizzy heights of history painting or to the elegant pose of portraiture but was also aided by political satires produced in both London and Dublin. In one London print, *Prerogatives Defeat or Liberties Triumph* (Fig. 33) of 1780, America and Ireland, the latter represented by a youthful Volunteer, stand side by side commenting on their willingness to act for Liberty, support Charles James Fox (in the centre) and the Whigs and defeat British corruption as represented by the trampled figures of Lords Bute and North.[35] Anticipating a change of ministry in London, America says, 'Now we will treat with them,' while Ireland comments, 'We are Loyal but we will be Free.'

On 19 April 1780, as portrayed in Wheatley's *Irish House of Commons* (Fig. 29), Henry Grattan proposed his resolution for Irish legislative freedom, insisting that 'we are too near the British nation, we are too convergent with her history, we are too much fired by her example, to be anything less than her equal'.[36] Grattan's declaration of equality, and by implication of nationhood, was heady stuff for the Irish Party and the majority of the Volunteers. In time, this motion was to lead to the granting by Westminster of a degree of freedom to the Irish legislature. Thus, as Wheatley's painting of the Volunteers was being

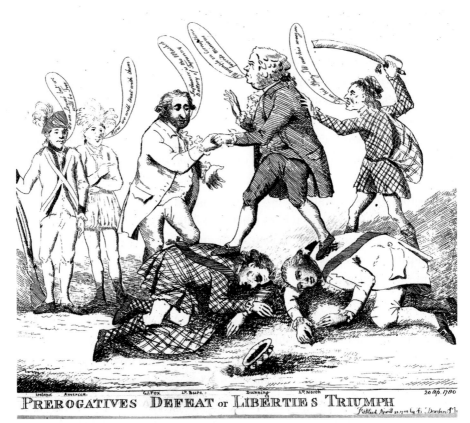

33) *Prerogatives Defeat or Liberties Triumph*, 1780

exhibited in Dublin and subsequently offered for sale by raffle, concern about the recognition of Ireland as a viable independent nation was slowly gathering momentum. But all the time it must be remembered how the Irish nation as defined by the Grattanites and the Volunteers was a Protestant, Whiggish ideal.

ENTER ST PATRICK

By gathering around the statue of William, the Volunteers stressed their commitment to constitutional liberty and their hatred of tyranny. But such close identification with the Williamite tradition contained an unfortunate disadvantage for the Volunteers. Almost totally confined to the Protestant population,[37] the initial concern of the Volunteers had been for the protection of Ireland against the despotic forces of Catholic France. In time, their chief cause became the furthering of the notion of independent nationhood, and yet it was a nation that would still exclude their Catholic countrymen and women. Although the early

1780s saw the successful passage of a number of Catholic Relief Acts, the culture of prejudice encouraged by the Penal Laws of earlier in the century was still an important force in Irish society. It is therefore not surprising that these fervent Williamites were not very successful in gaining the goodwill of the Catholic population. Although the Volunteers and their political brethren may have worshipped at the feet of King William, such expressions of Protestant loyalty were anathema to Catholics. The popularity of the Volunteers was both wide and determined, yet it was exclusory. Catholics showed little enthusiasm for the Irish parliamentary opposition's exclamations of national fervour, while, for obvious reasons, the government party and the representatives of the Crown at Dublin Castle were greatly concerned with the potential outcome of such self-determinist displays. Aware of the fine rhetoric and lofty ideals of the Grattanites, with their talk of liberty and an independent Irish nation, the government attempted in the early 1780s to retaliate by diverting Protestant loyalty and encouraging greater recognition of the indigenous Catholic majority. By fostering a common loyalty to the Crown amongst the various cultures of Ireland, Dublin Castle attempted to divert any impending threat to the imperial connection.[38]

To distract attention from the excitement of the Volunteers, and to attract support from the majority of the Catholic population, the creation of a new royal chivalric order for Ireland, the Illustrious Order of St Patrick, was proposed in late 1782.[39] The brainchild of George Nugent-Temple-Grenville, second Earl Temple (later first Marquis of Buckingham), who was sworn in as Lord Lieutenant of Ireland in September 1782, the new Order would act as part of a process of cultural reorientation to challenge the Whiggish fervour of the Volunteers and flatter the indigenous, yet more conservative, Catholic tradition. Founded as a uniquely Irish order, the St Patrick was to be comparable to the Scottish Order of the Thistle, second to the Garter yet above that of the Bath. The rapidity with which Temple set up the Order, a mere five months, is indicative of the importance he placed on its diversionary powers with regard to the popular Volunteers. Inaugurated on St Patrick's Day, 17 March 1783, the Order proudly boasted the Irishness of its insignia and the Irishness of its noble members. Harps and shamrocks dominated the designs of the collars, stars and badges of the Order, though they appeared interspersed with the rose of England and the crowned harp (Fig. 34). The most important insignia for any order is the cross or medallion attached to the collar and prominently displayed against the chest. In the case of the new Irish order, this cross was the so-called cross of St Patrick, a red saltire decorated with a green shamrock bearing three crowns, one on each leaf (representing the kingdoms of England, Scotland and Ireland), all mounted on a white enamel ground and surrounded by the motto 'Quis Separabit MDCCLXXXIII'.[40]

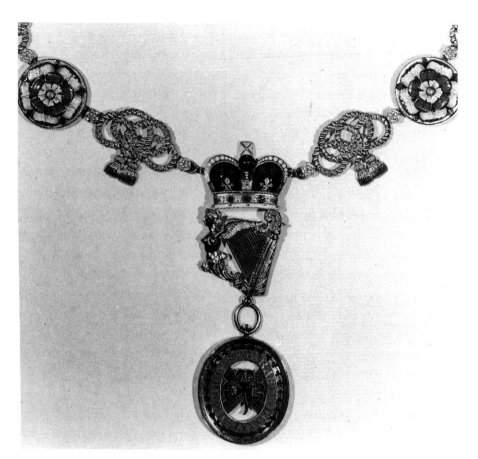

34) Regalia of Order of St Patrick, Badge and Collar, *c.* 1910

The interdependence of the three kingdoms was emphasised, while the regional individuality of Ireland, her Patrician tradition and national emblemata, was given respectful prominence. The dominant colour of the Order, St Patrick's blue, which was to be seen on the cloaks and sashes worn by the individual Knights, equally echoed these carefully orchestrated intentions. Indeed, in John Keyes Sherwin's large painting of *The Installation Banquet of the Knights of St Patrick*, where Earl Temple as Grand Master proposes the toast, the blue of the national saint as worn by the thirteen Knights dominates the painting, just as it had dominated the scene itself.[41] This was in marked contrast to the abundant orange ribbons that decorated the statue of King William on 4 November 1779. The blue chosen for the Knights of St Patrick was the colour of the field of the arms of Ireland. Such a choice implied royal favour towards the neighbouring kingdom and a deliberate rejection of the aggressive, self-determinist Protestantism associated with the colour orange.

The tradition of St Patrick offered a unique opportunity to appease the various factions within Irish society. Instead of ignoring the Volunteers, Temple formally acknowledged their existence. He invited the Earl of Charlemont, a prominent Volunteer and in 1783 leader of the opposition in the House of Lords,[42] and the Duke of Leinster to become Knights of St Patrick and cunningly invited the Volunteers to participate in the ceremonies connected with the inauguration of the new Order on 17 March 1783. The pro-government newspaper, *The Dublin Gazette*, stated in its account of the proceedings that the Volunteers 'lined the streets through which the Procession passed, and kept order in the church'.[43]

The greatest visible threat to government control in the early 1780s was the spectacle of national unity offered by the colourful Volunteers corps throughout the island. From the loud cannon blasts celebrated in Wheatley's painting of the gathering on College Green (Fig. 23) to such spectacular successes as the Dungannon Convention of February 1782 and the equally elaborate military review held in Phoenix Park in June of that year, the government was only too aware of the power of public display.[44] The cult of personalities was equally strong. Wheatley had attempted to market the popularity of Henry Grattan through his elaborate group portrait of the interior of the House of Commons (Fig. 29), while a head and shoulders mezzotint of Grattan by Valentine Green after Wheatley was marketed in 1782.[45] Some time between 1782 and 1783, Trinity College Dublin commissioned the artist Robert Home to include a portrait of Grattan amongst a set of eight portraits celebrating the Whig tradition of the university.[46] On a more popular level, James Gillray recorded the occasion on 30 May 1782 when a thankful Irish Parliament voted their hero, Henry Grattan, a sum of £50,000.[47] Other Volunteer leaders commissioned Wheatley to record their role in the movement, the most elaborate being the example of John Stratford, third earl of Aldborough, whose *Review at Belan Park, County Kildare*, today hangs in Waddeston Manor, Buckinghamshire.[48] In 1777 Aldborough had formed his own corps, the Aldborough Legion, with himself as Colonel. Fine uniforms and pride in belonging to the Volunteers are uppermost in all of these Wheatley paintings, but none match the *Review at Belan* for sheer personal exhibitionism – we are offered the earl's womenfolk, his horses and carriages, his estate and his localised seigneurial power.[49]

The installation of a newly-created Irish order was thus a means of reducing the Volunteer spectacle of national unity in favour of a more dominant imperial unity. The installation was itself a splendid and expensive occasion. A vast carriage procession wound its way through the streets of Dublin, taking the Grand Master and the Knights from Dublin Castle to St Patrick's Cathedral,

where each Knight was invested in the Choir and his banner raised above his head.[50] Temple renamed the ballroom at the Castle after St Patrick and stressed the use of Irish cloth in the making of the Knight's regalia and all gowns to be worn at State balls.[51] The city's pride in the display was captured by the *Dublin Evening Post*:

> the magnificence of the ceremony, the crowds of spectators of the first dis-
> tinction in the cathedral, and the myriads of all ranks of people in the streets
> to see the Knights, etc., pass and repass in their carriages to and from the
> castle, with the animation that lit up the countenances of the public, formed
> a scene that is indescribable, and which will long be remembered with pride
> and satisfaction by thousands of the sons and daughters of Hibernia.[52]

By naming the new Irish order after the national saint, Temple and by exten-sion the Government, was attempting to reorientate the loyalties of his Irish subjects. By honouring the apostle of Irish Christianity, the state offered a clear rebuttal of the sectarian, potentially divisive cult of William of Orange. An offi-cially sanctioned cult of St Patrick, as recent research has shown, could now replace, albeit slowly, the minority Williamite tradition.[53] From 1783 onwards the celebration of the national feast day of 17 March took on a new importance, as against the limited appeal of William III's birthday on 4 November. The Patrician tradition offered two unifying forces not available to the followers of William: a capacity for commanding the allegiance of Catholics and Protestants alike, and the creation of a distinctive national identity comparable to that of England, Scotland or Wales. The Williamite tradition was not, by contrast, unique to Ireland and had little or no appeal to Catholics. It must be stressed, however, that at no time in these years was the Patrician identity in any way sympathetic to separatist aspirations. Christianity had come to Ireland long before the Reformation, and its first Irish apostle could thus enjoy the devo-tion of both camps.[54] The authorities fully realised that regional identity was not necessarily a negative virtue, but could be encouraged if properly controlled and if loyalty to the centre was always in evidence.

The State's endorsement of the Patrician tradition over the more divisive Williamite tradition contained a grand irony in that a heretofore indigenous and strongly Catholic symbol was now being used by the Crown to forge a greater sense of unity amongst the people of Ireland, both Catholic and Protes-tant. The even greater irony is the fact that this late eighteenth-century revival of the Patrician tradition could in the following century be taken up by the numerous nationalist groups and fashioned into a separatist discourse that has

'been retained – though not, of course, unchallenged – down to the present'.[55] But that is another story.

The new enthusiasm shown by the Irish administration for such a powerful symbol of Ireland's past as St Patrick must be seen within the context of the growing late eighteenth-century interest in early history and antiquarianism. Just as Grattan and the Volunteers were attempting to inspire patriotic fervour in the hearts of their fellow citizens, so too historians and amateur scholars sought to provide general information about Ireland's past and create an atmosphere of interest in the native culture.[56] Growing interest in ancient Ireland, investigations into ethnic origins, the history of early Christianity and the explication of recent archaeological discoveries of Celtic artefacts culminated in 1785 with the setting up of the Royal Irish Academy. The status of the historical St Patrick within this antiquarian discourse is an important key to the political and cultural usage made of the past. From the mid-eighteenth century, discussion varied from Patrick's close involvement with Rome to his being an independent missionary. Catholic and Protestant historians clashed over interpretations, the former emphasising the links between Ireland and the Vatican while the latter strove to authenticate the origins of the Anglican Church of Ireland as the true heir of the Patrician ministry.[57] Indeed, as Clare O'Halloran has recently claimed, 'It was as if [St Patrick's] function in antiquarian writing was . . . mainly symbolic, to reinforce arguments about the authority of Gaelic tradition or the nature of the early Irish church.'[58] But by the 1780s his significance as a symbol of Ireland's past and as a potentially unifying force triumphed above sectarian debate.[59]

Although heretofore not unknown in visual representation, the subject of St Patrick was not common in Irish imagery prior to the 1780s. In the early 1760s James Barry had painted an oil of *The Baptism of the King of Cashel by Saint Patrick*, a subject and composition he repeated in an oil sketch some forty years later.[60] Luke Gibbons sees Barry's depiction of St Patrick as a subversive act, claiming that the artist was supposed to have found the subject of the *Baptism* not in any artistic source but through his acquaintance with Irish historiography, thus defying the Greco-Roman bias of British neoclassicists.[61] But given the subversive connotations that earlier periods would have associated with an obviously Irish symbol, together with the country's unimaginative artistic patrons and the general dearth of historical painting in both Ireland and Britain, representations of the saint were infrequent. By the early 1780s, as Irish identity took on a new vitality, Patrick did occasionally appear, especially in the popular media. As a more pertinent representation of Ireland than the conventional allegorised Hibernia, Patrick could now take his place alongside his fellow patron saints, George, David and Andrew.[62] By the end of the decade Patrick's role in

Irish political life had become firmly established: Rowlandson included him in at least two prints of 1789 relating to the fruitless yet comic embassy sent by the Irish Parliament to the Prince of Wales, supporting the latter's regency of Ireland during the King's mental illness. Patrick, astride an Irish bull, leads the parliamentary group that included Leinster and Charlemont, and shouts 'Make haste, my dear Honeys' (see Fig. 68 for a slightly later variation on this).[63]

By the end of the 1780s the national apostle had become a national symbol. Although contemporary historians might have differed over the historical missionary, the cultural force of his antiquity and sainthood were sufficiently powerful to arrest dissent. Antiquity was in fact the hallmark of the whole creation and investiture of the Irish Order. By offering an order similar to the medieval honours of the Garter and the Bath, Temple and, of course, George III were taking refuge in the past so as to control the present.[64] The elaborate costumes and regalia of the Order, fashioned as they were according to centuries of tradition and association, presented an image of timelessness and stability.

In June 1783, Earl Temple was relieved of his position as Lord Lieutenant. In the few months he was in Ireland he had founded and firmly established an Irish Order which formally demonstrated Irish affection for the Crown. Returning to Dublin in 1788, now as the Marquis of Buckingham, Temple was given an opportunity to complete his mission to usurp the popularity of the opposition. This was not an easy job. The Regency Crisis of 1788–9 deeply worried Dublin Castle, while the newly-returned Lord Lieutenant became the main focus of oppositional aggression. The Irish Party saw the King's illness as an opportunity to encourage a Whig initiative for Ireland. For the administration, the combined difficulties of the close family ties and political sympathies that existed between the Irish opposition and the followers of Charles James Fox, together with the known eagerness of the Prince of Wales to take up the mantle of Regent, offered a formidable problem.[65] The sending of a commission, armed with requests for change, to the Prince, which would then be implemented if he were made Regent for Ireland, was seen by Buckingham as tantamount to a declaration of separation.[66] In demanding a separate Regency for Ireland, the opposition was fighting for a degree of independence that would have negated the power of the Castle administration and of Westminster.

On 20 February 1789, at the height of the crisis, the Attorney-General for Ireland, John FitzGibbon, eloquently reminded parliament of the absolute necessity of Ireland remaining closely tied with Britain:

> Give me leave to tell the country gentlemen of Ireland, that the only security by which they hold their property, the only security which they can

have for the perfect establishment in church and state, is the connection of the Irish crown with, and the dependence upon, the crown of England . . . and if they are now duped into idle and fantastical speculations, which are to shake that connection, under the specious pretence of asserting national dignity and independence, they will feel, to their sorrow, that they are duped into a surrender of the only security by which they can hope to retain their property, or by which they hope to retain the present establishment in church and state. For give me leave to say, sir, that when we speak of the people of Ireland, it is a melancholy truth that we do not speak of the great body of the people. This is a subject on which it is extremely painful to me to be obliged to speak in this assembly, but when I see the right honourable member driving the gentlemen of Ireland to the verge of a precipice, it is necessary to speak out. Sir, the ancient nobility and gentry of this kingdom have been hardly treated, that act by which most of us hold our estates was an act of violence, an act palpably subverting the first principles of the common law of England and Ireland. I speak of the Act of Settlement . . . and that gentlemen may know the extent . . . I will tell them that every acre of land in this country, which pay quit-rent to the crown is held by title derived under the Act of Settlement; so I trust the gentlemen whom I see upon the opposite benches, will deem it a subject worth their consideration how far it may be prudent to pursue the successive claims of dignified and unequivocal independence made for Ireland by the rt. hon. gentleman.[67]

FitzGibbon, neatly and bluntly summarised the government's point of view. In time, the recovery of the King, Buckingham's firm hand on parliamentary deliberations combined with the farcical behaviour of the Irish commission, and a loss of nerve by various prominent members of the opposition, prevented any radical victory. On the government side a final image of unity which recognised diversity was needed, so as to distract attention from the opposition.

A SYMBOL OF UNITY

To satisfy this need, Buckingham returned to his own Order of St Patrick. During his second term of office as Lord Lieutenant (1788–9), Buckingham embarked on an elaborate decorative commission in St Patrick's Hall, Dublin Castle, the site of the investiture of the Knights of St Patrick and of their balls and annual banquet. As Grand Master of the Order, the Lord Lieutenant commissioned the little-known Italian artist, Vincent Waldré, to paint a series of

35) Vincent Waldré, *George III, supported by Liberty and Justice, c. 1788–c. 1801*

36) Vincent Waldré, *St Patrick converting the Irish to Christianity, c. 1788–c. 1801*

ceiling panels for the Hall: *George III, supported by Liberty and Justice; St Patrick Converting the Irish to Christianity* and *King Henry II receiving the submission of the Irish Chieftains* (Figs. 35, 36 and 37).[68] The subjects of these panels range from the historical to the allegorical, but, in the context of the fears of separation fuelled by the Regency Crisis, their unity of purpose is readily discernible: an ancient culture both Christian and loyal, Ireland can reap untold benefits while remaining firmly within the imperial orbit.

Waldré is known to have been in Dublin by 1789, having come from England where he had been resident from the mid-1770s. Originally from Faenza, Waldré was primarily a decorative artist who had been employed at Stowe, the Buckinghamshire country home of Lord Temple, where between 1777 and 1780 he decorated the Pompeian Music Room and Oval Saloon.[69] Temple's tenure of the Lord Lieutenancy of Ireland brought the artist to Dublin, where he was employed to decorate the 'Ceiling, Walls, &c. of St Patrick's Hall', a sum of £600 being awarded to him annually.[70] The original scheme for a fully-decorated hall has not survived, the three ceiling panels being the only remaining examples of Waldré's work in Dublin Castle. Long and complicated, the full history of this decorative commission has not been satisfactorily explained. Equally in need of explanation are the political and cultural implications of Buckingham's choice of subject for a hall that was the most glittering social venue of late eighteenth-century Dublin.

Accurate dating of the ceiling commission still evades us, but we do know that the as yet unfinished panels were installed in the Hall in 1792.[71] This means that they were only *in situ* after Buckingham had left Dublin, as he

37) Vincent Waldré, *King Henry II receiving the submission of the Irish Chieftains,*
 c. 1788–*c.* 1801

relinquished his viceregal office in late 1789. Given the absence of documentary proof of Buckingham having personally commissioned the Dublin Castle ceiling, the argument in his favour must rest on circumstantial evidence. A man of artistic discernment, Buckingham had delighted in the wall paintings at Pompeii while travelling on his Grand Tour in 1774. His extensive redecorations at Stowe, carried out in 1779, were those of a man well-versed in classical archaeology and aware of the by this time highly fashionable neo-classical taste in interior decoration.[72]

As a second-time Grand Master of his own order, Buckingham's interest in supplying the Knights with a suitably grand hall seems very much in keeping with what we know of the man's character. Lecky describes him as possessing 'great haughtiness, both of character and manner', while others refer to his being proud and overbearing.[73] Buckingham's desire to be closely and personally associated with the Knights of St Patrick is evidenced by the statues and portraits of the Lord Lieutenant produced in the late 1780s, where the collar of the Order is always much in evidence.[74] Seen as insecure, whimsical and self-indulgent, Buckingham was also much criticised as being only too ready to dip into the public purse to save having to spend his own money.[75]

St Patrick's Hall was redesigned as a suitable backdrop for the elaborate activities of the Order of St Patrick. The role of the ceiling decoration was to inspire confidence as well as imply history and legitimacy, necessary commodities as the Order had only been founded in 1783. Buckingham's deep-seated interest in the meaning of royal orders and their significance to the Crown lie behind the decoration of the Castle ceiling. Proof of his direct involvement with the iconography of the paintings is strengthened when we discover that, some years earlier, he was closely involved with the decoration of the King's Audience Chamber at Windsor. In 1786, some years after his first period as Lord Lieutenant and two years after being raised to a marquisate, Buckingham was made a Knight of the Garter.[76] The following year he played an advisory role at Windsor, where Benjamin West had been employed by George III to paint a sequence of scenes from the reign of Edward III. One of West's canvases commemorates an occasion that must have been dear to Buckingham at that particular time, *The Institution of the Order of the Garter* (Fig. 38). Recording an event of 1348, the painting is preoccupied with authenticity and includes, above the arches across the top of the painting, the arms of the original Knights of the Garter as well as historical personages such as Edward III, Queen Philippa, the Prince of Wales and the Bishops of Winchester and Salisbury.[77] Buckingham would have been well aware of the King's affection for the Garter, which was being revitalised in 1786, and of the propaganda potential in choosing relevant

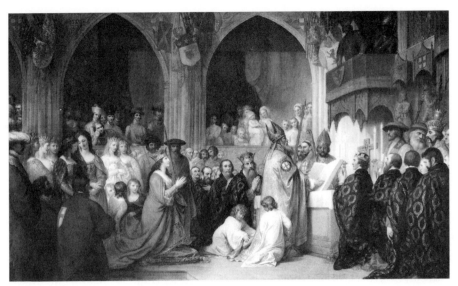

38) Benjamin West, *The Institution of the Order of the Garter*, 1787

moments from native history to improve the image of the Crown and encourage popular patriotism.[78]

Although conceived and begun during Buckingham's second tenure as Lord Lieutenant, Waldré's canvases, together with the elaborate decorative designs for the cove of the ceiling, were not completed until many years later. Throughout the 1790s and into the nineteenth century, Waldré was continuously distracted from finishing his grand scheme by other official commissions.[79] What now remains are the two Irish historical panels and the central allegorical oval. There also exists an oil sketch or *modello*, on canvas, for the ceiling design (Fig. 25).[80] This differs somewhat from the finished paintings (Figs. 35–37), the figures being invariably more squat, while their dress is often more in keeping with the Italian Baroque than late eighteenth-century neo-classicism. Given Buckingham's taste for neo-classical purity and historicism, it is not surprising to find that the finished paintings have a far tighter compositional structure than the loosely conceived sketch. The historically inappropriate Italianate buildings that appear in the background of the Henry II section of the sketch were to be replaced, in the final version (Fig. 37), by a semblance of Irish indigenous architecture, even if the rather wobbly round tower is far too early for the medieval fortress behind.

The main theme of the ceiling is the unity of purpose and traditions shared by Britain and Ireland. In the central panel (Fig. 35), George III, flanked by Britannia holding the union flag[81] and Hibernia dressed in green, accepts the gifts of the two crowns and two sceptres that fall from a cornucopia offered by Peace, who also proffers an olive branch. Justice and Liberty sit nearby. Above

the King some putti support the crown of St Edward, while others hold aloft the feathers of the Prince of Wales, implying dynastic continuation. All of this is broadcast by the fluttering figure of Fame sounding a trumpet. The classical dress and colonnaded architecture encourage a lack of specificity, the timeless-ness of the occasion implying the almost mythic bond of reconciliation and friendship that exists between the two kingdoms. In the central panel the por-trayal of such abstractions is aided by the unifying rhythm of the circular canvas. By contrast, the rectangular side panels invite a narrative structure, here convey-ing particular moments from Irish history.

The first panel one sees on entering St Patrick's Hall is the scene of St Patrick (Fig. 36), dressed in white, directing the lighting of the Paschal fire and thus establishing Christianity in Ireland. To the right a group of Druids turn away in fear, their circle of standing stones in the background overshadowed by the cross in St Patrick's right hand. The furthest panel (Fig. 37) records the meet-ing in 1171 between Henry II and the Irish chieftains where the latter promised their fidelity to the new Norman order. Although portrayed as an amicable exchange, the narrative focuses on a series of salient contrasts: the tunics of the Irish, doubtless implying nobility, are here contrasted with the modern effi-ciency of the invaders' armour. In the background the crude high walls of Dublin and the round tower are juxtaposed with Henry's military tent, packed as it is with elegantly carved furniture and silver plate. A late eighteenth-century view of the Irish state is thus neatly summarised. St Patrick is remem-bered as the instigator of a divine order, respected by all who were now calling themselves Irish. The arrival of Norman rule on the other hand, is seen as the instigation of a civil order. Both systems of control were of course still opera-tive at the end of the eighteenth century, and still deserving of the fidelity of the Irish people. The importance of the inclusion of Henry II would not have been missed by a late eighteenth-century visitor to St Patrick's Hall. Since the publication in 1698 of William Molyneux's *Case of Ireland . . . Stated*, Ascen-dancy Ireland had read the arrival of Henry II not as a conquest but as an his-torical episode, the submission of the Irish rulers to the King having been voluntary.[82] The legitimacy of the eighteenth-century élite to govern Ireland could thus be historically proven.[83]

As John FitzGibbon had said in his Commons speech of 1789:

> give me leave to tell the country gentlemen of Ireland, that the only secu-
> rity by which they hold their property, the only security which they can
> have for the present establishment in church and state, is the connection of
> the Irish crown with, and its dependence upon, the crown of England . . .

FitzGibbon went on to say that what the gentlemen of Ireland own, their estates, their position and their entire existence in Ireland, was dependent upon the maintenance of the ascendant position of the Protestant minority. By including the oath of fidelity to Henry II in the Dublin Castle ceiling, Buckingham, or more accurately the state, was underlining the need for Irishmen in positions of influence to remember their history, that privilege came with responsibilities, in this case a debt to the Crown. A refusal to honour that debt or a threat to shake that 'connection' could only lead to disaster. In his speech, FitzGibbon referred to the Act of Settlement of 1692, which confirmed ownership as laid down by Henry VIII in 1542. Only a hundred years old, this Act was not a legitimacy of great antiquity. The importance of the Castle ceiling as an instrument of political propaganda is that the inclusion of a reference to Henry II strengthens the historical claims of the ruling class to their part in a 'natural' order. Reference to St Patrick goes even further in authenticating the bond. As a symbol of the antiquity of Ireland, with its portrayal of Druids and standing stones, the panel dedicated to the Patrician apostolate confirms divine acquiescence on Ireland's need for a benign invader, priestly or otherwise. The Dublin Castle ceiling celebrates the Knights of St Patrick who were to gather below: the patron of their Order greets one on entering the Hall, the elevated cross banishing discord, as in some Counter-Reformation altarpiece; further on, still within the instructive realm of history, the Irish rightfully submit to Norman superiority. This submission of the Irish chieftains to Norman rule acts as an historical referent for the late eighteenth-century Irish peerage, whose loyalty to the Crown was to find its most extravagant expression in the establishment of its own chivalric order, the Knighthood of St Patrick.[84] To view the nobility as representatives of the nation was of course not uncommon. A contemporary pamphlet, vindicating Buckingham's tenure as Lord Lieutenant, discusses how 'the people esteemed [the new Order of St Patrick] as a token of respect to the nation conferred in the persons of its nobility – and [of how] it met with that sincere applause, which a measure having no other motive but patriotism – must ever experience'.[85] Finally, in the centre of the Dublin Castle ceiling, the present, in the person of George III, encourages reconciliation.

Buckingham's astute reading of Irish history and antiquarian writings attempts, in the subject matter of the Dublin Castle ceiling, to seek solutions to the tensions of the 1780s. Geoffrey Keating's Irish-language history of Ireland, *Foras Feasa ar Éirinn* (Basis of Knowledge about Ireland), completed in the 1630s, had appeared in a handsome English translation in 1723, stressing, as Clare O'Halloran has pointed out, 'the continuities between pagan and Christian Gaelic Ireland by making St Patrick an agent of reconciliation between the old

and the new'.[86] Meanwhile, contemporary scholars were actively suggesting such a reconciliation as an appropriate topic for painting. In 1790, in his *Outlines of a Plan for Promoting the Art of Painting in Ireland*, Joseph Cooper Walker advocated a school of Irish history painting which would include such subjects as 'St Patrick encompassed with Druids, Bards and Chieftains, explaining the nature of the Trinity by means of the shamrock. A Druidical temple *overthrown*, at some distance. The sun rising. [my italics]'[87] Although a liberal, Walker's suggestion for a painting of St Patrick was ironically taken up by the executive.

The need for reconciliation was vital. The formidable mobilisation of the Volunteers, the popularist reformist rhetoric of Grattan and, later, the nervous excitement of the Regency Crisis demanded and resulted in concerted government action. The language of the opposition was exclusive. Grattan might speak of the Irish nation, of how he found Ireland:

> on her knees, I watched over her with a paternal solicitude; I have traced her progress from injuries to arms, and from arms to liberty. Spirit of Swift, Spirit of Molyneux, your genius has prevailed, Ireland is now a nation; in that new character I hail her, and bowing to her august presence, I say, *Esto perpetua*.[88]

But this notion of an Irish nation was limited; it was a Protestant creation. As a means to extend its appeal, right across the sectarian divide, the activities of the government, as demonstrated by its encouragement of the cult of St Patrick, contain the irony inherent in reconciliation. Just as the Volunteers emphasised the divisionist culture of the Williamite tradition by tying orange ribbons round the statue of their hero, and just as Wheatley celebrated in paint their determination and self-assurance, so the state retaliated by means of the ceremonial symbols pertaining to the Order of St Patrick and the historically and politically pertinent language of the Dublin Castle ceiling. By exploiting a native motif, such as St Patrick, the state allowed, through a seeming generosity of spirit, the development of a specifically Irish, separate identification. But that motif had been removed from any sectarian identification, and had been translated through the triumphalism of a rejuvenated Baroque style into the passive language of reconciliation. By means of a subtle orchestration of visual imagery, the state indicated the need to move from a vocabulary of division, as represented in the progressive contemporaneity of Wheatley's *Volunteers*, towards the more amenable language of unity.[89]

- 3 -

PUBLIC AND PRIVATE

PORTRAITS OF UNCERTAINTY

THE GROWLING, SIMIANISED IMAGE OF THE IRISH TERRORIST, FIRST created by James Gillray in the late 1790s and later developed by George Cruikshank in the 1840s and John Tenniel from the 1860s to the 1880s (Fig. 39), is often seen as the predominant image of the Irish throughout the nineteenth century.[1] In fact he was only one element in the story. It is perhaps, as Roy Foster has suggested, not surprising that such a negative representation initially received both scholarly and popular attention some twenty-five years ago, 'just', as Foster says, 'when the British army was moving into Northern Ireland'.[2] Tenniel's Irishman is exaggerated, frightening and a recognisable threat to urban life during the period of Fenian activity. Yet he is but *one* of the variety of visual references we have of British attitudes to the Irish in Britain or the Irish in general. Perry Curtis's highly influential books *Anglo-Saxons and Celts* and *Apes and Angels* have coloured our view of the representation of the Irish to such an extent that we are left with a highly negative image.[3] Other studies such as *White Britain and Black Ireland* of 1976 by Richard Ned Lebow[4] and Frankie Morris's study of John Tenniel's cartoons for *Punch* have argued that, 'stereotypes helped to congeal attitudes on both sides, forming a "perceptual prison" in which practical political choices were severely limited'.[5]

A counter-attack in 1978 by Sheridan Gilley questioned Curtis's dependence on racial prejudice as the key to the negative representation of the Irish,

PUNCH, OR THE LONDON CHARIVARI.—October 29, 1881.

TWO FORCES.

39) John Tenniel, 'Two Forces', *Punch*, 1881

claiming that anti-Irishness only came to the fore in relation to specific religious and political issues.[6] In turn Luke Gibbons has asked us to consider a form of benevolent stereotyping, suggesting that Gilley's criticisms of Curtis are 'hampered by an assumption that racial stereotyping necessarily entails hostility and repulsion: "benevolent" stereotypes that depicted the imaginative Celt as *complementary* to Anglo-Saxon rationality served colonial domination far more effectively than crude forms of debasement, since they justified the continuation of "the Union" between Britain and Ireland'.[7]

Analysing the nature of stereotype, discrimination and the discourse of colonialism, Homi Bhabha, in *The Location of Culture*, has suggested that 'the point of intervention should shift from the ready recognition of images as positive or negative, to an understanding of the *process of subjectification* made possible (and plausible) through stereotypical discourse'.[8] The high art portraiture of a demonstratively Irish dimension that has come down to us from the hundred-year period, 1780 to about 1880, is understandably an array of the rich, the educated and the famous. The concentration in this chapter will be on four full-length portraits, three of which represent members of the Anglo-Irish minority, while one is of a man of indigenous Irish extraction. The portraiture of these individuals offer us an opportunity to examine what Bhabha has called the 'wide *range* of the stereotype, from the loyal servant to Satan, from the loved to the hated'. The subjects of the portraits of the Anglo-Irish, the Earl of Bellamont by Joshua Reynolds (Fig. 40), the Marquis of Wellesley by Robert Home (Fig. 47) and Lieutenant Richard Mansergh St George by Hugh Douglas Hamilton (Fig. 48), were ostensibly loyal servants to the Crown, while Daniel O'Connell, the sole indigenous Irish example chosen and represented here by two high art portraits, one by David Wilkie (Fig. 41) and one by Joseph Patrick Haverty (Fig. 45), endured throughout his public career a torrent of abusive visual (as well of course as verbal) attack by the popular media, to the extent that he could be seen to fit Bhabha's satanic category. What I am interested in doing here is examining what Bhabha goes on to call 'the shifting of subject positions in the circulation of colonial power'.[9] We must try to isolate the variety of Irishness in the portraiture of the period and see how representation throws up questions about the Anglo-Irish connection. The portraits will be examined under a variety of headings, starting with a division between the public and the private image. Bellamont, O'Connell and Wellesley fit the first category, rhetorical gesture and the traditions of public performance being very much in evidence. The more private reverie of Mansergh St George satisfies the second category. The more outwardly public portraits, such as Reynolds' Bellamont, also exhibit elements of the stereotypical representation of the Irishman in the late eighteenth and nineteenth centuries.

The Reynolds and Wilkie portraits will be investigated with this in mind while the Haverty and Home portraits will raise the issue of the cultural uncertainties that perplex the representation of Irishness in the period. Finally, Hamilton's portrait of Mansergh St George will take us into a more private realm, away from the public declarations of allegiance to a more heightened examination of uncertainty and a study of the sense of threat felt by the Anglo-Irish *c.* 1800. It is hoped that this discussion will broaden our use of visual references and not let us fall into the 'anti-Irish racism' trap, a condition condemned by Roy Foster as 'half-baked "sociologists" employed on profitably neverending research, determined to prove what they have already decided to be the case'.[10]

The art historical study of portraiture of Irish subjects for the period under discussion has been more about artists than sitters. This is understandable given the, admittedly now dwindling, prejudice within the art historical canon against artists from the periphery of these islands.[11] Anne Crookshank and the Knight of Glin have done valuable work in enlarging our knowledge of the *oeuvres* of innumerable Irish artists, but their methodology does not extend to extensive analysis: 'The Irish nobility and gentry may have shown a liking for exaggerated elaboration in their clothes and a delight in the overloaded decoration of their mahogany side-tables and chased silver, but in their portraits there is little to differentiate them from their English counterparts.'[12] The former might be true, as the discussion of Reynolds's portrait of the Earl of Bellamont will show, but the latter must be disputed. In formal terms a Reynolds of an Irish peer may indeed not differ ostensibly from one of an English peer, but that is to ignore cultural background. We need to ask not just *who* painted members of the Anglo-Irish elite but *how* they were painted and *why*. The *why* is perhaps the most important question to ask and will be examined in terms of the creation of a portraiture that satisfied on the one hand a benevolent form of stereotype of the Irishman, regardless of his religious or immediate cultural background, while also creating a portraiture that raises complex questions about cultural identity, a continuous 'shifting of subject positions in the circulation of colonial power'.

THE PUBLIC IMAGE

Reynolds's *The Earl of Bellamont*

At the beginning of our hundred-year period, in a portrait of an Irish peer such as Charles Coote, third Earl of Bellamont, painted by Joshua Reynolds between 1773 and 1774 (Fig. 40), the sitter is shown in the full regalia of the Order of

40) Joshua Reynolds, *Third Earl of Bellamont*, 1773–4

the Bath, his plumed hat and elaborate robes being similar to a very select number of portraits of English peers by Reynolds.[13] Following his own instructions in the 'Fourth Discourse' (1771), Reynolds avoids national particularity in preference for 'general nature',[14] the general nature here being the historic accoutrements of the Order with its medieval pretensions. We note the seemingly timeless, in fact Van Dyckian, costume worn by Bellamont, the great mantle with its star, the sword, a standard leaning against a column on the left and below a helmet with the peer's emblem of a coot on top.[15] Beyond the pulled-back drape we view a great hall with the banners and regalia of other new members of the Order. Lord Bellamont was a member of a colonial élite who, in Reynolds's portrait, exhibited at the Royal Academy in London in 1774, wished to be seen on a larger stage and to be accepted by the centre despite his regional origins.

A comparison with colonial American portraiture of the time is useful. In a recent essay, T. H. Breen, with a nod towards Benedict Anderson, has suggested that 'what we encounter in the portraits . . . are interpretations of reality, or more precisely, interpretations devised by artists and sitters of their place within an imagined Anglo-American society'.[16] Breen goes on to discuss three portraits by Copley of the mid-1760s where the female sitters wear what appears to be the same dress yet in different colours. The origin of the composition was an English mezzotint by John Faber, and each woman 'made a conscious decision to look exactly like the English lady depicted in the print'. Quoting another source Breen informs us that 'Copley was working from actual materials. All three ladies are painted in a very solid, three-dimensional manner and their voluminous gowns seem to stand out in a clearly defined space . . . This implies the actual presence of his sitters dressed in a model gown and could not have been achieved if he had merely copied the entire mezzotint except for the head.' 'In other words', according to Breen, 'for these three colonists the central element of the portrait was not how they looked in a specific garment. With Copley's help they maintained "reality". They were playing at being English.'[17]

The same could be said of Bellamont. To all intents and purposes he is shown by Reynolds as the acme of the peerage: elegant, relaxed, conscious of history and familial distinction. His garb and the overall composition is not unlike the portraits of others who received such honours, but Reynolds and/or his studio have produced a convincing representation of an individual. Bellamont is a convincing Englishman. But what of the plumed head-dress, granted an integral part of the formal dress of the Order? And what of the excessive flamboyance of the detail of his dress, the ribbons and bows, the emphatically knotted cords,

the flowing locks of hair that cascade over the shoulder? This is where we enter a more complex area of identification. Bellamont, like Copley's American sitters of a decade earlier, attempts to appear English, but his sartorial opulence and haughty demeanour accord with the eighteenth-century caricature of exaggerated behaviour popularly associated with Irish gentlemen visiting England. A quarter of a century earlier, Henry Fielding in *Tom Jones* had created, in the character of Fitzpatrick, a stereotypical image of the Irish gentry as wild, loud and excessive. Tobias Smollett repeated this caricature in *The Expedition of Humphrey Clinker* (1771): Sir Ulic Mackilligut, Bart., from Galway comes to England in search of a rich wife, his accent is exaggerated, his behaviour is 'prepasterous' and he lacks 'shivility'.[18]

Two main types of Irishmen were represented on the London stage in the mid-eighteenth century. There was the amusing and harmless, usually in the person of an uneducated servant, and there was the 'more socially elevated . . . a landowner, a man of means, with military experience'.[19] Bellamont fits the second category. As a landowner he owned extensive property in Cavan, served as its MP from 1761 to 1766 and afterwards as Lord Lieutenant of the country until 1773. In 1764, ten years prior to the painting of Reynolds's portrait, Bellamont had been made a Knight Companion of the Bath in honour of his efforts of the year before to suppress 'agrarian disturbances involving Oak Boys in Cavan and other Ulster counties'. This in turn led to his publishing an account of his military experiences.[20]

The Irish-born Thomas Sheridan produced a great success in both London and Dublin in his characterisation of Captain O'Blunder in *The Brave Irishman* of 1743. It tells the story of an Irishman in London in search of a wife. The captain's appearance and dress are much discussed and his pronunciation mocked. 'He's above six Feet high', says his rival Cheatwell, while another, Sconce, says that O'Blunder 'wears a great long Sword, which he calls his *Andrew Ferara* . . . a large Oaken Cudgel, which he calls his *Shillela* . . . a great Pair of Jackboots, a *Cumberland* Pinch to his Hat, an old red Coat, and a damn'd Potato Face'.[21] At the end, after winning the hand of Lucy, the daughter of Mr Trader, a merchant, O'Blunder generously encourages Cheatwell to accompany him to his '*Irish* Plantations', where he will give him '500*l*. to stock a Farm upon my own Estate, at *Ballmascushlain*, in the County of Monaghan, and the Barony of *Coogafighy*'.[22] Sheridan's exaggerated portrayal of O'Blunder conveys the essential perceptions of the Irish gentleman in London: loud and flamboyant, physically striking and daring. Even without the convenient proximity of geographical location to Ulster counties, we return to Reynolds's portrait of Bellamont with added interest. The Irish earl is certainly spectacular in his

appearance: his fine figure is emphasised by the delicate turn of the body and the casual crossing of the legs, his handsome face fully lit and framed by the costume and plumed hat. The military capability of the sitter is reinforced by the surrounding paraphernalia of standard, helmet and sword. Equally, from what we know of Bellamont, his personality was distinctly idiosyncratic. His early education in Geneva and a fondness for French ways led him to be allowed to deliver his maiden speech to the Irish House of Commons in that language, while a contemporary claimed that his 'ruling passion was women', another calling him 'the Hibernian seducer'.[23] His sartorial tastes ran to diamond shoe buckles and he was a stickler for hierarchical precedence and formality, yet another contemporary referring to him as 'a personage of disgusting pomposity'.[24] His vanity indeed led him to challenge Lord Townshend, the former Lord Lieutenant of Ireland, to a duel in London's Marylebone Fields in February 1773, where Bellamont was duly wounded in the groin.[25] Although duelling was on the decline in 1770s England, this was not the case in Ireland, where it acquired the dimension of what Joep Leerssen has called a national characteristic.[26] It could also carry a patriotic dimension, for, as James Kelly has recently shown in his study of duelling in Ireland, Bellamont's quarrel with Townshend may well have ended in the former Lord Lieutenant's favour but Bellamont, on returning to Ireland, was hailed as a hero. The *Hibernian Journal* of 22 October 1773 claimed that:

> The call which brought him to the field of honour was not the idle whim of a modern duellist, nor the instantaneous spirit of blood thirsty revenge; it was the cool deliberation of many months; it was the determined result of serious thought, actuated by a love of his country, which would not bear that even the representatives of majesty should, unpunished, insult the dignity of a subject.[27]

The duel occurred some six months before Bellamont's first recorded sittings for Reynolds.[28] What lay behind the commissioning of the portrait? Was it a personal celebration by Bellamont of his current popularity or a form of public distraction from what was also a private humiliation and an ethnic embarrassment? The popular contemporary Irish playwright, Hugh Kelly, attempted a comparable public disclaimer regarding popular conceptions of the Irish in his play *The School for Wives* of 1773. In the preface to the play, published a year later, the same year as Bellamont's portrait was shown at the Royal Academy, Kelly says that he attempts:

to remove the imputation of a barbarous ferocity, which dramatic writers,
even meaning to compliment the Irish nation, have connected with their
Idea of that gallant people . . . But to make [the gentlemen of Ireland]
proud of a barbarous propensity to Duelling; to make them actually delight
in the effusion of blood, is to fasten a very unjust reproach upon their gen-
eral character, and to render them generally obnoxious to society.[29]

The verbal dexterity of the stage Irishman, such as O'Blunder, who sings a song
which wins the heart of Lucy, was juxtaposed against his violent potential, his
litany of weaponry having being supplied at the beginning of the play. Indeed,
O'Blunder is also a duelling man who has killed, and is surprised that the Eng-
lish don't admire his sport – 'Arra, my jewel, they don't mind it in Ireland one
trawneen.'[30] O'Blunder can thus be seen as precursor of gentlemen like Bella-
mont who were described as possessing on the one hand 'the highest refine-
ments and most perfect elegance of manners' while on the other 'all his actions
were characterised by a singular mixture of diseased feeling and erroneous reas-
oning . . . like Satan, he contemplated paradise, and only entered it to
destroy'.[31] A contemporary Irish peer, the Earl of Barrymore was equally seen
in a contradictory light. John Bernard, an Irish actor, remembered him as:

> the most eminent compound of contrarieties, the most singular mixture of
> genius and folly, – of personal endowment and moral obliquity, which it
> has been my lot in life to encounter. Alternating between the gentleman
> and the blackguard – the refined wit, and the most vulgar bully, he was
> well-known in St Giles's and St James's . . . His Lordship could fence,
> dance, drive or drink, box or bet, with any man in the kingdom. He could
> discourse slang as trippingly as French; relish porter after port; and com-
> pliment her Ladyship at a ball, with as much ease and brilliance, as he could
> bespatter a 'blood' in a cider cellar.[32]

Although O'Blunder, Bellamont and Barrymore were all Protestants,[33] they
have all been tainted by what Oliver Goldsmith called 'long conversation with
the original natives'. The Irish Protestants, Goldsmith claimed in a piece in the
Weekly Magazine of 1759, are 'foolishly prodigal, hospitable, and often not to
be depended upon'. Equally, the 'original Irish are . . . frequently found fawn-
ing, insincere and fond of pleasure, prodigality makes them poor, and poverty
makes them vicious, such are their faults, but they have national virtues to rec-
ompence [*sic*] these defects. They are valiant, sensible, polite, and generally
beautiful.'[34]

The Irish Protestant is a victim of cultural confusion. On the one hand, Bel-lamont fulfilled the expectation of a gentleman of his position in obtaining a likeness from the leading London portraitist of the day, while, on the other, he had himself portrayed in a most extravagant fashion. That portrayal, not com-mon in Reynolds's wide range of poses, suggests alternative explanations. The Irish connection is thus a vital one. The need to travel to London and sit for Reynolds is proof, together with the mobility of the Irish playwrights such as Thomas Sheridan, of the cultural interaction that is an important element in the relationship between centre and periphery. As a two-way system, colonialism engenders interdependence. Cultural certainty may indeed be stressed by those, such as Bellamont, who aspire to the more dominant culture, but an underly-ing confusion will invariably make its presence felt. That confusion is visualised by a member of the Anglo-Irish élite fulfilling the stereotypical expectations of the Irish in England, while at the same time being painted by the most cele-brated sponsor of universal classicism in London. Bellamont's outlandish dis-play invokes a regionalist response and not the lack of specificity and timelessness expected of a Reynolds portrait. But such visual confusion is not limited to the higher echelons of the Anglican persuasion in Ireland. A study of the representation of Daniel O'Connell by David Wilkie (Fig. 41), a portrait that is equally loud and ornate, conveys similar uncertainties.

Wilkie's *Daniel O'Connell*

In the nineteenth century, no other Irish politician received the same degree of visual representation as Daniel O'Connell. Long vilified throughout his life as a treacherous and conniving politician, O'Connell's pictorial representation was wide and various.[35] In 1845 *Punch* carried its damning statement on O'Con-nell, *The Real Potato Blight of Ireland*, showing him as an immense potato luxu-riating in his capacity to extract pennies from the peasantry of Ireland, as evidenced by the plate of money on the floor in front of him.[36] Another motif was that of the Irish Frankenstein (Fig. 42), which first appeared in 1843 to comment on O'Connell's support of repeal.[37] O'Connell is shown 'conjuring up', as Perry Curtis has observed, 'a monstrous Irish peasant complete with horns, flaring nostrils, and thick lips who was supposed to epitomise the new movement for repeal of the Act of Union'.[38]

In 1868, twenty years after his death, a full-length portrait of O'Connell (Fig. 41) by Sir David Wilkie, painted some thirty years earlier, was shown in the Third Exhibition of National Portraiture held at the South Kensington

41) David Wilkie, *Daniel O'Connell*, 1836–8

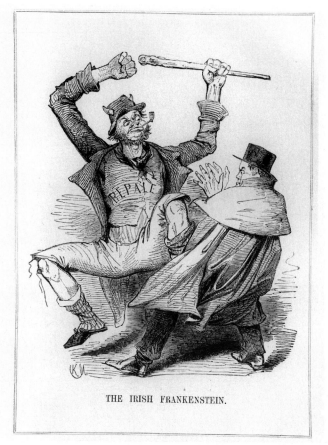

THE IRISH FRANKENSTEIN.

42) J. Kenny Meadows, 'The Irish Frankenstein', *Punch*, 1843

Museum.[39] This, and the two other national exhibitions which preceded it, played an important part, as Marcia Pointon has outlined, in establishing the validity of the fledgling National Portrait Gallery in London.[40] Included in an historical exhibition that covered the reign of George III and succeeding decades to 1867, Wilkie's portrait of O'Connell was surrounded by the great and the good of the last one hundred years of British history. The display of the O'Connell portrait can be seen as an antidote to the *Punch* and other negative images of O'Connell which continued well after his death and the arrival within the canon of recent British history of an acceptable face to Irish political life.[41] Granted, Irish politicians had enjoyed the benefits of grand style portraiture before O'Connell. In the late eighteenth century one finds representations of opposition figures such as Henry Grattan (Fig. 29) and Lord Edward FitzGerald, just as there were portraits of any number of be-wigged members of the executive such as John FitzGibbon, Earl of Clare and Irish Lord Chancellor.[42]

But what distinguishes O'Connell is his Catholicism and his unrivalled hold on the political and cultural life of Ireland at the beginning of Victoria's reign. Here is the liberal toast of Europe, the creator of the first mass movement in British politics, 'the man who discovered Ireland', as a German coachman told a tourist.[43] But how is he depicted? In 1835, when approached to paint the portrait by an English admirer of O'Connell, Wilkie worried about the commission being 'too political'.[44] At that time he was engaged in an historical imperial portrait of *Sir David Baird Discovering the Body of Sultan Tippoo Saib* (Fig. 43),

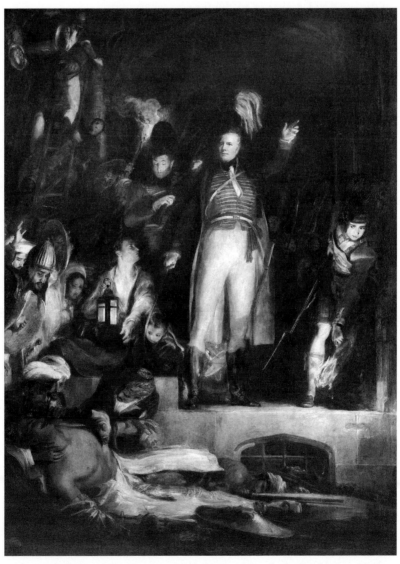

43) David Wilkie, *Gen. Sir David Baird Discovering the Body of Sultan Tippoo Saib*, 1835–8

highlighting the Scot's defeat of the Mysore leader. Eventually both paintings were shown at the Royal Academy, the *O'Connell* in 1838, the *Baird* in 1839.[45] The *O'Connell* is not unlike the *Baird* in its baroque pretensions. Instead of soldiers and armour we have books and papers, but a comparable triumphalism is to be found in the drapery and throne-like chair behind the Irishman and Baird's backdrop of the fortress at Seringapatam in central India. Furthermore, both Baird and O'Connell are fully lit, the brilliance of the soldier's white trousers, face and hands contrasting dramatically with the red of his uniform, while the statesman's darker form is framed by an equally rich red-lined cloak which picks up the light and directs us to the face.

The man who commissioned the portrait of O'Connell, the Rev. Horace Cholmondeley, was one of the first directors of the National Bank of Ireland, of which O'Connell himself was governor. In a letter, Wilkie quotes Cholmondeley as saying that at that moment, in late 1835, 'there was prejudice against' O'Connell but that he 'was a great man'.[46] The prejudice was largely aimed at O'Connell's seeming unchallenged power over the Whigs. In the same month as Cholmondeley's visit to Wilkie, *The Times* carried an aggressive attack on O'Connell:

> Scum condensed of Irish bog!
> Ruffian – coward – demagogue!
> Boundless liar – base detractor!
> Nurse of murders – treason's factor!
> Of Pope and priest the crouching slave,
> While thy lips of freedom rave;
> Of England's fame the vip'rous hater,
> Yet wanting courage for a traitor.
> Ireland's peasants feed thy purse,
> Still thou art her bane and curse.[47]

Contemporaneous visual representation of O'Connell was dominated by John ('HB') Doyle's series of subtle political sketches which, throughout 1835, exaggerated the dependence Melbourne and others placed on the Irish leader.[48]

In contrast to these representations of O'Connell, as on the one hand a scurrilous ruffian and on the other a sly and deceptive politician, Wilkie's portrait is celebratory. Here is the acceptable face of Irish politics, represented in a safe, hallowed style. O'Connell has all the status and poise of a senior senator and little to mark him out as the man Bismarck was later to refer to as 'a man I think I would have had shot'.[49] In contrast to the crudity of O'Connell as the

Irish Frankenstein (Fig. 42), Wilkie's portrait offers a more subtle exercise in what one might call cultural realignment. The painting is an image of O'Connell, the Irish leader who fought for repeal of the Union, presented through the language of acceptable baroque grand portraiture.

Commissioned by one of the first directors of the National Irish Bank, which O'Connell had help set up in 1835, the portrait was later presented to the bank.[50] As Oliver MacDonagh has outlined, the National Irish Bank was different from other Irish banks of the time, firstly in its national network and secondly as a financial organisation for Repealers. More importantly, despite its Irish nationalism, the Bank had access to London capital and expertise. 'Thus the whole enterprise', MacDonagh writes, 'was paradoxical in a way that reflected a dualism in O'Connell's own situation and disposition.'[51] The Bank was asked to join the London Clearing House and had a London headquarters and, equally, had a far wider clientele in Irish society than its rivals. MacDonagh writes that 'it does not seem extravagant to see all of this as mirroring O'Connell's double-sidedness, as, on the one hand, an extra-Irish giant, the very symbol of European liberal Catholicism and secular radicalism, and, on the other, the great Irish ethnogogue – to use Gladstone's telling word'. By extension, it is possible to read Wilkie's portrait as representing that double-sidedness, for O'Connell 'found no difficulty in inhabiting both an English and an Irish world'.[52] O'Connell may have found no difficulty in splitting his world between the two countries, but Wilkie's painting highlights an identity problem. The National Bank was innovative in drawing even 'the middle class of farmer and shopkeeper into its clientele; it tapped even the very small depositors; above all, it was the natural resource of the ordinary Catholic customer'.[53] O'Connell needed the middle classes, yet his portrait is élitist and turns its back on the ordinary.

The fact that Wilkie's *O'Connell* sticks to an old-fashioned baroque language says a lot about the problems of national identity as visualised in the portraiture of the period. O'Connell's status as a prominent Irish Catholic politician was an uncertain position, an untested zone for visual representation. This uncertainty and the old-fashioned nature of the portrait is made clearer if one compares the Wilkie with some other political portraits of the era, in particular a series commissioned by Robert Peel. An important patron of contemporary art of the period, Peel advocated a more modern style for political portraiture. Wilkie's painting of O'Connell, despite the Liberator's liberal credentials, is an aesthetically backward-looking portrait, high on rhetoric, short on innovation. Peel's collection of portraits by Thomas Lawrence of such fellow statesmen as Aberdeen, Canning (Fig. 44) and Liverpool conveys a more sober and more adventurous aesthetic.[54]

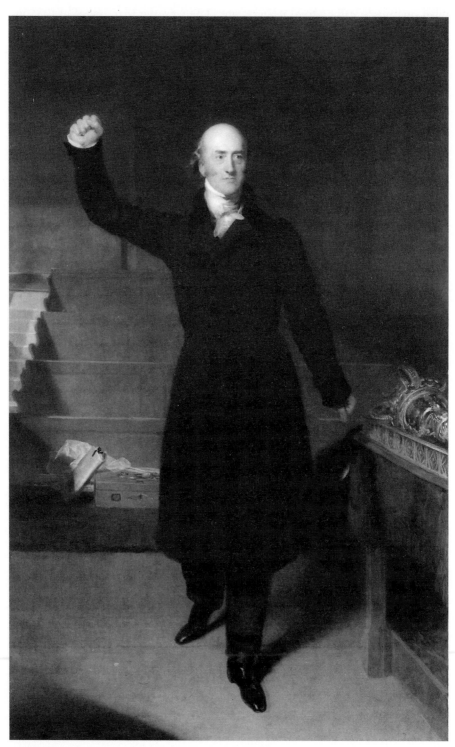

44) Thomas Lawrence, *George Canning MP*, 1825–6

Peel had a very clear idea about the visual nature of the portraits he commissioned. In a letter of 1844 he informed the painter Frederick Richard Say that he wanted 'the figure standing in plain dress. The likeness as accurate as possible – the full size of life without embellishment. The background to be a very plain and quiet one – without a variety of colours.'[55] And it was these elements that had long been admired in the Lawrence portraits Peel had commissioned. An 1830 portrait of Lord Aberdeen, when Foreign Secretary under Wellington, was seen by the *Spectator* as 'simple, natural and unostentatious . . . an air of courteous suavity pervades the whole'.[56]

Wilkie's original fears that his image might be 'too political' were to prove unfounded, for what we have here is a perfect example of what Luke Gibbons has called 'benevolent stereotyping', in a way that is complementary to 'Anglo-Saxon rationality', a perfect justification, it could be claimed, for 'the continuation of the Union between Britain and Ireland'.[57] There is no confrontation here, rather an emphasis on acceptability. The loud, almost vulgar, display of baroque paraphernalia reminds us of Reynolds' portrait of Bellamont (Fig. 40), where the tensions between what is English and what is Irish have been enunciated. In seeking acceptability, O'Connell in Wilkie's portrait sides with the past, just as much as Lord Bellamont surrounded himself with the symbols of ancient heraldry.

Haverty's *Daniel O'Connell*

Such a preoccupation with the past is also found in an earlier full-length portrait of O'Connell by the Irish painter Joseph Patrick Haverty (Fig. 45). Originally painted for the Catholic Association, which would date it to the 1820s, William Ward's mezzotint, printed in London and reproduced here, dates from 1836, the year after the Rev. Cholmondeley commissioned Wilkie's portrait. Shown amidst the glens of Kerry, a huge mastiff by his side and a ruined castle in the background,[58] O'Connell ostensibly recalls the 'semi-mythical memory of an ancient Gaelic chieftainry who had granted [the Irish] protection before the advent of [the Anglo-Irish]'.[59] And yet the Haverty portrait is very much an image of the early nineteenth century and very much a portrait emanating from the Celtic fringes of a newly enlarged United Kingdom. Haverty's painting emits Walter Scott-like pretensions and, as such, its ideology is less that of cultural independence than of retreat into passive nostalgia, in ways not dissimilar to a character in a Lady Morgan novel. Just as the cloak-wrapped chieftain set within his own wild landscape recalls any number of the Scottish

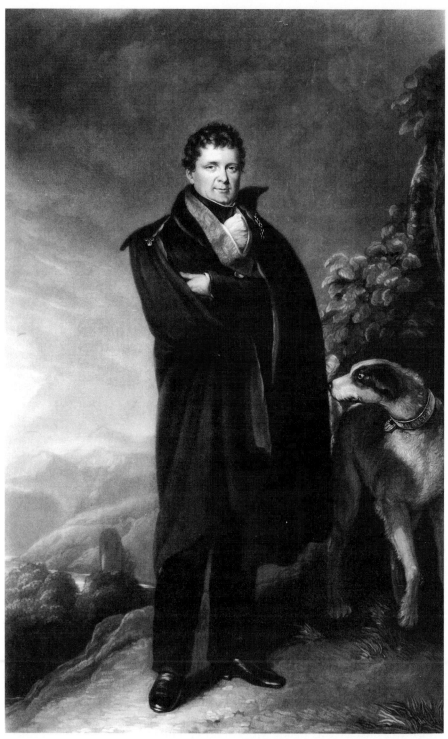

45) William Ward after Joseph Patrick Haverty, *Daniel O'Connell*, 1836

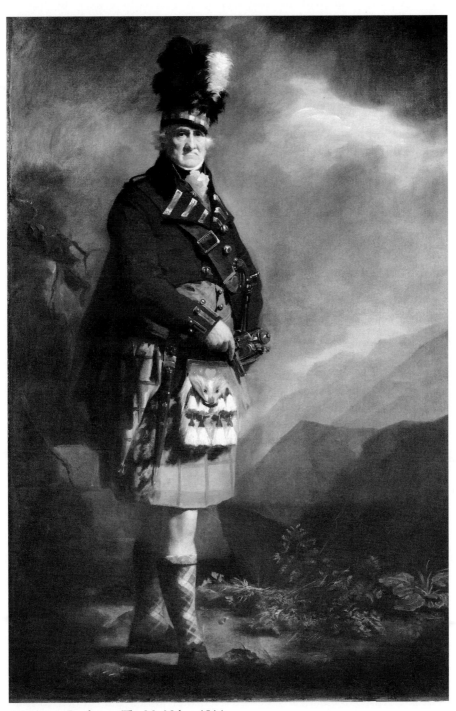

46) Henry Raeburn, *The MacNab, c.* 1814

novelist's Highland scenes, so too Haverty's portrait recalls, through setting and pose, the slightly earlier, tartaned chieftain portraits of Sir Henry Raeburn (Fig. 46).[60] A great admirer of the novels of Scott, indeed they were his 'leading pleasure' in the 1820s, for O'Connell they 'struck many chords – sentimental, romantic, costume-historical'.[61] In drawing a connection between this portrait of O'Connell, the novels of Scott and the Highland portraits of Raeburn, the end results are similar: an *ancien régime* world is evoked and cherished.

Towards the close of *Waverley* (also 1814), Scott describes a scene where the eponymous hero is confronted by a painting which represents himself and his recently executed Jacobite friend, Fergus Mac-Ivor:

> It was a large and spirited painting, representing Fergus Mac-Ivor and Waverley in their Highland dress, the scene a wild, rocky, and mountainous pass, down which the clan were descending in the background. It was taken from a spirited sketch, drawn while they were in Edinburgh by a young man of genius, and had been painted on a full length scale by an eminent London artist. Raeburn himself, (whose Highland Chiefs do all but walk out of the canvas) could not have done more justice to the subject; and the ardent fiery, and impetuous character of the unfortunate chief of Glennaquoich was finely contrasted with the contemplative, fanciful, and enthusiastic expression of his happier friend.[62]

In the novel, as Cairns Craig has pointed out:

> What links Waverley of the painting with the Waverley who has become a landed gentleman owning such a painting is . . . occluded. The process of history disappears out of life by being reduced to an imaginative construction held within its own frame, its own frame of reference. Art becomes a realm of romantic nostalgia incapable of communicating with the real world in which the characters now live.[63]

So too with O'Connell. The reality of his fight for Catholic Emancipation is occluded in Haverty's portrait in favour of a romantic nostalgia that would not upset the status quo. In Haverty's portrait, and in similar forms of representation such as Raeburn's portraits of Highland chieftains, this world of nostalgia has become a reality for its consumers. Fantasy has taken over the apparently prosaic genre of the portrait.[64]

At Derrynane O'Connell 'dispensed seigneurial justice' and satisfied, to again quote from MacDonagh's biography, his 'abiding sense of place . . . Half-way

about the compass, as one looked around, towered higher mountains, jagged in outline or lost, across a line, in mist or rain. Southward lay the vast stretch of Kenmare Bay, with its broken near-coast and dreaming or tortured sea, and in the distance, the dark mass of the opposing ranges in west Cork'.[65] 'A reasonably good landlord', O'Connell still wished to maintain a tribal-feudal relationship with his tenantry.[66] Indeed he opposed the introduction of a poor law as it would affect 'the network of mutuality and deference that rendered Irish poverty more endurable by creating a means of personal kindliness and humanity in the countryside'.[67] Paternalism, as Terry Eagleton has claimed, 'was part of the Ascendancy ethic' and it affected both Catholic and Protestant landlords.[68]

Uncertainty dominates these images. In the Wilkie, O'Connell satisfies a benevolent view of Irish political aspirations through his acceptance of the visual language of a conservative hegemony. In the Haverty, O'Connell reverts to an uncomplicated paternalism that echoes the representation of the conquered and now utterly assimilated chieftains of Highland Scotland. What is O'Connell? Thomas Flanagan has shown how the hero of Lady Morgan's slightly ridiculous 1814 novel, *O'Donnel, A National Tale*, was based on the royalist, Count Daniel O'Connell, uncle to the Liberator.[69] The story is of a descendant of an old Irish family now reduced in circumstances, but one who has maintained a clear sense of his family's greatness and conveniently still owns a host of family heirlooms, including a sixteenth-century portrait. Lady Morgan's innovation is that her hero is a Catholic and yet he has 'all the hallmarks of an English gentleman'[70] and, as Tom Dunne has remarked, 'not only accepted the colonial settlement, but also helped to preserve it'.[71] Such seeming contradiction makes the representation of the more famous Daniel O'Connell so in need of investigation. For here was a man whose ambition was the 'mobilization of Irish Catholicism'[72] and, later, the repeal of the Act of Union, but whose pictorial representation would seem to undermine those goals.

Home's *The Marquess of Wellesley*

Cultural uncertainty also affected such an exemplum of imperial service as Richard Wellesley, the Earl of Mornington and Governor-General of Bengal from 1798 to 1805. Born in Ireland, the son of an Irish peer, Wellesley was the elder brother of the future Duke of Wellington. In 1800 Wellesley had his portrait painted by the expatriate English portraitist, Robert Home (Fig. 47). Resting his right hand on a table littered with scrolls, Wellesley refers us to the

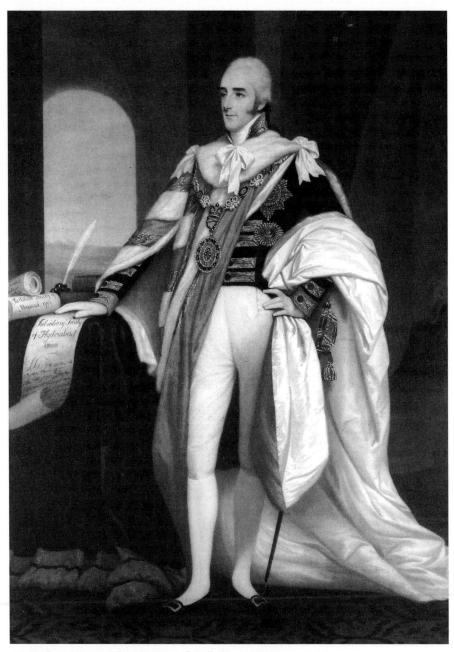

47) Robert Home, *The Marquess of Wellesley, c.* 1801

treaties that concluded the Fourth Mysore War. Ostensibly there is nothing particularly original or striking about this portrait. The pose is grandly aristocratic, the sitter's surroundings are suitably general yet palatial, and the arranged scrolls tell of high politics and imperial success.[73] Wellesley is wearing the robes of the Order of St Patrick, of which he was a founder member. The sitter displays prominently the impressive collar of the Order together with the large badge and the half-hidden star, where the Irish harp and shamrock are predominant motifs (Fig. 34). Legend has it that this regalia had been made from the plundered jewels of the defeated leader of Mysore, Tipu Sultan. Taken from Tipu's fortress after the storming of Seringapatam in 1799, the jewels were presented to Wellesley by the Court of Directors of the East India Company on behalf of the victorious British army in India.[74] Proudly wearing the regalia of the Order of St Patrick, Wellesley, in Home's portrait, represents the high achievement of the Irish élite who served the Crown in India. Dated to 1801, this portrait was produced only two years after Wellesley had been elevated to an Irish marquisate. Insulted by the offer, he created a considerable stir that in retrospect raises interesting issues regarding cultural confusion. Wellesley went to India as the holder of an inherited Irish title; however, he was offended by the award of an Irish marquisate in December 1799. What he really wanted was an English peerage. In a letter to William Pitt, he wrote of how he was 'confident there had been nothing *Irish* or *pinchbeck* in my conduct, or in its result, I feel an equal confidence that I should find nothing *Irish* or *pinchbeck* in my reward'.[75] While to friends in England, Wellesley could exclaim, '. . . for God's sake bring me home, home, home; home first, home last . . . No official letter has reached me respecting my *new brogues*; and it would not be correct to put them on *before I get them, by Jasus*', or '[no] remedy [can] afford me any hope of recovering what my friends in England have lost for me, excepting the change of my cursed Irish buttermilk into good English Ale'.[76]

Wellesley's tenure in India was notable for the extravagance of his lifestyle and his attempt to give his rule the aura of a regency: he equipped himself with a new government house, grandiose titles and, most particularly, the ritual of a court modelled on that of the Lord Lieutenant of Ireland.[77] It is ironic, of course, that he should wish to mimic the rituals of the Irish viceroyalty, given his dismay on receiving an Irish peerage. The anger exhibited by Wellesley was such that he saw his elevation as as much an insult to India as to him personally:

> Never was so costly a pride so abased: never was reward so effectively perverted to the purposes of degradation and dishonour. I will venture to assert that there does not exist a man in India who has not formed a more

mean opinion of me in consequence of the honours which have been inflicted.[78]

The sentiments are those of a man who had failed to get his own way in the coveted stakes of preferment. Wellesley proudly wears the Order of St Patrick but wishes to be recognised only in English terms. On a personal level, vanity may have been Wellesley's major problem, but the prominent display of his Irish gongs brings us back to the uncertainty that underlies all of the visual examples discussed. All these men are proud of their status, as politician and/or as aristocrat, but their visual representation undermines their self-assurance. Bellamont goes over the top in his portrait by Reynolds, thus bringing him into line with the unflattering stereotypical portrayal of the stage Irishman in London. O'Connell joins forces with the representation of the status quo, his Irishness thus lessened or, in the case of the Haverty portrait, reduced to an essay in nostalgia. Finally, Wellesley exhibits the classic uncertainties of his class by outwardly displaying his regional awareness, the wearing of the Order of St Patrick, while privately reneging on his Irishness. This in many ways is the reverse of Bellamont, who attempts in Reynolds' portrait to deny his regionality, but, in over-dressing in ornate regalia, actually highlights his origins.

THE PRIVATE IMAGE

Hamilton's *Richard Mansergh St George*

The problem with Ireland was that it was not England. Ireland was a mixture of things; it was not uniform like its neighbour, or at least as its neighbour conceived itself to be. In 1812 the novelist and Anglican priest Charles Maturin claimed that he set his novel *The Milesian Chief* in Ireland because he 'believe[s] it is the only country on earth, where . . . the extremes of refinement and barbarism are united, and the most wild and incredible situations of romantic story are hourly passing before modern eyes'.[79]

Those extremes of refinement and barbarism are pictorially realised in a portrait of a few years earlier (Fig. 48). Painted in the second half of the 1790s by the Irish portrait painter, Hugh Douglas Hamilton, the full-length portrait of Lieutenant Richard Mansergh St George of Headford Castle, Co. Galway, is an intriguing essay in the extremes of late eighteenth-century Irish life. On the one hand, the portrait records the grief of a distraught husband on the death of his wife and can be seen as an elegant example of a contemporary fashion for

48) Hugh Douglas Hamilton, *Lieutenant Richard Mansergh St George*, 1796–8

heightened sensibility. On the other hand, when we investigate the sitter and a surviving letter commissioning a portrait, an added complexity enters the discussion. Mansergh St George commissioned the portrait not only to assuage his grief but to exorcise some private demons. Yet those demons can be seen to be not purely private but relate to the man's social and political position. An Anglo-Irish landowner, magistrate and soldier who had fought in the American war and had reached the rank of Lieutenant by the time the portrait was painted, Mansergh St George was a firm upholder of his class and of his colonial position.[80] Reference to Maturin is apposite, for, like a Gothic novel, the letter and by implication the portrait reject the present, are preoccupied with the past and with memory. Mansergh St George's chronic grief leads him to imagine a scenario where the dead continue to live, where things will not actually have changed. Written in the early 1790s, with the portrait possibly following soon after, the letter must be read in the context of mounting Protestant fears in a troubling decade. As Oliver MacDonagh has stressed, 'From 1793 onwards Ireland . . . was whirled about once more in a descending spiral of religious mistrust and dread.'[81] Mansergh St George blocks off the reality of the uncertainties of the 1790s by revelling in a private, almost pleasurable, reverie. Similarly, if the Gothic novel *Melmoth the Wanderer* can be described as 'an allegory of Ireland, it is also a sublimating and aestheticizing of all that turmoil, a strategy for converting it into pleasurable sensation'.[82] By mourning and by attempting to remember through art, Mansergh St George strives to maintain continuity and stability. In this way his behaviour and his use of portraiture resemble the other Anglo-Irish examples discussed in this chapter. In all, the unsettled nature of the colonial psyche in late eighteenth-century Ireland fluctuates between refined sensibility and an excess of vanity or, in Mansergh St George's case, an excess of morbidity.

Hamilton's portrait commemorates a dead wife and a husband's grief, while the commissioning letter conveys a more Gothic tone, with the writer rejecting the present, exposing his fixation with the past and with memory.[83] Terry Eagleton has suggested that the 'Protestant Gothic might be dubbed the political unconscious of Anglo-Irish society, the place where its fears and fantasies most definitively emerge'.[84] As Eagleton says, 'if the Irish Gothic is a specifically Protestant phenomenon, it is because nothing lent itself more to the genre than the decaying gentry in their crumbling houses, isolated and sinisterly eccentric, haunted by the sins of the past . . . For Gothic is the nightmare of the besieged and reviled . . . of a minority marooned within a largely hostile people to whom they are socially, religiously and ethnically alien.'[85] As a reading of Hamilton's portrait and its supporting documentation will show,

Mansergh St George fits that Gothic scenario only too well. To Seamus Deane, the ruins of Melmoth's house 'are the emblems of an alienation and a failure, which the destitution of the peasantry intensifies . . . Maturin's ruins are the evacuated houses of Protestant civilization blighted by an environing and ener-vating Catholicism; his Romantic heroes are Irish Protestants in an Irish Catholic world which they repudiate and by which they are repudiated.'[86]

Hugh Douglas Hamilton's portrait, now owned by the National Gallery of Ireland, has been discussed elsewhere in terms of its 'excessive, if fashionable, morbidity'.[87] Hamilton shows Mansergh St George leaning against his recently dead wife's tomb, a secularised sarcophagus inscribed 'NON IMMEMOR'. An excess of contemporary melancholy is on show: the sitter has discarded his mil-itary headgear and is lost in private mourning. His isolation, contemplative aspect and abstracted stare locate the portrait firmly within a flourishing late eighteenth-century poetic tradition. Equally, his pose, while ostensibly harking back to antiquity, is formally reminiscent of more recent examples of mourn-ing figures, from paintings by Joseph Wright of Derby to tomb statuary by Hamilton's friend Antonio Canova.[88] The elegant grove of cypress trees on the left, leading to an island sanctuary, recalls the well-established symbolism of that particular tree which, when 'a branch is severed, it can no longer grow, just as he who succumbs to melancholic despair, gives up all chances of hope'.[89] The island sanctuary might equally refer to the island tomb at Ermononville of Rousseau, whom it is known was admired by Mansergh St George.[90]

Hamilton's portrait was painted, or at least begun, some time before Febru-ary 1798. This we can assume because in that month Mansergh St George came to a horrible end, a victim of the early stages of the 1798 rebellion. Hacked to death with a rusty scythe, Mansergh St George had attempted to defend him-self and his land agent against a band of South Tipperary/North Cork intrud-ers who had fashioned their pike holders from trees on their victim's land.[91] That Mansergh St George was to die so brutally adds extra spice to the letter that he left describing the kind of portrait he wished painted to commemorate his grief. The letter is to Henry Fuseli and allows Mansergh St George to enter into a Gothic discourse that takes the story of this peculiar individual onto an altogether more culturally intriguing plane than the mere formal merits and sources of Hugh Douglas Hamilton's painting would imply.[92]

The death in 1791 or 1792, perhaps in childbirth, of Anne Stepney, Mansergh St George's wife, was the catalyst for the letter and the eventual por-trait by Hamilton. The sitter seems to have originally sought Fuseli, but no record of such a work by that artist exists.[93] The couple had had two sons, Richard, born in 1789, and Stepney, born in 1791, who were left as mother-

less infants when the letter was written in late 1791 or shortly after.[94] Shocked at the death of his wife and concerned about the welfare of his children, Mansergh St George wrote to the artist requesting that an image be painted of himself which, together with some volumes that would describe 'The Circumstances of my Life from sixteen years old', would then be shown to his sons in the years to come so that, 'from your remembrance probably, of my face and your imagination you will make a sufficient historical resemblance conceiving the expression of convulsive horror and Incurability, Delirium, I should say, in my countenance'.[95]

Although this letter was not written with Hamilton in mind, it refers to the type of portrait the artist was in fact to execute. The letter reveals a man overcome with grief and deep feeling. He is suffering from 'convulsive attacks' and hallucinations and, with some uncanny premonition of his own death, Mansergh St George writes of how 'The dreadful picture (which I will never see) you are to paint for my children and posterity shall not be seen (nor known) to any person till they arrive at mature years'.

The painting was to be locked away in a specially built room:

> so as to be preserved from injury of time and weather . . . Instructions shall be left so managed that the time I may reasonably conceive their most impressionable and most permanently so, without any previous intimation of it, suddenly The Images of their Father and Mother may appear to Them in the terrible circumstances I have conveyed to you . . . This dreadful and strange apparition may be a sudden and powerful impulse (inducing them eagerly to read the history contained in the volumes which shall be deposited in a Trunk in the room with the Picture . . .) [and] produce the effects I wish for and hourly fill my thoughts . . .

Towards the end of the letter the writer describes how he now appears, although he could not have been more than forty years old, in terms close to that of some mythic vision: '. . . conceive me by care and years grown haggard – my hair and beard are white as snow – and I am an aged man in appearance, though but just advancing to middle age'.

What is intriguing here is not Mansergh St George's mental instability as such, but the context in which the letter and the eventual portrait were created. As suggested, Hamilton's painting bears all the hallmarks of an up-to-date essay in melancholic portraiture. The letter with its emphasis on the future potency of the portrait to inform and no doubt terrify the subject's children, together with such tropes as the locked room and volumes of family history

supposedly teaming with hidden secrets, remind us of the story lines of a num-
ber of 1790s Gothic novels that were no doubt easily available to a man of lit-
erary and intellectual interests such as Mansergh St George. A friend of a
number of adherents to the cult of sensibility, such as the poet Anna Seward,
the so-called 'Swan of Lichfield', Mansergh St George also knew Sir Brooke
Boothby of nearby Ashbourne in Derbyshire, through whom he may have met
Rousseau. He was also acquainted with the famous Ladies of Llangollen, the
Irishwomen Lady Eleanor Butler and Sarah Ponsonby, for whom he drew a
'striking likeness' of Rousseau, a suitable subject for such a follower of senti-
ment.[96] To Eleanor Butler, Mansergh St George was 'one of the most pleasing
men I ever conversed with . . . very pretty, slight figure, pale genteel Face, his
appearance is rendered even more interesting by the black silk cap he wears
upon his head to conceal the terrible wound he has received in the American
war'.[97] Earlier, while still an undergraduate at Cambridge, Mansergh St George
was active as an amateur caricaturist who enjoyed satirising London society in
a number of drawings that were duly engraved and published by the Matthew
Darly firm.[98] A sophisticated man, Mansergh St George had travelled to Italy,
seen the ancient sites and was privy to gossip about the Prince of Wales.[99]

In April 1798, two months after Mansergh St George's death, Seward wrote
of how her late friend reminded her of Falkland in William Godwin's *Caleb
Williams*, which had only appeared four years before. 'All that Orlando [sic]
Falkland would have been', she writes, 'had not disgrace blasted his course, dear
St George was.' A direct link is thus drawn between Richard Mansergh St
George and a contemporary Gothic hero:

> I cannot help thinking Godwin knew him, and that his talents, his excel-
> lencies, and peculiar cast of manners, suggested to this author the idea of
> his hero; – so exactly do we find the portrait of St George's person, genius,
> virtues, and singularities, in the description of Falkland, when he was
> serene and full of hope, at peace with himself, admired and respected by
> all who knew him. The slender, almost effeminate, yet graceful figure; –
> that mixture of dignified reserve, interesting sweetness, high spirit, and var-
> ied intelligence, which so amply recompensed the want of manly features
> in a pale fair face; that exquisitely jealous sense of honour; that romantic
> elevation of intrepid sentiment, despising every danger, capable of every
> exertion, and patient of every suffering, except infamy. Such was St
> George, and I can conceive the possibility of a mind thus tempered becom-
> ing demonized by what should appear to its feelings, deep, and, though
> undeserved, remediless disgrace.[100]

Despite her somewhat sentimental and self-indulgent description of Mansergh St George, Seward sees him in binary terms, as both refined and 'demonized'.[101] Mary Shelley, Godwin's daughter, was to highlight a similar reaction in her well-known account of the impact of *Caleb Williams* on the public, of how 'those in the lower classes saw their cause espoused, & their oppressors forcibly and eloquently delineated – while those of higher rank acknowledged & felt the nobleness, sensibility & errors of Falkland with deepest sympathy'.[102]

Mansergh St George is equally troubled, his letter jumps from semi-inarticulate passages of hysteria to lucid descriptions of what is to be done with the portrait and where the artist can avail of earlier portraits to help him in the creation of this new one. He can cry:

> O God that I could but for three hours in 24 be at ease – no effort nor medicine no trick can procure it – I take laudanum by advice – I try to divert thoughts [of] pain by every method every one proposes – I take snuff – I walk till I am fatigued, read, write, weary myself, drink wine – but in vain – I resist. I give way – sit quiet – run from room to room, from seat to seat, talk with servants, look out of the window, out of the door, eat against appetite, but I cannot . . . obtain momentary ease by change – I cannot weep – I have tried mechanical means to do it – This (jargon as it is) has too much the air of description for real suffering – but it is (and painful is the expression) to impress you how important to me the picture I mentioned.

And he can inform:

> I shall leave instructions with my executors that Henry Fusile [sic] is to be paid the price he demands for a Picture concerning which he has my instructions . . . If I die . . . a miniature painted here, more like than miniatures usually are, shall be transmitted to you . . . you will have access to the Picture by Gainsborough of me which you have seen.[103]

Early in *Caleb Williams*, Falkland is described as leading a reclusive and solitary life:

> He avoided the busy haunts of men . . . His features were scarcely ever relaxed into a smile, nor did that air which spoke the unhappiness of his mind at any time forsake them: yet his manners were by no means such as denoted moroseness and misanthropy. He was compassionate and consid-

erate for others, though the stateliness of his carriage and the reserve of his temper were at no times interrupted. His appearance and general behaviour might have strongly interested all persons in his favour; but the coldness of his address, and the impenetrableness of his sentiments, seemed to forbid those demonstrations of kindness to which one might otherwise have been prompted.[104]

Falkland fluctuates between 'frenzy' and 'inflexible integrity' but has a secret. Disturbed by Caleb as he hastily shuts a trunk, Falkland's angry reaction terrifies his servant.[105] In *his* letter, Mansergh St George wrote of how he too was to hide things in a trunk. P. N. Furbank has suggested that the secret in the trunk in *Caleb Williams* is 'the secret which Godwin brings to the light of day in [*Enquiry Concerning*] *Political Justice*, the guilty secret of government'.[106] Mansergh St George's secret is history itself, the Anglo-Irish condition.

Mansergh St George's locked away portrait and the volumes of family history recall the comparable secrets discovered by Amanda, the heroine of the Irish writer, Regina Maria Roche's highly popular novel of 1796, *The Children of the Abbey*.[107] Throughout the novel, portraits feature as holding secrets: early on, Captain Fitzalan, the heroine's Irish father, admires a portrait of his future wife which is then much later discovered by Amanda, long after her mother's death:

> Though faded by the damp, it yet retained that loveliness for which its original was to be admired, and which Amanda had so often heard eloquently described by her father. She contemplated it with awe and pity; her heart swelled with the emotions it excited, and gave way to its feelings in tears. To weep before the shade of her mother, seemed to assuage the bitterness of those feelings.[108]

Like so many other novels of the genre, *The Children of the Abbey* is riddled with old secrets and a terrible deed perpetrated in the past. A will and a portrait play a crucial role in exposing a hidden truth. Similarly for Mansergh St George, the room in which he will hide his portrait and personal history will, one day, 'produce the effects I wish for'. Indeed the first edition of Roche's novel, which Mansergh St George, conceivably, could have read, carried a frontispiece illustrating Amanda's discovery of the lost portrait in an abandoned room of an old castle.[109] As Siobhán Kilfeather has claimed, 'The moment of confrontation with the ghost enacts the terror of history and of the power of the dead which inflects so much gothic discourse about Ireland.'[110]

By the 1790s such Gothic machinery had had a long history.[111] Despite the thirty years that separate their publication, Horace Walpole's *The Castle of Otranto* (1764) and Ann Radcliffe's *The Mysteries of Udolpho* (1794) contain a common inclusion of the restless portrait or horrific image behind a veil. In *Otranto*, Manfred's grandfather is endowed with life and has power of stepping down from its frame, while Radcliffe's veiled picture in *Udolpho* turns out to be a wax figure within a recess of a wall, although Emily thinks it to be a rotting corpse. In both stories the two-dimensional (or the presumed two-dimensional) becomes three-dimensional and, in the case of the Otranto portrait, actually walks. St George's undiagnosed disease, with its frequent convulsive fits and resultant pain, allowed him no ease. His own face seems to haunt him, and he claims to have aged prematurely. By having his face transferred to canvas he suggests a possible cure.

Walpole's moral of the sins of the fathers visiting their children to the third and fourth generation[112] is similar to Mansergh St George's concern with saving his children from the undisclosed pain and torture that he and his wife have had to undergo. In Walpole's novel, the portrait of Don Ricardo with its sedate, 'but dejected', march 'to the end of the gallery', create in Manfred feelings of anxiety and horror. When evil is rampant the portrait must leave its frame. Similarly, to Mansergh St George, the portrait (together with the volumes) is to act as a force against evil or dissipation. Although he does not use the word, one feels on reading the letter that the writer is of the opinion that some kind of curse has fallen on his family. He claims that the whole exercise of commissioning the portrait is 'urged by the most powerful motives that actuate human nature, I mean human nature sublimated and rendered exquisitely sensible by Education and habits and circumstances peculiar as mine – by a nervous and too susceptible frame, by disease, calamity and reflection of neglected duties and affections ill rewarded.' The portrait will act as a talisman, or will magically remove that curse. The angst or anxiety that St George feels is comparable to Manfred's; the former is terrified by his own face, just as the Prince is horrified by the ghost of his ancestor.[113]

Mansergh St George is troubled by something and it is something beyond the death of his wife. He hints at his own past, while the one other major document known to be by him leads to further enlightenment. The owner of estates in Cork and Galway, St George was appalled, on returning from America, by the poverty that surrounded him. In 1790 he wrote an unpublished *Account of the State of Affairs in and About Headford, County Galway*, to which he amended a note by his friend Sir Brooke Boothby.[114] After a lengthy, somewhat rambling, account of the condition of the peasantry on his estate, which

Mansergh St George had left under the care of an agent, he considers setting up a linen industry but is dismayed by the feckless nature of the peasants. Terry Eagleton has asked us to remember that 'the deadweight of property and inheritance moulds an upper-class world', and that Irish Gothic is no exception: 'The encumbered nature of their estates was the true nightmare of many an Anglo-Irish landowner.' Art, be it the novel or the painted portrait, is one way out:

> Protestant Gothic is the unconscious screen on which a dying social class
> projects its fantasies; and it is, then, no wonder that it is so gripped by the
> prospect of immortality, or so morbidly quick to discern the imagery of
> death in the gesture of a limb or the curve of a landscape.[115]

Mansergh St George displays symptoms of chronic grief in his letter to Fuseli. The tone is at times self-accusatory. He says that he has 'lost all, the balm of life, the vital principle is destroyed', yet by hiding his portrait and the 'circumstances' of his life 'from sixteen years old', to the extent that they will only be revealed when his sons reach maturity, he is to some degree confronting the terrors of history. In *Mourning and Melancholy* (1917), Freud has asked us to read such self-accusations as potential reproaches against another, 'someone whom the patient loves or has loved or should love'.[116] Is that 'other' in Mansergh St George's case the multitude without, the feckless tenants on his estate and Catholic Ireland in general? A seemingly compassionate man, who wished to help his tenants, he is driven to melancholy which ostensibly focuses on himself, and is clearly delineated in Hamilton's portrait, but may in reality be perceived as self-reproach that is in fact a reproach 'against a loved object which [has] been shifted away from it on to the patient's ego'.[117] Summing up the Protestant Gothic and in particular Maturin's *Melmoth*, Terry Eagleton claims that:

> Predator and prey are fashioned in each other's image, share an ancient
> knowledge of each other more riveting and intimate than mere affection;
> and it is not difficult to see in this one of the familiar self-rationalizing
> fantasies of a colonial class. The lord has always had a soft spot for the
> beggar.[118]

Mansergh St George has all the symptoms of Freud's clinical picture of mourning and melancholy. There is 'painful dejection', a 'cessation of interest in the outside world', an 'inhibition of all activity', self-reproach, 'a delusional expectation of punishment' and an 'insistent communicativeness which finds

satisfaction in self-exposure.' A loss in regard to his ego is the end result.[119] Mansergh St George can no longer dwell on the present; instead we are treated to a world of memory: the inscription on the sarcophagus in the portrait asks us 'not to forget'. In such a world the dead continue to live, and things will not actually have changed. To again quote Eagleton: 'For Gothic is a form in which the dead take command of the living – in which the clammy hand of the past stretches out and manipulates the present, reducing it to a hollow repetition of itself.'[120] Mourning becomes pleasurable. This is reminiscent of Edmund Burke's discussion of joy and grief in *A Philosophic Enquiry into the Origin of our Ideas of the Sublime and Beautiful* of 1757,[121] where:

> The person who grieves suffers his passion to grow upon him; he indulges it, he loves it . . . It is the nature of grief to keep its object perpetually in its eye, to present it in its most pleasurable views, to repeat all the circumstances that attend it, even to the last minuteness; to go back to every particular enjoyment, to dwell upon each, and to find a thousand new perfections in all, that were not sufficiently understood before; in grief the pleasure is still uppermost.[122]

Mansergh St George speaks of the images of himself and his wife reappearing to his children in years to come. The implication is that through art they will not die but always be together. While writing the letter, he *sees* 'the blessed Dying Countenance close to mine'. In trying to deny death, Mansergh St George reworks a well-used Gothic trope. Terry Castle has reminded us of the similar fervour with which 'the finality of death is denied' by Ann Radcliffe in *The Mysteries of Udolpho*: 'Continuity is all.'[123] The portrait and letter are cries for the continuation of a class. The key ingredient in that continuation, in the Anglo-Irish having a future, is memory, a losing of oneself in romantic reverie. Indeed, a generation later, Mansergh St George himself was to become such a symbol of the glories of his class. In one of her better novels, *The O'Briens and the O'Flahertys* of 1827, Lady Morgan can only see the nineteenth century by looking back to the good old days of the 1780s, when the Anglo-Irish enjoyed a spurious Golden Age. Morgan's aim in this novel is to celebrate a class, the enlightened leadership of the Anglo-Irish.[124] A story of changing identities and a reassessment of late eighteenth- and early nineteenth-century history, *The O'Briens and the O'Flahertys* offers an engaging if highly gossipy description of Irish aristocratic and genteel society. Morgan placed Mansergh St George firmly within the elegant world of 'Irish gallantry' and 'the true smack of chivalry of the old times'. Early in the story we read a vivid re-creation of a Volunteer

review in Phoenix Park, a word-picture that echoes the colour of Wheatley's painting (Fig. 23). Real historical figures merge effortlessly with the fictitious. Amongst the throng are references to Lord Edward FitzGerald and his brother the Duke of Leinster, while mention is also made of:

> Manser [*sic*] St George (one of the last and best of the Irish fine gentlemen in Ireland's most brilliant day), was sent to the Duchess, begging permission to bring Lord Fitzcharles, of the Prince's Own, to her grace's *petit souper* and blind man's buff that evening.[125]

— 4 —

THE PEASANT,
GENRE PAINTING
AND NATIONAL CHARACTER

IN THE FIRST HALF OF THE NINETEENTH CENTURY, IN BOTH LITERATURE and the visual arts, Ireland was frequently represented through its peasant class.[1] National character, it was thought, exhibited itself most strongly and visibly in the rural poor. Criminality and, later, vagrancy became, by the mid-century, the all-purpose modes by which the Irish peasant both at home and abroad was represented. In a chapter about the Irish peasant, the focus will in due course move from the discussion of Irish cabin interiors to England and the representation of the immigrant.

In 1835 the Scottish-born artist, David Wilkie, visited Ireland with what his biographer, Allan Cunningham, called 'a picture or two of a national kind in his head'. Part of this chapter investigates how Wilkie's visualisation of Ireland may be seen to grow out of the then prevalent view of the defining characteristics of the nation as being embedded in its rural life and in its peasantry. In examining the pictorial form used by Wilkie to depict a neighbouring culture, we encounter aspects of the relationship between art, national identity and colonial manipulation. Exhibited at the Royal Academy in London, the two paintings that Wilkie completed (Figs. 49 and 50) conveyed to the metropolis a visual summation of centuries of generalised readings of Ireland: a peasant class who thrived on criminality. Yet, Wilkie spoke of the paintings as being 'connected with public events', thus implying that they were modern subjects

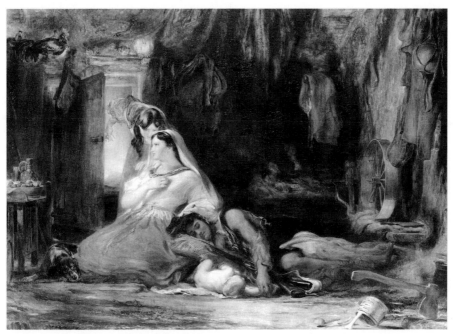

49) David Wilkie, *The Peep-O-Day Boy's Cabin, in the West of Ireland,* 1835–6

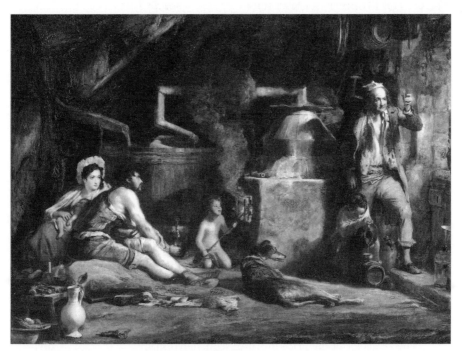

50) David Wilkie, *The Irish Whiskey Still,* 1840

redolent of Ireland's political and social problems and 'should be painted larger than merely domestic subject[s]'.[2] In the end, Irish specificity is compromised through the use of universalist visual quotations which deny regional difference and maintain the authorial detachment of genre painting.

Within a decade of Wilkie's paintings being shown, other London-based artists were producing large-scale depictions of the Irish, and in particular of the growing Irish diaspora. George Frederic Watts and Walter Howell Deverell painted representations of Irish vagrancy (Figs. 63 and 64), while the Pre-Raphaelite, Ford Madox Brown, was to include a strong Irish element in his complex painting, *Work* (Fig. 58), begun in 1852 and completed over a decade later. The representation of the Irish during this period was not limited to British artists, as is evidenced by Gustave Courbet's inclusion of a poor Irish-woman in *The Studio of the Painter: A Real Allegory Summing up Seven Years of my Artistic Life* (Fig. 65), painted in Paris between 1854 and 1855. In these images the concentration is on the displaced Irish family, in particular the mother and child, a trope that offers a range of stereotypes, from the rational to the palatable and the pathetic.

How to Depict a Nation

In the seventy-odd years that separate the classicised views of a mid-eighteenth-century Irish artist such as Thomas Roberts (Fig. 51) from the interiors of peasant cabins painted by Wilkie in the 1830s (Figs. 49 and 50), the representation of Ireland changed in terms of international stylistic influences. One can see a move from the tranquil Claudian view of the eighteenth-century landscape to memories, in the Wilkie compositions, of the more luxurious colour and sensuality of a sixteenth-century Italian altarpiece. Ireland was an area on which the centre – that is, London, in the case of Wilkie – could impose its imaginative perceptions.

Prior to the mid-eighteenth century, London was unacquainted with imagery of Ireland. In the Roberts (Fig. 51), exhibited in London in the early 1770s, the Irish aristocratic demesne, the example here being Lucan, near Dublin,[3] can be seen to be exerting a taming influence on the surrounding forest through the presence of rich pastures and pleasant walkways, an aspect underlined by the economist Arthur Young who visited this estate in 1776:

> The character of the place is that of sequestered shade . . . it is a walk on
> the banks of the river, chiefly under a variety of fine wood, which rises
> on varied slopes, in some parts gentle, in other steep . . . The river is of a

character perfectly suited to the rest of the scenery, in some places break-
ing over rocks; in others silent, under the thick shade of spreading wood.[4]

Equally, Ireland, as represented by the family group in Wilkie's *The Peep-O-Day
Boy's Cabin, in the West of Ireland* (Fig. 49), is conveyed in the language of an old
master: the main trio of woman, man and infant are arranged in a tightly uni-
fied triangular composition redolent of any number of sixteenth-century Holy
Family groups, while the woman's skirt, as Wilkie remarked in a letter from Ire-
land, 'brightens up the cabin or landscape, like a Titian or a Giorgione'.[5] In *The
Peep-O-Day* and in the slightly later *The Irish Whiskey Still* (Fig. 50), Wilkie
assisted in a complete appropriation of the region by the centre, where Ireland
could quite readily be re-created to suit whatever taste the centre so desired.

In the years immediately after the Act of Union of 1801, which brought Ire-
land under the direct control of Westminster, unity or cultural assimilation, as
manifested in the art of the period, moved from homage to the centre (for
example, Roberts' idealised landscape, Fig. 51) towards a subtle form of recog-
nition of cultural diversity. The subtlety lies in how an artist such as Wilkie ven-
tured to Ireland in search of 'new' subject matter, captured in sketch-form and
later on canvas a seemingly unexplored pictorial world, and yet ended up deny-
ing Ireland a recognisable regional difference.

By reverting to a Renaissance ideal in his representation of Ireland, Wilkie
ironically pre-dates by a few years the views of Thomas Davis, who, in an issue

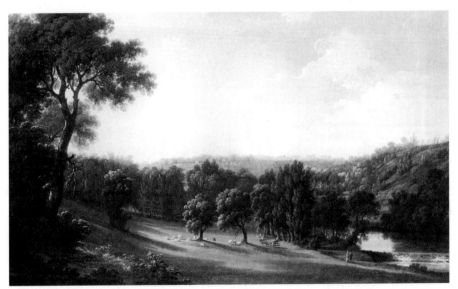

51) Thomas Roberts, *Lucan Demesne*, early 1770s

of *The Nation*, a newspaper he founded in the early 1840s, called for the creation of a national art, but one that depended on the imitation of the old masters:

> [the artist] pays the most minute attention to the truth in his drawings, shading, and colouring, and by imitating the force of nature in his composition, all the clouds that ever floated by him, 'the light of other days', and the forms of the dead, or the strange, hover over him.
>
> But Art in its higher stage is more than this. It is a creator . . . The ideal has resources beyond the actual . . . It is creation, it is representing beings and things different from our nature, but true to their own.[6]

Famous in the early nineteenth century for his genre paintings, Wilkie sought in the 1820s a more ambitious subject matter, and spent three years of that decade travelling in Italy and Spain. In Italy, as elsewhere in Europe, the artist was attached to subjects relating to Roman Catholicism, which offered a colourful exoticism to an artist who was the child of a Scottish manse. Although he is only known to have completed two subject paintings on Irish themes, Wilkie produced a wide range of drawings, concentrating on scenes of priests and nuns (Fig. 52), cabin interiors and country fairs.[7] Ireland had entered a select group of what Wilkie called 'untouched and new' areas waiting to be discovered.[8]

52) David Wilkie, *An Irish Baptism*, 1835

GENERALISED READINGS OF IRELAND

The artist visited Ireland for a little over a month in 1835. The concentration
of his travels, through August and September of that year, was the western
seaboard, from Mayo south to Kerry and Cork. The following year *The Peep-
O-Day Boy's Cabin* was shown at the Royal Academy in London, while *The
Irish Whiskey Still* was exhibited in 1840.[9] Both paintings centre around fam-
ily groups set within an Irish cabin. In *The Peep-O-Day Boy's Cabin* a watch-
ful wife protects her outlaw husband from possible capture. The drama is
created by the warning given by a young girl to the wife, while the tale itself
seemingly relates to Ireland's then recent violent agrarian wars. In the second
painting a family awaits the results of another day's illicit distilling. In both
paintings the families are arranged in a tight compositional unit of a naked
infant and the young parents. There is in fact a third adult in *The Irish Whiskey
Still*, perhaps a grandfather, who stands to the far right checking the quality of
the spirit emanating from the still, stoked by yet another naked child, while a
young girl crouches at the old man's feet pouring the liquid into a barrel.
Exhibited at the Royal Academy, these images of Ireland were, to all intents
and purposes, the dominant view of Ireland offered to a London audience.
Such exposure to Ireland is given added weight by the fact that these contri-
butions to the Academy were from an eminent artist, knighted in the same
year that *Peep-O-Day* was exhibited and by a man who was also Painter in
Ordinary to William IV and later to Victoria. The clichés displayed in these
paintings include rustic interiors of the shebeen or cottage, an all too common
setting for paintings with an Irish subject matter, as well as for plays on Irish
themes performed in London during this period.[10] Other clichés include
quaint customs and modes of dress, criminality, striking beauty in the women,
fine features in the men and a colourful mischievousness in the near-naked
children. The activities of the Irish are predictable: illegality is rampant, as is
guerrilla warfare. What we are offered is a visual summation of centuries of
generalised readings of Ireland.[11]

Criminality and wild habitation may have been the essential characteristics for
the representation of the Irish on the London stage in the 1830s and later, but in
relation to Wilkie these ingredients only increase our realisation that what we are
being offered in his Irish paintings is a continuation of his picturesque studies of
life in Roman Catholic nations. In the late 1820s, Wilkie had produced a series
of Spanish pictures, 'illustrative', he wrote 'of the late war'.[12] The paintings illus-
trate guerrilla activity. In one, *The Spanish Posada* (Fig. 53), or tavern, a guerrilla
council of war is taking place with a colourfully dressed Castilian guerrilla

standing on the right. Around the table are gathered three churchmen and a further guerrilla in Valencian costume. Yet no specific historical moment is referred to.[13] Seven years before visiting Ireland, Wilkie had written of the Spanish as 'a noble race . . . their costume, particularly of the men for variety and beauty is as it was heretofore the finest in Europe'.[14]

An equally important precedent for Wilkie's Irish paintings was the fashion for bandit paintings throughout the 1820s. Paintings of, in particular, contemporary Italian bandits, often accompanied by a wife and family, appeared throughout the decade from both British and French artists, while the subject was also popular on stage and in theatrical prints. Following a number of best-selling literary accounts of the perils of travelling in a brigandage-rife Italy, Charles Locke Eastlake, Thomas Uwins and others churned out bandit paintings for exhibition at the Royal Academy and at the British Institution.[15] The visual formula became something of a constant: a handsome bandit couple in finely detailed local costume, a Roman Catholic image clearly visible and the threat of violence indicated by the prominently displayed weaponry. A contemporary description of an Italian brigand's wife, one Maria Grazia of Sonnino, outside Rome, much painted by several artists including Eastlake, records her 'as

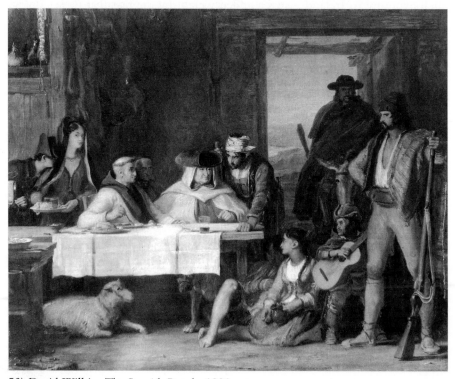

53) David Wilkie, *The Spanish Posada*, 1828

the true type of brigand's wife; of superb stature and form, her head crowned with the most magnificent tresses, strong, proud, fearless, with a commanding eye and gesture'.[16]

Wilkie's young woman is presented in similar terms. In a composition not unlike a highly popular 1826 painting by the Swiss artist, Léopold Robert, *The Brigand Asleep* (Fig. 54),[17] the Irishwoman is presented as possessing a finely shaped figure, strong shoulders, an elegant profile, rich black curls, a dignified gesture of protection and alert eyes. She and her sleeping partner are indeed a

54) Léopold-Louis Robert, *The Brigand Asleep*, 1826

handsome couple. Their clothes are perhaps less immediately exotic than the brigands of the Campagna, but Wilkie makes the woman's indigenous red skirt the most striking visual component in the painting. His choice is underlined by a remark in a letter from Limerick that:

> in Connaught and Cunnemara [sic], the clothes particularly of the women are the work of their own hands and the colour they are most fond of is a red they dye with madder, which as petticoat, jacket or mantle, brightens up the cabin or landscape, like a Titian or a Giorgione. Indeed the whole economy of the people furnishes the elements of the picturesque.[18]

Continuing the comparison with the vogue for bandit paintings, the Irish couple's religious affiliation is implied, not by a votive image of the Virgin, as was common with Eastlake and others, but by the rosary in the woman's left hand. Their allegiance to agrarian violence is indicated by the guns that lie all too dangerously under the man's arm, next to the sleeping baby. Finally, an axe is fixed in the ground in the right foreground, a potentially violent instrument, although here identified with domestic use.

The avoidance of historical specificity in *The Peep-O-Day Boy's Cabin* may create an attractive composition and an abundance of well-observed poses, but it may also lead to problems in the details. Wilkie is in fact in some confusion over what exactly it is he is representing. The Peep-O-Day Boys were a group of Protestant peasants, active primarily in Armagh from the 1780s, who in early morning raids attempted to rob Roman Catholics of their weaponry, 'in doing which', a contemporary source remarked, 'for want of knowledge of the law, they thought they acted legally'.[19] Yet, as the close viewing of the painting in the previous paragraph demonstrated, the woman in the centre holds a Catholic rosary.[20] There is obviously something wrong here and a major problem with Wilkie's title and who is actually represented, which is further complicated by a reference in a letter from the artist to Robert Vernon, who commissioned the painting. Wilkie wrote, shortly after his return to London, of his:

> being greatly impressed in my late journey to the recesses of Ireland, with the fitness, and novelty of Irish scenes for representation. I wish to get *one* done for [the] next Exhibition – The Sleeping Whiteboy, that is a young Irishman asleep on the floor of his cabin . . . I find people interested in this as a subject of expression and connected with public events. This suggests that it should be painted larger than a merely domestic subject.[21]

The term 'connected with public events' smacks of contemporary history paint-ing, and the subject matter of Wilkie's two Irish paintings does indeed relate most pertinently to political and social issues of the 1830s. Ireland was plagued by secret agrarian societies, while cash earnings from illegal distilling in Con-naught were a vital part of the economy for a large section of the population.[22] Yet, in his letter to his patron, Wilkie refers to a painting of 'The Sleeping Whiteboy'. How has that particular agrarian insurgent, one must ask, become the sleeping Peep-O-Day Boy of the finished painting? Clarification is needed here. Formed in the eighteenth century, the largely Roman Catholic White-boys mobilised peasant opposition to local taxes and grievances. The group was revived in the 1830s in reaction against the payment of church tithes to support Anglican Church of Ireland ministers.[23] Wilkie has confused his Irish rural secret societies. He has mixed up two separate peasant organisations, one Protestant, the other Catholic. One can go so far as to say that Wilkie does not know what he is painting: a Protestant insurgent whose wife clutches a Catholic symbol! His is a muddled view of Irish political agitation. Exhibited in the wake of the granting of Catholic Emancipation, Wilkie's painting displays a novel interest in topical Irish subject matter, but at the expense of accuracy. Irish secret societies were invariably short-lived, and, perhaps due to their abundance as well as to their often colourful nomenclature, they encouraged great popular interest. What we are getting here are confused representations of 'public events'.

The Role of Contemporary Fiction

The generalised nature of Wilkie's understanding of his Irish subject matter may depend more on his reading of popular fiction than on actual experience. The subjects of his major Irish paintings, *The Peep-O-Day Boy's Cabin* and *The Irish Whiskey Still*, have all the appearance of being picked out of the pages of one of the rich array of Irish novels of peasant life published in the 1820s and 1830s. In reading a story such as *John Doe*, later reissued as *Peep O'Day* in *Tales by the O'Hara Family*, a series of novels by John and Michael Banim, published in London in 1825,[24] Wilkie could have encountered an Ireland of strange complexity where the protagonists, two young English officers, are charged to seek out the leader of a secret society and, in the first thirty-odd pages, visit an illegal whiskey still. The subjects of Wilkie's two Irish paintings are conve-niently found in the one tale.

Wilkie's pictures, like the Banim's Tales, were produced for English con-sumption. As Thomas Flanagan has pointed out:

> Throughout much of the [nineteenth] century, Irish writers were not
> addressing their fellow countrymen (who rarely bothered to listen) but
> rather a neighbouring stranger . . . The audience for Irish books was in
> part at least a British one, and writers were therefore concerned to 'inter-
> pret' Ireland, to exploit as local colour or as provincial genre painting what-
> ever seemed unique, particular, or 'romantic' in Irish life.[25]

The audience for these pictorial and literary representations of Ireland was fun-
damentally ignorant of the realities of Ireland. What English readers liked in
their Irish fiction was what one contemporary review called its 'easy charm',
'the sketches, sometimes grave, sometimes humorous, and ever most lively and
faithful'.[26] Writing in 1829 of the Banims, their fellow novelist, Gerald Grif-
fin, spoke in binary terms of how the brothers offered an English audience the
good and the bad of Irish life. 'They were the first', he wrote:

> who painted the Irish peasant sternly from the life; they placed him before
> the world in all his ragged energy and cloudy loftiness of spirit, they painted
> him as he is, goaded by the sense of national and personal wrong, and vent-
> ing his long pent up agony in the savage cruelty of his actions, in the pow-
> erful idiomatic eloquence of his language, in the wild truth and unregulated
> generosity of his sentiments, in the scalding vehemence of his reproaches,
> and the shrewd and biting satire of his jests. They painted him also such as
> he is sometimes found, with his generous energies annihilated by the
> depression of centuries, and with the sense of resentment not subdued but
> stifled; mean, cringing, servile, crafty and sycophantic.[27]

In a similar way, Wilkie's paintings depict an Ireland full of opposites and con-
trasts: charming wives/mothers, young husbands/fathers, as well as delightful
children and grave old men, all gathered in scenes of affectionate anecdote. Grif-
fin and other novelists, and now Wilkie the painter, revealed what Tom Dunne
has called 'the fearful fascination' that novelists and their middle-class readers
both in Ireland and Britain had in 'the teeming millions, who dominated the
mental, as well as the physical worlds of pre-Famine Ireland'.[28] As Allan Cun-
ningham, Wilkie's biographer, observed of *The Peep-O-Day Boy's Cabin*:

> That love of fine colours, which Wilkie had remarked in the Irish peas-
> antry; and that true love in its women, which all have observed; together
> with the wild and reckless daring, whether the motive be good or evil,
> which distinguishes the men; are all to be found in this fine picture.[29]

The family groups in the two paintings are handsome and surprisingly refined in their appearance. This is contrasted with the crudeness of their dwelling and the illegality of their lifestyles. Such a depiction satisfied contemporary notions of the Irish character: 'The tear and the smile, as regards Ireland', as Mrs Hall put it, 'seem really twinborn'.[30] Wilkie saw the peasantry as living in:

> a state of primeval simplicity, honest, polite, and virtuous, with so few wants that even the children run about the cabins unclad, they realise to a fervid imagination an age of poetry, which nevertheless the poetry of our own times has not described, and which to painting is perfectly new and untouched. Indeed, I would say that a future painter, after he has seen and studied all that has been done by the Greeks and Italians, should see such a state of life as a basis for his imagination to work upon.[31]

The historical fact of rural secret societies became for both Wilkie and contemporary novelists the subject of colourful and charming genre. Just as the literary reviewers make no mention of the violence perpetrated by Banim's John Doe and his fellow outlaws, so too Wilkie distracts us from the illegal lifestyles of his protagonists by concentrating, as Cunningham observed, 'on the hardy and generous youth, on the beautiful and faithful woman and on the sweet child'.[32] This tactic of distraction is fully realised in *Peep-O-Day* by means of the graceful curve of the woman's neck, her bowed head and profiled face, emphasised by the white shawl and the blue scarf around her neck. It is also apparent in the serenity of the sleeping man, his fine untroubled facial features being echoed in the soft flesh of a conveniently exposed upper arm and lower leg.[33]

DENYING DIFFERENCE

The picturesque potential of the west of Ireland is the true theme of Wilkie's painting. In his letter from Limerick, the artist had noted that the red clothing of the women 'brightens up the cabin or landscape, like a Titian or a Giorgione'. By describing Ireland as being comparable to a sixteenth-century Venetian painting, Wilkie opts for the picturesque over any harsher reality. Writing of *The Irish Whiskey Still*, Marcia Pointon has spoken of it being 'redolent of sensuality, heat and fertility'.[34] Wilkie clearly took these prominent features of the painting from Italian precedents, as opposed to continuing his earlier debt to Dutch and Flemish humour or pathos.

In fact Wilkie's borrowings for *The Irish Whiskey Still* have recently become even clearer. In August 1839 the artist wrote in a letter of how much he admired a painting by the sixteenth-century Emilian artist, Correggio, which had been in his own collection for a decade, and of how 'It looks beautiful, I often look at it, and am now painting an Irish subject, where there are naked children like it.'[35] The Correggio referred to is an unfinished representation in oil of an *Allegory of Virtue*, now in the National Gallery of Scotland, the finished painting being in the Louvre (Fig. 55).[36] There is no Titianesque red here but the naked child stoking the fire in the *Whiskey Still* has close compositional similarities, albeit in reverse to the equally naked, semi-crouched infant on the right of the Correggio. Both have smiling open faces and comparable blond

55) Correggio, *An Allegory of Virtue*, c. 1525–30

curls. Other formal similarities include Wilkie's use, in the gently twisting form of his Irish mother (and the mother in *Peep-O-Day*), of the compositional device of a body facing in an opposite direction to the head, a feature which had been used by Correggio in portraying the personifications of Moral and Intellectual Virtue, who flank the central figure of Minerva (Fig. 55).

The Italian element in these canvases is most clearly demonstrated by the representation of Irish women as transplanted Renaissance Madonnas. Wilkie denies Ireland the very sense of difference that he so frequently commented upon in his letters. 'The mass of the population', he wrote in one letter, 'has a Spanish and Italian look; and one is only surprised that, with their appearance, their habits, and their faith, they should yet be our own people and speak our own language'.[37] Wilkie seems to be blissfully unselfconscious in his depiction of difference. He notices that he is in a different culture, but he paints it within old-master conventions. In *Orientalism*, Edward Said wrote of how it was 'not the gross political verity but the detail' that interested him when studying the 'persistence and durability of saturating hegemonic systems like culture', going on to say that:

> one only need remember that Lane's *An Account of the Manners and Customs of the Modern Egyptians* [printed in 1836, the year that *Peep-O-Day* was exhibited] is a classic of historical and anthropological observation because of its style, its enormous intelligent and brilliant details, not because of its simple reflection on racial superiority'.[38]

Similarly, Wilkie's Irish paintings are rich in detail, careful in execution and intriguing in their observations of Irish life, even if they get it wrong.

The Ireland that Wilkie discovered was re-created in the image of acceptable European high art. The Italianate madonna who appears in both of Wilkie's Irish paintings is in fact not very different from the modes of idealised maternal representation that Wilkie had used earlier in depicting a Spanish mother.[39] The uniqueness of what Wilkie saw as his previously undiscovered Irish woman is thus lessened. As Belinda Loftus has pointed out, in a study of the representation of Irish woman, 'Tom Moore's *Irish Melodies*, so frequently sung in English drawing rooms, and the popular songs offered by Irish artistes in English theatres and songsheets, made Irish womanhood . . . sentimental, melancholy . . . and submissive'.[40] Wilkie's Irishwomen are of the same mould.

And yet, Wilkie took Ireland seriously. In going to Ireland, he hoped to paint modern subjects, redolent of Ireland's political and social problems. Wilkie had written of how *Peep-O-Day* was to be a painting 'connected with public

events', going on to say that 'this suggests that it should be painted larger than a merely domestic subject'. Seventeen years earlier, in the well-known *The Penny Wedding* of 1819, Wilkie had depicted his native Scotland through means of an essay in national character. The painting is small in size and reminiscent of Dutch genre paintings of the seventeenth century. By contrast, the two Irish paintings are large and more serious in intent.[41] As Cunningham relates, in his biography of Wilkie:

> At the time of his visit to Ireland he was in search of higher subjects than those which excite mirth only. But of the convulsed condition of Ireland, one half of her talents wasted in idle controversy, the half of her fine energies exhausted in religious rancour, and oppressed by those who befriend her, he desired to evoke a series of national pictures, of a moral as well as characteristic kind, in which people might see her as a mirror. In this spirit he executed his picture of *The Peep-O-Day Boy* and the *Still among the Mountains*; and in the like train of moral thought he imagined several others, in which are sketched the devout feelings, unmingled with rancour and controversy, but calm and holy, of the ancient religion of the land.[42]

Cunningham's position is of course largely uncritical and to a late twentieth-century eye these paintings are not so much 'unmingled with . . . controversy' as bursting with inconsistencies and cultural confusion.

Wilkie's concern about how to represent his Irish subject matters reminds us of the similar dilemmas that faced earlier artists in the eighteenth century in their representation of the poor or the potentially unseemly. As John Barrell outlined in *The Dark Side of the Landscape*, artists from Gainsborough to Constable, when depicting low life, drifted in and out of the pastoral and the georgic traditions, sometimes following Claude, other times Teniers, sometimes both. The problem lay in how to make the unseemly tolerable and yet not a challenge to morality. Barrell quotes Wilkie commenting on George Morland:

> he seems to have copied nature in everything, and in a manner peculiar to himself. When you look at his pictures you see in them the very same figures that we see in London every day in the streets, which, from the variety and looseness in their dress, form an appearance that is truly picturesque, and much superior to our peasantry in Scotland.[43]

By which Wilkie means that aesthetic interest could safely be extended to the poor, the unseemly and, by the 1830s in his own case, to the impoverished Irish.

Wilkie's representation of Ireland is one seen through eyes steeped in the art of the past. 'Velasquez, Murillo, and Salvator Rosa, would here find the fit objects for their study', he wrote in a letter to his artist friend, William Collins, from Edgeworthstown, Co. Longford.[44] Ireland, he claims, is ready-made for art, needing no artifice:

> What one has often so much difficulty in contriving for a picture, and imagining for a poetical description, may, in the western provinces of Ireland, be found ready made to one's hands; and what is more, between ourselves, it is *untouched and new*. The question that you will naturally ask is, whether it will be applicable to your art . . . yet the rustic life that you paint would be here found in perfection, and being of that simple kind, with all its wildness and poverty, it is an approach to pastoral life, which, with all its homeliness, is best adapted to grandeur and poetical effect.[45]

In his letters Wilkie enthuses to his friends about the artistic potential of Ireland and wonders why Ireland has not been the subject of other painters' work. He predicts that Irish artists themselves will soon wake up to the fact that the nation needs to be painted, while foreigners who have, as he says, 'exhausted the Rhine, and Italy and Spain, and Barbary will soon come over *to do* Ireland.'[46] Ironically, Wilkie's call for artists to leave Barbary and come to Ireland was contemporaneously being paralleled by Eugène Delacroix. In 1832 the French artist made his famous trip to Morocco, a country which was then experiencing a growing colonial relationship with France. In his letters home, Delacroix had been saying much the same kind of things as Wilkie. He spoke of how 'the place is made for painters. Economists and Saint-Simonians might find much to criticise as regards human rights and equality before the law, but beauty abounds here; not the over-praised beauty of fashionable paintings.'[47]

In calling for painters to come and paint Ireland, Wilkie was in fact displaying his ignorance of an existing professional exhibition history. Topographical views of Ireland had been available to a London audience from the second half of the eighteenth century (Fig. 8), while the landscape artist James Arthur O'Connor (1792–1841) exhibited what were largely Wicklow scenes at the Royal Academy and the British Institution throughout the 1820s and 1830s.[48] Wilkie's ignorance of the contemporary visual representation of Ireland is given an ironic twist when we compare his seemingly topical Irish painting of illegal distilling with an almost contemporaneous painting by an Irish artist, Joseph Patrick Haverty, *Advocates in a Good Cause* (Fig. 56), which was exhibited at the Royal Hibernian Academy in Dublin in 1846 and addresses Irish 'public events'

56) Joseph Patrick Haverty, *Advocates in a Good Cause, c.* 1846

in a forthright if somewhat sentimental fashion.[49] The Roman Catholic priest, Theobald Mathew, had set up a temperance movement in 1838 which soon gained widespread popularity and the backing of Daniel O'Connell. The proffered Bible and the forgiveness of the man's wife and child will soon act, we understand, as a guarantee to the taking of the pledge of temperance. 'Pathos' may dominate the image, as noted by a reviewer for *The Nation*, while 'in the wife's lineaments, and expression especially, a whole domestic tragedy is legible'.[50] What we are being offered is a very up-to-date Irish subject, a subject that had also received the blessing of no less a figure than Thomas Davis.[51] It is also a subject that responds directly to public events of the late 1830s and early 1840s, thus creating a notable contrast to Wilkie's *Whiskey Still*, which becomes a fleeting visitor's view of Irish criminality and reprobate behaviour.

Wilkie's lack of knowledge of the actuality of contemporary Irish art feeds the acquisitive tone of his repeated comments that Ireland was 'new and untouched'. Writing from Limerick, the artist informs his friend, the physician Sir William Knighton, that he is anxious to show him what he calls 'the subjects I have picked up here'. Wilkie hopes that a painting 'can be set about before next year's Exhibition, as I find an Artist who paints in Watercolour has just been a week before me, here, and I feel quite afraid, that other Artists will

soon be coming the same road'.[52] In another letter of a fortnight later, to William Collins, Wilkie wrote of being preceded in his journey 'by an artist in aquareil', who he suspects has the same plans as himself.[53] Whether Wilkie's elusive watercolour artist was Irish or a foreign visitor we will never know, but at least one leading Irish artist, George Petrie, a future president of the Royal Hibernian Academy, had travelled this 'same road'. A frequent visitor to the west of Ireland, Petrie had been going on drawing expeditions to Co. Galway and even the Aran Islands from the early 1820s and exhibited large watercolours of remote areas throughout the 1830s.[54] One such drawing, *The Last Circuit of Pilgrims at Clonmacnoise* (Fig. 57), produced *c.* 1838, is a reworking of an original of 1828. It dramatically records the early Christian site on the side of the Shannon and, together with the foreground exertions of the pilgrims, feeds on national sentiment. A scholar and an antiquarian as well as an artist, Petrie was only too aware of the need to record the life and customs of the peasantry and the monuments that dotted the landscape. Later, his biographer William Stokes was to claim that Petrie's depiction of 'the ruin and its surroundings unite in giving a national character to the scene'.[55] Petrie himself, in a letter, explained the drawing of Clonmacnoise as his 'wish to produce an Irish picture somewhat historical in its object, and poetical in its sentiment' and that he 'desired to produce a picture which might have an interest and value, not merely pictorial,

57) George Petrie, *The Last Circuit of Pilgrims at Clonmacnoise, c.* 1838

beyond the present time'.[56] Wilkie had said as much about his planned *Peep-O-Day*, in the letter to Vernon of October 1835, referring to it as 'a subject of expression and connected with public events'. But Petrie's interest in west of Ireland subject matter and his admiration for the Connaught peasantry were both well established prior to Wilkie's visit. Indeed, Petrie had described the dress and appearance of Connemara women well over a decade prior to Wilkie's visit. In a letter he admired their:

> respectable and picturesque appearance . . . dressed in blue cloaks and madder gowns and petticoats. The young unmarried women do not look badly with their long black locks hanging on their shoulders or floating in the wind for . . . it is considered immodest among the lower orders here to turn up their hair until the zone of Venus has been loosened.[57]

Petrie may have got there first but, like Wilkie, he too distorts and in true picturesque fashion rearranges his scene. Petrie places the ruined remains of Clonmacnoise, together with the becloaked woman on the far right, in clear silhouette against the setting sun, despite the reality of the actual location of the buildings.[58]

Even if he was not the first to paint the west or the Irish peasantry, Wilkie's self-assured appropriation of the subject matter, as expressed in his letters, some of which were published within a few years of his visit to Ireland while others appeared shortly after his death in 1841, and his sophisticated visualisation of an Ireland seen through old-master spectacles, created an image of the country suitable for foreign consumption. In painting the two Irish mothers as Madonnas, Wilkie denied regionality through universalist quotations. On the whole, the response of the London critics to the exhibition of these paintings at the Royal Academy maintained that denial of specificity.[59] Little comment was made on the fact that they were Irish subjects, the concentration being on the drama of the narrative and formal values. After their exhibition at the Royal Academy both paintings entered private British collections, where their specific Irish content cannot have been of great importance. Robert Vernon, who commissioned *The Peep-O-Day*, was a wealthy former supplier 'of horses to the British armies during the wars with Napoleon', who just wanted a subject painting from the renowned Wilkie, stressing that he 'would prefer a female to be in it'.[60] As shown by Wilkie's previously quoted letter to Vernon, where he suggested a subject of 'The Sleeping Whiteboy', it was very much left to the artist to come up with a subject.[61] This he did, with a suitably elegant woman in the centre. Vernon was in fact to keep the painting for only a decade, as he

gave his extensive collection of British paintings to the nation in 1847.[62] The
Edinburgh version of *The Irish Whiskey Still*, painted some three years after *Peep-
O-Day*, was executed for the prominent London art dealer C. J. Nieuwenhuys,
who quickly sold it to the King of the Netherlands. Another version, in fact
the first (largely similar except for the omission of the figures on the right), was
sold on completion to a Latvian merchant and collector and has been in Riga
ever since.[63]

It is only in private responses to the images that one gets a criticism of their
'Irishness'. Maria Edgeworth viewed early sketches for the *Peep-O-Day* and
some years later wrote of how she found the 'dress and expression were not
characteristically Hibernian – too neat, too nice, too trim and orderly for [the]
Irish and Ireland – the wife's handkerchief too well put on and headgear ditto
. . . much more English or Scotch than Irish'. Edgeworth went on to criticise
what she called the 'excellent sleeping boy – but suspenders, or braces or what-
ever you would call them, out of character for his situation and circum-
stances'.[64] Elaborating on Edgeworth's observations one notices the surprisingly
well-wrought jug with a pewter lid in the left foreground of the *Whiskey Still*
or the colourful patterned scarf/cummerbund worn by the old man on the far
right of the painting. Finally, one puzzles over the incongruous (in an Irish con-
text) semi-nakedness of the young men in both paintings, which indicates a
greater attention to the European pictorial tradition for heroic nudity than the
actuality which the Irish climate would normally allow.

Cultural difference is denied in these paintings and, in the context of early
nineteenth-century Anglo-Irish relations, the Union is strengthened. By por-
traying the Irish peasantry in neat groups of intertwined Holy Families, Wilkie
lessens any sense of threat. These peasants are not a festering guerrilla force but
a series of pictorial effects as timeless in visual terms as sixteenth-century altar-
pieces appeared to nineteenth-century eyes. Although loosely 'connected with
public events', Wilkie's paintings do not confront an Irish reality and maintain
a genre-like detachment, the representation of a passing tourist. As Seamus
Deane has commented in the context of Irish literature of the nineteenth cen-
tury, 'If the Celts stay quaint they will also stay put'.[65]

THE PEASANT IMMIGRANT

The visual and literary representation of the Irish peasant in the nineteenth cen-
tury as synonymous with national character is all about being 'quaint' in the eyes
of the stranger. Deane's 'staying put' refers to the peasant knowing her or his social

position, but the history of the Irish in the nineteenth century is not one of stay-
ing put geographically. The thousands of Irish immigrants to Britain and else-
where have been the subject of rich research, but little has been written about
their visual representation. Apart from Perry Curtis's studies on racial stereotyp-
ing in the second half of the nineteenth century, little has been said of the repre-
sentation of the Irish emigrant in the work of either Irish or British-born artists.[66]

Having explored the representation of the peasant *in* Ireland, it is now time
to examine the representation of the Irish peasant abroad. A number of mid-
nineteenth-century British artists included representations of Irish immigrants
in their work, ranging from the Pre-Raphaelite painters, Ford Madox Brown
and Walter Howell Deverell, to George Frederic Watts. Away from the exalted
fora of the Royal Academy or the private exhibition, the representation of the
Irish peasant was frequently to be seen in the pages of *Punch* and other popu-
lar magazines. A wider study of that imagery reveals more subtle definitions of
Victorian perceptions of the Irish.

Ford Madox Brown's *Work* of 1852–63 (Fig. 58) is one of the best-known
British nineteenth-century paintings, but its representation of Irish themes has
not been sufficiently explored.[67] In a painting that celebrates the ennobling
nature of work, Brown gives central place to the navvy, surrounding him with
other representatives of a variety of types of work. We are shown those who are

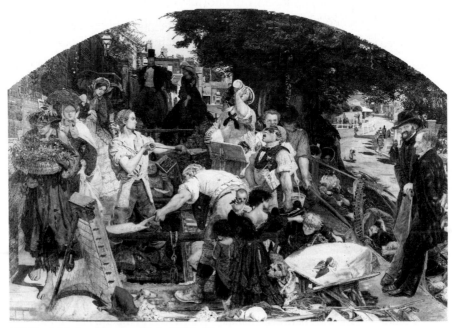

58) Ford Madox Brown, *Work*, 1852–63

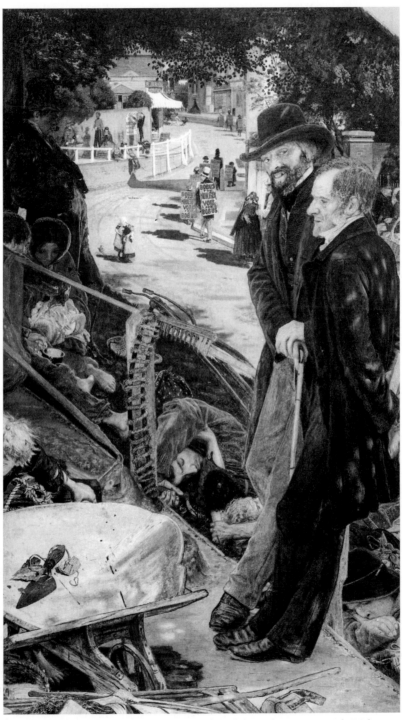

59) Ford Madox Brown, *Work*, detail of Carlyle and Maurice with Irish immigrants behind

idle, those who are busy; those who use the sweat of the body and those that use the brain. Within the idle category, Brown placed a collection of Irish immigrants, all of whom are visible on the right of the painting (Fig. 59). They are viewed through a space enclosed by the navvies on the left and the brain workers – Thomas Carlyle and the Christian Socialist, Frederick Denison Maurice – who lean against a railing on the extreme right. Carlyle's *Past and Present* had first appeared in 1843 and its celebration of the ennobling nature of work had made it one of Brown's favourite books.[68] In his lengthy descriptive account of the painting, Brown refers to a 'shaded bank' where there:

> are different characters out of work: haymakers in quest of employment; a
> Stoic from the Emerald Island, with hay stuffed in his hat to keep the draught
> out, and need for Stoicism just at present, being short of baccy; a young
> shoeless Irishman, with his wife, feeding their first-born with cold pap.[69]

The haymakers lie on the grass below the railing, the young Irish couple with their baby sit further along the bank, while the Irish 'Stoic' leans against a far tree. At least one Irish navvy may also be included, as Brown refers to 'Paddy with his larry and his pipe in his mouth'.[70] This figure is to be found immediately to the left of the couple with the baby (Fig. 58). He holds a hoe–like instrument with which he rakes cement. It has been pointed out by a recent commentator on *Work* that four of the navvies have red hair, a common means of representation of the Irish in Victorian iconography, while one of the orphaned children in the foreground of the painting carries a carrot, a standard association with red hair.[71] The implication is that Brown intended the navvies to be seen as largely Irish.[72] A range of representations of the Irish are thus on offer here.

Sheridan Gilley has called our attention to the inconsistencies of nineteenth-century English middle-class denunciations of 'proletarian idleness and immortality' with its 'quest for the picaresque in working-class mores, and with the glorification of study yeomen and Wordsworthian peasants and industrious mechanics, even Irish ones'. Gilley goes on to say that 'enthusiasm and abuse mingle oddly in the English literature on Irish immigrants in England'. The Irish could be despised as 'drunken and disloyal' but extolled for their 'industry, chastity, piety and patience in suffering'.[73] Brown's *Work* can be seen as displaying elements of that middle-class inconsistency with regards the representation of the Irish. We see a pathetic immigrant family, a somewhat suspicious looking idler leaning against a tree and hard-working navvies. Amidst this range of stereotypes we are offered both positive and negative images. The navvies and the family are portrayed sympathetically and referred to uncritically in Brown's commentary.

The navvies are fine-bodied men, proud and concentrated in their work. As for the couple on the bank (Fig. 59), it is only the woman's face we can see and she looks busy with her maternal task. Through industry, she, her family and the navvies are made acceptable, they are made 'palatable', to use Frantz Fanon's word.[74] The father is described in Brown's commentary as being honest and righteous, for he was to voice dismay at the policeman's man-handling of the orange-girl at the far right of the painting.[75] Such dismay may have been all the more meaningful to the Irishman, given that, although he does not identify the ethnic origins of the orange-girl, Brown may have inferred yet another Irish connection. The large number of Irish street sellers operating in London dealt mainly in fruit, 'more especially nuts and oranges; indeed', said Henry Mayhew in his extensive study of the London poor – carried out over the very years that Brown was painting *Work* – 'the orange season is called the Irishman's harvest'.[76] An illustration of an Irish street seller (Fig. 60) in Mayhew, clutching a basket of apples or oranges, has led Albert Boime to suggest that this image may have influenced Brown's inclusion.[77] But Irish orange-girls were common enough on the streets of London for Brown to have seen them for himself. Proof of that lies in a newly recovered small canvas of an *Irish Girl* by Brown (Fig. 61), dating from 1860,

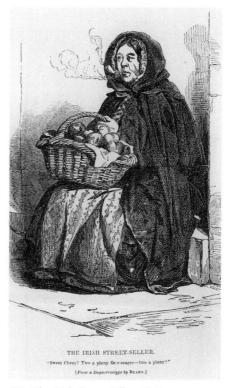

THE IRISH STREET-SELLER.
"Sweet Chany! Two a pinny Or-r-ranges—two a pinny!"
[From a Daguerreotype by BEARD.]

60) *The Irish Street Seller*, 1861

when *Work* was being completed. Here, according to Hueffer, we have a 'little Irish girl from the sister-isle, whom Madox Brown came across during his search for Irish models for *Work*'.[78] The girl, dressed in a cheap paisley shawl, holds a cornflower in her hand, a flower symbolic of celibacy and delicacy.[79] Painted for Thomas Plint, the Leeds industrialist for whom Brown was also painting *Work*, it has been rightly suggested that Brown 'manages to regularize and cosmeticize the Irish girl's features into a vision acceptable to Thomas Plint and his audience'.[80] The girl in this small painting is sympathetically portrayed and thus, like the Irish family in *Work*, offers a contrast to the developing simian-featured stereotype for the representation of the Irish.

The older Irishman, who leans against a tree (Fig. 59), keeps himself firmly in the shade and 'stares across the street and watches the progress of [the] police-man who is hustling [the]orange-seller along', is represented in terms similar to the then contemporaneous depiction in *Punch* of Irish hooligans.[81] Dressed in

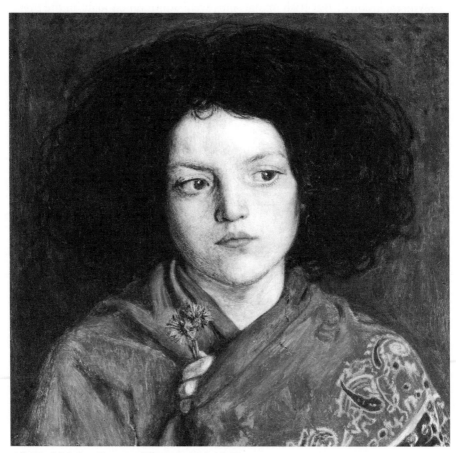

61) Ford Madox Brown, *The Irish Girl*, 1860

fustian, a 'cloth that could be linked to both a lower class and a criminal element',[82] the man slouches in the shade, short of cash, as Brown informs us, and presumably short on prospects. With his prognathous face of jutting jaw and sloping forehead, pipe, frock coat and sporting what was known as a 'Billy cock' hat, a garment much associated with the 'lower classes' and 'a rough clientele',[83] Brown's Stoic closely resembles the increasingly unflattering representation of the Irish peasant in the immediate pre-Fenian period in England. And yet this representation is counterbalanced by the honest family on the bank and the red-haired navvies on the road.

A *Punch* cartoon by John Leech of a decade earlier (Fig. 62), entitled *Height of Impudence*, depicts an Irishman, dressed as our shady-Stoic, tipping his hat to John Bull, saying 'Spare a trifle, yer honour, for a poor Irish Lad to buy a bit of – a blunderbus with.'[84] The contrast here is with the potentially violent, shabbily-dressed Irishman and the flabbergasted, pompous but well turned-out John Bull, a visual juxtaposition that may not have escaped Brown.[85] The artist places his dangerous Irishman on the other side of a row of trees (Fig. 58) from what he referred to as a 'couple on horseback . . . consist[ing] of a gentleman,

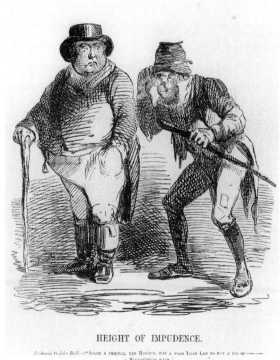

HEIGHT OF IMPUDENCE.

Irishman to John Bull.—"Spare a trifle, yer Honour, for a poor Irish Lad to buy a bit of———
a Blunderbus with."

62) 'Height of Impudence', *Punch*, 1846

still young and his daughter . . . evidently very rich, probably a colonel in the army, with a seat in Parliament, and fifteen thousand a year and a pack of hounds'.[86] This group are 'the *rich*, who "have no need to work" – not least for bread – the "bread of life" is neither here nor there'.[87] The Irishman is thus comparable in his wasted life with the idle rich on horseback. According to Brown, the Irish idler and the upper-class idler have much in common.

The presence of Thomas Carlyle on the right-hand side of the painting increases the Irish interest in *Work* (Fig. 59). Reference to Ireland in Carlyle's writings in the period before Brown's painting and up to its virtual completion – that is, from the late 1830s into the 1850s – varied from outright condemnation and severe criticism to humanitarian sympathy and a full recognition of England's mismanagement. In *Charterism* of 1839, in a chapter entitled 'Finest Peasantry in the World', Carlyle had addressed the issue of the 'crowds of miserable Irish [that] darken all of our towns'.[88] He spoke of how 'the wild Milesian features, looking false ingenuity, restlessness, unreason, misery and mockery, salute you on all highways and byways'. The Irish have 'sunk from decent manhood to squalid apehood'.[89]

A decade later, in one of the *Latter-Day Pamphlets*, Carlyle turned the metaphor from apehood to that of a Giant, 'named of Despair, [who] is advancing upon London itself, laying waste all English cities, towns and villages . . . I notice him in Piccadilly, blue-visaged, thatched in rags, a blue child on each arm; hunger-driven, wide-mouthed, seeking whom he may devour'.[90] Carlyle attacks the British government for their preoccupation with foreign issues when they should see the problems that exist closer to home. His image of a sickly Irish population spreading its way throughout Britain had been most evocatively caught a few years earlier in *Past and Present*, in his image of the Irish widow in Edinburgh who dies from typhus due to the refusal of 'Charitable Establishments' to take her in. Having to return to her 'lane', she infected 'seventeen other persons'. 'Would it not have been *economy* to help this poor Widow?' Carlyle asks. 'She took typhus-fever, and killed seventeen of you!' 'But', Carlyle goes on to say, 'she proves her sisterhood; her typhus-fever kills *them*: they actually were her brothers, though denying it! Had human creature ever to go lower for a proof?'[91]

By isolating this harrowing scene, Carlyle focuses on the plight of the Irish immigrant woman or mother as an exemplum of the Irish experience in Britain. Brown's *Work*, with its Irish mother feeding 'cold pap' to her child, was begun within a decade of *Past and Present*, as were at least two other large canvases by leading contemporaries which centralise the Irish mother theme. Watts's *The Irish Famine*, or *The Irish Eviction* (Fig. 63), was produced in 1849–50, while Deverell's *The Irish Vagrants* (Fig. 64) was produced slightly

63) George Frederic Watts, *The Irish Famine*, 1849–50

64) Walter Howell Deverell, *The Irish Vagrants*, 1853–4

later, between 1853 and 1854. Both highlight the already encountered mother
and child image, and such a consistent trope begs comparison and even com-
panionship with the racially acceptable Hibernia, sister of Britannia, so beloved
of Tenniel and other illustrators (Fig. 39).

In Watts's painting, as various commentators have pointed out, a Renaissance
Holy-Family model dominates the composition.[92] The compact triangularity of
the composition focuses our attention on a mother and child abandoned in a
famine wasteland. A man, the father of the child, looks grimly towards the spec-
tator, while another form, a St Anne-like figure for this misplaced Holy Family,
crouches in the background. But it is the woman who grabs our interest, just as
she seeks the physical grasp of her husband's tensely clenched fists.

But where are they located and what is actually happening? Is this an allegory
of the Famine or a genre-like scene of poverty? The displacement is made clearer
when, as Lindsay Errington has suggested, we read of Watts's friendship with the
Irish poet Aubrey de Vere.[93] The Irishman frequently visited Watts in his studio
in 1849, the same year that he wrote a series of four poems based on the seasons
under the general title of *The Year of Sorrow – Ireland*, which dealt with the devel-
opment of the Famine. Eviction is the central theme of *Autumn*, where we find:

> Make answer, Year, for all thy dead,
> Who found not rest in hallowed earth;
> The widowed wife, the father fled,
> The babe age-stricken from his birth.[94]

Watts was not to visit Ireland for another year or so and one can only suggest
that de Vere's knowledge of Ireland and sympathy with the effects of the Famine
influenced his friend the painter. But notice the reappearance of the motif of
the mother and child. Watts's painting, as Errington has eloquently shown, can
legitimately be seen in relation to the theme of emigration that was so preva-
lent in both high and popular visual imagery from the 1840s to the 1860s. Emi-
gration from throughout the United Kingdom became the subject of paintings
at the Royal Academy and elsewhere, as well as the subject of innumerable illus-
trations in *Punch* and the *London Illustrated News*.[95] The Irish were there, along
with the Scots and the English, one of the most famous examples of the latter
being Ford Madox Brown's *The Last of England*, of 1852–5, where a middle-
class couple and child are shown aboard a ship leaving England, 'depressed
enough in means to have to put up with the discomforts and humiliations inci-
dent to a vessel "all one class"'.[96] The family is the dominant trope, and the
mother and child the most visible pull on our emotions.

A similar compositional emphasis is made by Deverell in *The Irish Vagrants*, of 1853–4 (Fig. 64). The painting is unfinished but may have been one of three oils the artist submitted and then had rejected by the Royal Academy in 1853.[97] In his journal of that year Deverell wrote of how:

> If any of the pictures are rejected I should prefer it be this – Rossetti seemed of opinion that I should not exhibit it this year. As the subject was so good & important I had better paint it on a larger scale – I must confess however that I myself do not regard it so unfavourably, tho' I hardly know what to think of it till some little time has elapsed – when I shall be able to regard it with less partiality – The stern head of the Irish woman seems to offend greatly the few casual visitors I have had tho' it is certainly one of the most just & natural expressions I have ever done.[98]

The centre of the Deverell painting is occupied by a mother and child. Behind her are two men and, beyond, a couple of near-naked children. A wealthy man and woman ride by and ignore the impoverished Irish by the roadside. Beyond is a rich English landscape. Perhaps no other contemporary visual reference more perfectly illustrates Carlyle's imaginings of an Irish horror descending on mid-nineteenth-century Britain. Here, in the 'stern head of the Irish woman' whose children have been refused charity, Deverell has depicted Carlyle's 'forlorn' Irish widow who 'applies to her fellow-creatures, as if saying, "Behold I am sinking, bare of help: ye must help me! I am your sister, bone of your bone; one God made us: ye must help me!" They answer, "No, impossible; thou art no sister of ours."'[99] Similarily, the man behind in a farm-worker's smock looks out in despair, reminding us of Carlyle's 'Irish Giant, named of Despair . . . advancing upon London itself'.[100] William Holman Hunt had observed of Deverell that:

> He was an eager reader and had contracted the prevailing taste among the young of that day, which Carlyle had inaugurated and Charles Kingsley had accentuated, of dwelling on the miseries of the poor, the friendless, and the fallen, and with this special interest he had, perhaps all the more, a general sympathy for all social and human concerns.[101]

The sympathetic portrayal of the Irish couple feeding their child in *Work*, along with Ford Madox Brown's Irish navvies, balances the suspicious character under the tree. Equally, Watts's and Deverell's family groups evoke our concern. Recently, in her book *Toil and Plenty, Images of the Agricultural Landscape*

1780–1890, Christiana Payne has read the 'stern head of the Irish woman' in Deverell's painting as an expression of 'sullen defiance' in the face of the gentry's 'callous indifference'.[102] Rather, the Irishwoman, together with the family in the Watts painting, should be seen, not as expressions of potential anger, but as essays in pathos. Here sympathy leads to a benevolent outlook, emphasised by the use of the mother and child and the creation of a view of the Irish as in need of British help. In these images, that help is on a domestic plane, meaning that Ireland's relationship with Britain is quasi-familial. Such a relationship is only possible under the Union. This benevolent attitude was to be more fully exploited by Matthew Arnold in his famous lectures at Oxford *On the Study of Celtic Literature*, delivered in 1865 and 1866. Arnold saw the Celtic genius as having 'sentiment as its main basis, with love of beauty, charm, and spirituality for its excellence, ineffectualness and self-will for its defect'. Altogether, the Celt lacks the capacity for self-government, he claimed, 'the skilful and resolute appliance of means to end which is needed both to make progress in material civilization, and also to form powerful states, is just what the Celt has least turn for'.[103]

COURBET AND THE IRISHWOMAN

This concentration on the 'miseries of the poor' and, in particular, the use of Irish emigrants to visualise the problem was not, understandably, the preserve of English artists. Linda Nochlin has drawn our attention to the similarities that exist between two great mid-nineteenth-century depictions of reality, one English, Brown's *Work* of 1852–65 (Fig. 58), and the other French, Gustave Courbet's *The Studio of the Painter: A Real Allegory Summing up Seven Years of my Artistic Life* of 1854–5 (Fig. 65). These paintings are not, she says:

> merely pictorial statements of problematic themes of their era, but, at the same time, are given greater force and coherence in the midst of apparent diversity, by a deeply-felt adherence to one of the many social religions of the day: in Courbet's case Fourierism, in that of Brown, the social doctrines of Maurice and Carlyle.[104]

In his famous letter describing the painting, written to his friend Champfleury, who is included in *The Studio of the Painter*, Courbet wrote of how it represents 'society at its best, its worst and its average – in short, it's my way of seeing society with all its interests and passions; it's the whole world coming to me to be

painted'. Situated in the middle of his 'real allegory' Courbet divides his world into two parts, 'On the right are all the shareholders, that is to say friends . . . On the left is the other world of commonplace life: the masses, wretchedness, poverty, wealth, the exploited and the exploiters, people who live on death.' One of this latter group is an Irishwoman 'suckling a child' (Fig. 66). Courbet wrote of how he 'saw her in a London street wearing nothing but a black straw hat, a torn green veil and a ragged black shawl, and carrying a naked baby under her arm'.[105]

It has been suggested that this poor Irishwoman is part of an age-old iconographical formula for the representation of *Paupertas*[106] and one could thus easily connect her with the representation of the Irish mother in Brown's *Work*, Watts's *Eviction* and Deverell's *Vagrants*. All are slumped on the ground holding a baby. But Nochlin has gone further and has suggested that the Irishwoman 'cannot be reduced to standing merely for poverty or the condition of Ireland'.[107] Others have drawn our attention to the fact that the Irishwoman is placed directly in front of a distinguished looking man with waxed moustaches, a dog and wearing boots. This figure, although not referred to by Courbet in his letter to Champfleury, is now accepted as a representation of Napoleon III. The Emperor thus stares at abject poverty and, it is suggested, is bluntly reminded, as an ex-revolutionary, of his publication of a decade earlier, *De l'extinction du paupérisme*.[108] On the other hand, Klaus Herding has analysed the

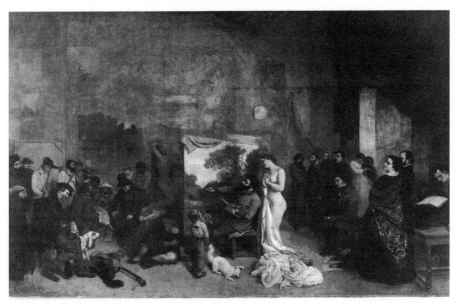

65) Gustave Courbet, *The Studio of the Painter*, 1854–5

painting as an *adhoratio ad principem*, or an exhortation to Louis-Napoleon call-
ing for reconciliation between him, his people and the world, all through the
good offices of the artist and art.[109] But to Nochlin these explanations are not
enough. The Irishwoman:

> becomes the central figure, the annihilation-cancellation of Courbet's pro-
> ject, not merely a warning about its difficulty. Figuring all that is unassimi-
> lable and inexplicable – female, poor, mother, passive, unproductive but
> reproductive – she denies and negates all the male-dominated productive
> energy of the central portion, and thus functions as the interrupter and over-
> turner of the whole sententious message of progress, peace, and reconcilia-
> tion of the allegory as a whole. In my rereading of Courbet's *Painter's
> Studio*, the Irishwoman as a figure refuses to stay in her place and be a mere
> vehicle of another more general meaning, whether that meaning be Poor
> Ireland or the Problem of Pauperism, an incidental warning signal on the
> high road to historic reconciliation. In her dumb passivity, her stubborn
> immobility, she swells to the dimensions of an insurmountable, dark stum-
> bling block on that highway to constructive progress. Uneasily positioned
> within the composition, pressing up almost against, yet somewhat behind
> the edge of the canvas that establishes a barrier between the defeated world
> of the anonymous downtrodden and the triumphant one of the artist, her
> unstable spatial position reinforces the spatial ambiguity of the composition
> as a whole, at the same time that it threatens the apparent stability of the
> central group.[110]

But why did Courbet choose an Irishwoman to represent such a powerful
stumbling-block in the visualisaton of progress? To Nochlin she is a modern
Melancholy, and harks back to Dürer's *Melancholia I*, 'the loss of meaningful-
ness itself'.[111] Ireland, unsurprisingly in the decade after the Great Famine, rep-
resents emigration, poverty and 'an abandonment of self-respect', the last two,
as Nochlin has forcefully pointed out, are visible in the woman's 'bare, flabby,
pale, unhealthy' legs, yet legs:

> not without a certain unexpected, pearly sexual allure, the left one folded
> back in on itself, exposing its vulnerable fleshiness to the gaze of the
> viewer yet suggestively leading to more exciting, darker passages, passages
> doubly forbidden because this is a figure of a mother as well as an object
> of charity.[112]

But is that all? Could the reference to the Irishwoman not also have a specifically political significance? Her identity as an Irishwoman is based solely on Courbet's reference in the Champfleury letter, where she is the only personage ethnically identified, apart from 'a Jew whom I saw once in England' on the far left of the painting. Due to their predominantly pauperised state, the Irish in Britain were the outcasts of Victorian society:

> Outcasts from British capitalism as the poorest of the poor, from the 'Anglo-Saxon' race as 'Celts', and as catholics from the dominant forms of British protestantism, the Irish were the outcasts of Victorian Britain on the basis of class, nationality, race and religion, with an accumulated body of disadvantages possessed by no other group of similar size until the east European, largely Jewish immigration of the late-Victorian period.[113]

As a committed reformist and supporter of the internationalism of the revolution of 1848, did Courbet see the Irish as perhaps the most rejected and despised victims of contemporary political systems? Could the reference to the Irishwoman not then be developed beyond the claim by the artist that he merely saw such a woman on the streets of London?[114] Courbet, it has been suggested by Hélène Toussaint, littered the left side of *The Studio* with a range of personifications of different nations. Toussaint's highly convincing research into the possible identity of these men and women draws a blank with regard to the Irishwoman.[115] Nearly all of the men are identified with real people, reactionaries and radicals, Frenchmen and foreigners, all of whom were involved in public life. Yet the Irishwoman is left unchartered, a personification of poverty with no clear contemporary or recent historical significance.

Painted to be exhibited at the 1855 World Fair in Paris and famously rejected, *The Studio* was shown in a temporary pavilion in the avenue Montaigne, opposite the Fair in the Palais des Beaux-Arts.[116] Included in the centre-left of the painting (Fig. 66) is a host of national freedom fighters. Directly behind the figure of Louis-Napoleon, dressed in white with a gun and a red-striped scarf, a Garibaldi look-alike, whom Courbet refers to as a 'hunter', may represent the resurgent Italy,[117] while others allude to the insurgent Hungary and Poland, as well as Russian anarchists and/or socialists. Turkey, China and Greece or Romania are also, possibly, included, though like Ireland these are not individualised. An up-to-date awareness of a troubled Europe and beyond is offered to us.[118] A linking figure in all of these national personages is the kneeling figure in the centre, whom Courbet refers to as 'the old-clothes man' who 'presides over all of this, displaying his frippery to all these people'. Toussaint has identified him

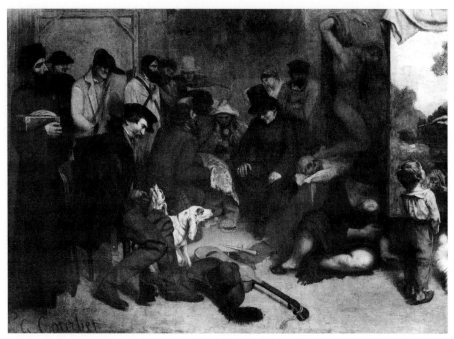

66) Gustave Courbet, *The Studio of the Painter*, detail

as Victor Fialin, duc de Persigny and Louis-Napoleon's Minister of the Interior, commonly known as 'the hawker of the *Idées napoléoniennes*'.[119] Mentioned by Courbet immediately after the Irishwoman, Persigny addresses her just as much as he offers his wares to the Italian, Hungarian or Russian.

The painting, it must be remembered, is partially entitled, *Summing up Seven Years of my Artistic Life*. Painted so as to be exhibited in 1855, those seven years take us back to 1848 and the European year of revolution. It was France that started the revolution and it was France that all Europe looked to for assistance. In the first months after the overthrow of the monarchy in February 1848, revolutionary missions crowded into Paris seeking the support of the provisional government. No less than two Irish delegations were received, in March and April, by Alphonse de Lamartine, the head of the provisional government and Foreign Minister. Reported in the *Moniteur Universel*, it is possible that Courbet read of these Irish missions to the new government. Both Lamartine and Alexandre-Auguste Ledru-Rollin, the Minister for the Interior, were personally sympathetic to Irish nationalist claims but, in the end, failed 'to commit the French Republic to open support for the cause of Irish nationalism'.[120] The first delegation was made by Irish residents in Paris, where an Irish flag was presented and accepted by Lamartine, who spoke warmly of O'Connell. Following immediate criticism from the British authorities,

Lamartine, acknowledging his new government's need for recognition from Britain, recanted on his support for Irish nationalist aspirations and 'declared that France recognised in the case of the United Kingdom only one national flag'.[121] On 3 April, William Smith O'Brien, who was to lead an abortive rising in Co. Tipperary five months later, together with Thomas Francis Meagher and Edward Hollywood, a Dublin silk weaver, formed a second delegation, this time representing the Irish Confederation, a radical group who a year before had broken away from O'Connell's pacifist movement to repeal the Act of Union.[122] On this occasion Lamartine politely refused to make any significant comment on Irish affairs. Rejected officially, the Irish found some support in the revolutionary clubs of Paris.[123]

By placing the Irishwoman in the centre of his real allegory, near, yet separate, from the other Europeans, was Courbet actively remembering 1848? He himself was later to claim that, 'In 1848 I opened a Socialist club in opposition to the Jacobins, Montagnards, etc. – the men I have classified as "republicans of no particular type", republicans out of the past.'[124] Had Courbet met some of the Irish delegation when they were fêted in the republican clubs of Paris? Furious about Lamartine's speech to the Irish delegation, the radical clubs had favoured 'positive action on the part of France on behalf of the oppressed peoples of Europe'.[125] When painting *The Studio* in 1854–5, six to seven years after the event, did Courbet recall Ireland's recent bad press, the terrible Famine, the failed Irish rebellion and France's refusal or inability to assist? Could such a sympathy with the Irish cause have led him to privilege Ireland as the only nation referred to specifically in his letter to Champfleury? Can one thus conclude that he used the character of the Irishwoman as an up-to-date representation of a downtrodden, emergent Europe, a Europe that still needed to be reformed?

In his study of Courbet and his friend the philosopher, Pierre-Joseph Proudhon, J. H. Rubin makes reference to the Irishwoman who, like the Jew carrying a casket on the far left of the painting, is 'another English product'.[126] Courbet, of course, claimed to have seen both on the streets of London. Eternal immigrants, the Jew and the Irish are the victims of that which Courbet and Proudhon attacked.[127] Victims of industrialisation and urbanisation, they are the ones who 'live on death'. Rubin claims that:

> all those on the left side of *The Studio* were part of, that is, they either believed in or were victimized by, political systems, political solutions not political action. Proudhon and his co-believer Courbet refused any such externally imposed structures, no matter whether their authority was of the right or the left.[128]

Saying that he originally saw the Irishwoman in London, whether true or not, indicates Courbet's wish to focus the blame of contemporary social ills on industrial England, whose influence was becoming only too apparent in the France of Louis-Napoleon. Jack Lindsay has suggested that Courbet's awareness of conditions in London might have come from reading Flore Tristan's *Les Promenades dans Londres*, which was first published in France in 1840. Tristan's horrific description of the Irish inhabitants of the parish of St Giles, Holborn, includes a passage where she enters a narrow alley and observes 'children *without a stitch of clothing*, barefoot girls and women with babies at their breasts, wearing nothing but a torn shirt that revealed almost the whole of their bodies'.[129]

Courbet's Irishwoman (Fig. 66), with what Nochlin has called her 'bare, flabby, pale unhealthy' legs, has obvious similarities with this description. Yet Rubin has asked us to be careful of Lindsay's too literal dependence on Tristan as a source but agrees that such literature 'points to a general body of opinion about the state of civilization in England'.[130] But in the context of the growth of negative opinion on urban life in Britain in the decade leading up to the production of *The Studio*, what we are reminded of most of all when we look at Courbet's indigent mother is the already quoted description by Carlyle of the pathetic demise from typhus of the poor Irish widow of the lanes of Edinburgh, published in *Past and Present* in 1843. Courbet's friend Proudhon had advocated the removal of social 'disarray' and the need 'to give democracy the idea and standard that have been lacking . . . That idea . . . [being] . . . the notion of inevitable progress.'[131] Referring to the Irish widow and with dry sarcasm, Carlyle had asked, a decade earlier, 'Would it not have been *economy* to help this poor Widow?'

Linda Nochlin has rightly stressed the role of the Irishwoman, seeing her centrality in this huge canvas as being an indicator of Courbet's concern to use her as a symbol of unfinished business. The world is still not made right, for 'the Irishwoman resists the light of productive reason and constructive representation, that luminous and seductive aura surrounding the artist and his minions'.[132]

IRELAND AS A WOMAN

Courbet's decision to portray Ireland as a woman is of course part of a visual tradition that goes back a long time. Belinda Loftus has retraced the imagery of Hibernia to the seventeenth century, and the earlier discussion of Waldré's ceiling in Dublin Castle (Fig. 35) showed her continued usefulness to the executive

in the final years of the eighteenth century.[133] She could also be used by a com-
mitted radical like James Barry to represent the possible benefits of Union (Fig.
67). In some preparatory drawings of *c.* 1801 for a painting on the theme of what
he called 'the happy union of Great Britain and Ireland', designed for the cen-
tre of the east wall of the Great Room of the Society of Arts in London, Barry
commented, again through allegory, on the benefits that would result from this
historic action. Hibernia (in the centre between Britannia and Justice) and her
sister country, in Barry's drawings, are dressed in timeless costumes, surrounded
by suitably classical props and a background rich in symbolism. In the drawing
we notice the inclusion of the shield of Britannia and the Irish harp, the only
specific references, apart from the classicised portraits of George III and his
queen, to the actuality of 1800.[134]

Other visual media such as medals and cartoons, invariably produced in Lon-
don, convey blatant one-dimensional statements on the relationship between
Britain and Ireland.[135] Print satire was the other great source for the represen-
tation of allegorical figures and an antidote to the solemnity of the Barry image.
Here, too, Hibernia is usually accompanied by her harp, along with the Irish
crown and a wreath of shamrock, all of which, in a print of March 1800 (Fig.
68), she has dropped in the Irish Sea. Entitled *Carrying the Union*, this print
shows a young, classically draped Hibernia being removed to Holyhead on the
British lion, strapped by a 'Union Belt' to Pitt the Younger and Lord Clare, the
Irish Chancellor. Hibernia urges her escorts to 'Push on', for hot on her heels
and riding Irish bulls come St Patrick and 'his wild Irish patriots', including
Henry Grattan and John Foster, the Speaker of the Irish House of Com-
mons.[136] In Chapter One reference was made to Daniel Maclise's painting, *The
Origin of the Harp*, of the early 1840s (Fig. 20), where, as symbols of Ireland,
the harp and, by extension, the sorrowful woman created an image of the
nation as synonymous with loss and submissiveness. Later in the century, the
mother in the Irish family groups depicted by Brown, Watts and Deverell, as
well as the classically-pure Hibernia of *Punch* (Fig. 39), maintained the tradi-
tion of the younger sister of Britannia in need of guidance and support.

Given Courbet's central inclusion of the Irishwoman in *The Studio of the
Painter* of 1854–5 (Fig. 66), it is perhaps not altogether surprising that he should,
within a decade, return to the portrayal of an Irishwoman. Between 1865 and
1866, the artist painted no less than four versions of a composition he was to
call *La Belle Irlandaise*, a portrait of Jo Hiffernan, the Irish mistress of his friend
James McNeill Whistler (Fig. 69). Depicted with rich red hair, Jo Hiffernan
draws her hand through her thick, long curls as she looks at herself in a hand
mirror. The composition recalls the century-old tradition of a Vanitas, where

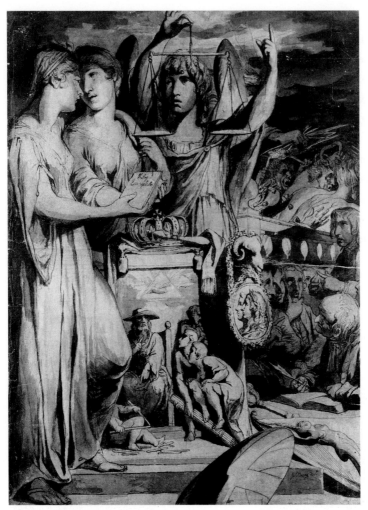

67) James Barry, *The Act of Union, c.* 1801

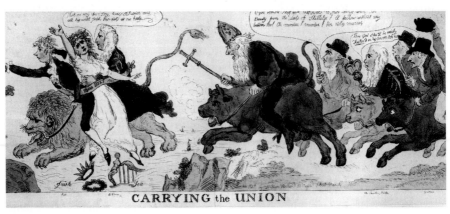

68) *Carrying the Union,* 1800

Venus or some such deity admires herself in a mirror, and yet we are not asked to consider mortality. Courbet avoids such didacticism and concentrates on her moment of privacy.[137]

Courbet's choice of title, with its reference to the ethnic origins of his subject, had a significance which goes well beyond the French artist's knowledge. The concentration on Irish women as the subject of genre painting, where they are specifically labelled as 'Irishwomen', was to be repeated over the next half century by a number of Irish-born artists. In 1891, John Lavery exhibited in Glasgow and London a canvas entitled *An Irish Girl*, a portrait of his first wife, a former flower girl, Kathleen MacDermott.[138] In time, paintings of similar titles were produced by William Orpen, for example *The New Bonnet; Portrait of a Young Irish Girl*, of *c.* 1905, and in 1907 a portrait of the artist and political activist, Grace Gifford, labelled, *Young Ireland*, which was soon followed by a painting called *The Colleen*.[139] The dominant image in all of these paintings is one of passivity and wistfulness, a combination that was to find its climax in Lavery's later representation of his second wife, Hazel, Lady Lavery, as Kathleen Ní Houlihan of 1928. With her head wrapped in a shawl, her elbow resting on a

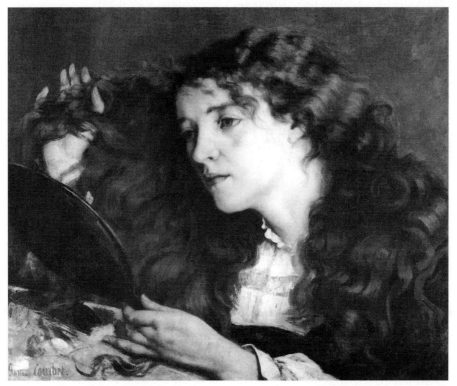

69) Gustave Courbet, *Portrait of Jo, the Beautiful Irish Girl*, c. 1865

harp and a Killarney-like view behind, this allegorised portrait of Lady Lavery was to find a lasting significance as the sole image on Irish banknotes up to the 1970s. Despite its new role as a form of Free State advertising, the banknote image of Kathleen Ní Houlihan, in visual terms, continues more than a hundred years of representation where a static yet beautiful woman is offered as the embodiment of the nation.[140] There is little in Lavery's 1920s image of Ireland to distinguish Kathleen Ní Houlihan from her earlier incarnation as Hibernia with the proverbial harp. She had appeared in similar terms in Barry's attempts at a depiction of Union c. 1801 (Fig. 67), or as the beautiful yet meek young woman of contemporaneous political satires (Fig. 68). Later, in the Victorian period, Maclise's abandoned siren of the early 1840s (Fig. 20) merely adds sentiment to a now growingly standardised image, while forty years later Tenniel reduces her to a quivering young girl (Fig. 39). The end result of all this is that in the search for a way to represent Ireland, even after independence, there is a constant looking back to the amenable language of unity as articulated by Waldré (Fig. 35), among others, in the late eighteenth century and the London establishment of Maclise and Tenniel in the nineteenth century. Existing modes of representation were, the new state was to discover, the only means available.[141]

Discussion of Courbet's visualisation of Whistler's Irish lover demands that reference be made to the American artist's innumerable depictions of Jo Hiffernan. Apart from such dazzling proto-modernist images as the three paintings he called *Symphonies in White* (1862–7), where Hiffernan's form acts as an essay in harmony to assist in Whistler's developing aestheticism, the Irishwoman was also the subject of a host of superb etchings. In one of the most famous of these, *Weary*, of 1863 (Fig. 70), Whistler is, on the one hand, depicting 'the beautiful Irish girl', but, on the other, he is indulging in a most emphatically male view of conscious female languor.[142]

Some thirty years later, in the late 1890s, John Butler Yeats, father to the poet, did a series of sketches, mainly of female family members, that capture an intensely private world but also one of marked passivity (Fig. 71).[143] They suggest, in stylistic terms, a continuation of a Whistlerian aesthetic (Fig. 70), but they can also be seen as part of a late nineteenth-century preoccupation with the representation of Irishwomen as listless and uninvolved. While acknowledging Whistler's dry-points, Yeats also nods in the direction of the Pre-Raphaelites, and Dante Gabriel Rossetti in particular. Yeats's drawing recalls the Pre-Raphaelite female, especially Rossetti's innumerable drawings of Elizabeth Siddall. Recent commentary on the representation of Siddall has focused on her extremely passive role and on Rossetti's deliberate creation of a feminine 'look', which he as creator could then proceed to 'own'.[144] Whistler's women may

avoid the excessive wistfulness of the Pre-Raphaelite, but, together with Yeats's drawings, an image of woman as silent and passive is established and maintained.

From what we know of the Yeats women in the 1890s, their lives were greatly confined by the artist's penury, a significant consequence of which was the unmarried status of the sisters, Lily and Lollie. Although doubtlessly cognisant of the difficulties in his daughters' lives, Yeats in his drawings only increases the suggestion of female inactivity. The sketch, *Lily Yeats Reclining* (Fig. 71), thus becomes not just an intimate reflection of the artist's mood, or the chance capturing of a moment in time, but also the encapsulation of an Irish male view of woman as having a singular visual appearance, that is, passive. All of this is in marked contrast to Yeats's drawings of the male members of his family. The sketches of W. B. Yeats (Fig. 72) that date from the last decade of the century are of a dreamy poet whose intellectual vigour is consistently conveyed. In the early years of the new century, Yeats *père* was to produce many portraits of the

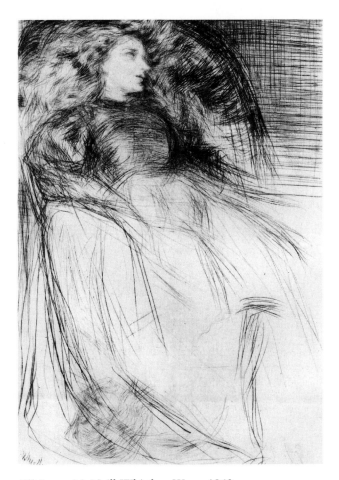

70) James McNeill Whistler, *Weary*, 1863

71) John Butler Yeats, *Lily Yeats Reclining, c.* 1897

72) John Butler Yeats, *W.B. Yeats,* 1889

male world of writers, artists and bohemians, his most successful public offering being the oil of the old Fenian, John O'Leary, now in the National Gallery of Ireland.[145] The active intellectuality of Yeats's wash drawing of his son the poet, as compared with the introverted passivity of the artist's daughter, Lily, is achieved through the spectator's proximity to the sitter, whose firmly placed arms strengthen the solidity of his presence. A sharp shadow falls across Lily Yeats's face, while her brother is lit from the spectator's direction. She is locked into a private world, her sideward gaze and her folded arms preventing us from entering the picture. One is led again to quote from Linda Nochlin, writing of the inclusion of the Irishwoman in Courbet's *The Studio of the Painter*, '[she] resists the light of productive reason and constructive representation, that luminous and seductive aura surrounding the artist and his minions'.[146]

— 5 —

PAINTING THE MODERN

M̲UCH OF THE CONCENTRATION OF THIS BOOK HAS BEEN ON THE
visual language used to represent Ireland. An attempt has been made to equate
form with subject, to examine why a particular style is used to represent a spe-
cific subject, be it a member of the élite in the late eighteenth century or a
Connemara peasant in the 1830s. With the development of modernism, from
the late nineteenth to the early twentieth centuries, the formal choices facing
the artist dramatically increase.

John Butler Yeats's drawing, *Lily Yeats Reclining* (Fig. 71), of *c.* 1897, boldly
exploits the fidelity to nature that had been the hallmark of late nineteenth-
century French painting. Yeats had a particular admiration for Whistler and for
the French painter Henri Fantin-Latour (1836–1904), and was eager to associ-
ate himself with what he thought were the latest trends in western European
art. Fantin's faithfulness to visible reality, with its emphasis on direct painting
from the model onto the canvas, excited Yeats, as did Whistler's sketchily drawn
lighting effects and a tendency to leave extensive areas of the image unfinished.
In a letter of 1904, Yeats referred to his work of this period as 'modern and
impressionist'.[1] Modern they certainly are, for in the context of his comment
Yeats was comparing his work with that of his younger contemporary, William
Orpen, whose style the artist claimed was 'learned and like an old master'. In
his concentrating more on naturalistic effects and less on technical bravura,

160

Yeats, by 1900, was certainly justified in his opinion that his work was up to date; yet the drawings of this period are not truly impressionist. In the first place, they do not deal with a radically new subject matter, as do the paintings of the French artists of the 1870s; further, they do not explore pure colour or the dissolution of light, as do those of Monet or Pissarro. To Yeats, impressionism was an ensemble of tone rather than a pattern of lines and tints. Yeats's use of the term 'impressionism' was a result of his admiration for such artists as Whistler, Fantin and, by extension, Manet. Technically, such an art saw a lightening of the palette, a loosening of brush strokes; in short, a new diversity of techniques. What it did not see was a radical new subject matter that confronted the changes in modern urban life that so dominated avant-garde French art from the 1860s to after Manet's death in 1883.

Herein lies the rub. Yeats and other Irish artists of the turn of the century and well into the early years of the creation of the newly independent Ireland, experimented with the modern, the impressionist, or even the abstract, but rarely did they confront the Ireland of their day.[2] Much of the concentration of recent Irish art historical writing has been on the activities of Irish-born artists who went to France in the late nineteenth century. There they met up with some of the most famous names in the history of art and were, it is implied, promptly touched by greatness. Artists such as Nathaniel Hone the Younger, Walter Osborne, Roderic O'Conor, Frank O'Meara, John Lavery and others are indeed painters of note and their lives and *oeuvres* must be studied.[3] However, frequently, the very fact that they worked in the now accepted birthplaces of modernism is cited as sufficient reason for the examination and inevitable celebration of their work. In the context of this study what needs to be asked is how these artists relate to their home country, with perhaps less dominance given to the discourse of modernism.

Nathaniel Hone the Younger has been praised for the naturalness of his landscapes, for the careful attention to cloud formations and other natural phenomena. Such sensitivity owes its origins, we are told, to his time spent in Fontainebleau with such French artists as Corot and Harpignies.[4] In the next generation, by spending time in Grez-sur-Loing, Lavery and O'Meara, and later Osborne and O'Conor in Brittany, were making connections with the avant-garde and thus lending legitimacy to a potentially modern Irish school. An obsession with that old art historical chestnut of 'influence' has perhaps preoccupied commentators on Irish painting for far too long:

> O'Conor seems to have been one of those relatively overcultured men
> who are almost too impressionable and responsive for their own good, too

easily stamped with the imprint of personalities stronger and more unified than their own. In the long run, his place probably lies closer to the secondary Post-Impressionists, such as Angrand, Manguin, Anquetin, Russell and Emile Bernard, than it does to the great innovators at the apex of the pyramid.[5]

But art history is not just a story of the periphery making it to the centre, it is also a story of the periphery being involved with itself.

THE CASE FOR REALISM

An approach to this alternative story is to compare and contrast the works of two contemporaries, Seán Keating and Mainie Jellett.[6] These artists represent the two strands of artistic production that dominated the world of Dublin art exhibitions in the first decades of the Free State. Keating, a pupil of Orpen, was firmly rooted in the figurative-based, Academic camp, while Jellett is celebrated as an innovative modern who, it is thought, showed the first non-representational canvases in Dublin. In a book about the representation of Ireland, the question that needs to be asked is how do these two, seemingly conflicting, artists address the national issue?

The emphasis will be on work produced by Keating and Jellett in the 1920s (Figs. 73, 74 and 75), a pivotal decade in the development of modern Ireland. Throughout this event-packed period, from the War of Independence, the Treaty and ensuing Civil War to the setting up of a viable Free State, Keating and Jellett produced very different art. The main question raised by such a comparison is that of the role of realism in the development of early twentieth-century art. In the Keating paintings (Figs. 73 and 74), there are recognisable human forms separated into types: people hold and do recognisable things. In the Jellett (Fig. 75), no such information is allowed. The composition has an autonomy of its own, seemingly born out of the artist's imagination and not out of a naturalist tradition, as in the Keating. The other question is about the role of national identity. Traditionally, modernism in the history of art has been read as being separate from politics, as having a preoccupation with form for form's sake. This is now being questioned, but still avant-garde forms dominate the discourse. In a traditionalist society like early twentieth-century Ireland, where awareness of the Parisian avant-garde was limited, is it permissible to dismiss the non-avant-garde as merely reactionary and out of step and see any form of *ad hoc* modernism as preferable?[7] In

contrast to the discussion of artistic development in the period as a drive towards the appropriation of innovative form, is it not more legitimate to examine what exactly was being produced and see how it addressed the issues of the day, and in Keating's case the representation of national aspirations in a struggling decade?

The question then is, does realism, as represented in the art of Seán Keating, have a leading role to play in the history of early twentieth-century Irish art? In much art historical writing, realism is too often banished to the sidelines and not recognised for the questions it raises, which are often public and not exclusively private, as is so often the case, it is suggested, with modernism.[8] A case in point is S. B. Kennedy's wonderfully informative but misleading study, *Irish Art and Modernism*.[9] To Kennedy, those, like Jellett, who pursued the modernist line are seen as good, and those that did not are akin to deviants. Kennedy praises those artists who ignored what he calls the 'cultural pull' of Ireland of the 1920s and 1930s.[10] In searching for what he frequently refers to as a modernist universalism, the author denies history. Keating is dismissed as a propagandist for the national struggle and Kennedy claims that, during the period, Ireland produced no art that conveyed 'a keen political edge', adding that this 'can be accounted for by the quest for national identity'.[11] There is a problem of terminology here: political preoccupations are only too clearly evident in Keating's work of the 1920s, most particularly the politics of national identity. Both *Allegory* of 1925 (Fig. 73) and *Night's Candles Are Burnt Out* of a few years later (Fig. 74) are intriguing statements about an emerging Ireland, the latter perhaps more positive than the former. Various Irish types are presented to us: we notice the family, a dominant trope, as we have seen in so many representations of the Irish throughout the previous century. A mother and child and disgruntled father are shown beneath the tree in the centre of the earlier painting, while they are grouped in the background right of *Night's Candles*, looking off towards the future. In both paintings a priest and a contractor, or businessman, act as replacement authority figures for the now redundant gunman. In *Allegory*, the gunmen bury their dead, while, in the later painting, a lone, trench-coated Volunteer succumbs to the sneers of the new order. In the background of both paintings, symbolic edifices convey change: in *Allegory*, the Great House is in ruins, while a hydro-electric station dominates the skyline in *Night's Candles*. The paintings may almost read like essays in socialist realism, but they address the realities of 1920s Ireland.

Keating's paintings are examinations of the modern. They address the issues of a vital moment in Irish self-assertion and are thus important 'modern' pictures. Mainie Jellett, by contrast, saw modernism as a purifying force that rid

art of a 'national' purpose. To quote from her mentors, Albert Gleizes and Jean Metzinger, writing in 1912:

> That the ultimate end of painting is to reach the masses, we have agreed; it is, however, not in the language of the masses that painting should address the masses, but in its own, in order to move, to dominate, to direct, and not in order to be understood . . . The artist who abstains from any concessions, who does not explain himself and who tells nothing, builds up an internal strength whose radiance shines all around.[12]

This is only one strand in the development of art in the early twentieth century and does not necessarily apply to all situations. Ireland is a case in point. A recent commentator on Irish art of the period has seen the attention paid by Roderic O'Conor and Walter Osborne, et al, to developments in late nineteenth-century French art, and Jellett's interest in Parisian cubism, as the triumph of a free spirit over the stifling conservatism of Irish cultural nationalism and the eventual establishment of the Free State.[13] Despite the dominance of biography in Irish art historiography, no connections are drawn between the backgrounds of these particular artists and that stifling myopia. A

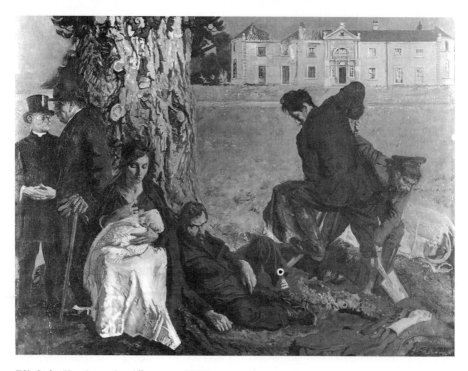

73) Seán Keating, *An Allegory*, *c.* 1925

possible reason for Jellett's and others' appropriation of modernism was their financial security and freedom to travel. The sons and daughters of well-to-do professional Anglo-Irish or, in O'Conor's case, Catholic landed stock, these artists were in a position to take on the new ideas in the French ateliers: they could turn their backs on the minutiae of the national struggle and pursue their careers abroad. For those that stayed behind, artists such as Keating and Maurice MacGonigal, who came from more traditionalist, Catholic backgrounds, training was almost exclusively in Ireland.[14] In the early 1920s they were involved in or supported republican activity, and, later, they painted images that espoused the ideals of a new Gaelic Ireland. It is easy in the 1990s to look back on the myopia of the 1920s and condemn the limited vision of the generation that took over after the Treaty, but such condemnation hardly leads to satisfactory historical or visual analysis.

Terry Eagleton has talked about the peculiarly 'mandarin modernism' that came about in Ireland in the early twentieth century. Monopolised by the Anglo-Irish, this modernist trend represented their 'in-betweenness, wedged as they were between London and Dublin, Big House and peasant cabin'. Art offered the Anglo-Irish, Eagleton believes:

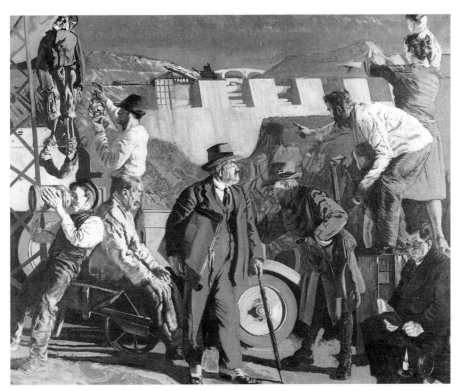

74) Seán Keating, *Night's Candles Are Burnt Out*, 1928–9

an ersatz kind of identity and belonging, a community of sorts which was painfully lacking in historical fact; so that the celebrated formalism and aestheticism of the modernists, their scandalous insistence that one could live inside a myth or language or archetype, that the art-work was its own origin, audience and *raison d'être*, was among other things a defiant rationalization of their own rootless condition.[15]

An examination of the early modernist works of Mainie Jellett benefits from such a framework. Bruce Arnold, one of Jellett's most ardent recent supporters, has written in clear, unequivocal terms of her position as 'the acknowledged leader of the modern art movement in Ireland', as 'the only painter who consistently produced and exhibited pure abstract works during the 1920s in the British Isles', and thus predates Ben Nicholson to become 'a pioneering figure in the front lines of modernism'.[16] As 'the single greatest force for change in art in Ireland between the two world wars', Arnold sees Jellett as an artist continuously blocked by 'walls of prejudice' which 'outlasted her, so that her early and very painful death was made more painful by the unfinished business of purifying and revitalising the art of her own time in her own country'.[17]

Decoration (Fig. 75) was one of the first abstract paintings that Jellett exhibited in Dublin. It is an essay in translation and rotation, a formula that she was then working on in Paris with the cubist painter Albert Gleizes. Exhibited in Dublin in 1923, *Decoration* suffered from the acid tongue of the editor of the *Irish Statesman*, George Russell ('AE'). He saw Jellett's art as 'sub-human', as repetitive and pertaining to 'some sub-section of [cubism's] artistic malaria'.[18] Throughout the 1920s Russell continued to criticise Jellett's work, concluding in a review of 1927 that:

> Many artists tired of realistic painting, dreamed of an art which would be like music which does not rely on any mimicry of the sound of nature but moves us by echoes of our bodiless and soundless moods. Some may have thought it possible for the painter deserting all mimicry of natural forms to move us by artful arrangements of abstract colour and form.

Russell ended his piece saying: 'I feel, somehow that the cubist movement is wrong-headed, and that it springs from the reason rather than the imagination'.[19] A year later, Russell articulated a more pertinent aesthetic for the conditions of 1920s Ireland:

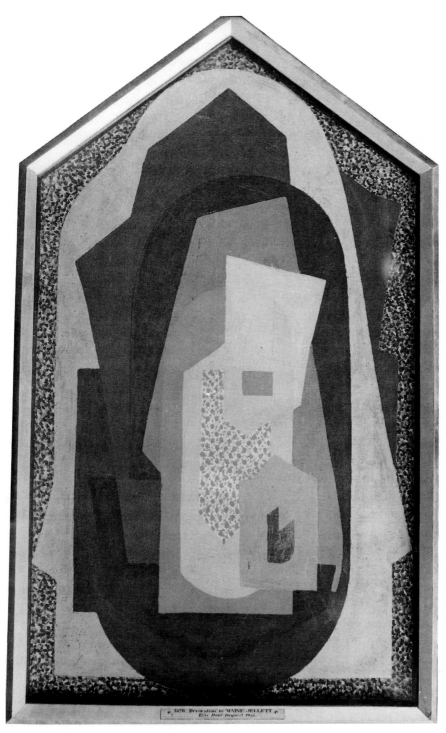

75) Mainie Jellett, *Decoration*, 1923

> The nation at present is frankly realistic in its politics. It is concerned about
> economics, about the organisation of its farmers, the development of
> industry, the Shannon scheme, electricity, sugar beet, inland fisheries, but-
> ter, eggs, cattle, horses, quite admirable interests, but the inevitable reac-
> tion from the mood of seven years ago, when the world was well lost for
> freedom. The disregard for human life which was rampant before the truce
> has been replaced by a national hatred of violence. No party desiring the
> confidence of the voters talks at all about physical force in our politics.[20]

Realism is here identified as the dominant social mood of the period: 'the idea-
lists', he says 'in politics and literature are becoming realists'. Russell sees the
country full of what he calls 'jobbers and grafters', about whom the Irish must
be warned, and yet he is optimistic that the country will prosper: 'We have faith
that if the Irish will really use their intellect they can make their country one
of the most brilliant in Europe.'[21]

Turning to Keating's *Night's Candles Are Burnt Out* (Fig. 74), a painting he
exhibited at the Royal Academy in London in 1929, we find an uncanny par-
allel with Russell's observations. 'Frankly realistic' in its dependence on figura-
tion, Keating's painting is also an allegory on the new Ireland of the Free State.
In keeping with Russell's editorial, the painter sets his scene against the back-
drop of developing industry, 'the Shannon scheme', represented by the dam at
Ardnacrusha, near Limerick, while, as already suggested, in the central fore-
ground we witness a disavowal of violence.[22] The besuited engineer, portfolio
of plans in hand, who looks with disdain at the gunman on the right, is one of
Russell's 'jobbers and grafters', 'who were quiescent during the Anglo-Irish
war, who lay low because of the danger, [but who now] are having their period
of activity'.[23] Progress is the theme of Keating's allegory. The mechanical dig-
ger (seen on the horizon) has replaced the armoured car (seen behind the group
to the left); the eager young family on the right look towards the new source
of power, while the corresponding three men on the left either sit immobile
on a wheelbarrow, drink buttermilk or use an old-fashioned oil lamp to exam-
ine a skeleton. Keating supplied his own features for the figure of the protec-
tive father on the right, whose intellectual excitement as he points out the
future to his son is in sharp contrast to the dangling skeleton which the artist
referred to as 'the stage Ireland and the stage Irishman'.[24] This modern Irish
family are not only youthful but healthy, an added emphasis aimed at ridding,
once and for all, the legacy of 'the nineteenth-century simianisation of the Irish
peasant in the English press'.[25] Keating's assortment of a well-fed Irish busi-
nessman and an ideal family is a confident reclaiming of the representation of

the Irish almost half a century after Tenniel's insult (Fig. 39). Finally, the now redundant 'night's candle' of the painting's title is in the right foreground helping a priest to read his breviary: 'the dim candlelight of surviving medievalism in Ireland', as Keating himself put it, 'is fading before the rising sun of scientific progress'.[26] Didactic and dependent on types, Keating's carefully delineated figures and pointedly contemporary references, as well as his known nationalist sympathies, are all ripe for criticism when compared with the seeming universalism of Jellett's abstraction.

But what was Keating trying to do? In *Night's Candles*, national identity is incorporated into the painting's theme of progress due to the fact that Keating centralises the contractor's smirk and the need for industrial development. Furthermore, the tightly-knit unit of the family to the far right who point at that industrial future personifies an acceptable morality, one given visual support by the traditionalist image of the priest buried in his prayer book who sits below. By formally juxtaposing Keating and Jellett and then itemising their differences, one enters upon something comparable to 'the battle of two civilisations', as labelled throughout the 1920s by the journalist D. P. Moran. Although never an established ideology, Irish Irelandism attracted many supporters in defying the dominance of universalism. Moran distinguished between what Luke Gibbons has called 'a form of cultural isolationism, a narrow provincialism' and the 'more outgoing *rapprochement* with the rest of the world' advocated by 'the Anglo-Irish and other enlightened forces'.[27] In art historical terms, such cultural preoccupations would crudely place Keating in the Irish Ireland camp and Jellett in the universalist.

Strengthening a specificity of location in Keating's *Night's Candles* is the fact that the theme and the arrangement of a tableau of types is comparable to aspects of Irish literary activity of the period, in particular the short story. Terence Brown has referred to the stories of Sean O'Faoláin and others as representing a 'post-revolutionary, petit bourgeois society in a state of transition', while Frank O'Connor argued that the short story articulated the feelings of a submerged population.[28] The richness of this particular genre in early to mid-twentieth-century Ireland, it has been argued, highlighted the submergence of a once rural, Irish-speaking culture by a modernising, urban social order.[29] Keating's Ireland is, to use O'Faoláin's phrase, 'an unshaped society',[30] but it is a representation of Ireland facing up to its contemporary condition. This is what distinguishes Keating from Jellett and makes the comparison of their respective images a worthwhile art historical venture.

In his paintings of the 1920s, Keating was concerned with describing and explaining local conditions, in his desire to tell his and his nation's story. Basing

his image on figurative reality, he wished national identity to be forged from the stuff of tradition. Jellett, on the other hand, saw her art as a purifying source, ridding art of a national purpose. In this, of course, she echoed Gleizes' belief in the fact that reality exists essentially as consciousness. The idea of nation has little to do with Jellett's vision and everything to do with Keating's. In seeking an Irish subject matter, he also sought an Irish mode of representation. Realism was his answer. Jellett, by contrast, chose a more abstract voice. Such a juxta-position repeats arguments that were then raging in various countries. In France, where Jellett had trained, Gleizes, among others, favoured a return to what was seen as the more authentic art of northern Europe, the Celtic and the Gothic.[31] 'The art of our race', he had called it, while the classicist strain in European art was the art of the foreigner, an art of 'frozen attitudes'. In an essay published in 1912, as Mark Antliff's recent study of the Parisian avant-garde shows, Gleizes characterised 'the Cubists as liberators of a French tradition previously crippled by "the detestable Italian influence, the sad heritage of the Renaissance of the sixteenth century"'.[32] Well over a decade later, Jellett echoed these views in a lecture given in Dublin:

> One of the great differences between the cubist theories and the post renaissance theories is in their idea of form. Form through the ages has ever moved between two extremes, one mobile, the other immobile. One non-materialistic the other materialistic. The Cubists and Futurists have chosen the mobile non-materialistic ideal of the Middle Ages in France and Italy and the Celtic and Eastern ideals in contrast to the immobile materialistic ideal of the late Renaissance in Europe.[33]

Some years later, Jellett would criticise realism as a mere 'copying' of nature. To her:

> the function of creation is what makes a work of art a *work of art* . . . if this was not so the artistic heritage of the ages would not count and a photo-graph would be of greater artistic value than any picture – Eastern art has happily kept its ideal pure from this base form of materialism but Western art is ever fluctuating between the two.[34]

Influenced by Gleizes' belief in the Celtic roots of French culture and in a preference for intuition over academic regulation and for an organic art over a derivative materialism, Jellett's approach is, of course, in marked contrast to Keating's carefully delineated allegory. And yet both claimed a legitimacy from

the past. Jellett could look back to Celtic art to support her 'non-materialistic truths', while Keating could boast, 'I may fairly claim to have inherited a share in Latin culture & civilization via the Beaux Arts & the Prix de Rome, from the man who taught the man who taught Tonks who taught Orpen who taught me.'[35]

Keating and Jellett were inherently conservative. Jellett's adoption of a Gleizes-inspired cubism occurred a decade after the innovations of Picasso and Braque. Keating's figurative histories of the 'teens and the 'twenties, his heroic celebrations of the gunmen of the revolutionary period, as well as his more perplexing Night's Candles, are preoccupied with forging a definitive view of Irishness. Ciarán Benson has pointed out that, 'of the eight depicted adults' in Night's Candles:

> only Keating – the artist dressed as a working man – and his wife point out the future in the form of the hydro-electric dam to their children, the oncoming generation. The artist's job was to create images which best represented the idea of what it was to be truly Irish.[36]

To Keating, to be truly Irish was to be traditional. In formal terms it was to maintain old forms of representation and academic draughtsmanship, while in subject matter it was to be concerned with what Terence Brown has called 'provincial issues of personal morality and national identity'.[37] In his earlier images of revolutionary gunmen (1917 and 1922), the style is iconic and uncomplicated: Ireland is embodied as youthful manhood, dressed in either Aran Island costume or buttoned trench-coat.[38] In his later paintings, Keating reverts to the age-old image of the family as our guide to an optimistic future. His view of industrial advancement is a far cry from the cynicism of Denis Johnston's treatment of a similar theme in his play, The Moon in the Yellow River, first performed at the Abbey Theatre in 1931, two years after Keating's painting.[39] To Keating, the Shannon scheme symbolised nationhood and self-determination; to Johnston, whose play tells of the destruction of an electricity plant, such modernity was but a chimera, the essence of self-determination being personal honesty and an avoidance of sentimentality. Johnston satirises the 'truly Irish', be it Blake, 'the romantic, intellectual Republican' or Lanigan, 'the pedestrian but highly effective Free State officer-killer'.[40] Keating, by contrast, sees virtue, as Ciarán Benson has pointed out, in the family. By falling back on this standard motif, Keating reinforces the reactionary tone and moral certainties of post-Independence Ireland. Equally, Keating unwittingly echoes contemporary opinion in the United States of America, where the art critic,

Thomas Craven, wrote: 'Again and again, with all the temper at my command, I have exhorted our artists to remain at home in a familiar background, to enter emotionally into strong native tendencies, to have done with alien cultural fetishes.'[41] In calling for an art dedicated to depiction, as opposed to what might be called spiritual values, Craven and, in turn, the Federal Art Project of the 1930s attempted to revitalise a 'vernacular' tradition of visual representation in the United States. 'If the taste was not always of the best', wrote another commentator, 'it was an honest taste, a genuine reflection of community interests and of community experience.'[42] The regional voice is here claiming legitimacy and claiming national identity as a worthwhile issue in the face of modernist uniformity.

CONCLUSION

As an Irish Catholic, the presence of Seán Keating is a relatively new inflection in the chorus of artistic voices that populates this book. Many of those voices, Ford Madox Brown or Gustave Courbet, never visited Ireland, some, like Francis Wheatley, stayed for a few years, while others, like David Wilkie, visited for only a few weeks. Even among the Irish-born there are differences: many came from the Protestant middle class, for example Hugh Douglas Hamilton, Daniel Maclise and Mainie Jellett, while a few, a surprisingly small number during the period under discussion, were Catholic in background. Apart from Keating, we have met only James Barry and Joseph Patrick Haverty. The representation of Ireland has thus been examined, on the whole, by exterior forces, a case of artists 'looking in' rather than participating. The fact that so many of the artists discussed were not fully involved in Ireland goes some way to explaining the visual variety that makes up the representation of Ireland from 1750 to 1930. Equally, that visual variety is made political by the fact that what we are so often offered is a contemporaneous range of attitudes to Ireland from the point of view of the powerful. Keating and later artists challenge that point of view; Jellett does not.

Thomas Hogan, in an essay on the playwright Denis Johnston, sees him, like his hero Dobelle in *The Moon in the Yellow River*, as the 'last of the Anglo-Irish'.[43] Hogan, as Tom Kilroy has shown, identified Johnston as 'an intellectual in a theatre given to emotionalism . . . [he] had no antecedents in the local theatrical scene and has had no influence on those who followed him'.[44] 'It is not possible', Hogan claimed, writing in 1950, 'to be an Anglo-Irish writer any more. The old blind fiddler, with his mysterious ways and his dark traditions,

has moved in.' Can one call Mainie Jellett the last Anglo-Irish painter? Is Seán Keating 'the old fiddler, with mysterious ways'? The former had little influence on her successors, while Keating went on to become an influential teacher at the National College of Art and president of the Royal Hibernian Academy.[45] Can we see Jellett's lack of influence as a realisation that, like Johnston, she was an Anglo-Irishwoman who, to quote Kilroy, 'never really seems at ease with the native'? Like Wilkie a hundred years earlier, Jellett put all her talents into visualising a universalist language of representation, as opposed to a confrontation with the realities of Irish life.

Although facing up to the Ireland of the 1920s and using a highly realistic style of presentation, Keating's *Night's Candles* (Fig. 74) is an allegory, an allegory of progress. Like Denis Johnston's stage characters, the figures in the painting are mere personifications. But, like all true allegories, Keating's painting is concerned with time, a past, a present and a future.[46] Johnston's play ultimately fails because it is too dominated by cynicism; Keating's painting works because it addresses history and is concerned with achieving a result. What that result will be is, of course, in the future. The tableau structure of the painting is neatly divided by the solid figure of the engineer; he separates the old world of the past, represented by the skeleton and the lumpen workers, from the more energetic youth and intelligence of the family who view the Shannon scheme. The engineer is the architect of the new Ireland and attracts the old and the new around him. He can thus be seen as a continuation of Courbet's central role as the artist who brings in the whole world to be painted in *The Studio of the Painter* (Fig. 65), of three-quarters of a century earlier. Courbet's huge painting is also an allegory: he had subtitled it *A Real Allegory Summing up Seven Years of my Artistic Life*. Keating's painting could just as easily boast a similar claim: 'A Real Allegory Summing up the First Decade of the Irish Free State'. The element of unfinished business is a further connection between the two paintings. Linda Nochlin has called our attention not only to the Irishwoman next to Courbet's easel in the centre left of *The Studio* (Fig. 66) but also to the *croque-mort*, or lay figure, that hangs above her and the skull that lies on a newspaper directly behind her head.[47] Nochlin sees the poverty of the Irishwoman, who sits in front of Napoleon III, as an unsolved problem, her future being implied by the ominous objects behind. Incompleteness equally features in Keating's composition. His inclusion of the dangling skeleton and the motionless labourers underlines the need for change. The dam in the background is literally incomplete, indicating the work that is yet to be done, while the family are young and at the beginning of their role as citizens of a new State.

As discussed in Chapter Two, allegory, as represented by Waldré's ceiling paintings of the 1780s and 1790s (Fig. 35), had the capacity to act as an amenable signifier of unity in the face of a growing visualisation of separateness. In concluding this book with Keating's allegory, we are faced with proof of the enduring adaptability of allegory.[48] In the eighteenth century it satisfied a convenient aesthetic for the coloniser; in the mid-nineteenth century it was utilised by a distinctly radical voice; while in the 1920s, the cautiously conservative, fledgling Irish state, through its newly-formed Electricity Supply Board,[49] inspired Keating to paint *Night's Candles*, where allegory is orchestrated pictorially as an ongoing agent for unity.

NOTES AND REFERENCES

INTRODUCTION

1 For the period covered, the most useful survey is Anne Crookshank and the Knight of Glin, *The Painters of Ireland c.1660–1920*, London, Barrie and Jenkins, 1978.

2 Seamus Deane (ed.), *The Field Day Anthology of Irish Writing*, 3 vols., Derry, Field Day Publications, 1991.

3 Seamus Deane, *A Short History of Irish Literature*, London, Hutchinson, 1986; Luke Gibbons, 'Romanticism, Realism and Irish Cinema' in Kevin Rockett, Luke Gibbons and John Hill, *Cinema and Ireland*, London, Routledge, 1987, and Luke Gibbons, *Transformations in Irish Culture*, Cork University Press, 1996; David Lloyd, *Nationalism and Minor Literature: James Clarence Mangan and the Emergence of Irish Cultural Nationalism*, Berkeley, University of California Press, 1987, and his *Anomalous States: Irish Writing and the Post-Colonial Moment*, Dublin, The Lilliput Press, 1993; Terry Eagleton, *Heathcliff and the Great Hunger: Studies in Irish Culture*, London, Verso, 1995; W. J. McCormack, *From Burke to Beckett: Ascendancy, Tradition and Betrayal in Literary History*, Cork University Press, 1994.

4 R. F. Foster, *Paddy and Mr Punch: Connections in Irish and English History*, London, Allen Lane, 1993; Tom Dunne (ed.), *The Writer as Witness, Literature as Historical Evidence*, Cork University Press, 1987 and Oliver MacDonagh, *States of Mind: A Study of Anglo-Irish Conflict, 1780–1980*, London, George Allen & Unwin, 1983.

5 See Fintan Cullen, 'Still a Long Way to Go: Recent Irish Art History', *Art History*, 15, no. 3, September 1992, pp. 378–83.

6 Raymond Gillespie and Brian P. Kennedy (eds.), *Ireland: Art into History*, Dublin, Town House, 1994, and Adele M. Dalsimer (ed.), *Visualizing Ireland: National Identity and the Pictorial Tradition*, Boston and London, Faber & Faber, 1993. See Fintan Cullen, 'Tackling the Visual: Recent Studies in Irish Art History', *Bullán, An Irish Studies Journal*, vol. 2, no. 2, Winter/Spring 1996, pp. 111–115.

7 Dalsimer, op. cit., p. 7.

8 Ibid, pp. 145–163.

9 Mainie Jellett, 'An Approach to Painting' in *Irish Art Handbook*, Dublin, 1943, p. 18.

10 I have been influenced here by the questions posed by T. J. Clark in a series of unpublished talks on J. L. David's *Death of Marat* given at Yale University in April 1984.

11 See Arthur M. Hind, *Engraving in England in the Sixteenth and Seventeenth Centuries: Part 1. The Tudor Period*, Cambridge University Press, 1952, pp. 4–6.

12 The most complete edition with the twelve plates is in the Drummond Collection of the University of Edinburgh Library; the versions in the British Library and at Oxford lack the plates. Two facsimile editions were produced in the nineteenth century, both with notes by Sir Walter Scott, 1809–15 and 1883; the latter has been consulted: John Derricke, *The Image of Irlande with a Discouerie of Woodkarne*, ed. with Introduction by John Small, Edinburgh, Adam & Charles Black, 1883.

13 Hind, op. cit.

14 Mary O'Dowd, 'Gaelic Economy and Society' in Ciaran Brady and Raymond Gillespie (eds.), *Natives and Newcomers: Essays on the Making of Irish Colonial Society, 1534–1641*, Dublin, Irish Academic Press, 1986, p. 121.

15 See Andrew Hadfield and Willy Maley, 'Introduction: Irish Representations and English Alternatives' in B. Bradshaw, A. Hadfield and W. Maley (eds.), *Representing Ireland: Literature and the Origins of Conflict, 1534–1660*, Cambridge University Press, 1993, p. 7, and A. Hadfield and J. McVeagh (eds.), *Strangers to that Land: British Perceptions of Ireland from the Reformation to the Famine*, Gerrards Cross, Colin Smythe, 1994, pp. 41–3.

16 Kathleen Rabl, 'Taming the "Wild Irish" in English Renaissance Drama', in W. Zach and H. Kosok (eds.), *Literary Interrelations: Ireland, England and the World*, Tübingen, Gunter Narr Verlag, 1987, pp. 47–59.

17 Derricke, op. cit., pl. 2.

18 Rabl, op. cit., p. 49. This play is attributable to Thomas Hughes and others.

19 Derricke, op. cit., plate 4. 'The friar, then, that trait'rous knave, with Ough! Ough! hone! lament/To see his cousin-devil's sons to have so foul event'; James P. Myers, Jr. supplies a modernised reading in *Elizabethan Ireland: A Selection of Writings by Elizabethan Writers on Ireland*, Hamden, CT, Archon Books, 1983, p. 40.

20 Rabl, op. cit., p. 49–50.

21 An account of the feast is also given in the poem proper, see Derricke (1883), Preface, p. 11 and pp. 52–6; for further discussion of this and other plates by Derricke, see David Beers Quinn, *The Elizabethans and the Irish*, Ithaca, Cornell University Press, 1966, pp. 99–105.

22 G. C. Duggan, *The Stage Irishman: A History of the Irish Play and Stage Characters from the Earliest Times*, London, Longmans, Green & Co, 1937, p. 53; J. O. Bartley, *Teague, Shenkin and Sawney: Being an Historical Study of the Earliest Irish, Welsh and Scottish Characters in English Plays*, Cork University Press, 1954, pp. 14–16.

23 Quinn, op. cit., p. 104.

24 Derricke, op. cit., p. 11.

25 Bradshaw et al, op. cit., p. 7.

26 Quoted in Thomas Bartlett, '"A weapon of war yet untried": Irish Catholics and the Armed Forces of the Crown, 1760–1830' in T. G. Fraser and Keith Jeffery (eds.), *Men, Women and War*, Dublin, The Lilliput Press, 1993, p. 78. For the print see F. G. Stephens and M. D. George, *Catalogue of Political and Personal Satires Preserved in the Department of Prints and Drawings in the British Museum*, 12 vols., London, 1870–1954, vol. 8, no. 10092; for other examples see ibid., pp. 153–202.

27 Ibid., no. 10050. For further information on the Irish contribution to the imperial war effort see R. B. McDowell, 'Ireland and the Eighteenth-century British Empire' in J. G. Barry (ed.), *Historical Studies, IX*, Belfast, 1974, pp. 49–63.

28 See Marianne Elliott, *Partners in Revolution: The United Irishmen and France*, New Haven and London, Yale University Press, 1982, pp. 303–12.

29 For recent discussion of the painting see William J. Chiego (ed.), *Sir David Wilkie of Scotland (1785–1841)*, Raleigh, North Carolina Museum of Art, 1987, pp. 28–30, 184–92, and C. M. Kauffmann, *Victoria and Albert Museum: Catalogue of Paintings in the Wellington Museum*, London, HMSO, 1982, pp. 150–3.

30 Maria Edgeworth, *Letters from England, 1813–1844*, Christina Colvin (ed.), Oxford University Press, 1971, p. 347.

31 Allan Cunningham, *The Life of Sir David Wilkie*, 3 vols., London, 1843, vol. 2, p. 76. Chiego, op. cit., pp. 365–7 supplies the text of the original key to the painting, where the wording of the reference to this pair is slightly different. See also Linda Colley, *Britons: Forging the Nation*, New Haven and London, Yale University Press, 1992, pp. 364–7.

1 ARTISTS ON THE MAKE

1 See Crookshank and Glin, op. cit., for Scotland see Duncan Macmillan, *Painting in Scotland: The Golden Age*, Oxford, Phaidon, 1986.

2 See Carole Fabricant, *Swift's Landscape*, Baltimore and London, The Johns Hopkins University Press, 1982, pp. 19–20, and the Knight of Glin and Edward Malins, *Lost Demesnes: Irish Landscape Gardening, 1660–1845*, London, 1976, *passim*.

3 J. H. Andrews, 'Land and people, c. 1780', in T. W. Moody and W. E. Vaughan (eds.), *A New History of Ireland, IV, Eighteenth Century Ireland*, Oxford University Press, 1986, p. 237.

4 Algernon Graves, *The Society of Artists of Great Britain, 1760–91*, London, 1907, pp. 22, 173. See also Crookshank and Glin, op. cit., p. 116; for More see Patricia R. Andrew, 'Jacob More's "Falls of Clyde" paintings', *Burlington Magazine*, 129, February 1987, pp. 84–8.

5 There are two known versions of the Corra Linn painting, the painting in Edinburgh was first owned by Reynolds (Andrew, op. cit., p. 86).

6 Algernon Graves, *The Royal Academy Exhibitions, 1769–1904*, 8 vols., London, 1905–6, vol. 1, p. 72, and Crookshank and Glin, op. cit., pp. 134–6.

7 The painting is one of a pair of Dublin views (both in the National Gallery of Ireland) where the arrangement of the foliage in each painting is complementary.

8 Sarah or Islandbridge was erected in 1791; the courts first sat at the Four Courts in November 1796, see Maurice Craig, *Dublin, 1660–1860*, Dublin, Allen Figgis Ltd., 1980, pp. 243, 288–9.

9 David H. Solkin, *Richard Wilson: The Landscape of Reaction*, London, Tate Gallery, 1982, pp. 102–3.

10 Crookshank and Glin, op. cit., p. 136; see also Anne Crookshank, 'A Life Devoted to Landscape Painting: William Ashford (*c.* 1746–1824)' in *Irish Arts Review Yearbook*, 1995, vol. XI, p. 129. A comparable view (Brighton Museum and Art Gallery), signed and dated 1797, yet minus the Magazine Fort and including a group of military on horseback, was done for another Lord Lieutenant (ibid., p. 128).

11 For Dublin art schools see John Turpin, *A School of Art in Dublin since the Eighteenth Century: A History of the National College of Art and Design*, Dublin, Gill & Macmillan, 1995, part I.

12 The letters are among the MSS Canoviani in the Biblioteca Civica, Bassano del Grappa, Veneto, see Fintan Cullen, 'Hugh Douglas Hamilton's Letters to Canova', *Irish Arts Review* 1, no. 2, summer 1984, pp. 31–5.

13 MSS Canoviani, Bassano del Grappa, Epistolario Scelto II, 79, 1556, letter dated 8 November 1802; author's translation.

14 Dublin, Royal Irish Academy, MS 24K14, fol. 244, dated 1801.

15 Edinburgh, National Library of Scotland, MS 1003, fol. 47, letter dated 21 September 1819. See also David and Francina Irwin, *Scottish Painters at Home and Abroad, 1700–1900*, London, Faber & Faber, 1975, pp. 162–3.

16 For Irish artists in Italy see Nicola Figgis, 'Irish Portrait and Subject Painters in Rome, 1750–1800', in *The Irish Arts Review Yearbook*, 1988, pp. 125–36.

17 Foster, op. cit., pp. 281–305, xi.

18 James Barry, *The Works of James Barry, Esq., Historical Painter*, 2 vols., London, Cadell & Davies, 1809, vol. 2, pp. 255–6. See William L. Pressly, *The Life and Art of James Barry*, New Haven and London, Yale University Press, 1981, pp. 64–5.

19 Deane, op. cit., p. 126.

20 Andrew Hemingway, *Landscape Imagery and Urban Culture in Early Nineteenth-Century Britain*, Cambridge University Press, 1992, p. 46.

21 Peter Funnell, 'William Hazlitt, Prince Hoare, and the Institutionalisation of the British Art World' in Brian Allen (ed.), *Towards a Modern Art World*, New Haven and London, Yale University Press, 1995, p. 148, and Hemingway, op. cit., chap. 3.

22 Martin Archer Shee, *Rhymes on Art, or, the Remonstrance of a Painter*, London, Murray, 1805, p. 9.

23 Oliver Millar, *The Later Georgian Pictures in the Collection of Her Majesty The Queen*, London, Phaidon, 1969, 2 vols., no. 1210, key illustrated.

24 John Newman, 'Reynolds and Hone: The Conjuror Unmasked' in Nicholas Penny (ed.), *Reynolds*, London, Royal Academy of Arts, 1986, pp. 344–54.

25 Martin Postle, *Sir Joshua Reynolds: The Subject Pictures*, Cambridge University Press, 1995, pp. 161–7.

26 Newman in Penny, op. cit., p. 353.

27 See Martin Butlin, 'An Eighteenth-Century Art Scandal: Nathaniel Hone's "The Conjuror"', *The Connoisseur*, vol. 174, May 1970, pp. 1–9.

28 O. Dudley Edwards, 'The Stage Irish' in Patrick O'Sullivan (ed.), *The Irish World Wide: History, Heritage, Identity*, vol. 3, *The Creative Migrant*, Leicester University Press, 1994, pp. 108–9.

29 Deane, op. cit., p. 126.

30 See Newman in Penny, op. cit.

31 See Anne Crookshank and the Knight of Glin, *Irish Portraits: 1660–1860*, London, 1969, pp. 47–9, and *Painters of Ireland*, op. cit., pp. 86–8.

32 Hone's taste for the empirical directness of Dutch art as opposed to classical allusion is reflected in his portraits of his sons, Horace and John Camillus, both of the 1760s and both in the National Gallery of Ireland.

33 For anti-Reynolds sentiment in the later eighteenth century see William Vaughan, 'The Englishness of British Art', *Oxford Art Journal*, 13, no. 2, 1990, pp. 11–23, and his 'When was the English School?', *XXV Internationaler Kongress fur Kunstgeschichte: Probleme und Methodender Klassifizieren*, 3, Vienna, 1983, p. 105.

34 Anthony Pasquin, *An Authentic History of the Professors of Painting, Sculpture, & Architecture, in Ireland*, facsimile reprint, R.W. Lightbown (ed.), London, Cornmarket Press, 1970, p. 9.

35 Arthur Friedman (ed.), *The Collected Works of Oliver Goldsmith*, 5 vols., Oxford, Clarendon Press, 1966, vol. 4, pp. 82–3.

36 See Crookshank and Glin (1969), p. 49, for a 'classical' portrait of Lady Curzon by Hone in the Fitzwilliam Museum, Cambridge.

37 Barry (1809), op. cit., vol. 1, p. 241.

38 Pressly (1981), op. cit., pp. 137–41.

39 Barry, op. cit., vol. 2, pp. 475–645.

40 Ibid., p. 624.

41 Ibid., pp. 355–8.

42 Pressly, op. cit., *passim*.

43 Sir James George Frazer (ed.), *Publii Ovidii Nasonis. Fastorum Libri Sex (The Fasti of Ovid)*, 5 vols., London, Macmillan, 1929, vol. 1, p. 273.

44 William L. Pressly, *James Barry: The Artist as Hero*, London, The Tate Gallery, 1983, p. 56.

45 J. Gwyn Griffiths (ed. and trans.), *Plutarch's De Iside et Osiride*, Cambridge, University of Wales Press, 1970, p. 131. Barry's quoted translation ends 'and my vail no mortal hath raised' (Barry, op. cit., vol. 2, p. 591).

46 I am most grateful to Ellen Chirelstein for this observation which was made after a presen-
 tation of this material at a symposium in honour of Jules Prown, Yale University, October
 1995. See Leo Steinberg's *Michelangelo's Last Paintings: The Conversion of St Paul and the Cru-
 cifixion of St Peter in the Cappella Paolina, Vatican Palace*, Oxford University Press, 1975, p. 7.

47 Pressly, op. cit., p. 36. For the death of Chiron see Frazer, *Fasti*, op. cit., vol. iv, pp. 31–2.

48 See Macmillan, op. cit., pl. 25, p. 41.

49 See Luke Gibbons, '"A Shadowy Narrator": History, Art and Romantic Nationalism in Ire-
 land, 1750–1850' in Ciaran Brady (ed.), *Ideology and the Historians*, Dublin, The Lilliput
 Press, 1991, pp. 99–127 and chap. 2 below.

50 John Barrell, *The Political Theory of Painting from Reynolds to Hazlitt*, New Haven and Lon-
 don, Yale University Press, 1986, chap. 2.

51 For Barry's writings see Barry, op. cit. *An Inquiry* is in vol. 2, pp. 167–299.

52 Barrell, op. cit., p. 169.

53 Ibid., pp. 202–3; Pressly, op. cit., pp. 100–1, discusses references to the papacy in the *Crown-
 ing of Victors at Olympia*.

54 Barry, op. cit., vol. 1, pp. 443–4.

55 See Pressly, op. cit., pp. 12–13; the friends were the artists James Paine, Jr., and Dominique
 Lefèvre.

56 Ibid., pp. 20–6. I am grateful to Luke Gibbons for allowing me to read a draft of his forth-
 coming essay on 'James Barry's *Philoctetes*: The Body as National Narrative', where he draws
 a very convincing connection between the artist's choice of classical subject and late eight-
 eenth-century Irish thought.

57 See Pressly, op. cit., pp. 21–40.

58 Barry, op. cit., vol. 1, p. 364. For a discussion of late eighteenth-century French artists and how
 they drew connections between ancient Greece and liberty, see Thomas Crow, *Emulation: Mak-
 ing Artists for Revolutionary France*, New Haven and London, Yale University Press, passim.

59 See Sarah Symmons, 'James Barry's *Phoenix*: An Irishman's American Dream', *Studies in
 Romanticism*, 15, no. 4, Fall 1976, pp. 531–48, and Pressly op. cit., pp. 77–9.

60 The painting is in Manchester City Art Gallery.

61 Barry (1809), op. cit., vol. 2, pp. 150–1

62 Ibid. The engraving of Minerva appears opposite p. 149. I am grateful to Luke Gibbons for
 this reference; Gibbons uses this quotation in his discussion of Barry's *Philoctetes* as national
 allegory, see n. 56 above. For Barry and Pandora see Pressly, op. cit., pp.147–8, and John
 Barrell, *The Birth of Pandora and the Division of Knowledge*, London, Macmillan, 1992, pp.
 145–220, who reproduces the Minerva, p. 178.

63 Gibbons in Brady, op. cit., p. 120. The painting is owned by Terenure College, Dublin; see
 Pressly, op. cit., pp. 2–4, and his article, 'James Barry's "The Baptism of the King of Cashel
 by St Patrick"', *The Burlington Magazine*, 118, September 1976, pp. 643–7.

64 Barry (1809), op. cit., vol. 2, p. 371; see also Gibbons in Brady, op. cit., p. 114.

65 The Rev. James Wills, Chaplain of the Incorporated Society of Artists, see William Whit-
 ley, *Artists and Their Friends in England, 1700–1799*, 2 vols., London and New York, B.
 Blom, 1968, vol. 2, p. 272.

66 *The Morning Chronicle*, 19 April 1773, p. 2; see also Pressly, op. cit., p. 39.

67 *The Morning Chronicle, and London Advertiser*, 3 May 1773, p. 2; see also Pressly (1981), op.
 cit., p. 40, and Whitley, op. cit., vol. 1, pp. 290–1.

68 *Morning Chronicle*, op. cit., 3 May 1773, and 10 and 19 May 1773; see Pressly (1981), op.
 cit., pp. 39–41.

69 Barry (1809), op. cit., vol. 2, p. 574.

70 Ibid., pp. 570–1. Pressly (1981), op. cit., p. 84, has misread these passages, claiming that they
 show a 'contemptuous opinion' of the Irish, when in fact they criticise English attitudes to
 the Irish.

71 Anthony Pasquin, *Memoirs of the Royal Academicians*, facsimile reprint, ed. R. W. Lightbown,
 London, Cornmarket Press Ltd.,1970, pp. v, 63.

72 Anthony Pasquin (John Williams), *The Royal Academicians: A Farce*, London, 1786, pp.
 25–31. See also Pressly (1981), op. cit., pp. 134–5.

73 Oliver Yorke (Rev. Francis Mahony), 'The Painter, Barry' in *The Reliques of Father Prout*,
 London, Bell & Daldy, 1873, p. 508. Mahony invented the fame of the Blarney stone, see
 Deane (1986), p. 114, and Deane (1991), vol. 2., pp. 38–40.

74 Deane (1986), op. cit., p. 114.

75 Ibid.

76 Mahony, op. cit., p. 499; see also Deane (1991), op. cit., vol. 2, p. 39.

77 Barry (1809), op. cit., vol. 2, pp. 221–2.

78 Pressly (1981), op. cit., pp. 139–41, and Barrell, op. cit., p. 183.

79 Pressly (1981), op. cit., p. 299.

80 The Roberts landscape will be discussed in Chap. Four. The study of Irish landscape
 imagery is slowly emerging from connoisseurship, see P. J. Duffy, 'The Changing Rural
 Landscape, 1750–1850: Pictorial Evidence' in Gillespie and Kennedy, op. cit., pp. 26–42.

81 Martin Archer Shee, *The Life of Sir Martin Archer Shee*, 2 vols., London, Longmans, 1860,
 vol. 1, pp. 213–14.

82 Crookshank and Glin (1978), op. cit., pp. 94–8.

83 Sidney C. Hutchinson, *The History of the Royal Academy, 1768–1986*, London, 1986, p. 99.

84 Royal honours were not as readily given to artists in the eighteenth century as they were to
 be in the nineteenth century. Thornhill had been knighted, as were Reynolds and later
 Lawrence, as presidents of the RA (West turned it down). The Scots could boast of John
 Medina, knighted in 1707, Henry Raeburn in 1823 and then Wilkie in 1836. The next Irish
 artist to be knighted after Shee was Frederick William Burton, when appointed director of
 the National Gallery in London in 1874, although the architect Thomas Deane was hon-
 oured during his stint as president of the Royal Hibernian Academy between 1866 and 1868.

85 Walter Strickland, *A Dictionary of Irish Artists*, 2 vols., Dublin, Maunsel & Co, 1913, vol. 2, p. 334.

86 Shee (1860), op. cit., vol. 1, pp. 83–4; see also Pressly (1981), op. cit., p. 135.

87 From *English Bards and Scotch Reviewers*, quoted in Shee (1860), vol. 1, p. 332.

88 Ibid., vol. 2, *passim*. See also Hutchinson, op. cit., pp. 99–101.

89 Shee (1860), op. cit., vol. 1, pp. 351–7.

90 See Strickland op. cit., vol. 2, pp. 608fn.

91 Shee (1860), op. cit., vol. 1, p. 2.

92 Strickland, op. cit., vol. 2, p. 67.

93 Ibid., vol. 1, pp. 401–2.

94 Katryn Moore Heleniak, *William Mulready*, New Haven and London, Yale University Press, 1980, p. 26.

95 Ibid., pp. 34–5.

96 Quoted in Elizabeth Gilmore Holt (ed.), *The Triumph of Art for the Public, 1785–1848: The Emerging Role of Exhibitions and Critics*, Princeton University Press, p. 359; see *Fraser's Magazine*, June 1838, p. 759

97 Heleniak, op. cit., p. 213. cat. no. 149, plate 132.

98 Julian Treuherz, *Victorian Painting*, London, Thames & Hudson, 1993, p. 26. See also Graves (1905–6), op. cit., vol. 5, pp. 152–3, and Arts Council of Great Britain, *Daniel Maclise*, London, 1972, pp. 64–6.

99 Ibid., p. 16; for illustrations see Kenneth McConkey, *A Free Spirit, Irish Art 1860–1960*, Woodbridge, Suffolk, Antique Collectors' Club, 1990, p. 20, and John Turpin, 'The Life and Work of Daniel Maclise (1806–1870)', Ph.D. dissertation, University of London, 1973, plate 15.

100 See chap. 4 above for discussion of a comparable painting by Wilkie.

101 Quoted in Turpin (1973), p. 90; see also *Fraser's Magazine*, XVII, 1834, p. 117. Here I take a different view from that proposed by Luke Gibbons in a paper on the painting, 1996 annual conference of The Society for the Study of Nineteenth-Century Ireland, University College, Galway.

102 See Patrick O Sullivan, 'A Literary Difficulty in Explaining Ireland: Tom Moore and Captain Rock, 1824' in R. Swift and S. Gilley (eds.), *The Irish in Britain, 1815–1939*, London, Pinter Press, 1989, pp. 239–74.

103 Shee (1860), op. cit., vol. 1, pp. 403–6.

104 Marcia Pointon, *Mulready*, London, Victoria and Albert Museum, 1986, p. 18.

105 Heleniak, op. cit., p. 1.

106 Pointon, op. cit., p. 18.

107 Quoted in Arts Council of Great Britain (1972), op. cit., p. 49; see also *Fraser's Magazine*, IX, 1834, facing p. 300.

108 Terence de Vere White, *Tom Moore: The Irish Poet*, London, 1977, p. 77.

109 Seamus Deane in Deane (1991), op. cit., vol. 1, p. 1055.

110 *The Poetical Works of Thomas Moore*, London, Longman, Green, Longman & Roberts, 1860, p. 106.

111 See Belinda Loftus, *Mirrors, William III and Mother Ireland*, Dundrum, Co. Down, Picture Press, 1990, pp. 59–61, and Arts Council of Great Britain (1972), op. cit., pp. 73–4 and 79–80.

112 Ibid., pp. 98–100.

113 Crookshank and Glin (1978), op. cit., p. 237, Jeanne Sheehy, *The Rediscovery of Ireland's Past: The Celtic Revival, 1830–1930*, London, Thames & Hudson, 1980, pp. 45–6; Brian Fallon, *Irish Art, 1830–1990*, Belfast, Appletree Press, 1994, p. 36 and Catherine Marshall, 'Painting Irish History: The Famine', *History Ireland*, autumn 1996, p. 50; see also Arts Council of Great Britain (1972), op. cit., pp. 99–100.

114 W. J. McCormack in Deane (1991), op. cit., vol. 1, p. 1079.

2 THE ROLES OF HISTORY PAINTING

1 I am borrowing the word 'unresolved' from Luke Gibbons, in Brady, op. cit., pp. 99–127, see especially p. 120; Gibbons comments that at this time 'due to the pressure of Irish politics, history painting was finally forced to confront the exigencies of actual history', p. 244, note 75. Sections of this chapter first appeared in the *Oxford Art Journal*, 18, no. 1, 1995, pp. 58–73.

2 Helmut von Erffa and Allan Staley, *The Paintings of Benjamin West*, New Haven and London, Yale University Press, 1986, pp. 208–9, and Ann Uhry Abrams, *The Valiant Hero: Benjamin West and the Grand-Style of History Painting*, Washington, D.C., Smithsonian Institute Press, 1985, pp. 195–7.

3 Gibbons in op. cit., pp. 111–20.

4 See Mary Webster, *Francis Wheatley*, New Haven and London, Yale University Press, 1970, pp. 8–35, 126–7, also Albert Boime, *Art in an Age of Revolution, 1750–1800*, The University of Chicago Press, 1987, pp. 281–4; Gibbons in Brady, op. cit., pp. 125 and 244, note 75, and James Kelly, 'Francis Wheatley in Ireland, 1779–83' in Dalsimer, op. cit., pp. 145–63.

5 For Chatham see Jules David Prown, *John Singleton Copley*, 2 vols., Cambridge, Mass., Harvard University Press, 1966, vol. 2, pp. 284–8, 437.

6 Edgar Wind, 'The Revolution of History Painting', *Journal of the Warburg and Courtauld Institutes*, 2, 1938–9, pp. 122–3.

7 Abrams, op. cit., p. 195, the painting is illustrated p. 193.

8 Edward McParland has similarly emphasised the importance of local versus English politics in the architectural development of Dublin in the late eighteenth century, see his 'The Wide

Streets Commissioners: Their Importance for Dublin Architecture in the late 18th and early 19th century', *Irish Georgian Society*, XV, no. 1, January–March 1972, pp. 4–5, and *James Gandon, Vitruvius Hibernicus*, London, Zwemmer, 1985, especially chap. 2.

9 See James Kelly, *Prelude to Union: Anglo-Irish Politics in the 1780s*, Cork University Press, 1992, p. 198.

10 James Gandon Jr. and T. J. Mulvany, *The Life of James Gandon, Esq.*, Dublin, 1846, p. 206.

11 Strickland, op. cit., vol. 2, p. 496.

12 Ibid., who quotes the *Freeman's Journal,* 17 June 1802, see also Anonymous Diary of 1801, Royal Irish Academy, Dublin, MS 24K14, p. 253.

13 See George Breeze, *Society of Artists in Ireland: Index of Exhibits, 1765–80*, Dublin, National Gallery of Ireland, 1985, p. 30 and *passim*.

14 Strickland, op. cit., vol. 2, p. 521. There is a virtually identical watercolour by Wheatley, which was possibly done for the engraver, in the Victoria and Albert Museum, London, see Webster, op. cit., pp. 28, 126 and 161.

15 Gandon and Mulvany, op. cit., p. 206, and Strickland, op. cit., vol. 2, pp. 520–1.

16 For prints and a bust of the Duke of Leinster see Adrian Le Harivel (ed.), *Illustrated Summary Catalogue of Prints and Sculpture*, Dublin, National Gallery of Ireland, 1988, pp. 271–3, 569; for other media see Arthur Deane, *City of Belfast Museum and Art Gallery: A Guide to the Irish Volunteer, Yeomanry and Militia Relics*, Belfast, 1938, pp. 39–40; G. A. Hayes-McCoy, *A History of Irish Flags from Earliest Times*, Dublin, Academy Press, 1979, pp. 83–99; Webster, op. cit., pp. 32–3; Fintan Cullen, 'A Kingdom United: Images of Political and Cultural Union in Ireland and Scotland, *c.* 1800', Ph.D. dissertation, Yale University, 1992, pp. 73–7, and Loftus, *Mirrors*, op. cit., pp. 54–6 and 89. Controversy presently shrouds the production of Volunteer glassware in the 1780s. Peter Francis has shown that much of it was actually made in the later nineteenth century, see 'Franz Tieze (1842–1932) and the re-invention of history on glass', *The Burlington Magazine*, CXXXVI, no. 1094, May 1994, pp. 291–302, and Mary Boydell's response, *The Burlington Magazine*, CXXXVI, no. 1098, September 1994, pp. 621–2. For a pre-controversy analysis of the glass see Catriona MacLeod, *Irish Volunteer Glass*, Dublin, National Museum of Ireland, *c.* 1986.

17 Edward Said, *Orientalism*, New York, Vintage Books, 1979, pp. 14–15.

18 Benedict Anderson, *Imagined Communities: Reflections on the Origin and Spread of Nationalism*, London, Verso, 1983, p. 19 and chap. 4.

19 Linda Colley, *Britons: Forging the Nation, 1707–1837*, New Haven and London, Yale University Press, 1992, p. 5.

20 Timothy Brennan, 'The National Longing for Form' in Homi K. Bhabha (ed.), *Nation and Narration*, London and New York, Routledge, 1990, p. 49, quoted in Leith Davis, '"Origins of the Specious": James Macpherson's Ossian and the Forging of the British Empire', *The Eighteenth Century: Theory and Interpretation*, 34, no. 2, Summer 1993, p. 132.

21 For the Volunteers see T. MacNevin, *The History of the Volunteers*, Dublin, 1845; M. R. O'Connell, *Irish Politics and Social Conflict in the Age of the American Revolution*, Philadelphia, University of Pennsylvania Press, 1965; R. B. McDowell, *Ireland in the Age of Imperialism and Revolution, 1760–1801*, Oxford University Press, 1979, chap. 5; and P. D. H. Smyth, 'The Volunteer Movement in Ulster: Background and Development, 1745–1785', Ph.D. dissertation, Queen's University, Belfast, 1984.

22 For Irish political life of the period see E. M. Johnston, *Great Britain and Ireland, 1760–1800: A Study in Political Administration*, Edinburgh and London, Oliver Boyd, 1963; Moody and Vaughan, op. cit., and Kelly, op. cit.

23 See MacNevin, op. cit., pp. 118–19; J. T. Gilbert, *A History of the City of Dublin*, 3 vols., Dublin, 1861, vol. 3, pp. 45–7; James Kelly in Dalsimer (1993), op. cit., pp. 150–1.

24 A key to the painting is reproduced in Webster, op. cit., p. 127.

25 See MacNevin, op. cit., pp. 118–19; Gilbert, op. cit., vol. 3, p. 127. The statue was destroyed earlier this century.

26 MacNevin, op. cit., pp. 118–19.

27 Gandon and Mulvany, op. cit., p. 207 and Webster, op. cit., pp. 128 and 186–7. A key to the identity of the sitters in the *Irish House of Commons* was published in 1801, but an engraving never appeared, see ibid., pp. 128, 186–7.

28 H. Grattan, *The Speeches of the Right Honourable Henry Grattan in the Irish and Imperial Parliament*, London, 1822, vol. 1, pp. 39–53.

29 On the dissemination of American images see Stephens and George, op. cit., vols. 5 and 6, *passim*; D. H. Cresswell, *The American Revolution in Drawings and Prints: A Checklist of 1765–1790 Graphics in the Library of Congress*, Washington, D.C., Library of Congress, 1975.

30 W. C. Wick, *George Washington: An American Icon*, Washington, D.C., National Portrait Gallery, 1982, p. 26; illustrated, figure 15, p. 29. For Irish interest in America see, R. B. McDowell, *Irish Public Opinion, 1750–1800*, London, Faber and Faber, 1975, chap. 3, and O. Dudley Edwards, 'The Impact of the American Revolution on Ireland' in R. R. Palmer et al, *The Impact of the American Revolution Abroad*, Washington, D.C., Library of Congress, 1976, pp. 127–58. Belinda Loftus has discussed the foreign influences that helped shape the various images of Liberty that occurred in the last decades of the century, see Loftus, op. cit., pp. 56 and 89.

31 Cresswell, op. cit., p. 50, cat. no. 156; *Hibernian Magazine*, August 1777, opp. p. 513. For Montgomery (1738–75) see H. A. Cooper, *John Trumbull: The Hand and Spirit of a Painter*, New Haven, Yale University Press, 1982, pp. 52–3.

32 The comparison is with Charles Willson Peale's various versions of Washington at the Battle of Princeton, in both oil and mezzotint, see Wick, op. cit., pp. 28–33, 85, and Jules David Prown, 'Paintings and Drawings and Watercolors' in Charles F. Montgomery and Patricia E. Kane (eds.), *American Art; 1750–1800: Towards Independence*, New Haven, Yale University Art Gallery, 1976, p. 92.

33 James Kelly, 'James Napper Tandy: Radical and Republican' in James Kelly and Uaitear MacGearailt (eds.), *Dublin and Dubliners*, Dublin, Helicon, 1990, p. 7.

34 Wind, op. cit., p. 126.

35 George, op. cit., vol 5, no. 5659.

36 Grattan, op. cit., vol. 1, p. 51.

37 The Volunteers had been admitting some Catholics from 1781, see O'Connell, op. cit., pp. 375–8.

38 See J. R. Hill, 'National festivals, the State and "Protestant Ascendancy" in Ireland, 1790–1829', *Irish Historical Studies*, 24, May 1984, pp. 30–51.

39 For a general history of the Order see P. Galloway, *The Most Illustrious Order of St Patrick*, Chichester, Phillimore, 1983.

40 Ibid., pp. 90–3.

41 The *Dublin Evening Post*, 13 September 1785, mentions how Sherwin's painting, commissioned by Temple, was in the process of being completed by Sherwin at Dublin Castle. By 1788 the painting was at Stowe, Temple's seat in Buckinghamshire (now in a private collection), *Dublin Evening Post*, 30 October 1788. A sketch version by Sherwin is in the National Gallery of Ireland, while a line engraving by Sherwin appeared in 1803. For the various representations of Temple/Buckingham see Richard Walker, *National Portrait Gallery: Regency Portraits*, 2 vols., London, National Portrait Gallery, 1985, vol. 1, pp. 72–3. J. S. Copley had hoped to produce a large group portrait of the Installation of the Irish Knights, making it a 'companion to the picture of Lord Chatham, and the English House of Peers' (Fig. 24). The project never came about, see Prown (1966), op. cit., vol. 2, pp. 296–7.

42 See Maurice Craig, *The Volunteer Earl, Being the Life and Times of James Caulfield, First Earl of Charlemont*, London, 1948.

43 O'Connell, op. cit., pp. 360–1.

44 Wheatley produced another, as yet untraced, Volunteers painting, *Review of the Irish Volunteers in the Phoenix Park in Dublin*, which he exhibited at the Society of Artists in London in 1783, see Strickland (1913), op. cit., vol. 2, pp. 525–6. For reasons of uniform and personnel, this is not the painting now in the National Portrait Gallery, London, listed as no. 36 by Webster (1970), op. cit., p. 129.

45 Ibid., p. 127, no. 32.

46 Anne Crookshank and David Webb, *Paintings and Sculptures in Trinity College Dublin*, Dublin, Trinity College Dublin Press, 1990, p. 15; the portrait was subsequently destroyed *c.* 1800, due to accusations that Grattan was a United Irishman, and was replaced by portraits of the conservatives Edmund Burke and John FitzGibbon, by then Earl of Clare, ibid., p. 61.

47 Stephens and George, op. cit., vol.5, no. 6003 (London, 13 June 1782). Little has been written on the cult of Grattan, see Gerard O'Brien, 'The Grattan Mystique', *Eighteenth-Century Ireland*, vol. 1, 1986, pp. 177–94.

48 Webster, op. cit., p. 129, no. 35, see also Mary Webster, 'Francis Wheatley's Review in Belan Park', *Apollo*, October 1984, pp. 275–9.

49 An anonymous pamphleteer of 1779 commented that 'no man thinks of volunteering who is not able to cloathe himself in a handsome uniform', *The First Lines of Ireland's Interest in the Year 1780*, Dublin, 1779, quoted in Smyth (1984), op. cit., p. 75. Grattan commented that 'Reviews were attended with every circumstance of brilliancy. There was no absence of the pomp of war . . . They had received many presents of ordnance; numerous stands of colours had been presented to them, with no absence of ceremony or splendour, by women of the highest station and figure in the country, whose pride it was to attend the reviews in their handsomest equipages and clothed in their gayest attire' (Henry Grattan Jr. [ed.], *Memoirs of the Life and Times of the Rt. Hon. Henry Grattan*, 5 vols., London, 1839–52, vol. 2, p. 124). For further Volunteer portraits see Eileen Black, 'Volunteer Portraits in the Ulster Museum, Belfast', *The Irish Sword*, 13, no. 52, Summer and Winter 1978, pp. 181–4, see also F. Glenn Thompson, 'The Flags and Uniforms of the Irish Volunteers and Yeomanry', *Bulletin of the Irish Georgian Society*, 33, 1990, pp. 3–30.

50 Galloway, op. cit., p. 17.

51 Ibid., p. 16; Hill (1984), op. cit., p. 31. This interest in Irish dress manufacturing extended to historical investigations, for example, Joseph Cooper Walker, *An Historical Essay on the Dress of the Ancient and Modern Irish*, Dublin, 1788, which appeared in the form of a letter to Lord Charlemont. Some years earlier, in 1777, at a fancy dress ball at the duke of Leinster's house, all the guests were expected to wear only items of Irish manufacture, see Mairead Reynolds, *Some Irish Fashions and Fabrics, c.1775–1928*, Dublin, 1984, p. 6, and Mairead Dunlevy, *Dress in Ireland*, London, 1989, p. 120.

52 *Dublin Evening Post*, 18 March 1783.

53 Hill (1984), op. cit., *passim*.

54 Clare O'Halloran, 'Irish Re-creations of the Gaelic Past: The Challenge of Macpherson's Ossian', *Past and Present*, 124, August 1989, pp. 69–95, and her 'Golden Ages and Barbarous Nations: Antiquarian Debate on the Celtic Past in Ireland and Scotland in the Eighteenth Century', Ph.D. dissertation, University of Cambridge, 1991, chap. 4. See also J. R. Hill, 'Popery and Protestantism, Civil and Religious Liberty: The Disputed Lessons of Irish History, 1690–1812', *Past and Present*, 118, February 1988, pp. 96–129.

55 Hill (1984), op. cit., p. 51.

56 Ann de Valera, 'Antiquarian and Historical Investigations in Ireland in the Eighteenth Century', M.A. dissertation, University College Dublin, 1978, p. 286 and *passim*. N. Vance, 'Celts, Carthaginians and Constitutions: Anglo-Irish Literary Relations', *Irish Historical Studies*, 22, 1980–1, pp. 216–38. See also Sam Smiles, *The Image of Antiquity: Ancient Britain and the Romantic Imagination*, London and New Haven, Yale University Press, 1994, pp. 11–13.

57 Hill (1988), op. cit., *passim*.

58 Clare O'Halloran (1991), op. cit., pp. 272–3.

59 Hill (1984), op. cit., *passim*.

60 Pressly (1981), op. cit., pp. 228 and 235–6; see also his 'James Barry's "The Baptism of the King of Cashel by St Patrick"', *The Burlington Magazine*, CXVIII, no. 882, September 1976, pp. 643–7.

61 Gibbons in Brady, op. cit., pp. 120 and 243, note 60.

62 A series of anonymous engravings of the national saints appeared in London in 1781, see Stephens and George, op. cit., vol. 5, nos. 5942–5; Patrick's Irishness is expressed through emblem (harp), diet (potatoes and fish) and music (bagpipes). It is reproduced in Cullen (1995), op. cit., p. 66.

63 Stephens and George, op. cit., vol. 5, nos. 7518–9, and Nicholas Robinson, 'Caricatures and the Regency Crisis: An Irish Perspective', *Eighteenth-Century Ireland*, 1, 1986, pp. 157–76.

64 For the late eighteenth-century cult of the past see Mark Girouard, *The Return to Camelot: Chivalry and the English Gentleman*, New Haven and London, Yale University Press, 1981, and Colley (1992), chap. 5.

65 Brian FitzGerald, *Emily, Duchess of Leinster, 1731–1814: A Study of Her Life and Times*, London, 1949, *passim*; P. N. Meenan, 'The Regency Crisis in Ireland, 1788–9', M.A. dissertation, University College Dublin, 1971, p. 73; McDowell (1979), op. cit., pp. 240, 283 and *passim*. A Whig Club was formed in Dublin in June 1789 where the same uniform was worn as in the Whig Club in London, see T. H. D. Mahony, *Edmund Burke and Ireland*, Cambridge, MA, 1960, p. 133.

66 *Historical Manuscripts Commission, Fortesque MSS*, London, 1892–1927, vol. 1, pp. 364–81; Buckingham-Grenville correspondence.

67 *The Parliamentary Register: or History of the Proceedings and Debates of the House of Commons of Ireland, 1781–1797*, 17 vols., Dublin, 1782–1801, vol. 9, pp. 129–30. It will be recalled that FitzGibbon (1749–1802) had appeared in Wheatley's *Volunteers* as a member of the cavalry regiments (Fig. 27). At that time he had given moderate support to the opposition. He was later raised to the peerage and made Lord Chancellor in 1789.

68 Strickland, op. cit., vol. 2, pp. 495–6; John Gilmartin, 'Vincent Waldré's ceiling paintings in Dublin Castle', *Apollo*, 95, January 1972, pp. 42–7, and Edward McParland, 'A Note on Waldré', *Apollo*, 96, November 1972, p. 467.

69 Desmond FitzGerald, 'A History of the Interior of Stowe', *Apollo*, 97, June 1973, pp. 572–85. For Waldré in general see Strickland (1913), vol. 2, pp. 494–7, and note 68 above.

70 Official Papers, 559/437/5, Memorial from Mary Waldré to the Lord Lieutenant, Lord Whitworth, *c.* 1814, State Paper Office, Dublin Castle; quoted in McParland, *Apollo* (1972), op. cit. For the hall see F. O Dwyer, 'The Ballroom at Dublin Castle: The Origins of St Patrick's Hall' in A. Bernelle (ed.), *Decantations: A Tribute to Maurice Craig*, Dublin, The Lilliput Press, 1992, pp. 149–67.

71 McParland, *Apollo* (1972), op. cit.

72 D. FitzGerald, op. cit., p. 578.

73 W. E. H. Leckey, *A History of Ireland in the Eighteenth Century*, 5 vols., London, 1892, vol. 2, p. 464. For Buckingham's ambition and character see Peter Jupp, *Lord Grenville, 1759–1834*, Oxford, Clarendon Press, 1985, pp. 43 and *passim*, also John Beckett, *The Rise and Fall of the Grenvilles: Dukes of Buckingham and Chandos, 1710 to 1921*, Manchester University Press, 1994, pp. 68–75.

74 Walker, op. cit., pp. 72–3; Strickland, op. cit., vol. 2, p. 389, and Anne Crookshank, 'Robert Hunter' in *The GPA Irish Arts Review Yearbook*, 1989–1990, p. 180.

75 Robinson, op. cit., plate 4, pp. 163–5, reproduces Rowlandson's print of January 1789, *Vice Q——'s Delivery at the Old Soldier's Hospital in Dublin*, see Stephens and George (vol. 6), op. cit., no. 7491, the implication being that the Buckinghams had a child at the public's expense.

76 Buckingham's academic interest in chivalric orders is reflected in the abundance of papers on the peerage and Order of the Garter that appear in the Stowe MSS, see *Catalogue of the Stowe MSS in the British Museum*, London, 1895, vol. 1, pp. 472–7, 595.

77 Von Erffa and Staley, op. cit., pp. 199–200; see also Wendy Greenhouse, 'Benjamin West and Edward III: A Neoclassical Painter and Medieval History', *Art History*, 8, June 1985, pp. 176–91.

78 Colley, op. cit., pp. 216–17.

79 McParland, *Apollo* (1972), op. cit.

80 Gilmartin, op. cit., pp. 45–7, and Crookshank and Glin (1978), op. cit., p. 169.

81 Although the Union of the two kingdoms did not occur until 1801, the union flag was the official standard of Ireland throughout the eighteenth century, see Hayes-McCoy, op. cit., p. 78.

82 W. Molyneux, *Case of Ireland Being Bound by Acts of Parliament in England Stated*, J. G. Simms (intro.), Dublin, Cadenus Press, 1977, pp. 12–13, 34–5 and *passim*; also P. Kelly, 'William Molyneux and the Spirit of Liberty', *Eighteenth-Century Ireland*, 3, 1988, pp. 133–48.

83 See Clare O'Halloran (1991), op. cit., pp. 296–304, for a discussion of contemporary evaluations of Henry II, especially *Thomas Campbell's Strictures on the Ecclesiastical and Literary History of Ireland*, Dublin, 1789, and London, 1790. See also Smiles, op. cit., pp. 101–3, for a brief mention of Waldré's *St Patrick* in the context of ancient history being used to validate contemporary aspirations.

84 On the political usages made of the peerage in the late eighteenth century, see M. W. McCahill, 'Peerage creations and the changing character of the British nobility, 1750–1830', *English Historical Review*, 96, 1981, pp. 259–84. Regardless of the undoubted significance of the founding of the Order of St Patrick, it should be pointed out that the most important political and cultural event for the Irish peerage during this period was the incorporation, as a result of the 1801 Act of Union, of the most prominent lords of Ireland into the British nobility, ibid., p. 263, and Colley (1992), op. cit., pp. 156–64.

85 *Common Sense, in Vindication of His Excellence the Marquis of Buckingham, During His Government of Ireland by a Candid Enquirer*, Dublin, 1789, pp. 10–11.

86 Clare O'Halloran (1991), op. cit., p. 270; she discusses the use made by Protestant historians of Keating's text, pp. 283–4; see also Hill (1988), op. cit., pp. 102–3. Keating's book appeared as *The General History of Ireland*, translated by Dermo'd O'Connor.

87 J. C. Walker, *Outlines of a Plan for Promoting the Art of Painting in Ireland: With a List of Subjects for Painters Drawn from the Romantic and Genuine Histories of Ireland*, 1790, pp. 23, 30.

88 S. Gwynne, *Henry Grattan and His Times*, London, George G. Harrap & Co., 1939, p. 125.

89 This discussion of reconciliation has been influenced by a piece by Seamus Deane in *The Irish Times*, 7 September 1988, p. 14.

3 PUBLIC AND PRIVATE

1 See L. Perry Curtis, Jr., *Apes and Angels: The Irishman in Victorian Caricature*, Newton Abbot, David & Charles, 1971, chap. 4.

2 Foster (1993), op. cit., p. 171.

3 L. Perry Curtis, Jr., *Anglo-Saxons and Celts: A Study of Anti-Irish Prejudice in Victorian England*, Bridgeport, Connecticut: Conference on British Studies, 1968, and Curtis (1971), op. cit.

4 Richard Ned Lebow, *White Britain and Black Ireland, The Influence of Stereotypes on Colonial Policy*, Philadelphia, Institute for the Study of Human Issues, 1976.

5 Frankie Morris, *John Tenniel, Cartoonist: A Critical & Sociocultural Study in the Art of the Victorian Political Cartoon*, Ann Arbor, University Microfilms International, 1985, p. 270.

6 Sheridan Gilley, 'English Attitudes to the Irish in England, 1780–1900' in Colin Holmes (ed.), *Immigrants and Minorities in British Society*, London, George Allen & Unwin, 1978, pp. 81–110.

7 Luke Gibbons in Deane (1991), op. cit., 3, p. 585, n. 8; see also Gibbons's 'Race Against Time: Racial Discourse and Irish History', *Oxford Literary Review*, 13, nos. 1–2, 1991, pp. 95–117.

8 Homi K. Bhabha, *The Location of Culture*, London and New York, Routledge, 1994, p. 67.

9 Ibid., p. 79.

10 Roy Foster, 'We Are All Revisionists Now', in Deane (1991), op. cit., 3, p. 584.

11 The subject has only really been tackled by two scholars, Crookshank and Glin (1969 and 1978).

12 Crookshank and Glin (1969), op. cit., p. 21.

13 For example, the son of George II, *William, Duke of Cumberland*, 1758, illustrated p. 192 in Penny, op. cit. For further discussion of Bellamont see John Coleman, 'Images of Assurance or Masks of Uncertainty: Joshua Reynolds and the Anglo-Irish Ascendancy, 1746–1789', M.Litt dissertation, University of Dublin, 1993, chap. 4.

14 Joshua Reynolds, *Discourses on Art*, Robert R. Wark (ed.), New Haven and London, Yale University Press, 1981, p. 73.

15 Penny, op. cit., p. 261, states that the Order of the Bath did indeed have its roots in the medieval period but was revived in 1725.

16 T. H. Breen, 'The Meaning of "Likeness": Portrait-Painting in an Eighteenth-Century Consumer Society', in Ellen G. Miles (ed.), *The Portrait in Eighteenth-Century America*, London and Toronto, Associated University Presses, and Newark, University of Delaware Press, 1993, p. 39.

17 Ibid., p. 54. Breen quotes Frederick A. Sweet, 'Mezzotint Sources of American Colonial Portraits', *Art Quarterly*, 14, 1951, pp. 148–57.

18 Tobias Smollett, *The Expedition of Humphrey Clinker*, ed. Lewis M. Knapp, revised edn. by Paul-Gabriel Bouce, Oxford University Press, 1984, p. 30.

19 Christopher Murray in Deane (1991), op. cit., vol. 1, p. 504.

20 Coleman, op. cit. See *A Genuine Account of the Progress of Charles Coote, Esq., in Pursuing and Defeating the Oak-boys in the Counties of Monaghan, Cavan and Fermanagh*, Dublin, 1763.

21 Thomas Sheridan, *The Brave Irishman*, 1743, reprinted in Deane (1991), op. cit., vol. 1, p. 533.

22 Ibid., p. 540.

23 John Gamble, *Sketches in Dublin and the North of Ireland*, Dublin, 1810; *Town and Country*, Dublin, 1786, vol. 28, p. 457 (both quoted in Coleman, op. cit.)

24 Brian FitzGerald, *Lady Louisa Conolly 1743–1821: An Anglo-Irish Biography*, London, 1950, p. 83, quoted in Coleman, op. cit., and Penny, op. cit.

25 For the background to the petty dispute see James Kelly, *'That Damn'd Thing Called Honour': Duelling in Ireland, 1570–1860*, Cork University Press, 1995, pp. 106–11.

26 Joep Th. Leerssen, *Mere Irish and Fíor-Ghael: Studies in the Idea of Irish Nationality, its Developments and Literary Expression Prior to the Nineteenth Century*, Amsterdam and Philadelphia, John Benjamin Publishing Co., 1986, p. 160.

27 Quoted by Kelly (1995), op. cit., p. 110.

28 Penny, op. cit., p. 261.

29 Hugh Kelly, Preface to *The School for Wives*, dated 1 Jan, 1774, reprinted in Deane (1991), op. cit., vol. 1, p. 567. See also G. C. Duggan, *The Stage Irishman: A History of the Irish Play and Stage Characters from the Earliest Times*, London, Longmans, Green and Co., 1937, pp. 226–8.

30 Quoted in J. O. Bartley, *Teague, Shenkin and Sawney: Being an Historical Study of the Earliest Irish, Welsh and Scottish Characters in English Plays*, Cork University Press, 1954, pp. 114–15, and not in Deane (1991), op. cit.

31 Gamble, quoted in Coleman, op. cit.

32 John Bernard, *Retrospections of the Stage*, 2 vols., 1830, vol. 2, pp. 209–10, quoted by R. W. Lightbown in Pasquin (1970), op. cit., p. 20.

33 O'Blunder says that his sidekick, the sergeant, 'has for a long time lain under the computation of being a Papist', quoted in Bartley, op. cit., p. 114.

34 Oliver Goldsmith, 'A Description of the Manners and Customs of the Native *Irish*. In a Letter from an *English* Gentleman', 1759, reprinted in Deane (1991), op. cit., vol. 1, p. 664.

35 The literature on the representation is not extensive, see Fergus O'Ferrall, 'Daniel O'Connell, the "Liberator", 1775–1847: Changing Images', in Gillespie and Kennedy (1994), op. cit., p. 91–102, and 233–4, and Foster (1993), op. cit., pp. 171–94.

36 *Punch*, 9, July–December 1845, p. 255. This tuberous trope had been used before in a cartoon of March 1829, at the time of Catholic Emancipation, where O'Connell, the legal wizard, is shown excreting 'Popery' on 'Protesant Ground', reproduced by Stephen J. Campbell, *The Great Irish Famine*, Strokestown, The Famine Museum, 1994, p. 27; *The Real Potato Blight* is reproduced, ibid., p. 19.

37 See H. L. Malchow, 'Frankenstein's Monster and Images of Race in Nineteenth-Century Britain', *Past and Present*, no. 139, May 1993, p. 124.

38 Curtis (1971), op. cit., p. 32.

39 *Catalogue of the Third Concluding Exhibition of National Portraits*, London, The South Kensington Museum, 1868, no. 432.

40 Marcia Pointon, *Hanging the Head: Portraiture and Social Formation in Eighteenth-Century England*, New Haven and London, Yale University Press, 1993, p. 234.

41 For a discussion of the continued use by *Punch* of O'Connell in reference to Irish issues, see Foster (1993), op. cit., p. 187.

42 See Walker (1985), op. cit., vol. 1, pp. 182–4 and 223–4, and Fintan Cullen, 'The Oil Paintings of Hugh Douglas Hamilton', *The Walpole Society*, L, 1984, pp. 184, 187–8, plates 97 and 98. Bust length portraits of Grattan and FitzGerald were, coincidentally, included in the 1868 London National Portraits Exhibition, nos. 741 and 748.

43 T. Desmond Williams, 'O'Connell's Impact on Europe' in Kevin B. Nowlan and Maurice R. O'Connell (eds.), *Daniel O'Connell: Portrait of a Radical*, Belfast, Appletree Press, 1984, p. 106.

44 David Wilkie to Sir William Knighton, 4 November 1835, Mitchell Library, University of Glasgow. I am grateful to Nicholas Tromans for leading me to this letter.

45 The portrait of O'Connell was again shown in 1842 at the British Institution, London, no. 118, and in 1853 and 1872 in Dublin, see *Irish Art Loan Exhibitions 1765–1927*, compiled by Ann M. Stewart, vol. 2, John Appleby Publishing/Manton Publishing, St. Ouen's, Jersey and Dublin, 1995. For the portrait of Baird see Fintan Cullen, 'The Art of Assimilation: Scotland and its Heroes', *Art History*, 16, no. 4, December 1993, pp. 600–18.

46 Wilkie to Sir William Knighton, 4 November 1835, Mitchell Library, University of Glasgow, this section printed in Cunningham (1843), op. cit., vol. 3, p. 112. For information on Cholmondeley, I am grateful to Philip Winterbottom and Alison Turton of the Archives Section of the Royal Bank of Scotland. Cholmondeley presented the Wilkie portrait to the National Bank of Ireland in 1848.

47 *The Times*, 26 November 1835, quoted in Oliver MacDonagh, *O'Connell: The Life of Daniel O'Connell, 1775–1847*, London, Weidenfeld & Nicolson, 1991, p. 407.

48 James N. McCord, 'The Image in England: The Cartoons of HB' in M. O'Connell (ed.), *Daniel O'Connell, Political Pioneer*, Dublin, Institute of Public Administration, 1991, pp.

57–71. See MacDonagh, op. cit., chapters 16 and 17.

49 T. Desmond Williams in Nowlan and O'Connell, op. cit., p. 106.

50 Archives of the Royal Bank of Scotland, Minute Books of the National Bank of Ireland, 8 December 1848 and 19 January 1849.

51 MacDonagh (1991), op. cit., p.395.

52 Ibid., pp. 396–7.

53 Ibid., p. 396.

54 See Kenneth Garlick, *Sir Thomas Lawrence*, Oxford, Phaidon, 1989, p. 26, illustrated pp. 132, 163 and 226.

55 Peel to F. H. Say, Esq., 1 March 1844, British Museum, Add. MSS 40541, fol.9. I am grateful to Peter Funnell for this source.

56 *Spectator*, 8 May 1830, quoted by Michael Levey, *Sir Thomas Lawrence, 1769–1830*, London, National Portrait Gallery, 1979, p. 85, where the portrait is illustrated.

57 Gibbons in Deane (1991), op. cit.

58 There are two oil versions of this portrait, one in Derrynane, Co. Kerry, from which Fig. 45 is derived and which may be the first; the other, signed and dated 1830, is in the Reform Club, London. The latter differs from the Derrynane version in that the dog is seen from the rear.

59 Terry Eagleton, *Heathcliff and the Great Hunger: Studies in Irish Culture*, London, Verso, 1995, p. 59.

60 See Cullen (1993), op. cit., p. 600–18.

61 MacDonagh (1991), op. cit., p.194.

62 Walter Scott, *Waverley, or, 'Tis Sixty Years Since*, ed. Claire Lamont, Oxford University Press, 1981, p. 388.

63 Cairns Craig, 'Myths against History: Tartanry and Kailyard in 19th Century Scottish Literature' in Colin McArthur (ed.), *Scotch Reels: Scotland in Cinema and Television*, London, 1982, p. 14.

64 I am grateful to Marcia Pointon for this observation.

65 MacDonagh (1991), op. cit., p. 284.

66 Maurice R. O'Connell, 'O'Connell: Lawyer and Landlord' in Nowlan and O'Connell (1984), op. cit., p. 119.

67 Oliver MacDonagh, 'The Economy and Society, 1830–45' in Vaughan (1989), op. cit., p. 226, quoted by Eagleton, op. cit., p. 57.

68 Ibid.

69 Thomas Flanagan, *The Irish Novelists, 1800–1850*, New York, Columbia University Press, 1959, pp. 131–7.

70 Ibid., p. 133.

71 Tom Dunne, 'Fiction as "the best history of nations": Lady Morgan's Irish novels' in Dunne (1987), op. cit., p. 143.

72 MacDonagh (1991), op. cit., p. 213.

73 The long scroll refers to the final treaty with the Nizam of Hyderabad of 1800, whereby the Nizam became an ally of the British. The other scrolls refer to earlier treaties with Mysore. For a discussion of the portrait see Mildred Archer, *India and British Portraiture, 1770–1825*, London, 1979, pp. 314–15 and 462–3, also Walker (1985), op. cit., p. 524, who lists eight versions by Home.

74 For Wellesley's military successes see Iris Butler, *The Eldest Brother: The Marquess Wellesley, 1760–1824*, London, 1973, *passim*, and Percival Spear, *The Oxford History of Modern India, 1740–1975*, Delhi, 1979, pp. 106–13, and Cullen (1993), op. cit., pp. 600–18. For Welles-ley's wearing of the Order of St Patrick see George Annesley, *Voyages and Travels to India, Ceylon, the Red Sea, etc.*, 2 vols., London, 1809, vol. 1, p. 61. For the gift of the jewels see *Historical Manuscript Commission, Report on the Manuscripts of J. B. Fortesque, Esq., preserved at Dropmore*, 10 vols., London, 1892–1927, vol. 6, p. 50, and *Robert R. Pearce, Memoirs and Correspondence of the Noble Richard Marquess Wellesley*, 3 vols., London, 1846, vol. 1, pp. 336–7.

75 Wellesley to Pitt, 6 October 1801, quoted in Edward Ingram, *Two Views of British India: The Private Correspondence of Mr Dundas and Lord Wellesley, 1798–1801*, Bath, Adams and Dart, 1970, p. 259. See also E. Brynn, 'The Marquess of Wellesley', Ph.D. dissertation, University of Dublin, 1977, p. 672, and M. McCahill, 'Peerage Creations and the Changing Character of the British Nobility, 1750–1830', *English Historical Review*, 96, no. 379, 1981, p. 273.

76 *Fortesque MSS* (vol. 6), p. 210, Mornington to Lord Grenville, 1 May 1800; Wellesley MSS, British Library Add. MS 37282, fol. 210, Wellesley to Speaker (unspecified), 9 October 1800.

77 C. A. Bayly (ed.), *The Raj: India and the British, 1600–1947*, National Portrait Gallery, London, 1990, p. 132.

78 Wellesley MSS, British Library Add. MS 37282, fol. 190, Wellesley to Lord Grenville, 4 April 1800.

79 Quoted by Gibbons in Rockett et al (1987), op. cit., p. 217.

80 The course of Mansergh St George's military career is somewhat confusing but Jenny Spencer-Smith, of the National Army Museum, London, is of the opinion that in Hamilton's portrait, Mansergh St George wears the uniform of a cavalry Lieutenant (18th regiment of Light Dragoons), a rank he assumed in April 1796; letter on file (cat. no. 4585), National Gallery of Ireland. I am grateful to Adrian Le Harivel for this information. For a brief account of Mansergh St George's career see *Alumni Cantabrigienses*, compiled by J. A. Venn, London, 1951, part 2, vol. iv, p. 314, which might not be entirely accurate, also *Burke's Irish Family Records*, London, 1976, p. 781. For evidence of Mansergh St George's loyalty see his account of smuggling in Galway in a letter to Dublin Castle, dated 1794, Kevin Whelan, *The Tree of Liberty, Radicalism, Catholicism and the Construction of Irish Identity 1760–1830*, Cork University Press, 1996, p. 16.

81 MacDonagh (1983), op. cit., p. 4.

82 Eagleton, op. cit., p. 193.

83 In formulating this section I have found the following most helpful: Terry Castle, 'The Spectralization of the Other in *The Mysteries of Udolpho*' in Felicity Nussbaum and Laura Brown (eds.), *The New Eighteenth Century: Theory, Politics, English Literature*, New York and London, Methuen, 1987, pp. 231–53, and Siobhán Kilfeather, 'Origins of the Irish Female Gothic', *Bullán: An Irish Studies Journal*, 1, no. 2, Autumn 1994, pp. 35–45.

84 Terry Eagleton, op. cit., p. 187.

85 Ibid., pp. 188–9.

86 Deane (1986), op. cit., p. 100.

87 See Fintan Cullen, 'Hugh Douglas Hamilton: "painter of the heart"', *Burlington Magazine*, CXXV, July 1983, pp. 417–21.

88 See Wright's *Dorothy Gell of Hopton*, 1786, catalogue no. 65 in Benedict Nicolson, *Joseph Wright of Derby: Painter of Light*, London, Routledge & Kegan Paul, 1968, pl. 266; and Canova's figure of *Temperance* on the lower left of his tomb monument to Clement XIV in SS Apostoli, Rome, 1783–7. Another eighteenth-century source is possibly Giovanni Guelfi's *Cragg Monument* in Westminster Abbey, 1727, see Margaret Whinney, *Sculpture in Britain, 1530–1830*, Harmondsworth, Penguin, 1988, p. 81. An antique source is probably *Pothos* or 'Longing' Statue (attributed to Scopas) in the Capitoline Museum, Palazzo dei Conservatori, Rome, see Gisela Richter, *A Handbook of Greek Art*, Oxford, Phaidon, 1959, pl. 201. For Hamilton's friendship with Canova see Fintan Cullen, 'Hugh Douglas Hamilton in Rome, 1779–92', *Apollo*, February 1982, pp. 86–91.

89 William Hauptman, *The Persistence of Melancholy in Nineteenth-Century Art: The Iconography of a Motif*, 2 vols., Ann Arbor, University Microfilms, 1975, vol. 1, p. 155–6.

90 An engraving by Mérigot *fils* of Rousseau's tomb dates from *c.* 1778 and shows an island dotted with cypress and poplar trees, and is reproduced in Robert Rosenblum, *Transformations in Late Eighteenth-Century Art*, Princeton University Press, 1974, fig. 126.

91 Thomas Pakenham, *The Year of Liberty*, Hodder & Stoughton, London, 1969, p. 35.

92 A typescript of the original letter is in the collection of the previous owner of the portrait, a descendant of Mansergh St George. For an abridged transcription of the letter see Cullen (1983), and for the full version see David H. Weinglass (ed.), *The Collected English Letters of Henry Fuseli*, Millwood, NY, London and Nendeln, Liechtenstein, Krauss International Publications, 1982, pp. 66–71. The late Gert Schiff was firmly of the opinion that the letter was intended for Fuseli and perhaps never sent off to him; communicated to the author by letter, 27 September 1982.

93 Mansergh St George might have been attracted to Fuseli's work by the thematic precedent of his friend, Sir Brooke Boothby, who, having lost his five-year-old daughter in 1791, commissioned a large commemorative painting from the Swiss artist. The painting, now in Wolverhampton Art Gallery, depicts an angel lifting up the 'soul' of Penelope Boothby. The image was engraved as frontispiece to Brooke Boothby, *Sorrows, Sacred to the Memory of Penelope*, London, 1796.

94 The actual date of Anne Stepney's death or that of the birth of her second son has not been found. She was painted by George Romney in a double portrait with her first son in July–August 1791 and must have died shortly after that, see H. Ward and W. Robert, *Romney*, 2 vols., London, 1904, vol. 2, p. 138; see Cullen (1983), op. cit., for an illustration of the portrait.

95 All quotations are from Weinglass, op. cit. Punctuation has been improved.

96 Stephens and George, op. cit., vol. 5, xxxv, n.2, quoting from Mrs. G. H. Bell (ed.), *The Hamwood Papers*, London, 1930, p. 74. Rousseau had died in 1778 and Brooke Boothby is known to have visited him in Paris in 1776. In Wright's famous portrait of Mansergh St George's friend, Brooke Boothby, of 1781 (Tate Gallery, London), the sitter is shown holding a copy of *Rousseau Juge de Jean Jacques*, 'that had just come out in Lichfield', see Nicolson, op. cit., p. 127, and Cullen (1983), op. cit.

97 Eleanor Butler's journal, 4 February 1788, quoted in Elizabeth Mavor, *The Ladies of Llangollen*, London, Michael Joseph, 1971, p. 146, who in turn is quoting from Bell, op. cit., pp. 74–5.

98 See Stephens and George, op. cit., vols. 4 & 5, nos. 4138, 4640, 4643, 4699, 4702, 4997, 5173, 5176, 5372 and 5482. The last two are reproduced in *English Caricature: 1620 to the Present*, London, Victoria & Albert Museum, 1984, pl. 32, and Peter D. G. Thomas, *The English Satirical Print: The American Revolution*, Cambridge, Chadwyck-Healey, 1986, no. 71, respectively.

99 Mavor, op. cit., p. 146.

100 Anna Seward to Humphrey Repton, Lichfield, 13 April 1798, *Letters of Anna Seward Written between the Years 1784 and 1807*, 6 vols., Edinburgh, Constable, 1811, vol. 5, pp. 68–9. In another letter of April 24, to the Ladies of Llangollen, she again refers to the murder of St George, ibid., pp. 75–6.

101 Seward has been described by Marilyn Butler as quite 'absurd', both as a woman and as a writer, see *Maria Edgeworth: A Literary Biography*, Oxford at the Clarendon Press, 1972, p. 39.

102 Quoted by Maurice Hindle in the Introduction to his edition of William Godwin, *Things as they Are or The Adventures of Caleb Williams*, London, Penguin Books, 1988, p. xxiv.

103 A small head-and-shoulders oil portrait of Mansergh St George by Hamilton is in a private collection in Ireland; the other portraits mentioned in the letter have not been traced, see Cullen (1984), op. cit., p. 199, no. 103, and Cullen (1983), op. cit.

104 Godwin, op. cit., p. 8.

105 Ibid., p. 9.

106 Quoted in Godwin, op. cit., p. xxiv; see P. N. Furbank, 'Godwin's Novels' in *Essays in Criticism*, v, 1955, p. 216.

107 For its popularity see Dorothy Blakey, *The Minerva Press, 1790–1820*, Oxford University Press, 1939, pp. 57–9, and W. J. McCormack, 'Irish Gothic and After, 1820–1945' in Deane (1991), op. cit., vol. 2, p. 831–2.

108 Regina Maria Roche, *The Children of the Abbey*, London, George Virtue, 1836, p. 545.

109 Illustrated in Blakey, op. cit., pl. III.

110 Kilfeather, op. cit., p. 44.

111 Devendra P. Varma, *The Gothic Flame*, London, A. Barber, 1957, p. 59.

112 Preface to the first edition of *The Castle of Otranto*, 1764.

113 Northrop Frye, 'Towards Defining an Age of Sensibility' in J. L. Clifford (ed.), *Eighteenth-Century English Literature: Modern Essays in Criticism*, 1959, p. 316.

114 Trinity College Library, Dublin, MS 1749 (1-6.24).

115 Eagleton, op. cit., pp. 194–5.

116 *The Standard Edition of the Complete Psychological Works of Sigmund Freud*, gen. ed. James Strachey, vol. 14, London, Hogarth Press, 1957, p. 248.

117 Ibid. For a comparable reaction to 1798 horror, see *Retrospections of Dorothea Herbert 1770–1806*, Town House, Dublin, 1988, pp. 376–7. I am grateful to Siobhán Kilfeather for this reference.

118 Eagleton, op. cit., pp. 192–3.

119 Freud, op. cit., p. 244–7.

120 Ibid., p. 194.

121 Kilfeather, op. cit., p. 37, has suggested Burke as providing 'an aesthetic guide for writers of gothic fiction'.

122 Edmund Burke, *A Philosophic Enquiry into the Origin of our Ideas of the Sublime and Beautiful*, ed. James T. Boulton, Oxford, Basil Blackwell, 1987, p. 37.

123 Terry Castle in Nussbaum and Brown, op. cit., p. 245; Castle quotes the passage where the dying St Aubert discourses on the afterlife with La Voisin.

124 Dunne, op. cit., p. 151.

125 Lady Morgan, *The O'Briens and the O'Flahertys: A National Tale*, London, Pandora, 1988, p. 96.

4 The Peasant, Genre Painting and National Character

1 See Seamus Deane, 'Irish National Character, 1790–1900' in Dunne, op. cit., pp. 90–113.

2 Wilkie to his patron, Robert Vernon, 15 October 1835, National Library of Scotland, MS 10995/29–30; quoted (in part) in Chiego, op. cit., p. 242.

3 Adrian Le Harivel and Michael Wynne, *Acquisitions, 1982–83*, Dublin, National Gallery of Ireland, 1984, p. 39.

4 Ibid., p. 40.

5 Wilkie to Sir William Knighton, 30 August 1835, Mitchell Library, the University of Glasgow, MS 308895; quoted in Sir William W. Knighton, *Memoirs of Sir William Knighton, Bart., G.C.H.*, 2 vols., London, R. Bentley, vol. 2, 1838, pp. 226–9, and in Lindsay Erring-

ton, *Work in Progress. Sir David Wilkie: Drawings into Paintings*, Edinburgh, National Gallery of Scotland, 1975, p. 21.

6 Thomas Davis, 'National Art', *The Nation*, 2 December 1841, p. 122.

7 For a list of Wilkie's Irish drawings see Cunningham, vol. 3, op. cit., pp. 99–100; for Wilkie's drawings in general see Chiego, op. cit., pp. 59–72 and 273–360.

8 Wilkie to William Collins, RA, 12 September 1835, quoted in Cunningham, op. cit., vol. 3, p. 106.

9 For previous comment on these paintings see Chiego, op. cit., pp. 38–9 and 242–5; Errington, op. cit., pp. 21–4, and Errington's *Tribute to Wilkie*, Edinburgh, National Gallery of Scotland, 1985, pp. 82–3.

10 Michael R. Booth, 'Irish Landscape in the Victorian Theatre' in *Place, Personality and the Writer*, ed. Andrew Carpenter, Gerrards Cross, Colin Smythe, 1977, p. 169.

11 See David Cairns and Shaun Richards, *Writing Ireland: Colonialism, Nationalism and Culture*, Manchester University Press, 1988, chap. 1.

12 Chiego, op. cit., p. 33, from a letter to Andrew Wilson dated September 1828.

13 Ibid., p. 33, and Millar, op. cit., pp. 139–41, where all are illustrated.

14 National Library of Scotland, MS 9836, ff. 1–3, Wilkie to Alexander Nasmyth, Seville, 23 April 1828. I am grateful to Nicholas Tromans for this source.

15 See Cecilia Powell, 'Turner and the Bandits: *Lake Albano* Rediscovered', *Turner Studies*, Winter 1984, vol. 3, no. 2, pp. 22–7, David Robertson, *Sir Charles Eastlake and the Victorian Art World*, Princeton University Press, 1978, pp. 251–60, and Eric Hobsbawm, *Bandits*, London, Weidenfeld & Nicolson, 1969, *passim*; Hobsbawm briefly discusses the popularity of the genre in both imagery and popular theatre.

16 Quoted by Hugh Honour, *Romanticism*, Harmondsworth, Penguin, 1981, p. 242.

17 This is one of fourteen versions by Roberts, see John Ingamells, *The Wallace Collection Catalogue of Pictures: French Nineteenth Century*, London, the Trustees of the Wallace Collection, 1986, pp. 204–5.

18 Letter from Wilkie to Sir William Knighton, Limerick, 30 August 1835, Mitchell Library, University of Glasgow, quoted in Knighton (1838), op. cit., vol. 2, p. 228.

19 Rev. William Campbell to the Earl of Charlemont, 9 February 1788, quoted in David W. Miller, 'The Armagh Troubles, 1780–95', *Irish Peasants, Violence and Political Unrest, 1780–1914*, eds. Samuel Clark and James S. Donnelly, Jr., The Manchester University Press, 1983, p. 183. See also Jim Smyth, *The Men of No Property: Irish Radicals and Popular Politics in the Late Eighteenth Century*, London, Macmillan, 1992, pp. 46–7.

20 I am grateful to Joy Pepe for discussing this point with me. For recent comment on rosaries and Catholic Ireland in the early nineteenth century see Loftus (1990), p. 56.

21 15 October 1835, National Library of Scotland, Ms 10995/29–30, quoted (in part) in Chiego, op. cit., p. 242. For Vernon see Robin Hamlyn, *Robert Vernon's Gift: British Art for the Nation, 1847*, London, Tate Gallery, 1993.

22 Cormac Ó Gráda, 'Industry and Communication, 1801–45' in Vaughan (1989), op. cit., p.146. See also Elizabeth Malcolm, *Ireland Sober, Ireland Free*, Dublin, 1986, pp. 33–8, and K. H. O'Connell, *Irish Peasant Society: Four Historical Essays*, Oxford, Clarendon Press, 1968, pp. 1–50.

23 See Michael Beames, *Peasants and Power: The Whiteboy Movements and their Control in Pre-Famine Ireland*, Brighton and New York, 1983.

24 J. and M. Banim, *Tales by the O'Hara Family: Crohoore of the Bill-Hook, The Fetches, John Doe*, 3 vols., with an Introduction by Robert Lee Wolff, New York and London, Garland, fac-simile edn., 1978, vol. 1, x–xii; vol. 2, pp. 39–40.

25 Flanagan, 'Literature in English, 1801–1891' in Vaughan (1989), op. cit., p. 484.

26 Klaus Lubbers, 'Author and Audience in the Early Nineteenth Century' in *Literature and the Changing Ireland*, ed. Peter Connolly, Gerrards Cross, Colin Smythe, 1989, p. 33.

27 Gerard Griffin, 'Conclusion of Tales of the Munster Festivals' in *The Rivals and Tracy's Ambi-tion*, John Cronin (Introduction), Université de Lille III, 1978, n.p.; see also Tom Dunne, 'Murder as Metaphor: Griffin's Portrayal of Ireland in the Year of Catholic Emancipation' in *Ireland and Irish Australia: Studies in Cultural and Political History*, eds. Oliver MacDonagh and W. F. Mandle, London, Croom Helm, 1986, p. 72.

28 Ibid., p. 78.

29 Cunningham, op. cit., vol. 3, p. 116.

30 Mrs S. C. Hall, quoted by Luke Gibbons in Rockett et al, op. cit., pp. 218–19.

31 Knighton, op. cit., vol. 2, p. 228.

32 Cunningham, op. cit., vol. 3, p. 116.

33 For a delightfully delicate preparatory chalk sketch of the sleeping man, in the Ashmolean Museum, Oxford, see Chiego, op. cit., pp. 317–18.

34 Marcia Pointon, exhibition review, *The Burlington Magazine*, 77, October 1985, p. 731.

35 National Library of Scotland MS 3812, Wilkie to Andrew Wilson, 12 August 1839; this pas-sage also appears in Cunningham, op. cit., vol. 3, p. 274, see also Errington (1975), pp. 21–4. Wilson co-owned the painting with Wilkie; it seems to have been bought as a spec-ulative venture. I am grateful to Helen Smailes of the National Gallery of Scotland for her help with this issue.

36 Cecil Gould, *The Paintings of Correggio*, London, 1976, pp. 272–3, and Lauren Soth, 'A Note on Correggio's Allegories of Virtue and Vice', *Gazette des Beaux Arts*, 160 year, 6th series, 1964, vol. 64, pp. 297–300.

37 Knighton, op. cit., vol. 2, p. 227.

38 Said, op. cit., p. 15.

39 See Chiego, op. cit., pp. 231–3, and Helen Smailes and Mungo Campbell, *Hidden Assets: Scottish Paintings from the Flemings Collection*, Edinburgh, National Galleries of Scotland, 1995, pp. 22–3

40 Loftus, op. cit., p. 60.

41 For *The Penny Wedding* see Chiego, op. cit., pp. 168–72.

42 Cunningham op. cit., vol. 3, p. 488; quoted in Chiego, op. cit., p. 39.

43 John Barrell, *The Dark Side of the Landscape: The Rural Poor in English Painting, 1730–1840*, Cambridge University Press, 1980, p. 105.

44 Knighton, op. cit., vol. 2, p. 227.

45 Cunningham, op. cit., vol. 3, pp. 106–7.

46 Ibid., p. 107.

47 Letter from Delacroix to Frédéric Villot, Tangiers, 29 February 1832, in *Eugène Delacroix: Selected Letters, 1813–1863*, ed. Jean Stewart, London, Eyre & Spottiswoode, 1971, p. 186.

48 John Hutchinson, *James Arthur O'Connor*, Dublin, National Gallery of Ireland, 1985, pp. 192–3.

49 For Haverty see Strickland, op. cit., vol. 1, pp. 453–6.

50 Quoted in Sheehy, op. cit., p. 34.

51 Davis had suggested the subject of 'Father Mathew Administering the Pledge in a Munster County' in 'Hints for Irish Historical Paintings' published in *The Nation*, see *Prose Writings of Thomas Davis*, ed. T. W. Rolleston, London, Walter Scott, n.d., p. 157, and Cyril Barrett, 'Irish Nationalism and Art,1800–1921', *Studies*, Winter 1975, p. 397.

52 Letter of 30 August 1835, Mitchell Library, the University of Glasgow; quoted in Errington (1975), op. cit., p. 21, not quoted in Knighton (1838). In fact a number of British artists had been visiting Ireland from the 1820s and exhibiting the results of their tours back in London, for example G. F. Robson's views of Killarney, *c.* 1828, see *The Royal Watercolour Society: The First Fifty Years, 1805–1855*, Woodbridge, Suffolk, Antique Collectors' Club, 1992, pp. 234–6.

53 Cunningham, op. cit., vol. 3, p. 107.

54 See Adrian Le Harivel, *National Gallery of Ireland: Illustrated Summary Catalogue of Drawings, Watercolours and Miniatures*, Dublin, National Gallery of Ireland, 1983, pp. 622–40. See also Crookshank and Glin (1994), op. cit., pp. 158–63; another artist who travelled this road was Frederick William Burton (1816–1900), see Marie Bourke, 'Rural Life in Pre-Famine Connacht: A Visual Document' in Gillespie and Kennedy, op. cit., pp. 61–74.

55 William Stokes, *The Life and Labours in Art and Archeology of George Petrie*, London, 1868, p. 395, quoted in Crookshank and Glin (1994), op. cit., pp. 162–3.

56 Quoted in Sheehy, op. cit., p. 22.

57 Quoted in Peter Murray, 'George Petrie, 1789–1866', M.Litt. dissertation, University of Dublin, 1980, p. 49; Petrie visited Connemara and the Aran Islands in 1821 and 1822.

58 Sheehy, op. cit., pp. 20–2, who shows how Petrie 'rearranged' the scene.

59 See *The Gentleman's Magazine*, 1836, p. 71; Chiego, op. cit., refers to other reviews, p. 47; see also Hamlyn (1993), p. 65.

60 Ibid., pp. 9 and 65.

61 Chiego, op. cit., p. 242.

62 Hamlyn, op. cit., p. 65.

63 The purchaser was Fredrich Wilhelm Brederlo, archives of the National Gallery of Scotland; for a photograph of the Riga version see Errington, (1975), op. cit., fig. 11 and pp. 21–4. Neither painting was exhibited in Ireland although *The Peep-O-Day* was loaned to the National Gallery of Ireland at the end of the nineteenth century.

64 Maria Edgeworth to Allan Cunningham, letter of 25 July 1842, quoted in Chiego, op. cit., p. 244.

65 Seamus Deane, 'Irish Poetry and Irish Nationalism', *Two Decades of Irish Writing: A Critical Survey*, ed. D. Dunn, Cheadle, 1975, p. 8; quoted in Declan Kiberd, *Anglo-Irish Attitudes*, Derry, Field Day, 1984, p. 11.

66 Curtis (1968) and Curtis (1971), op. cit., see also Martin Weimer, *Das Bild der Iren und Irlands im Punch 1841–1921. Strukturanalyse des hibernistischen Heterostereotyps der englischen satirischen Zeitschrift dargestellt an Hand von Karikaturen und Texten*, Frankfurt am Main, Peter Lang, 1993.

67 The exception being Gerard Curtis, 'Ford Madox Brown's *Work*: An Iconographic Analysis', *Art Bulletin*, December 1992, CXXIV, no. 4, pp. 623–36, and to a lesser extent Albert Boime, 'Ford Madox Brown, Thomas Carlyle, and Karl Marx: Meaning and Mystification of Work in the Nineteenth Century', *Arts Magazine*, September 1981, pp. 116–23.

68 G. Curtis, op. cit., p. 623.

69 Ford M. Hueffer, *Ford Madox Brown: A Record of His Life and Work*, London, Longmans, 1896, p. 191.

70 Ibid., p.190.

71 G. Curtis, op. cit., p. 631.

72 Brown searched for Irish models for *Work*, see Hueffer, op. cit., p. 168, and the entry for 16 March 1857 in *The Diaries of Ford Madox Brown*, ed. V. Surtees, New Haven and London, Yale University Press, 1981, p. 194.

73 Sheridan Gilley, 'English Attitudes to the Irish in England, 1780–1900' in Holmes (1978), op. cit., p. 88.

74 See Homi K. Bhabha, *The Location of Culture*, London and New York, Routledge, 1994, p. 78.

75 Hueffer, op. cit., p. 194: Brown tells us that the Irishman who modelled for the father was shown the finished painting and commented on the orange-girl episode, 'his mouth quivering at the reminiscence, he said, "That, Sir, I know to be true"' (Brown's emphasis).

76 Henry Mayhew, *London Labour and the London Poor*, John D. Rosenberg (Introduction), vol. 1, New York, Dover Publications, 1968, p. 104.

77 Boime (1981), op. cit., pp. 120, 124. The Mayhew illustration appears in Mayhew, op. cit., vol. 1, p. 97.

78 Hueffer, op. cit., p. 168.

79 I am grateful here to notes made by Susan Casteras in the file on this painting in the Yale Center for British Art. The painting was exhibited at the Hogarth Club, London, 1860, see Deborah Cherry, 'The Hogarth Club', *The Burlington Magazine*, April 1980, p. 242.

80 Susan Casteras, Yale Center for British Art, op. cit. For sale to Plint see Hueffer, op. cit., p. 439.

81 G. Curtis (1992), op. cit., p. 634.

82 Ibid., p. 633.

83 Ibid., p. 634; Brown purchased such a hat for a model in the painting on 18 March 1857, Surtees, op. cit., pp. 194–6.

84 *Punch*, XI, 1846, p. 245; see Weimer, op. cit., pp. 642–3; see also L. P. Curtis (1971), op. cit., p. 31.

85 See Morris, op. cit., pp. 258–60, for other suggestions on the derivation of this character.

86 Hueffer, op. cit., p. 193.

87 Ibid., p. 191.

88 *Charterism* is reprinted in full in *Thomas Carlyle: Selected Writings*, ed. Alan Shelston, Harmondsworth, Penguin, 1971, p. 171.

89 Ibid.

90 *Latter-Day Pamphlets, No. 3, Downing Street* in Carlyle, op. cit., p. 301.

91 *Past and Present*, Book Three, chapter 2, 'Gospel of Marmion', Carlyle, op. cit., pp. 279–80.

92 F. Cummings and A. Staley, *Romantic Art in Britain: Paintings and Drawings, 1760–1860*, Detroit and Philadelphia, 1968, no. 204, pp. 288–9; Julian Treuherz, *Hard Times: Social Realism in Victorian Art*, Manchester City Art Galleries, 1987, p. 28, and his *Victorian Painting*, London, Thames & Hudson, 1993, pp. 39–40.

93 Lindsay Errington, *Social and Religious Themes in English Art, 1840–1860*, New York and London, Garland Publishing, 1984, pp. 183–7.

94 Ibid., quoted p. 184.

95 See A. I. Grieve, *The Art of Dante Gabriel Rossetti, 2, The Pre-Raphaelite Modern-Life Subject*, Norwich, 1976, pp. 21–2; Susan Casteras, '"Oh! Emigration! thou'rt the curse . . .", Victorian Images of Emigration Themes', *Journal of Pre-Raphaelite Studies*, 1985, pp. 1–19; Treuherz (1987), op. cit., pp. 10, 18–20, and Errington (1984), op. cit., chapter 5. Irish commentators have frequently used some of the images here discussed (for example, Watts and Deverell), but rarely do they investigate the actual visual language used; a recent culprit is Peter Gray, *The Irish Famine*, London, Thames & Hudson, 1995.

96 F. M. Brown, *The Exhibition of WORK, and other Paintings, by Ford Madox Brown*, 191 Piccadilly, London, 1865, p. 9, quoted in Arts Council of Great Britain, *Great Victorian Pictures: Their Path to Fame*, London, 1978, p. 26. The painting is in Birmingham Museum and Art Gallery.

97 Mary Lutyens, 'Walter Howell Deverell (1827–1854)', *Pre-Raphaelite Papers*, ed. L. Parris, London, Tate Gallery/Allen Lane, 1984, pp. 90–1; see also Tate Gallery, *The Pre-Raphaelites*, London, 1984, no. 53, pp. 112–14.

98 Quoted by M. Lutyens in Parris, op. cit., p. 89; pages from the artist's journal are included in an unpublished memoir by F. Deverell and W. M. Rossetti (1899) in the Henry E. Huntington Library at San Marino, California.

99 Carlyle, op. cit., p. 280.

100 Ibid., p. 301.

101 Quoted in Tate Gallery, op. cit., p. 112, from W. Holman-Hunt's *Pre-Raphaelitism and the Pre-Raphaelite Brotherhood*, 2 vols., 1905, vol. 1, p. 197.

102 Christiana Payne, *Toil and Plenty: Images of the Agricultural Landscape in England, 1780–1890*, New Haven and London, Yale University Press, 1993, p. 45.

103 Quoted in Terence Brown, 'Saxon and Celt: The Stereotypes' in *Ireland's Literature: Selected Essays*, Mullingar, The Lilliput Press, and Totowa, NJ, Barnes and Noble Books, 1988, p. 7. For the complete texts see Matthew Arnold, *Lectures and Essays in Criticism*, ed. R. H. Super, Ann Arbor, The University of Michigan Press, 1962, pp. 291–386.

104 Linda Nochlin, *Realism*, Harmondsworth, Penguin Books, 1971, p.130.

105 Arts Council of Great Britain, *Gustave Courbet, 1819–1877*, 1978, p. 254. The letter is dated to autumn 1854.

106 Ibid., p. 274.

107 Linda Nochlin in Sarah Faunce and Linda Nochlin (eds.), *Courbet Reconsidered*, New Haven and London, Brooklyn Museum and Yale University Press, 1989, p. 27.

108 Arts Council of Great Britain (1978), op. cit., p. 266.

109 Klaus Herding, *Courbet: To Venture Independence*, New Haven and London, Yale University Press, 1991, pp. 55–61.

110 Faunce and Nochlin, op. cit., p. 27.

111 Ibid., p. 26.

112 Ibid., p. 28.

113 Roger Swift, 'The Outcast Irish in the Victorian City: Problems and Perspectives', *Irish Historical Studies*, XXV, no. 99, May 1987, p. 274.

114 Various Courbet scholars have doubted whether the artist actually ever visited London, see Arts Council of Great Britain (1978), op. cit., p. 256, and Jack Lindsay, *Gustave Courbet: His Life and Art*, Bath, Adams and Dart, 1973, pp. 129–30.

115 Arts Council of Great Britain (1978), op. cit., pp. 260–5.

116 See Patricia Mainardi, *Art and the Second Empire: The Universal Expositions of 1855 and 1867*, New Haven and London, Yale University Press, 1987, p. 57–61.

117 Hélène Toussaint has suggested that Courbet probably never saw Garibaldi but may have met Mazzini in Paris in 1848, Arts Council of Great Britain (1978), op. cit., p. 263. Appalled by the Famine, Mazzini wrote extensively on Ireland, see Nicholas Mansergh, *The Irish Question, 1840–1921*, London, George Allen & Unwin Ltd., 1965, pp. 75–82.

118 See also Herding, op. cit., pp. 46–7, and James Henry Rubin, *Realism and Social Vision in Courbet and Proudhon*, Princeton University Press, 1980, p. 42.

119 Arts Council of Great Britain (1978), op. cit., pp. 254, 256, 262.

120 Kevin B. Nowlan, *The Politics of Repeal: A Study in the Relations between Great Britain and Ireland, 1841–50*, London, Routledge & Kegan Paul, 1965, p. 191; for an account of the Irish delegations see pp. 182–92.

121 Ibid., p. 189.

122 See Richard Davis, *The Young Ireland Movement*, Dublin, Gill & Macmillan, 1987, p. 152.

123 Nowlan, op. cit., p. 191.

124 Quoted in T. J. Clark, *Image of the People: Gustave Courbet and the Second Republic 1848–1851*, London, Thames and Hudson, 1973, p. 47. This comment was not made until 1871 and has been interpreted by Clark as an attempt by Courbet to prove his revolutionary credentials in the middle of the Commune. Clark goes on to say that there is no trace of Courbet's activity in the clubs. See also Linda Nochlin, *Gustave Courbet: A Study of Style and Society*, New York and London, Garland Publishing Inc., 1976, pp. 82–4.

125 Lawrence Jennings, *France and Europe in 1848: A Study of French Foreign Affairs in Time of Crisis*, Oxford, Clarendon Press, 1973, p. 80.

126 Rubin, op. cit., pp. 40–1.

127 Ibid., p. 41. Proudhon is also included in the painting, third from the left of the group of men on the right of the painting (Fig. 65), see Arts Council of Great Britain (1978), op. cit., pp. 254, 276.

128 Rubin, op. cit., p. 43.

129 Jean Hawkes (trans.), *The London Journal of Flora Tristan: The Aristocracy and the Working Class of England*, London, Virago, 1982, p. 157. For discussion of the Irish in the parish of St Giles in the Fields see Lynn Hollen Lees, *Exiles of Erin: Irish Migrants in Victorian London*, Manchester University Press, 1979, *passim*. See also Lindsay (1973), op. cit., p. 129.

130 Rubin, op. cit., p. 144, n. 6. Nochlin has drawn parallels between Tristan's description of the 'fall and desecration' of a beautiful Irishwoman in a London brothel and Courbet's *The Young Ladies on the Banks of the Seine (Summer)*, a painting of 1856–7 (Musée du Petit Palais, Paris), see Faunce and Nochlin, op. cit., pp. 34–5.

131 Rubin, op. cit., p. 44. Knowledge of Carlyle in progressive French circles is discussed in a number of essays in John Clubbe (ed.), *Carlyle and his Contemporaries: Essays in Honor of Charles Richard Sanders*, Durham, NC, Duke University Press, 1976, see especially the comments of K. J. Fielding and Frederick W. Hilles, pp. 35–59 and 74–90.

132 Faunce and Nochlin, op. cit., p. 28.

133 Loftus, op. cit., pp. 52–64. For Waldré see chapter 2 above. See also Innes, op. cit., chapter 1.

134 See David Blaney Brown, *Ashmolean Museum, Oxford. Catalogue of the Collection of Drawings, 4: The Earlier British Drawings: British Artists and Foreigners Working in Britain Born Before 1775*, Oxford University Press, 1982, p. 188; see also Pressly (1981), op. cit., pp. 175–9, 251–2.

135 See Laurence Brown, *A Catalogue of British Historic Medals, 1760–1960, Vol. 1: The Accession of George III to the Death of William IV*, London, 1980, p. 128, no. 523.

136 Stephens and George, op. cit., no. 9529.

137 Faunce and Nochlin, op. cit., pp. 162–3. Courbet produced at least three other versions of

the portrait. For Hiffernan see Richard Dorment and Margaret F. Macdonald, *James McNeill Whistler*, London, Tate Gallery, 1994, pp. 74–84.

138 Kenneth McConkey, *Sir John Lavery*, Edinburgh, Canongate Press, 1993, p. 149.

139 Ibid., p. 164, and McConkey (1990), op. cit., pp. 54–7.

140 For the portrait of Lady Lavery, owned by the Central Bank of Ireland, Dublin, see McConkey (1993), op. cit., pp. 164–5. See also Virginia Hewitt, *Beauty and the Banknote: Images of Women on Paper Money*, London, British Museum Press, 1994, p. 60.

141 Loftus, op. cit., p. 59.

142 Dorment and Macdonald, op. cit., pp. 76–83, and Fintan Cullen and William M. Murphy, *The Drawings of John Butler Yeats (1839–1922)*, Albany Institute of History and Art, 1987, pp. 27–8, see also Elizabeth Prettejohn, 'Locked in the Myth', *Art History*, 19, no. 2, June 1996, pp. 301–7.

143 Ibid., nos. 10, 19 and 22.

144 Ibid., p. 28; see Griselda Pollock and Deborah Cherry, 'Woman as Sign in Pre-Raphaelite Literature: A Study of the Representation of Elizabeth Siddall', *Art History*, 7, no. 2, June 1984, pp. 206–77; see also Pollock's revision of the article in *Vision and Difference. Feminity, feminism and histories of art*, London and New York, Routledge, 1988, pp. 91–114.

145 Cullen and Murphy, op. cit., pp. 19 and 82. Lily and Lollie Yeats have been the subject of recent scholarship, Gifford Lewis, *The Yeats Sisters and Cuala Press*, Dublin, Irish Academic Press, 1994, and Joan Hardwick, *The Yeats Sisters: A Biography of Susan and Elizabeth Yeats*, London, Pandora, 1996.

146 Faunce and Nochlin, op. cit., p. 28.

5 PAINTING THE MODERN

1 John Butler Yeats to William Butler Yeats, quoted in Joseph Hone (ed.), *J. B. Yeats: Letters to his Son W. B. Yeats and Others*, New York, E. P. Dutton, 1946, p. 57. See also Cullen and Murphy, op. cit., pp. 26–29.

2 John Butler Yeats's portraits of participants of the Irish Literary Revival (W. B. Yeats, George Moore, J. M. Synge, et al) have been seen as part of a nationalist agenda (see James White, *John Butler Yeats and the Irish Renaissance*, Dublin, Dolmen, 1972), but Yeats saw the original commission from Hugh Lane as, in effect, a stylistic 'competition' with Orpen, see Cullen and Murphy, op. cit., p. 29.

3 These artists have been well researched, see Julian Campbell, *Nathaniel Hone, 1831–1917*, Dublin, National Gallery of Ireland, 1991; Jeanne Sheehy, *Walter Osborne*, Dublin, National Gallery of Ireland, 1983; Roy Johnston, *Roderic O'Conor 1860–1940*, London and Belfast, Barbican Art Gallery and the Ulster Museum, 1985; Julian Campbell, *Frank O'Meara and his Contemporaries*, Dublin, The Hugh Lane Municipal Gallery of Modern Art, 1989, and

McConkey (1993). For general histories see Julian Campbell, *The Irish Impressionists: Irish Artists in France and Belgium, 1850–1914*, Dublin, National Gallery of Ireland, 1984, also McConkey (1990), op. cit., and Fallon, op. cit.

4 Campbell, op. cit.

5 Fallon, op. cit., p. 54.

6 Some of these ideas first appeared in a review article, Fintan Cullen, 'Still a Long Way to Go: Recent Irish Art History', *Art History*, 15, no. 3, September 1992, pp. 378–83; see also Ciarán Benson, 'Modernism and Ireland's Selves', *Circa*, no. 61, January/February 1992, pp. 18–23.

7 This has been the norm in recent Irish art history, see S. B. Kennedy, *Irish Art and Modernism, 1880–1950*, Belfast, the Institute of Irish Studies at Queen's University of Belfast, 1991, and Bruce Arnold, *Mainie Jellett and the Modern Movement in Ireland*, New Haven and London, Yale University Press, 1991.

8 A welcome change to this approach are such studies as Kenneth E. Silver, *Esprit de Corps: The Art of the Parisian Avant-Garde and the First World War, 1914–1925*, Princeton University Press, 1989; Romy Golan, *Modernity & Nostalgia: Art and Politics in France between the Wars*, New Haven and London, Yale University Press, 1995, and Briony Fer et al, *Realism, Rationalism, Surrealism: Art between the Wars*, New Haven and London, Yale University Press, 1993.

9 S. B. Kennedy, op. cit.

10 Ibid., p. 87.

11 Ibid., opp. 180 and 205.

12 Albert Gleizes and Jean Metzinger, *Du Cubisme*, 1912, quoted in Charles Harrison and Paul Wood (eds.), *Art in Theory, 1900–1990: An Anthology of Changing Ideas*, Oxford, Blackwell, 1992, p. 195. See also Jellett, op. cit.

13 McConkey (1990), op. cit., p. 77.

14 The literature on Keating is sparse, see S. B. Kennedy, op. cit., *passim*; Royal Hibernian Academy of Arts, *Seán Keating, PRHA, 1889–1977*, Dublin, 1989, and Touring Exhibition Service, *Seán Keating and the ESB*, Dublin, n.d. For MacGonigal see Katherine Crouan, *Maurice MacGonigal, RHA, 1900–1979*, Dublin, Hugh Lane Municipal Gallery of Modern Art, 1991.

15 Eagleton, op. cit., p. 300. See also Terence Brown, *Ireland: A Social and Cultural History, 1922–79*, London, Fontana, 1981, chapter 4, and Brown in Deane (1991), op. cit., vol. 2, pp. 517–19.

16 Arnold, op. cit., vii, p. 82.

17 Bruce Arnold, 'Mainie Jellett and Modernism', *Irish Women Artists*, Dublin, National Gallery of Ireland and the Douglas Hyde Gallery, 1987, pp. 30, 33.

18 Arnold (1991), op. cit., p. 80. See also the Irish Museum of Modern Art, *Mainie Jellett*, Dublin, 1991, p. 65, no. 63.

19 Ibid., p. 99, *The Irish Statesman*, 15 January 1927.

20 George Russell, editorial, *The Irish Statesman*, 29 December 1928, reprinted in Deane (1991), op. cit., vol. 3, pp. 94–5.

21 Ibid.

22 For the Shannon Scheme see Maurice Manning and Moore McDowell, *Electricity Supply in Ireland: The History of the ESB*, Dublin, Gill & Macmillan, 1984, chapters 2 and 3.

23 George Russell, quoted in Deane (1991), op. cit., p. 94.

24 Quoted in John Turpin, 'Irish History Painting', *The GPA Irish Arts Review Yearbook*, 1989–1990, p. 243, who is quoting from 'The Problem Picture: End of the Stage Irishman', *The Irish Times*, 6 May 1929.

25 Catherine Nash, '"Embodying the Nation" – The West of Ireland Landscape and Irish Identity' in Barbara O'Connor and Michael Cronin (eds.), *Tourism in Ireland: A Critical Analysis*, Cork University Press, 1993, p. 104. Appropriately, Nash goes on to quote from George Russell writing about a contemporary need for health and beauty. See also Nash's Ph.D. dissertation, 'Landscape, Body and Nation: Cultural Geographies of Irish Identities', University of Nottingham, 1995, chapter 2.

26 Quoted in Turpin (1989–90), op. cit., p. 243, who is quoting Hugh Butler, 'Ireland's Industrial Renaissance', *The Sphere*, 9 May 1931.

27 Gibbons in Deane (1991), op. cit., vol. 2, pp. 952–3.

28 Terence Brown in Deane (1991), vol. 3, p. 92.

29 Ibid., pp. 92–3.

30 Ibid., p. 93, from 'The Dilemma of Irish Letters', *The Month*, 2, no. 6, 1949, p. 375.

31 Mark Antliff, *Inventing Bergson: Cultural Politics and the Parisian Avant-Garde*, Princeton University Press, 1993, chapter 4: 'The Body of the Nation: Cubism's Celtic Nationalism'.

32 Ibid., p. 127.

33 Quoted by Arnold (1991), op. cit., p. 101; lecture given in January 1927.

34 Ibid., p. 135; lecture of 1932.

35 S. B. Kennedy, op. cit., p. 180. The academic lineage Keating is referring to began with the French neoclassicist, Ingres, who taught Alphonse Legros who taught Henry Tonks, ibid., p. 365, n. 62.

36 Benson, op. cit., p. 22.

37 Brown in Deane (1991), op. cit., vol. 2, p. 90.

38 For the two paintings see S. B. Kennedy, op. cit., pp. 310–11; Hugh Lane Municipal Gallery of Modern Art, *Images and Insights*, Dublin, 1993, pp. 102–3, and Crawford Municipal Art Gallery, *Irish Art, 1770–1995: History and Society*, Cork, 1995, pp. 34–5.

39 Denis Johnston, *The Moon in the Yellow River*, with a Foreword by C. P. Curran, London, Jonathan Cape, 1949.

40 Thomas Kilroy, '*The Moon in the Yellow River*: Denis Johnston's Shavianism' in Joseph Ronsley (ed.), *Denis Johnston: A Retrospective*, Gerrards Cross, Colin Smythe, 1981, p. 52.

41 Thomas Craven, *Modern Art: The Men, the Movements, the Meaning*, New York, Simon & Schuster, 1934, p. 260, quoted by Jonathan Harris in Paul Wood et al, *Modernism in Dispute: Art Since the Forties*, New Haven and London, Yale University Press, 1993, p. 8.

42 Holger Cahill, *New Horizons in American Art*, New York, Museum of Modern Art, 1936, quoted in Wood, op. cit., p. 16.

43 Quoted by Kilroy in Ronsley, op. cit., p. 50; Hogan's essay was in *Envoy*, 3, no. 9, August 1950, p. 46.

44 Kilroy in Ronsley, op. cit., p. 50.

45 Turpin (1995), op. cit., chapter 19.

46 For this discussion of allegory I have been influenced by Linda Nochlin's analysis of the topic in Faunce and Nochlin, op. cit., pp. 21–9; Nochlin in turn has been influenced by Angus Fletcher, Walter Benjamin and Terry Eagleton.

47 Ibid., pp. 26–29.

48 For recent debates on the use of allegory in the Irish context see Lloyd (1993), pp. 125–62; Gibbons (1996), chapter 11, and a rebuttal of both by Kevin Barry, 'Critical Notes on Post-Colonial Aesthetics', *Irish Studies Review*, 14, Spring 1996, pp. 2–11.

49 Touring Exhibitions Service, *Seán Keating and the ESB*, Department of the Taoiseach, Dublin, n.d., and S. B. Kennedy, op. cit., p. 180, and Fintan O'Toole, 'The Means of Production' in *Labour in Art*, Dublin, The Irish Museum of Modern Art, 1994, p. 8.

BIBLIOGRAPHY

MANUSCRIPTS

Biblioteca Civica, Bassano del Grappa, Veneto
MSS Canoviani, Epistolario Scelto II, 79, 1556

Trinity College Dublin
MS 1749 (1–6.24): Richard Mansergh St George, 'Account of the State of Affairs in and about Headford, County Galway'

Royal Irish Academy, Dublin
MS 24K14, Anonymous Diary

National Library of Scotland, Edinburgh
Wilkie letters, MSS 3812; 9836; 10995/29–30

University of Glasgow, Mitchell Library
Wilkie letters, MS 308895

British Library, London
Wellesley Mss

Private Collection
Surrey, MS Letter by Richard Mansergh St George, 1790s

PRINTED PRIMARY SOURCES

Arnold, Matthew, *Lectures and Essays in Criticism*, ed. R. H. Super, Ann Arbor, University of Michigan Press, 1962

Banim, John and Michael, *Tales of the O'Hara family: Crohoore of the Bill-Hook, The Fetches, John Doe*, 3 vols., with an Introduction by Robert Lee Wolff, New York and London, Garland, 1978

Barry, James, *The Works of James Barry, Esq., Historical Painter*, 2 vols., London, Cadell & Davies, 1809

Bell, Mrs G. H., *The Hamwood Papers of The Ladies of Llangollen and Caroline Hamilton*, London, Macmillan, 1930

The Diaries of Ford Madox Brown, ed. V. Surtees, New Haven and London, Yale University Press, 1981

Burke, Edmund, *A Philosophic Enquiry into the Origin of our Ideas of the Sublime and Beautiful*, ed. James T. Boulton, Oxford, Basil Blackwell, 1987

Carlyle, Thomas, *Thomas Carlyle: Selected Writings*, ed. Alan Shelston, Harmondsworth, Penguin, 1971

Catalogue of the Third Concluding Exhibition of National Portraits, London, South Kensington Museum, 1868

Cunningham, Allan, *The Life of Sir David Wilkie*, 3 vols., London, Murray, 1843

Davis, Thomas, *Prose Writings of Thomas Davis*, ed. T. W. Rolleston, London, Walter Scott, n.d.

Deane, Seamus (gen. ed.), *The Field Day Anthology of Irish Writing*, 3 vols., Derry, Field Day Publications, 1991

Derricke, John, *The Image of Irlande with a Discouerie of Woodkarne*, ed. John Small, Edinburgh, Adam & Charles Black, 1883

Dublin Exhibition of Arts, Industries and Manufactures, Dublin, 1872

Fortesque MSS, Historical Manuscripts Commission, London, 1892–1927

Frazer, Sir James George (ed.), *Publii Ovidii Nasonis. Fastorum Libri Sex (The Fasti of Ovid)*, 5 vols., London, Macmillam, 1929

Gandon, Jr., James, and T. J. Mulvany, *The Life of James Gandon, Esq.*, Dublin, 1846

Gilbert, J. T., *A History of the City of Dublin*, 3 vols., Dublin, James Duffy, 1861

Godwin, William, *Things as they Are or the Adventures of Caleb Williams*, ed. Maurice Hindle, London, Penguin, 1988

Grattan, H., *The Speeches of the Right Honourable Henry Grattan in the Irish and Imperial Parliament*, London, Longmans, Hurst and Co., 1822

Hueffer, Ford M., *Ford Madox Brown: A Record of His Life and Work*, London, Longmans, 1896

Ingram, Edward (ed.), *Two Views of British India: The Private Correspondence of Mr Dundas and Lord Wellesley, 1798–1801*, Bath, Adams and Dart, 1970

Jellett, Mainie, 'An Approach to Painting' in *Irish Art Handbook*, Dublin, 1943

Johnston, Denis, *The Moon in the Yellow River*, with a Foreword by C. P. Curran, London, Jonathan Cape, 1949

Knighton, Sir William, *Memoirs of Sir William Knighton, Bart., G.C.H.*, 2 vols., London, R. Bentley, 1838

MacNevin, T., *The History of the Volunteers*, Dublin, James Duffy, 1845

Mahony, Francis (Sylvester), *The Reliques of Father Prout*, London, Bell & Daldy, 1873

Maturin, Charles Robert, *Melmoth, the Wanderer: A Tale*, ed. Douglas Grant, Oxford University Press, 1968

Mayhew, Henry, *London Labour and the London Poor*, with a new Introduction by John D. Rosenberg, vol. 1, New York, Dover Publications, 1968

Molyneux, William, *Case of Ireland being Bound by Acts of Parliament in England Stated*, Intoduction by J. G. Simms, Dublin, Cadenus Press, 1977

Morgan, Lady, *The O'Briens and The O'Flahertys: A National Tale*, London, Pandora, 1988

Parliamentary Register, The, or History of the Proceedings and Debates of the House of Commons of Ireland 1781–1797, 17 vols., Dublin, 1782–1801

Pasquin, Anthony, *The Royal Academicians. A Farce*, London, 1786

————— *An Authentic History of the Professors of Painting, Sculpture, and Architecture in Ireland; Memoirs of the Royal Academicians*, facsimile reprint; ed. R. W. Lightbown, London, Cornmarket Press Ltd., 1970

Roche, Regina Maria, *The Children of the Abbey*, London, George Virtue, 1836

Scott, Sir Walter, *Waverley, or 'Tis Sixty Years Since*, ed. Claire Lamont, Oxford University Press, 1981

Seward, Anna, *Letters of Anna Seward Written between the Years 1784 and 1807*, 6 vols., Edinburgh, Constable, 1811

Shee, Martin Archer, *Rhymes on Art, or, The Remonstrance of a Painter*, London, Murray, 1805

Shee, Martin Archer, *The Life of Sir Martin Archer Shee*, 2 vols., London, Longmans, 1860

Stephens, F. G., and M. Dorothy George, *Catalogue of Political and Personal Satires Preserved in the Department of Prints and Drawings in the British Museum*, 12 vols., London, 1870–1954

Strickland, Walter, *A Dictionary of Irish Artists*, 2 vols., Dublin and London, Maunsel & Co., Ltd., 1913

Surtees, V. (ed.), *The Diaries of Ford Madox Brown*, New Haven and London, Yale University Press, 1981

Walpole, Horace, *The Castle of Otranto*, London, 1764

Weinglass, David H. (ed.), *The Collected English Letters of Henry Fuseli*, Millwood, NY, London and Nendeln, Liechtenstein, Krauss International Publications, 1982

PRINTED SECONDARY SOURCES

Abrams, Ann Uhry, *The Valiant Hero: Benjamin West and the Grand-Style of History of Painting*, Washington, D.C., Smithsonian Institute Press, 1985

Anderson, Benedict, *Imagined Communities, Reflections on the Origins and Spread of Nationalism*, London, Verso, 1983

Andrew, Patricia, R., 'Jacob More's "Falls of Clyde paintings"', *The Burlington Magazine*, 129, February 1987, pp. 84–8

Antliff, Mark, *Inventing Bergson: Cultural Politics and the Parisian Avant-Garde*, Princeton University Press, 1993

Arnold, Bruce, *Mainie Jellett and the Modern Movement in Ireland*, New Haven and London, Yale University Press, 1991

Arts Council of Great Britain, *Daniel Maclise, 1806–1870*, London, 1972

———— *Gustave Courbet, 1819–1877*, London, 1978

Bartley, J. O., *Teague, Shenkin and Sawney: Being an Historical Study of the Earliest Irish, Welsh and Scottish Characters in English Plays*, Cork University Press, 1954

Barrell, John, *The Dark Side of the Landscape: The Rural Poor in English Painting, 1730–1840*, Cambridge University Press, 1980

———— *The Political Theory of Painting from Reynolds to Hazlitt: 'The Body of the Public'*, New Haven and London, Yale University Press, 1986

Benson, Ciarán, 'Modernism and Ireland's Selves', *Circa*, 61, January/February 1992, pp. 18–23

Bhabha, Homi K., *Nation and Narration*, London and New York, Routledge, 1990

———— *The Location of Culture*, London and New York, Routledge, 1994

Blakey, Dorothy, *The Minerva Press, 1790–1820*, Oxford University Press, 1939

Boime, Albert, 'Ford Madox Brown, Thomas Carlyle and Karl Marx: Meaning and Mystification of Work in the Nineteenth Century', *Arts Magazine*, September 1981, pp. 116–23

Bradshaw, B., A. Hadfield and W. Maley (eds.), *Representing Ireland: Literature and the Origins of Conflict, 1534–1600*, Cambridge University Press, 1993

Brady, Ciaran (ed.), *Ideology and the Historians*, Dublin, The Lilliput Press, 1991

Campbell, Julian, *Nathaniel Hone, 1831–1917*, Dublin, National Gallery of Ireland, 1991

Casteras, Susan, '"Oh! Emigration! thou'rt the curse . . .", Victorian Images of Emigration Themes', *Journal of Pre-Raphaelite Studies*, 1985, pp. 1–19

Chiego, William J. (ed.), *Sir David Wilkie of Scotland (1785–1841)*, Raleigh, North Carolina Museum of Art, 1987

Clark, Samuel, and James S. Donnelly (eds.), *Irish Peasants, Violence and Political Unrest, 1780–1914*, The Manchester University Press, 1983

Clark, T. J., *Image of the People: Gustave Courbet and the Second French Republic, 1848–1851*, London, Thames & Hudson, 1973

Colley, Linda, *Britons: Forging the Nation, 1707–1837*, New Haven and London, Yale University Press, 1992

Cresswell, D. H., *The American Revolution in Drawings and Prints: A Checklist of 1765–1790, Graphics in the Library of Congress*, Washington, D.C., Library of Congress, 1975

Crookshank, Anne, and the Knight of Glin, *Irish Portraits, 1660–1860*, London, Paul Mellon Centre for Studies in British Art, 1969

———— *The Painters of Ireland, c.1660–1920*, London, Barrie & Jenkins, 1978

———— *The Watercolours of Ireland, Works on Paper in Pencil, Pastel and Paint, c.1660–1914*, London, Barrie & Jenkins, 1994

Cullen, Fintan, 'Hugh Douglas Hamilton: "painter of the heart" ', *The Burlington Magazine*, CXXV, July 1983, pp. 417–21

———— 'The Oil Paintings of Hugh Douglas Hamilton', *Walpole Society*, L, 1984, pp. 165–208

———— and William M. Murphy, *The Drawings of John Butler Yeats (1839–1922)*, Albany Institute of History and Art, 1987

———— 'Still a Long Way To Go: Recent Irish Art History', *Art History*, 15, no. 3, September 1992, pp. 378–83

———— 'The Art of Assimilation: Scotland and its Heroes', *Art History*, 16, no. 4, December 1993, pp. 600–18

———— 'Visual Politics in 1780s Ireland: The Roles of History Painting', *Oxford Art Journal*, 18, no. 1, 1995, pp. 58–73

Curtis, Gerard, 'Ford Madox Brown's Work: An Iconographic Analysis', *Art Bulletin*, CXXIV, no. 4, December 1992, pp. 623–36

Curtis, L. Perry, Jr., *Anglo-Saxons and Celts: A Study of Anti-Irish Prejudice in Victorian England*, Bridgeport, CT, Conference on British Studies, 1968

———— *Apes and Angels: The Irishman in Victorian Caricature*, Newton Abbot, David & Charles, 1971

Dalsimer, Adele M. (ed.), *Visualizing Ireland: National Identity and the Pictorial Tradition*, Boston and London, Faber & Faber, 1993

Deane, Seamus, *A Short History of Irish Literature*, London, Hutchinson, 1986

Dorment, Richard, and Margaret F. Macdonald, *James McNeill Whistler*, London, Tate Gallery, 1994

Duggan, G. C., *The Stage Irishman: A History of the Irish Play and Stage Characters from the Earliest Times*, London, Longmans, Green & Co., 1937

Dunne, Tom (ed.), *The Writer as Witness: Literature as Historical Evidence*, Cork University Press, 1987

Eagleton, Terry, *Heathcliff and the Great Hunger: Studies in Irish Culture*, London and New York, Verso, 1995

Errington, Lindsay, *Work in Progress. Sir David Wilkie: Drawings into Paintings*, Edinburgh, National Gallery of Scotland, 1975

———— *Social and Religious Themes in English Art, 1840–1860*, New York and London, Garland Publishing, 1984

———— *Tribute to Wilkie*, Edinburgh, National Gallery of Scotland, 1985

Fallon, Brian, *Irish Art, 1830–1990*, Belfast, Appletree Press, 1994

Faunce, Sarah, and Linda Nochlin (eds.), *Courbet Reconsidered*, New Haven and London, Brooklyn Museum and Yale University Press, 1989

FitzGerald, Desmond, 'A History of the Interior of Stowe', *Apollo*, 97, June 1973, pp. 572–85

Flanagan, Thomas, *The Irish Novelists, 1800–1850*, New York, Columbia University Press, 1959

Foster, R. F., *Modern Ireland, 1600–1972*, London, Allen Lane, 1988

———— 'Protestant Magic: W. B. Yeats and the Spell of Irish History', *Proceedings of the British Academy*, LXXV, 1989, pp. 243–66

———— *Paddy and Mr Punch: Connections in Irish and English History*, London, Allen Lane, 1993

Freud, Sigmund, 'Mourning and Melancholy' in James Strachey (gen. ed.), *The Standard Edition of the Complete Psychological Works of Sigmund Freud*, vol. 14, London, Hogarth Press, 1957

Galloway, Peter, *The Most Illustrious Order of St Patrick*, Chicester, Phillimore, 1983

Gibbons, Luke, 'Race Against Time: Racial Discourse and Irish History', *Oxford Literary Review*, 13, nos. 1–2, 1991, pp. 95–117

———— *Transformations in Irish Culture*, Cork University Press, 1996

Gillespie, Raymond, andBrian P. Kennedy (eds.), *Ireland: Art into History*, Dublin, Town House, 1994

Gilmartin, John, 'Vincent Waldré's Ceiling Paintings in Dublin Castle', *Apollo*, 95, January 1972, pp. 42–7

Hamlyn, Robin, *Robert Vernon's Gift: British Art for the Nation, 1847*, London, Tate Gallery, 1993

Hauptman, William, *The Persistence of Melancholy in Nineteenth-Century Art: The Iconography of a Motif*, 2 vols., Ann Arbor, University Microfilms, 1975

Hayes-McCoy, G. A., *A History of Irish Flags from Earliest Times*, Dublin, Academy Press, 1979

Heleniak, Katryn Moore, *William Mulready*, New Haven and London, Yale University Press, 1980

Hemingway, Andrew, *Landscape Imagery and Urban Culture in Early Nineteenth-Century Britain*, Cambridge University Press, 1992

Herding, Klaus, *Courbet: To Venture Independence*, New Haven and London, Yale University Press, 1991

Hill, J. R., 'National Festivals, the State and "Protestant Ascendancy" in Ireland, 1790–1829', *Irish Historical Studies*, 24, May 1984, pp. 30–51

———— 'Popery and Protestantism, Civil and Religious Liberty: The Disputed Lessons of Irish History, 1690–1812', *Past and Present*, 118, February 1988, pp. 96–129

Hind, Arthur M., *Engraving in England in the Sixteenth and Seventeenth Centuries. Part I. The Tudor Period*, Cambridge University Press, 1952

Holmes, Colin ed., *Immigrants and Minorities in British Society*, London, George Allen & Unwin, 1978

Hutchinson, Sidney C., *The History of the Royal Academy, 1768–1986*, London, 1986

Innes, C. L., *Woman and Nation in Irish Literature and Society, 1880–1935*, Athens, GA, The University of Georgia Press, 1993

Kelly, James, *Prelude to Union: Anglo-Irish Politics in the 1780s*, Cork University Press, 1992

———— 'That Damn'd Thing Called Honour': Duelling in Ireland, 1570–1860, Cork University Press, 1995

Kennedy, S. B., *Irish Art and Modernism, 1880–1950*, Belfast, Institute of Irish Studies at The Queen's University of Belfast, 1991

Kiberd, Declan, *Anglo-Irish Attitudes*, Derry, A Field Day Pamphlet, no. 6, 1984

Kilfeather, Siobhán, 'Origins of the Irish Female Gothic', *Bullán: An Irish Studies Journal*, 1, no. 2, Autumn, 1994, pp. 35–45

Lebow, Richard Ned, *White Britain and Black Ireland: The Influence of Stereotypes on Colonial Policy*, Philadelphia, Institute for the Study of Human Issues, 1976

Leerssen, Joep Th., *Mere Irish and Fíor Ghael: Studies in the Idea of Irish Nationality, its Developments and Literary Expression Prior to the Nineteenth Century*, Amsterdam and Philadelphia, John Benjamin Publishing Co., 1986

Le Harivel, Adrian (ed.), *National Gallery of Ireland: Illustrated Summary Catalogue of Drawings, Watercolours and Miniatures*, Dublin, National Gallery of Ireland, 1983

Levey, Michael, *Sir Thomas Lawrence, 1769–1830*, London, National Portrait Gallery, 1979

Lindsay, Jack, *Gustave Courbet: His Life and Art*, Bath, Adams and Dart, 1973

Lloyd, David, *Nationalism and Minor Literature: James Clarence Mangan and the Emergence of Irish Cultural Nationalism*, Berkeley, University of California Press, 1987

––––––– *Anomalous States: Irish Writing and the Post-Colonial Moment*, Dublin, The Lilliput Press, 1993

Loftus, Belinda, *Mirrors: William III and Mother Ireland*, Dundrum, Co. Down, Picture Press, 1990

McConkey, Kenneth, *A Free Spirit: Irish Art, 1860–1960*, Woodbridge, Suffolk, Antique Collectors' Club, 1990

––––––– *Sir John Lavery*, Edinburgh, Canongate Press, 1993

MacDonagh, Oliver, *States of Mind: A Study of Anglo-Irish Conflict, 1780–1980*, London, George Allen & Unwin, 1983

––––––– and W. F. Mandle (eds.), *Ireland and Irish Australia: Studies in Cultural and Political History*, London, Croom Helm, 1986

––––––– *O'Connell: The Life of Daniel O'Connell, 1775–1847*, London, Weidenfeld & Nicolson, 1991

McDowell, R. B., *Ireland in the Age of Imperialism and Revolution, 1760–1801*, Oxford University Press, 1979

McParland, Edward, 'A Note on Waldré', *Apollo*, 96, November 1972, p. 467

Manning, Maurice and Moore McDowell, *Electricity Supply in Ireland: The History of the ESB*, Dublin, Gill & Macmillan, 1984

Mavor, Elizabeth, *The Ladies of Llangollen*, London, Michael Joseph, 1971

Miles, Ellen G., *The Portrait in Eighteenth-Century America*, London and Toronto, Associated University Presses, and University of Delaware Press, Newark, 1993

Millar, Oliver, *The Later Georgian Pictures in the Collection of Her Majesty The Queen*, London, Phaidon, 1969

Moody, T. W., and W. E. Vaughan (eds.), *A New History of Ireland, vol. 4, Eighteenth-Century Ireland, 1691–1800*, Oxford University Press, 1986

Morris, Frankie, *John Tenniel, Cartoonist: A Critical and Sociocultural Study in the Art of the Victorian Political Cartoon*, Ann Arbor, University Microfilms International, 1985

Nicolson, Benedict, *Joseph Wright of Derby: Painter of Light*, London, Routledge & Kegan Paul, 1968

Nochlin, Linda, *Realism*, Harmondsworth, Penguin, 1971

––––––– *The Politics of Vision: Essays in Nineteenth-Century Art and Society*, London, Thames & Hudson, 1991

Nowlan, Kevin B., *The Politics of Repeal: A Study in the Relations between Great Britain and Ireland, 1841–50*, London, Routledge & Kegan Paul, 1965

––––––– & Maurice R. O'Connell (eds.), *Daniel O'Connell: Portrait of a Radical*, Belfast, Appletree Press, 1984

Nussbaum, Felicity, and Laura Brown (eds.), *The New Eighteenth Century: Theory, Politics, English Literature*, New York and London, Methuen, 1987

O'Connell, Maurice R., *Irish Politics and Social Conflict in the Age of the American Revolution*, Philadelphia, University of Pennsylvania Press, 1965

——— (ed.), *Daniel O'Connell: Political Pioneer*, Dublin, Institute of Public Administration, 1991

O'Halloran, Clare, 'Irish Re-creations of the Gaelic Past: The Challenge of Macpherson's Ossian', *Past and Present*, 124, August 1989, pp. 69–95

Ó Tuathaigh, M. A. G., 'The Irish in Nineteenth-Century Britain: Problems of Integration', *Transactions of the Royal Historical Society*, Fifth Series, vol. 31, London, 1981, pp. 149–73

O'Sullivan, Patrick (ed.), *The Irish World Wide: History, Heritage, Identity*, vol. 3, *The Creative Migrant*, Leicester University Press, 1994

Pakenham, Thomas, *The Year of Liberty*, London, Hodder & Stoughton, 1969

Parris, L. (ed.), *Pre-Raphaelite Papers*, London, Tate Gallery/Allen Lane, 1984

Penny, Nicholas ed., *Reynolds*, London, Royal Academy of Arts and Weidenfeld & Nicolson, 1986

Pointon, Marcia, *Mulready*, London, Victoria and Albert Museum, 1986

——— *Hanging the Head: Portraiture and Social Formation in Eighteenth-Century England*, New Haven and London, Yale University Press, 1993

Powell, Cecilia, 'Turner and the Bandits: *Lake Albano* rediscovered', *Turner Studies*, 3, no. 2, Winter 1984, pp. 22–7

Pressly, William L., 'James Barry's "The Baptism of the King of Cashel by St Patrick"', *Burlington Magazine*, CXVIII, September 1976, pp. 643–6

——— *The Life and Art of James Barry*, New Haven and London, Yale University Press, 1981

——— *James Barry: The Artist as Hero*, London, Tate Gallery, 1983

Prown, Jules David, *John Singleton Copley*, 2 vols., Cambridge, Mass., Harvard University Press, 1966

Quinn, David Beers, *The Elizabethans and the Irish*, Ithaca, Cornell University Press, 1966

Robinson, Nicholas, 'Caricature and the Regency Crisis: An Irish Perspective', *Eighteenth-Century Ireland*, 1, 1986, pp. 157–76

Rockett, Kevin, Luke Gibbons and John Hill, *Cinema in Ireland*, London, Routledge, 1987

Ronsley, Joseph (ed.), *Denis Johnston: A Retrospective*, Gerrards Cross, Colin Smythe, 1981

Rubin, James Henry, *Realism and Social Vision in Courbet and Proudhon*, Princeton University Press, 1980

Said, Edward, *Orientalism*, New York, Vintage Books, 1979

Sheehy, Jeanne, *The Rediscovery of Ireland's Past: The Celtic Revival, 1830–1920*, London, Thames & Hudson, 1980

Smiles, Sam, *The Image of Antiquity: Ancient Britain and the Romantic Imagination*, New Haven and London, Yale University Press, 1994

Swift, R., and S. Gilley (eds.), *The Irish in Britain, 1815–1939*, London, Pinter Press, 1989

Tate Gallery, *The Pre-Raphaelites*, London, 1984

Treuhertz, Julian, *Hard Times: Social Realism in Victorian Art*, Manchester City Art Galleries, 1987

——— *Victorian Painting*, London, Thames & Hudson, 1993

Turpin, John, 'Irish History Painting', *The GPA Irish Arts Review Yearbook*, 1989–1990, pp. 233–47

——— *A School of Art in Dublin since the Eighteenth Century: A History of the National College of Art and Design*, Dublin, Gill & Macmillan, 1995

Vaughan, W. E. (ed.), *A New History of Ireland, Vol. 5: Ireland under the Union I, 1801–70*, Oxford University Press, 1989

von Erffa, Helmut, and Allan Staley, *The Paintings of Benjamin West*, New Haven and London, Yale University Press, 1986

Walker, Richard, *National Portrait Gallery: Regency Portraits*, 2 vols., London, National Portrait Gallery, 1985

Webster, Mary, *Francis Wheatley*, New Haven and London, Yale University Press, 1970

Weimer, Martin, *Das Bild der Iren und Irlands im Punch 1841–1921. Strukturanalyse des hibernistischen Heterostereotyps der englischen satirischen Zeitschrift dargestellt an Hand von Karikaturen und Texten*, Frankfurt am Main, Peter Lang, 1993

Whitley, William, *Artists and their Friends in England, 1700–1799*, 2 vols., London and New York, B. Blom, 1968

Wick, W. C., *George Washington: An American Icon*, Washington, D.C., National Portrait Gallery, 1982

Wind, Edgar, 'The Revolution of History Painting', *Journal of the Warburg and Courtauld Institutes*, 2, 1938–9, pp. 116–27

Wood, Paul, et al., *Modernism in Dispute: Art Since the Forties*, New Haven and London, Yale University Press, 1993

Zach, Wolfgang, and Heinz Kosok (eds.), *Literary Interrelations: Ireland, England and the World, Vol. 3: National Images and Stereotypes*, Tübingen, Gunter Narr Verlag, 1987

Unpublished Dissertations

Coleman, John, 'Images of Assurance or Masks of Uncertainty: Joshua Reynolds and the Anglo-Irish Ascendancy, 1746–1789', University of Dublin, M.Litt., 1993

Cullen, Fintan, 'A Kingdom United: Images of Political and Cultural Union in Ireland and Scotland, c. 1800', Yale University, Ph.D., 1992

de Valera, Anne, 'Antiquarian and Historical Investigations in Ireland in the Eighteenth Century', University College Dublin, M.A., 1978

Murray, Peter, 'George Petrie, 1789–1866', University of Dublin, M.Litt., 1980

Nash, Catherine, 'Landscape, Body and Nation: Cultural Geographies of Irish Identities', University of Nottingham, Ph.D., 1995

O'Halloran, Clare, 'Golden Ages and Barbarous Nations: Antiquarian Debate on the Celtic Past in Ireland and Scotland in the Eighteenth Century', University of Cambridge, Ph.D., 1991

Ó Muirithe, Donncha, 'The Portrayal of Ireland's People and Landscape in Illustrated Travel Books from the Act of Union to the Aftermath of the Great Famine', University of Dublin, M.Litt., 1993

Smyth, P. D. H., 'The Volunteer Movement in Ulster: Background and Development, 1745–1795', The Queen's University of Belfast, Ph.D., 1984

Turpin, John, 'The Life and Work of Daniel Maclise (1806–1870)', University of London, Ph.D., 1973

INDEX

Page numbers of illustrations and captions are given in italics

Names beginning with Mc are treated as Mac

Abbey Theatre, 171
Aberdeen, Lord, 95, 97
Abrams, Ann Uhry, 53
Accademia Clementina, Bologna, 33
Act of Settlement, 73, 79
Act of Union, 11, 119, 189n
 movement for repeal of, 90, 95,
 101, 151
agrarian disturbances, 87, 121, 124,
 125
American War of Independence *see*
 United States of America
Anderson, Benedict, 57, 86
Andrews, J. H., 15
Antliff, Mark, 170
Arnold, Bruce, 166
Arnold, Matthew
 On the Study of Celtic Literature, 146
Ashford, William, 16
 View of Dublin from Chapelizod,
 16–18, *17*, 41

bandit paintings, 122–4
Banim, John and Michael
 Tales by the O'Hara Family, 125–6,
 127
Banks, P. W., 44
Barrell, John
 The Dark Side of the Landscape,
 130
 The Political Theory of Painting, 31
Barret, George, 14

View of Powerscourt, 15, *15*, 18, 41
Barry, James, 20, 21, 22, 44–5, 50–1,
 172, 179n
 The Act of Union, *154*, 156
 admiration for Greek culture, 31,
 33, 36
 artistic preoccupations of, 27–8
 attacked by Fresnoy, 37
 *The Baptism of the King of Cashel
 by St Patrick*, 36, 71
 cycle of mural paintings, 31, 153
 *Elysium and Tartarus or the State
 of Final Retribution*, 31,
 36, 51
 The Distribution of Premiums, 27
 The Education of Achilles, 27–8, 29,
 37, 40
 iconography of Minerva, 28,
 29, 33–6, 40, 44
 themes of, 29–30, 31–2, 33, 40
 *Inquiry into the Real and Imaginary
 Obstructions to the Acquisition
 of the Arts in England*, 20,
 31, 40
 A Letter to the Dilettanti Society, 27,
 37–8
 and Ossian, 36–7
 and the Royal Academy, 26–7,
 30, 31, 32
 expelled from, 41
 Self-Portrait (1767), 33
 Self-Portrait (1803), 33

(Barry, *cont.*)
 and *The Torso Belvedere*, 32–3, 36,
 39
 see also history painting
Barrymore, Earl of, 89
Bartley, J. O., 9
Belfast, art collections in, 2–3
Bellamont, Earl of *see* Coote, Charles
Benson, Ciarán, 171
Bernard, John, 89
Bhabha, Homi
 The Location of Culture, 83
Bismarck, Otto von, 94
Blarney, Co. Cork, 39, 180n
Boothby, Sir Brooke, 109, 112, 191n
Braque, Georges, 171
Breen, T. H., 86
Brennan, Timothy, 57
British Institution, 122, 189n
British Museum, 42
Brown, Ford Madox, 5, 153, 172
 The Irish Girl, 139–40
 The Last of England, 144
 Work, 118, 136–9, *136*, *137*,
 140–2, 145, 146, 147
Brown, Terence, 169, 171
Buckingham, Marquis of *see*
 Nugent-Temple-Grenville,
 George
Burke, Edmund, 30, 184n, 192n
 *A Philosophic Enquiry into the Ori-
 gin of our Ideas of the Sublime
 and Beautiful*, 114
Burton, Frederick William, 181n,
 200n
Bute, Lord, 65
Butler, Eleanor, 109
Byron, Lord, 42

Camden, Earl, 17
Canning, George, 95
Canova, Antonio, 18–19
 tomb statuary of, 107, 195n
Carlyle, Thomas, 145, 146
 Charterism, 142
 Latter-Day Pamphlets, 142

Past and Present, 138, 142, 152
 representations of, *137*, 138, 142
cartoons *see* satires
Castle, Terry, 114
Catholic Association, 97
Catholic Emancipation, 43, 100,
 125, 192n
Catholic Relief Acts, 67
Catholics
 discrimination against, 7, 57,
 66–7
 see also Penal Laws
 disenfranchised, 65
 and Patrician tradition, 71
Celtic artefacts, discovery of, 71
Central Bank of Ireland, 205n
Champfleury *see* Courbet, Gustave
Charlemont, Earl of
 Knight of St Patrick, 69
 representations of, 72
Cholmondeley, Rev. Horace, 94, 95,
 97, 192n
church art, 33
Clark, T. J., 176n
Claude, Lorrain, influence of, 14,
 16, 17, 118, 130
Colley, Linda, 57
Collins, William, 131, 133, 193n
colonialism, 83, 84, 90
 Irish literature and, 2, 101, 116
 visual representation and, 7–8, 17,
 47–8, 50–1, 56, 106, 116,
 174
Coote, Charles, Earl of Bellamont,
 83, 84, 87, 89, 90
 duel with Lord Townshend, 88
 see also Reynolds, Joshua
Copley, John Singleton, 53, 62, 65,
 86, 87
 *The Collapse of the Earl of Chatham
 in the House of Lords*, 51, *52*
 as portraitist, 51
Cork, art collections in, 2–3
Corot, Camille, 161
Correggio
 An Allegory of Virtue, 128–9, *128*

Cosway, Richard, 38
Courbet, Gustave, 172
 La Belle Irlandaise or *Portrait of Jo,*
 the Beautiful Irish Girl,
 153–5, *155*, 156
 The Studio of the Painter, 6, 118,
 146–8, *147*, 149–50, *150*,
 151–2, 153, 159, 173
 letter to Champfleury on,
 146–7, 149, 151
 The Young Ladies on the Banks of
 the Seine, 204n
Craig, Cairns, 100
Craven, Thomas, 172
Crookshank, Anne, 84
Cruikshank, George, 81
cubism, 6, 164, 170, 171
 see also Jellett, Mainie
Cunningham, Allan, 116, 126, 127,
 130
Curtis, L. P., 81–3, 90, 136
 Anglo-Saxons and Celts, 81
 Apes and Angels, 81

Dalsimer, Adele
 Visualizing Ireland: National Identity
 and the Pictorial Tradition, 3
Darly, Matthew, 109
David, J. L.
 Death of Marat, 176n
Davis, Thomas, 119–20, 132
Deane, Seamus, 2, 21, 39, 47, 107,
 135
Deane, Thomas, 181n
Delacroix, Eugène
 visit to Morocco, 131
de Lamartine, Alphonse, 150–1
Derricke, John
 The Image of Irlande, 7–11, *8*, 9
Derrynane, Co. Kerry, 100–1, 193n
de Vere, Aubrey
 The Year of Sorrow – Ireland, 144
Deverell, Walter Howell, 118, 136,
 153, 202n
 The Irish Vagrants, 142–4, *143*,
 145–6, 147

Disraeli, Benjamin
 Young England party, 43
distilling, illegal, 121, 125, 131
 see also Wilkie, David: *The Irish*
 Whiskey Still
Doyle, John ('HB'), 94
Dublin, 61, 69, 178n
 art collections in, 2–3
 art schools in, 18, 19, 165
 exhibitions held in, 18–19, 54,
 162, 166
 see also Society of Artists
 the Pale, 10
 representations of, 16–17, 51, 54
 St Patrick's Cathedral, 69–70
 Terenure College, 180n
 Trinity College, 69
Dublin Castle, 69
 St Patrick's Hall, 6, 53, 70, 73–5,
 76, 78, 79, 80
 see also Waldré, Vincent
Dublin Evening Post, 70
Dublin Gazette, The, 69
Duggan, G. C., 9
Dungannon Convention, 69
Dunne, Tom, 2, 101, 126
Dürer, Albrecht
 Melancholia I, 148

Eagleton, Terry, 2, 101, 106, 113,
 114, 203n
 and 'mandarin modernism',
 165–6
East India Company, 103
Eastlake, Charles Locke, 122, 124
Edgeworth, Maria, 13, 135
Edgeworthstown, Co. Longford,
 131
Edward III, 76
Edwards, Owen Dudley, 24
Electricity Supply Board *see* Shannon
 scheme
emigration, from England, 144
 from Ireland *see* immigrants
Emmet, Robert
 rebellion of 1803, 11

Errington, Lindsay, 144
Exshaw, John, 63

Faber, John, 86
Famine, The, 144, 148, 151, 197n
*The Famous History of Captain Stuke-
 ley*, 9–10
Fanon, Frantz, 139
Fantin-Latour, Henri, 160, 161
Fialin, Victor, 150
Field Day Anthology of Irish Writing, 2
Fielding, Henry
 Tom Jones, 87
FitzGerald, Lord Edward
 representations of, 92, 115, 192n
FitzGibbon, John, 60, 72–3, 78–9
 portraits of, 92, 186n, 188n
Fitzwilliam Museum, Cambridge,
 179n
Flanagan, Thomas, 101, 125–6
Flaubert, Gustave, 56
Foster, Roy, 2, 81, 84
 'Marginal Men and Micks on the
 Make: The Uses of Irish
 Exile, *c.* 1840–1922', 19
Fox, Charles James, 65, 72
Foxe, John
 Actes and Monuments, 7
France, 204n
 Celtic roots of, 170
 fears of invasion from, 11
 influence of art of, 161, 164, 165,
 170, 180n, 206n
 Irish delegations to, 150–1
 revolution of 1848, 149, 150
Fraser's Magazine, 43, 45–6
Free State, Irish, 162, 164, 168, 174
Fresnoy, 37
Freud, Sigmund
 Mourning and Melancholy, 113
Furbank, P. N., 111
Fuseli, Henry, 107, 110

Gainsborough, Thomas, 110
Gandon, James, 17
Gardiner, Luke, 60

genre painting, 18, 144
 Dutch, 130
 Irish women as subject for, 155–6
 see also Wilkie, David
*Gentleman's and London Magazine,
 The*, 63
George III, 11, 72, 76–7, 92
 illness of, 72, 73
Gibbons, Grinling
 Equestrian statue of William III, 59,
 60, 61, *61*, 66, 68, 80, 183n
Gibbons, Luke, 2, 36, 71, 83, 97,
 169, 180n, 182n
Gifford, Grace, 155
Gillespie, Raymond, and Kennedy,
 Brian P.
 Ireland: Art into History, 3
Gilley, Sheridan, 81–3, 138
Gillray, James, 69, 81
Gladstone, William Ewart, 95
Gleizes, Albert, 164, 166, 170, 171
Glin, Knight of, 84
Godwin, William
 Caleb Williams, 109–11
 Enquiry Concerning Political Justice,
 111
Goldsmith, Oliver, 20–1, 24
 The Deserted Village, 24
 The Vicar of Wakefield, 25, 26
 in *Weekly Magazine*, 89
Grattan, Henry, 59, 65, 69, 80, 185n
 followers of, 66, 67
 portraits of, 63, 69, 92, 153,
 192n
Green, Valentine, 63, 69
Grenville, Lord, 11
Griffin, Gerald, 126
Grosvenor, Lord Richard, 50
group portraiture, 51, 53, 62
Guelfi, Giovanni
 Cragg Monument, 195n

Hadfield, Andrew, 11
Hamilton, Gavin
 *Agrippina with the Ashes of Ger-
 manicus*, 30, *30*

Hamilton, Hugh Douglas, 18–19, 108, 172
Lieutenant Richard Mansergh St George, 83, 84, 104–6, *105*, 106, 107, 108, 113, 114
miniature of Mansergh St George, 196n
Harpignies, Henri, 161
Haverty, Joseph Patrick, 172
Advocates in a Good Cause, 131–2, *132*
Daniel O'Connell, 83, 84, 97–100, *98*, 101, 104
Haydon, Benjamin Robert, 41–2
Hazlitt, William, 47
Headford Castle, Co. Galway, 104
Hemingway, Andrew
Landscape Imagery and Urban Culture in Early Nineteenth-Century Britain, 3
Henry VIII, 79
Herding, Klaus, 147–8
Hibernian Journal, 88
Hibernian Magazine, 63, 65
Hiffernan, Jo, 153, 156
history painting, 20, 26, 30, 50–9, 66–80, 183n
contemporary, 50, 53, 59–66
James Barry and, 20, 36, 37, 39, 41
Royal Academy rules of, 65
Hogan, Thomas, 172–3
Hogarth, William, 25
Hogarth Club, London, 196n
Holbein, Hans, the Younger, 7
Hollywood, Edward, 151
Holy Family imagery, 5, 6, 119, 135, 144
see also mother and child imagery
Home, Robert, 69
The Marquess of Wellesley, 83, 84, 101–3, *102*
Homer's *Iliad*, 28
Hone, Nathaniel, 20, 22, 25, 26, 42, 44
early career as portraitist, 25

founding member of the Royal Academy, 20, 25
London exhibition, 24
The Pictorial Conjuror, Displaying the Whole Art of Optical Deception, 20, 22–5, *23*, 26, 38
Hone, Nathaniel the Younger, 161
Hueffer, Ford M., 140
Hughes, Thomas
The Misfortunes of Arthur, 8
Hunt, William Holman, 145

Illustrated London News, 144
Illustrious Order of St Patrick, 67–8, 69–70, 72, 73, 79
blue as colour of, 68
inauguration of, 67, 69–70
regalia of, 67–8, *68*, 70, 103
imagery of Ireland *see* symbols and imagery of Ireland
immigrants
Irish, 139, 142, 149, 151, 152
representations of, 6, 116, 136, *137*, 138–40, 146
and vagrancy, 118, 141
Jewish, 151
impressionist art, 160–1
independence for Ireland, 67
Ingres, Jean-Auguste-Dominique, 207n
Irish Confederation, 151
Irish Party, 57, 59, 65, 72
Irish Statesman, 166

Jellett, Mainie, 4–5, 162, 163–4, 165, 166, 169, 170–1, 172, 173
Decoration, 166, *167*
interest in cubism, 164, 166, 170, 171
Johnston, Denis, 172, 173
The Moon in the Yellow River, 171, 172, 173

Kauffmann, Angelica, 22–4

Keating, Geoffrey
 Foras Feasa ar Éirinn, 79
Keating, Seán, 4–5, 6, 162, 163, 165,
 172, 173
 Allegory, 163, *164*
 Night's Candles Are Burnt Out,
 163, *165*, 168–9, 171, 173,
 174
 and national identity, 169–70,
 171, 174
 realism and, 163, 170–2
 teacher at National College of
 Art, 173
Kelly, Hugh
 The School for Wives, 88
Kelly, James, 3, 88
Kennedy, S. B.
 Irish Art and Modernism, 163
Kilfeather, Siobhán, 111
Kilroy, Tom, 172, 173
Knighton, Sir William, 132

landscape painting
 classical, 6, 14, 16
 country house, 14–15, 16
 in English culture, 3
 of Ireland, 41, 131
 of Wales, 17
 see also individual artists
Lane, Edward William
 *Manners and Customs of the Modern
 Egyptians*, 56, 129
Lane, Hugh, 205n
La Touche, David, 60
Lavery, Lady Hazel, 155–6
Lavery, John, 161
 An Irish Girl, 155
 Kathleen Ní Houlihan, 155–6
Lawrence, Thomas, 95, 97, 193n
 George Canning MP, 95, *96*
Lebow, Richard Ned
 White Britain and Black Ireland, 81
Ledru-Rollin, Alexandre-Auguste,
 150
Leech, John
 Height of Impudence, 141, *141*

Leerssen, Joep, 88
Lefèvre, Dominique, 180n
Legros, Alphonse, 207n
Leinster, Duke of, 56, 61, 184n
 Knight of St Patrick, 69
 representations of, 56, *58*, 59, 63,
 72, 115, 182n
Lindsay, Jack, 152
literature, 135
 Gothic novels, 106, 109–12, 114,
 196n
 popular novels of peasant life, 125
 short story, 169
 see also colonialism; national
 identity
Lloyd, David, 2
Loftus, Belinda, 129, 152–3
Louvre, Paris, 128
Lover, Samuel
 Handy Andy, 39
Lucan, Co. Dublin, 118–19
 see also Roberts, Thomas
Lucian
 Of Gymnastik Exercises, 40

McCormack, W. J., 2
 on Thomas Moore, 49
MacDermott, Kathleen, 155
MacDonagh, Oliver, 2, 95, 100, 106
MacGonigal, Maurice, 165
Maclise, Daniel, 20, 21, 47, 172
 Anglicisation of surname, 43
 *Daniel O'Connell and Richard Lalor
 Sheil*, 46
 illustrations for *Fraser's Magazine*, 45
 'Gallery of Illustrious Literary
 Characters', 45
 under pseudonym of Alfred
 Croquis, 45
 illustrations for *Moore's Irish
 Melodies*, 47
 The Origin of the Harp, 47, *48*,
 49, 153, 156
 The Installation of Captain Rock, 44
 Marriage of Strongbow and Eva,
 47–9, *49*

Merry Christmas in the Baron's Hall,
 43–4, *45*
Snap-Apple Night, or All-Hallows
 Eve, in Ireland, 44
The Wood Ranger with a Brace of
 Capercailye or Cock of the
 Wood, 43
MacSweeney clan, 7
Maginn, William, 46
Mahony, Francis Sylvester, 180n
 The Reliques of Father Prout, 39, 45
 satire on Barry, 39–40
 The Attractions of a Fashionable
 Irish Watering-place, 40
Maley, Willy, 11
Manet, Édouard, 161
Mansergh St George, Richard, 83,
 107, 109, 112, 113–14, 194n
 Account of the State of Affairs in and
 About Headford, Co. Galway,
 112–13
 as caricaturist, 109
 death of, 107
 letter commissioning portrait,
 106, 107–8, 110, 111, 112,
 113, 114
 volumes of family history, 108,
 111, 112
 see also Hamilton, Hugh Douglas
manufacturing of Irish dress, 187n
Mathew, Father Theobald, 132
Maturin, Charles, 106
 Melmoth the Wanderer, 106, 107,
 113
 The Milesian Chief, 104
Maurice, Frederick Denison, *137,*
 138, 146
Mayhew, Henry, 139
 The Irish Street Seller, 139
Meagher, Thomas Francis, 151
Medina, John, 180n
Melbourne, William Lamb, 94
Metzinger, Jean, 164
Michelangelo, 29
modernist art, 6, 160, 161, 162,
 163–4, 165–6, 172

Molyneux, William, 80
 Case of Ireland . . . Stated, 78
Monet, Claude, 161
Moniteur Universel, 150
Montgomery, Richard
 portrait of 63, *64,* 65
Moore, Thomas, 21, 47, 49
 Irish Melodies, 47, 129
 Memoirs of Captain Rock, 44
 Memoirs of the Right Honourable
 Richard Brinsley Sheridan, 44
Moran, D. P., 169
More, Jacob
 The Falls of Clyde, Corra Linn, 15,
 16
Morgan, Lady
 The O'Briens and the O'Flahertys,
 114–15
 O'Donnel, A National Tale, 101
Morland, George, 130
Morris, Frank, 81
Moser, Mary, 22
mother and child imagery, 118,
 144–5, 163
 see also Holy Family imagery
Mulready, William, 20, 21, 45, 47
 and the Royal Academy, 43
 Seven Ages of Man or All the
 World's a Stage, 43–4
Mysore wars, 103, 194n

Napoleon III, 147, 148, 149, 150,
 152
 De l'extinction du paupérisme, 147
Nasmyth, Alexander, 14, 198n
Nation, The, 120, 132
National Bank of Ireland, 94, 192n
 joins the London Clearing House,
 95
National Gallery, London, 42
National Gallery of Canada, Ottawa,
 53
National Gallery of Ireland, 3, 56,
 107, 159, 180n, 182n, 193n
National Gallery of Scotland, 128,
 198n

national identity
 in art, 56, 57, 95, 116, 162, 163,
 169
 in literature, 57, 169
 see also Keating, Seán; Protestants
National Portrait Gallery, London,
 92, 186n
Nicholson, Ben, 166
Nieuwenhuys, C. J., 135
Nochlin, Linda, 146, 147, 148, 152,
 159, 173
North, Lord, 65
Nugent-Temple-Grenville, George,
 67, 69, 70, 72, 73, 75, 76–7,
 79
 Knight of St Patrick, 76
 relinquishes viceregal office, 75–6
 representations of, 68

O'Brien, William Smith
 leads abortive rising, 151
O'Connell, Count Daniel (uncle to
 Liberator), 101
O'Connell, Daniel, 44, 46, 83, 93,
 94, 95, 100–1, 132, 150, 151,
 194n
 admirer of Scott's novels, 100
 attacked by The Times, 94
 and Catholic Emancipation, 100
 opposed poor law, 101
 visual representations of, 44, 46,
 83, 90, 92, 94, 194n
 see also Haverty, Joseph Patrick;
 Wilkie, David
O'Connor, Frank, 169
O'Conor, Roderic, 161–2, 164, 165
O'Faoláin, Sean, 169
O'Halloran, Clare, 71, 79
O'Leary, John, 159
O'Meara, Frank, 161
O'Neill, Thurlough Luinagh, 7
Order of the Bath, 67, 72, 86, 87
Order of the Garter, 67, 72, 76,
 189n
Order of St Patrick see Illustrious
 Order of St Patrick

Order of the Thistle, 67
Orpen, William, 160, 161, 171,
 205n
 The Colleen, 155
 The New Bonnet, 155
 Young Ireland, 155
Osborne, Walter, 161, 164

Paine, James, 180n
Palace of Westminster, 47
Pasquin, Anthony
 An Authentic History of the Artists
 of Ireland, 25
 on Hone, 25, 26, 38
 The Royal Academicians, 38–9
patronage, 21
 in England, 20
 in Ireland, 18
Payne, Christiana
 Toil and Plenty, 145–6
Peale, Charles Willson, 185n
Pearce, Edward Lovett, 54
peasantry, representations of, 5, 45,
 116–18, 130, 133, 134, 135–6,
 141
 cabin interiors, 116, 118, 120,
 121
 see also Wilkie, David
 and criminality, 116, 121, 127,
 141
 see also immigrants; literature;
 Peep-O-Day Boys; White-
 boys
Peel, Robert, 95–7
Peep-O-Day Boys, 124
Penal Laws, 67
Peters, Matthew William, 38
Petrie, George, 133, 134
 The Last Circuit of Pilgrims at Clon-
 macnoise, 133–4
Picasso, Pablo, 171
pictorial reportage see history painting
Pissarro, Camille, 161
Pitt, William, 103
Plint, Thomas, 140, 202n
Plutarch's Isis and Osiris, 29

Pointon, Marcia, 92, 127
 on James Barry, 44–5
 on Mulready, 45
politics in eighteenth-century Ire-
 land, 57–9
Pompeii, wall paintings at, 76
Ponsonby, Sarah, 109
portraiture, 95, 106
 in Ireland, 18, 83, 84
 in London, 65
 in USA, 86
 see also South Kensington Museum
post-impressionism, 162
Powerscourt, Co. Wicklow, 15
Pre-Raphaelite Brotherhood, 6, 118,
 136, 156–7
Pressly, William, 20, 26, 28–9, 30, 36
Protestants, 89–90
 and Irish Gothic, 106–7, 113
 nationalism of, 56, 66, 68
 and Patrician tradition, 71
 propaganda of, 7
 see also Volunteers
Proudhon, Pierre-Joseph, 151, 152
Prown, Jules, 180n, 185n
Prout, Father, *see* Mahony, Francis
 Sylvester
Punch, 5, 81, 92, 136, 140, 141, 144,
 192n
 'The Irish Frankenstein', 90, 95
 The Real Potato Blight of Ireland, 90
 see also Tenniel, John

Quinn, D. B., 10

Rabl, Kathleen, 8, 9
Radcliffe, Ann
 The Mysteries of Udolpho, 112, 114
Raeburn, Henry, 19, 181n
 chieftain portraits of, 100
 The MacNab, *99*
realism in twentieth century, 162,
 168, 170–1
 see also Keating, Seán
rebellion of 1798, 18, 107, 196n
Reform Club, London, 193n

Regency Crisis, 72–3, 75, 80
religious imagery, 122, 124
 see also Holy Family imagery
Renan, Ernest, 56
Reynolds, Sir Joshua, 22, 24, 25, 26,
 30, 37, 38, 179n, 180n, 181n
 'Fourth Discourse', 86
 plagiarism of, 22, 24, 26
 and the Royal Academy, 20, 22
 Third Earl of Bellamont, 5–6, 83,
 84–7, *85*, 87–8, 90, 97, 104
 William, Duke of Cumberland,
 190n
Robert, Léopold-Louis, 123, *123*
Roberts, Thomas
 Lucan Demesne, 41, 118, 119, *119*
Robson, G. F., 200n
Roche, Regina Maria
 The Children of the Abbey, 111
Romney, George, 196n
Rossetti, Dante Gabriel, 156
Rousseau, Jean-Jacques, 107, 109,
 196n
Rowlandson, Thomas, 72
 *Vice Q—'s Delivery at the Old Sol-
 dier's Hospital in Dublin*, 189n
Royal Academy, London, 13, 16, 18,
 20, 21, 22, 24, 26, 27, 36, 41,
 47, 65, 136, 144
 exhibitions, 30, 43–4, 50, 51, 86,
 88, 94, 116, 121, 122, 134,
 168
 moves to Trafalgar Square, 42
 Schools of, 27, 31, 43
 at Somerset House, 22, 26, 27
 see also Barry, James; Reynolds,
 Sir Joshua; Zoffany, Johann
Royal Hibernian Academy, Dublin,
 42, 131, 133, 173, 181n
Royal Irish Academy, 71
Royal Society of Arts, London, 27,
 31, 36, 42, 50, 153
Rubens, Peter Paul
 Whitehall scheme, 53–4
Rubin, J. H., 151, 152
Russell, George ('AE'), 166–8

Said, Edward, 56
 Orientalism, 129
St Patrick, 71
 feast day of, 67, 70
 see also Illustrious Order of St
 Patrick; symbols and
 imagery of Ireland; Waldré,
 Vincent
St Paul's Cathedral project, 22, 26,
 38
Saint Simon, followers of, 131
satirical cartoons depicting the Irish,
 5, 10, 39, 153, 156
 Attempt on the Potatoe Bag, An, 11,
 12
 Carrying the Union, 72, 153, *154*
 Corsican Locust, The, 11, *12*
 *Prerogatives Defeat or Liberties Tri-
 umph*, 65, *66*
 see also Punch; stereotyping of
 Irish; Tenniel, John
Say, Frederick Richard, 97
Schiff, Gert, 195n
Scopas
 Pothos, 195n
Scotland, 14, 15, 97–100, 101, 130
 Edinburgh, 19
 see also Raeburn, Henry
Scott, Sir Walter, 97, 100, 176n
 Waverley, 100
secret societies, 125, 127
Seward, Anna, 109–10
Shannon scheme (ESB), 168, 171,
 173, 174
Shee, Sir Martin Archer, 20, 21,
 41–2, 44, 47
 achievements of, 42
 admiration for Daniel O'Connell,
 44
 Anglicisation of surname, 42
 and Catholicism, 43
 on James Barry, 42
 President of the Royal Academy,
 41, 42, 43
 and the Royal Hibernian Acad-
 emy, 42

Sheil, Richard Lalor, 46
Shelley, Mary, 110
Sheridan, Richard Brinsley, 20–1
 School for Scandal, 24
Sheridan, Thomas, 90
 The Brave Irishman, 87
Sherwin, John Keyes
 *The Installation Banquet of the
 Knights of St Patrick*, 68
Siddall, Elizabeth, 156
Sidney, Sir Henry, 7–8
Sidney, Sir Philip, 7
Smollett, Tobias
 *The Expedition of Humphrey
 Clinker*, 87
Society of Artists, Dublin, 15, 51,
 55, 184n
Solkin, David, 17
South Kensington Museum
 Third Exhibition of National Por-
 traiture, 90–2
Spectator, 97
stage Irish *see* stereotyping of Irish
Steinberg, Leo, 29
Stepney, Anne, 107–8
stereotyping of Irish, 5, 10, 13,
 81–4, 87, 90, 116, 135, 136,
 138–41, 142
 benevolent form of, 83, 84, 97,
 145–6
 stage Irish, 6, 8, 9, 39, 87, 88–9,
 104, 121, 168
 see also satirical cartoons
Stokes, William, 133
Stowe, Bucks, 75, 76
Stratford, John, Earl of Aldborough,
 69
Strickland, Walter, 42
Swift, Jonathan, 80
symbols and imagery of Ireland, 47
 harp, 47, 48, 67, 156, 188n
 Hibernia, 54, 71, 77, *82*, 144,
 152–3, *154*, 156
 Kathleen Ní Houlihan, 155, 156,
 188n
 potato imagery, 11, 90

St Patrick, 6, 54, 70, 71–2,
 79–80, 188n
 see also Illustrious Order of St
 Patrick; St Patrick

Tandy, James Napper, 61
 attempts to create National Con-
 gress, 65
 portraits of, *4*, 54, 60, 63–5, *64*
temperance movement, 132
Temple, Earl *see* Nugent-Temple-
 Grenville, George
Teniers, David, 130
Tenniel, John, 81, 144
 cartoons for *Punch*, 81
 'Two Forces', *82*, 153, 156,
 169
Thackeray, William Makepeace, 43
 as M. A. Titmarch, 43
Tipu Sultan, 93-94, 103
Tonks, Henry, 171, 207n
The Torso Belvedere, *32*
 see also Barry, James
Toussaint, Hélène, 149–50
Townshend, Lord, 88
Trade Laws, 57–9
 Irish Free Trade Bill, 59
 repeal of Trade Laws, 59, 61
Tresham, Henry, 41
Tristan, Flore
 Les Promenades dans Londres, 152
Trumbull, John, 65
 General Washington, 63, *64*, 65

Union with Britain, 49, 72–3, 97,
 153
 see also Act of Union
United States of America
 American War of Independence,
 57, 106, 109
 images of heroes of, 63
 art of, 53, 86, 171–2
 Federal Art Project, 172
 links with Volunteers, 65
 see also portraiture
Uwins, Thomas, 122

vagrancy *see* immigrants
Vanitas tradition, 153–5
Vernon, Robert, 124, 134–5, 197n
Volunteers, 53, 54, 59, 60, 61, 65,
 66, 67, 69, 80, 114–15, 186n
 formation of, 57
 as Protestant defence force, 57, 66
 representations of, 56, 63, 185n,
 186n
 see also Wheatley, Francis

Waldré, Vincent, 156
 Pompeiian Music Room and Oval
 Saloon at Stowe, 75, 76
 St Patrick's Hall ceiling, 53, 54–5,
 55, 56, 73–6, 77, 78, 152,
 174
 *George III, supported by Liberty
 and Justice*, 74, 75, 77–8
 *King Henry II receiving the sub-
 mission of the Irish Chief-
 tains*, 54, 75, *75*, 77
 *St Patrick converting the Irish to
 Christianity*, 54, *74*, 189n
 modello for, 77, 79
 themes of, 54, 75, 77–8
Wales, 14, 17
Walker, Joseph Cooper
 *Outlines for a Plan for Promoting
 the Art of Painting in Ireland*,
 80
Walpole, Horace
 The Castle of Otranto, 112
Ward, William, 97, 98
Washington, George
 portraits of, 63, 183n
Watts, George Frederic, 5, 118, 136,
 153, 202n
 The Irish Famine, or *The Irish Evic-
 tion*, 142–4, *143*, 146, 147
Wellesley, Marquis of, 83, 101
 dismay on receiving Irish peerage,
 103–4
 as Knight of St Patrick, 103, 104,
 190n
 tenure in India, 103

Wellington, Duke of, 11, 13, 97, 101
West, Benjamin, 53, 65
 The Battle of the Boyne, 50, 51, *51*
 The Death of General Wolfe, 53
 *The Institution of the Order of the
 Garter*, 76, 77
 *William Penn's Treaty with the Indi-
 ans*, 53
Wheatley, Francis, 172, 184n
 and the conversation piece, 51–3
 as portraitist, 53
 The Irish House of Commons, 62–3,
 65
 group portraiture of, 63, 69
 Review at Belan Park, Co. Kildare,
 69
 *A View of College Green with a
 Meeting of the Volunteers*, 3,
 4, 51, *52*, 53, 54–6, 57, *58*,
 59, 61, 63, 65–6, 69, 80,
 115
 group portraiture of, 59–60, 62
 line engraving after, 56–7, 62
Whistler, James McNeill, 153,
 156–7, 160, 161
 Symphonies in White, 156
 Weary, 156, *157*
Whiteboys, 125
Wilkie, David, 5, 6, 19, 44, 45, 94,
 118, 128, 129, 131, 173, 192n,
 198n
 *Chelsea Pensioners Reading the
 Waterloo Despatch*, 11–13, *13*
 Daniel O'Connell, 83, 84, 90–2,
 91, 93, 94, 95, 97, 101
 genre painting of, 6, 118, 120,
 127, 135
 An Irish Baptism, *120*
 The Irish Whiskey Still, 45,
 116–18, *117*, 119, 125–9,
 130, 131, 132, 135
 letters to friends, 124–5, 127,
 128, 131, 132–3, 134
 Painter in Ordinary to William IV
 and Victoria, 121

The Peep-O-Day Boy's Cabin,
 116–18, *117*, 119, 121,
 123–4, 125–7, 128, 129–30,
 134–5
The Penny Wedding, 130
*Sir David Baird Discovering the Body
 of Sultan Tippoo Saib*, 93–4,
 93
The Spanish Posada, 121–2
travels in Italy and Spain, 120,
 122
visit to Ireland, 116, 119, 121,
 129, 172
William of Orange
 birthday celebrations, 61–2, 70
 cult of, 67, 70, 80
 orange as colour of, 68
 see also Gibbons, Grinling
Wilson, Andrew, 198n, 199n
Wilson, Richard, 14, 17
Winckelmann, Johann, 31
Wind, Edgar, 53, 65
Windsor Castle
 decoration of King's Audience
 Chamber, 76
World Fair, Paris, 149
Wright, George, 22
Wright, Joseph, 107
 portrait of Boothby, 196n

Yeats, John Butler, 156, 157–9
 and impressionism, 160–1
 and Irish Literary Revival, 199n
 Lily Yeats Reclining, 157, *158*, 159,
 160
 sketches of W. B. Yeats, 157
 W. B. Yeats, *158*, 159
Yeats, Lily, 157, 205n
Yeats, Lollie, 157, 205n
Young, Arthur, 118–19

Zoffany, Johann
 *The Academicians of the Royal Acad-
 emy*, 22, *230*